INDONESIAN EYE Contemporary Indonesian Art

INDONESIAN EYE

INDONESIAN EYE

Contemporary Indonesian Art

edited by
Serenella Ciclitira

SKIRA

Design
Marcello Francone

Editorial coordination
Eva Vanzella

Copy editor
Emanuela Di Lallo

Layout
Serena Parini

First published in Italy in 2011
by Skira Editore S.p.A.
Palazzo Casati Stampa
via Torino 61
20123 Milano
Italy
www.skira.net

© 2011 Parallel
Contemporary Art
© 2011 Skira editore
© Mella Jaarsma by SIAE 2011

Printed and bound in Italy.
First edition

ISBN Skira: 978-88-572-1075-9
ISBN Parallel Contemporary Art:
978-88-572-1132-9

Distributed in USA, Canada,
Central & South America
by Rizzoli International
Publications, Inc., 300 Park
Avenue South, New York,
NY 10010, USA.
Distributed elsewhere in the
world by Thames and Hudson
Ltd., 181A High Holborn,
London WC1V 7QX,
United Kingdom.

INDONESIAN EYE

Presented by

PRUDENTIAL

Founder of Indonesian Eye
David Ciclitira

Editor and Project Director
Serenella Ciclitira

Assistant Editor
Eun Young Kim

Curators
Serenella Ciclitira
Nigel Hurst
Tsong-Zung Chang

Indonesian Curators
Jim Supangkat
Asmudjo Jono Irianto
Farah Wardani

Sponsorship and Event Director
Charles Perring

Exhibition and Project Coordinator
Eun Young Kim

Authors of the Essays
Sue Ingham
Asmudjo Jono Irianto
Amanda Katherine Rath
Jim Supangkat
Leonor Veiga

Interns
Alvian Azaria
Jihye Kim
Niken Palupi
Bayu Soedarsono

*Thank you to those who have
contributed:*

*Curators in Indonesia and Singapore
who introduced artists to us and
helped to collect the materials*
Rifky Effendy
Agung Hujatnikajennong
Agung Kurniawan
Boonhui Tan
Siuli Tan
Farah Wardani

*Galleries who kindly provided
artists' materials*
Ark Galerie, Galeri Apik, Galeri
Canna, Galeri Semarang, Heri Pemad
Art Management, Kersan Art Studio,
Langgeng Gallery, Mon Decor Art
Gallery, Nadi Gallery, SIGIarts Gallery,
Tonyraka Art Gallery, Valentine Willie
Fine Art, Vanessa Artlink, Vivi Yip
Art Room

Special thanks to

Ciputra Artpreneurship Gallery
Rina Ciputra Sastrawinata,
President Director

British Council
Keith Davies, *Director*
Yudhi Soerjoatmodjo,
Programme Manager

Jakarta Art Council
Firman Ichsan, *Director*

Sotheby's in Indonesia
Deborah Iskandar,
Managing Director

Supported by

Ministry of Culture and Tourism,
Republic of Indonesia

Ministry of Foreign Affairs
Republic of Indonesia

**MINISTRY OF TRADE
REPUBLIC OF INDONESIA**

wonderful
indonesia

PARALLEL
CONTEMPORARY ART

SAATCHI GALLERY

**MINISTRY OF TRADE
REPUBLIC OF INDONESIA**

It gives me great pleasure to provide a foreword for this book and to learn about the upcoming exhibition of Indonesian contemporary art.

I found the concept interesting and highly appropriate for Indonesia. It takes into consideration our diverse cultures and wealth of heritage, yet at the same time it is mindful of modern Indonesia with its commentary on real society. The blend of which gave birth to the aptly named collection: *Fantasies and Realities.*

The time is ripe for Indonesia's art to be showcased internationally. As a nation, we have proven our perseverance and resilience to establish the country as a key regional and global player. The largest democracy in the region, our 240 million citizens co-exist peacefully despite their diversity and together we have managed to create one of the most vibrant, dynamic and fastest growing economies in the world. This growth will continue for many years to come as more than half of our population are below 29 years of age.

This age group plays a significant role in the way our contemporary arts are shaped. Rooted in a magnificent tradition, Indonesia contemporary artists are able to soak up the global and local issues, moulding them into their work while still putting in their individual characteristics, which result in a uniqueness that I believe would make the art world impressed and take notice. It is quite easy to recognize the ingenuity and diversity of Indonesian art, so different from other contemporary expressions. Unfortunately, despite bearing very rich artistic tradition, Indonesian art is not very well known internationally and we strongly believe the inaugural *Indonesian Eye* exhibition will provide a fantastic opportunity for the world to see the strength and depth of the contemporary Indonesian artistic offering.

Our Ministry is a great supporter of the creative economy and the arts. It is our role to facilitate, to act as the hub agency and to provide a public outreach platform for our creative economic agents to flourish. The creative industry has contributed 7.6% of our total GDP and has created jobs for as many as 7.4 million people. It is thus natural for our Ministry to support *Indonesian Eye* in producing this magnificent book and to provide a regular platform for Indonesian art and artists to promote themselves through exhibitions, both at home and abroad.

I see the publication of this book and the exhibition as a celebration of "Remarkable Indonesia", a concept showcasing the multidimensional facets of this fascinating country on the global stage. The artists included in the collection are not only among Indonesia's brightest and emerging contemporary figures but also represent the four regions of Indonesia. Art, as a form of expression, broadens our experience and our vision; it serves as a reminder of our diversity and our commonality, our past and our future, our challenges and our opportunities. The art you will find here embodies all of this in a unique and creative way.

This programme came at an exciting time of cultural and economic transformation for Indonesia and the dynamics we experience are well reflected in the works included in this book. I am thankful for the support, commitment and partnership that have gone into the production of the book and the exhibition, from Prudential whose sponsorship has brought this programme into reality, to the curators whose expert eye has made this book and the exhibition truly enjoyable, and to the artists for sharing their remarkable work.

Dr. Mari Elka Pangestu
Minister of Trade, Republic of Indonesia

Ministry of Culture and Tourism,
Republic of Indonesia

I am truly delighted to support the *Indonesian Eye* exhibitions and this book. I sincerely admire the noble intention of this programme to bring the work of this country's best and brightest contemporary artists to the world's attention.

One needs only to spend a short time in Indonesia to appreciate the diversity of its geography, history, culture, language, religion, architecture and ethnicity. Indonesia is a country where art and culture are central to people's lives. "Wonderful Indonesia" reflects the country's beautiful nature and unique culture. I am pleased to see this diversity embraced by and reflected in the *Indonesian Eye* book and exhibition. It is a collection that I feel is a fitting introduction to Indonesian contemporary art and it is with great excitement that I look forward to sharing this book with a global audience.

Much of what Indonesia has to offer remains unexplored by the rest of the world. The Ministry of Culture and Tourism encourages everyone to visit our beautiful archipelago. Art is one of the main values of Indonesia's culture and our traditional heritage has gained recognition by UNESCO who include our *Batik* (woven textile), *Keris* (blade dagger) and *Wayang* (shadow puppets) in their List of World Intangible Cultural Heritage. Beyond our historic and traditional arts and crafts, we are committed to the development of contemporary art in Indonesia. Our existing presence on the global contemporary art scene is nascent and it is for this reason that I nurture great enthusiasm for the *Indonesian Eye*: it offers a magnificent opportunity to celebrate and promote our artists on a world stage.

This year we will see the launch of the *Indonesian Eye* collection in Jakarta where the artists as well as Indonesia's many art enthusiasts will come together to celebrate the work. Bringing the collection to the prestigious Saatchi Gallery in London as a next phase will really bring the aims of the *Indonesian Eye* to life: showcasing the work to an international audience who are unlikely to have yet been exposed to the complexity and diversity of Indonesian contemporary art. Indeed, the international platform that the *Indonesian Eye* will build for these artists will allow them to continue to promote themselves and their work for years to come, paving the way for future generations to benefit from increased global interest in Indonesian contemporary art.

This book shares a broader selection of artists and works than the exhibitions and I am pleased that we have an opportunity to introduce the world to some of this country's most fascinating and inspiring work from both emerging and recognized artists. I hope this book will whet readers' appetites to learn more about the beauty and diversity of Indonesia.

I am highly appreciative of the sponsor, publisher and particularly the artists who have contributed to this book.

Jero Wacik
Minister of Culture and Tourism, Republic of Indonesia

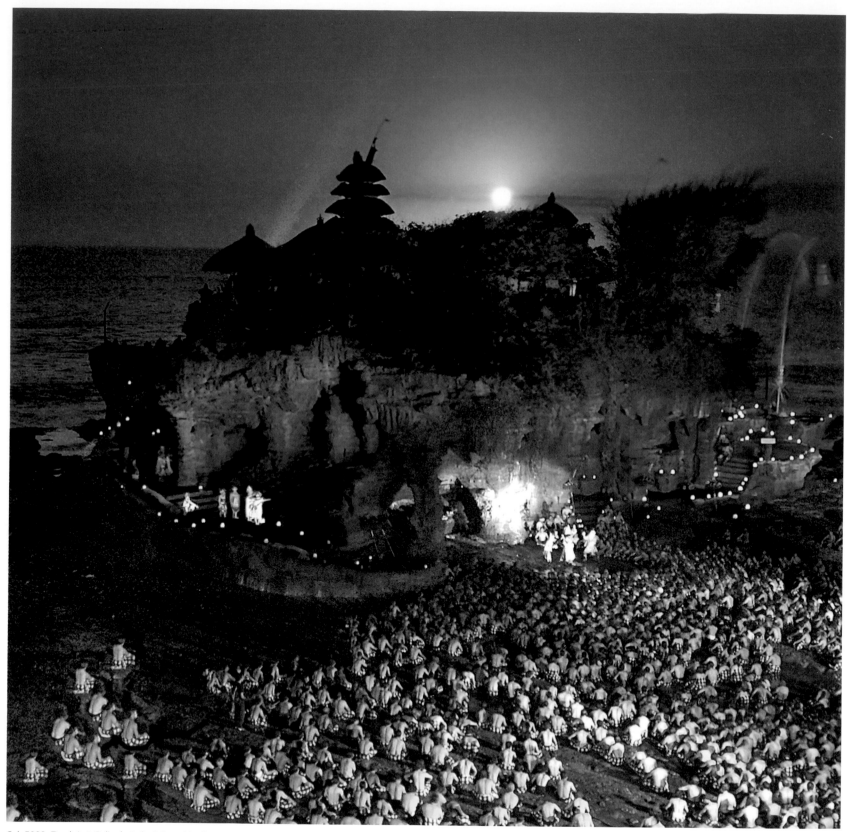

Cak 5000, Tanah Lot, Bali, photo by Johnny Hendarta, courtesy of Directorate for Promotional Publication, Ministry of Culture & Tourism

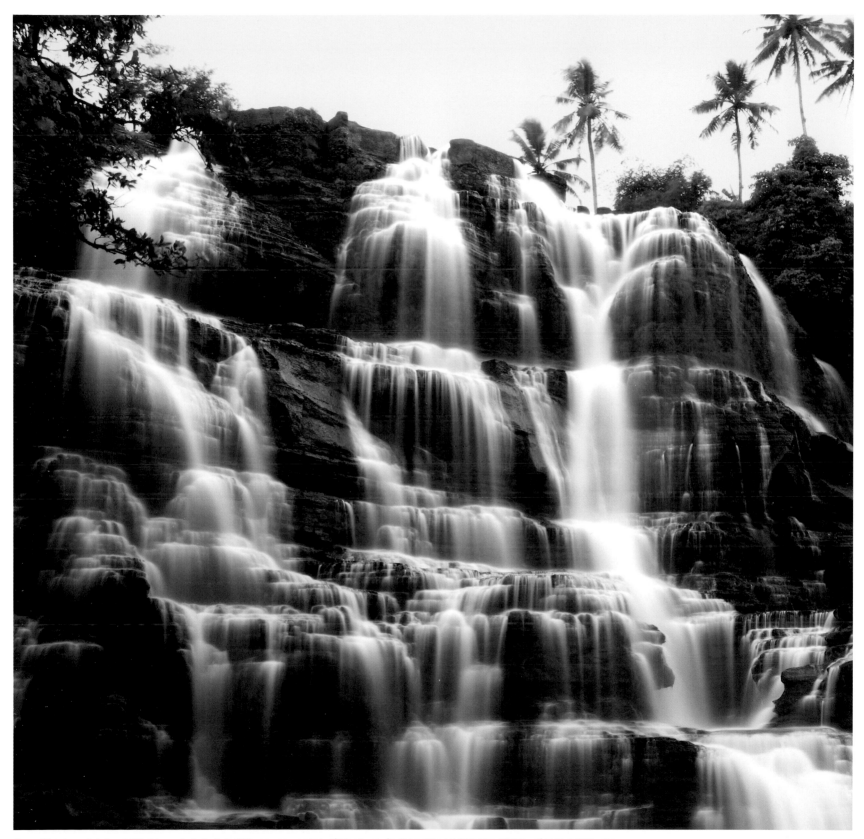

Curug Ciangsana, Sukabumi, West Java, photo by Setiadi Darmawan, courtesy of Directorate for Promotional Publication, Ministry of Culture & Tourism

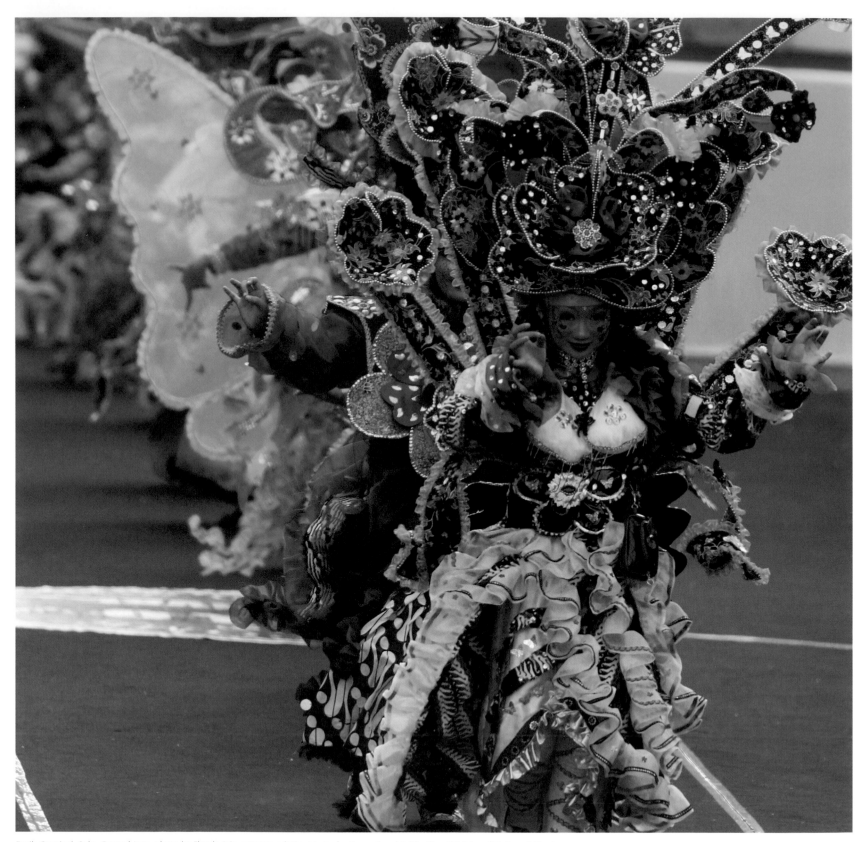

Batik Carnival, Solo, Central Java, photo by Flendy Arie, courtesy of Directorate for Promotional Publication, Ministry of Culture & Tourism

Anyone who visits Indonesia is instantly struck by the warmth and vibrancy of the Indonesian people. I travel to Indonesia frequently and I am continually impressed by the diversity and talents of this country and its people. The dynamism is not only expressed through Indonesia's rich cultural traditions, but also through the country's visual, literary and performing arts. To showcase the depth of this talent and creativity, Prudential is pleased to sponsor the *Indonesian Eye* exhibitions in Jakarta and London. Through the *Indonesian Eye*, we will celebrate the quality and diversity of Indonesian artists by showcasing their work first in Jakarta, and then again on a global stage at the Saatchi Gallery in London.

The *Indonesian Eye* book which you now hold features artwork created by both recognized and up-and-coming contemporary Indonesian artists using a broad range of visual media – from oil and acrylic to video, photography and mixed media installations. These one-of-a-kind works reflect a delicate blend of traditional and contemporary elements – much like Indonesia's culture today – and they demonstrate the energy and individuality of Indonesia's large and increasingly young population.

Art offers a unique window into a country's people, cultural traditions and ethnic heritage. Through the *Indonesian Eye*, we hope to inspire creativity, evoke emotion and bring attention to Indonesia's own culture and emerging art scene. Indonesia is already widely recognized globally for its handicrafts, textiles and other national riches, yet its contemporary art scene is rapidly becoming one of Southeast Asia's most active and vibrant, with new and emerging galleries, artists and activities driving innovation and creativity across the entire nation.

Art is a powerful medium to express one's hopes and aspirations. As a leading life insurer in Asia, Prudential is focused on helping people prepare and plan for their future through listening to and understanding their motivations, goals and dreams. With our roots in the United Kingdom, we have built a strong platform across Asia that today features more than fifteen million customers in thirteen diverse and dynamic economies. Since launching our business in Jakarta in 1995, Indonesia has quickly grown to become one of Prudential's largest markets in Asia. Today, we are proud of our position as the country's leading life insurer, with more than 80,000 employees and agents.

As our business has grown, so too has our commitment to corporate citizenship, particularly in the important areas of youth development, health and financial literacy. Our principal sponsorship of the *Indonesian Eye* is indicative of Prudential's strong interest in supporting the arts.

Our community engagement programmes in Indonesia and across Asia reflect our strong commitment to our communities. "Doing well by doing good" is at the core of Prudential's culture, whether this is bringing benefit to our customers and their families, our local communities or, more broadly, the countries in which we operate. The *Indonesian Eye* exhibitions and the book together provide a unique platform for Prudential to support emerging talents in Indonesia and to celebrate the energy and vibrancy that has long captured our interest and commitment.

For our employees, agents, customers, partners and communities in Indonesia, we look forward to bringing together a diverse and dynamic collection of art that reflects contemporary Indonesian culture.

This initiative is the result of close cooperation among numerous partners – in Indonesia, as well as in the UK and across Asia. I would like to thank David and Serenella Ciclitira of Parallel Contemporary Art for their passion for Indonesian art and leadership on the project. I would also like to thank our co-sponsors, without whom this programme could not have been achieved. We are grateful to those who have shared our vision for *Indonesian Eye* and are committed with us to promoting the development of contemporary Indonesian art.

Barry Stowe
Chief Executive, Prudential Corporation Asia

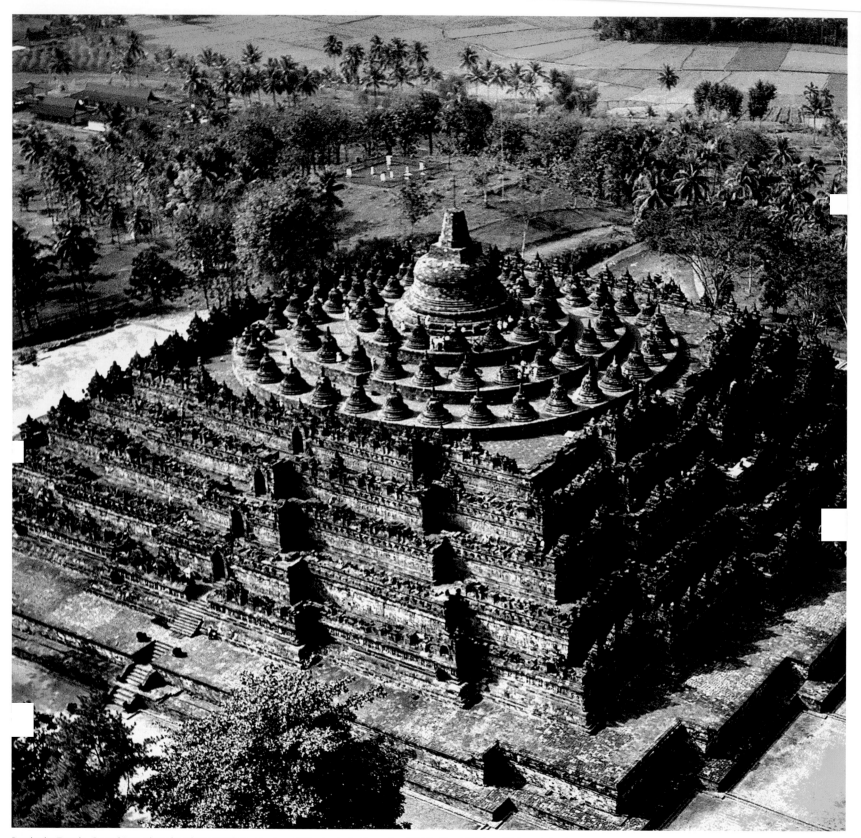

Borobudur Temple, Central Java, photo by Johnny Hendarta, courtesy of Directorate for Promotional Publication, Ministry of Culture & Tourism

INDONESIAN EYE

We have always shared a love for contemporary art; if you have been able to visit one of the *Korean Eye* exhibitions or have listed through the book *Korean Eye: Contemporary Korean Art*, then you will know what led us to create *Korean Eye* in 2009. *Korean Eye* was a project that we started in partnership with Standard Chartered and the Saatchi Gallery to help to promote emerging Korean artists internationally.

Our travels to Asia over the last twenty years and time spent with Asian artists in our capacity as Honorary Fellows of the Royal College of Art meant that following the success of *Korean Eye* we were keen to develop the "Eye" programme further. Whilst in Singapore with *Korean Eye* during the 2010 exhibition, we met many Indonesian artists whose passion and ability made Indonesia a natural successor to the Korean initiative.

For many, Indonesia is a special country, home to 240 million people and boasting an extraordinarily diverse culture spanning from Jakarta to Bali. There is an effervescent contemporary art scene which has provided us and the team with a wealth of talent to work with on the production of this book.

Art transcends language and social barriers. *Indonesian Eye* provides a platform not only for young artists but also for the Government and sponsors to promote Indonesia both locally and internationally.

We are delighted that we have received the support of the Minister of Culture and Tourism, Jero Wacik and the Minister of Trade, Dr. Mari Elka Pangestu and have been able to launch this initiative as part of the World Economic Forum hosted in Jakarta this summer. In doing so, we have met like-minded people on our journey – particularly our lead sponsor Prudential, the Saatchi Gallery in London and the Ciputra Artpreneurship Gallery in Jakarta.

It is always refreshing to find a company that shares our vision and Prudential has a fantastic team in Asia. With the support of Julie Lyle, chief marketing officer of Prudential Asia, we are making the inaugural step towards the development of other Asian "Eyes" and the furtherance of the "Eye" concept.

The Ciputra Artpreneurship Gallery will host our initial exhibition in Jakarta in June; the exhibition will then move at the end of August to the Saatchi Gallery in London where it will run until mid-October.

As with *Korean Eye*, it seemed to us a natural progression to create a book to coincide with the exhibition. We sincerely hope that everyone will enjoy the book and for many years to come we hope it will become a point of entry to those wishing to discover Indonesian contemporary art.

As with every project there are several people without whom both this project and this book would not have been possible.

We would like to take this opportunity to thank the following: Julie Lyle and her team from Prudential, Rina Ciputra Sastrawinata and her team at the Ciputra Artpreneurship Gallery, Minister Dr. Mari Elka Pangestu and Minister Jero Wacik, the Governor of Jakarta, Fauzi Bowo, the curatorial panel of Nigel Hurst, director of Saatchi Gallery, Tsong-Zung Chang, director of Hanart TZ Gallery and the Indonesian curators Jim Supangkat, Asmudjo Jono Irianto and Farah Wardani. All of the artists and other contributors including the team at Skira, with a very special thanks to Francesco Baragiola. It remains for us to thank the *Indonesian Eye* team which includes the assistant editor, Eun Young Kim who has been working with us night and day to edit this book, Charlie Wale, Charles Perring, Shana Hong, Liz Roberts, Monica Fleary, Joe Sole, Nicolas De Santis of Corporate Vision Strategists and Calum Sutton and all of his team. Finally thanks go to Joan Lee whose help and participation on *Indonesian Eye* have been invaluable.

Monaco, May 2011

David and Serenella Ciclitira
Co-founders of Indonesian Eye

Contents

Contemporary Art in the Indonesian Eye

Jim Supangkat

What, specifically, must we observe when looking at Indonesian contemporary art? The answer to this question is that we need to consider how reading Indonesian contemporary art works – in any of their myriad forms – cannot stop at text alone, because textual signs will mostly preoccupy themselves with superficial tokens or issues. A deeper meaning can only be found when we pay closer attention to reading how languages of expression are developed in these works.

Indonesian artists commonly employ languages that are closer to the body than to the mind as their chosen expressive phraseology. This language is acutely sensitive in recording feeling, emotion, anxiety, joy, happiness and other mental conditions. Through their creative experiences, artists may recognize the connection between expression and their own feelings and emotions. Indonesian artists will normally understand that the language they use, in various forms, can record each subtlety found within the realm of feeling.

However, the languages of expression found in Indonesian contemporary art works can become problematic when we try to find a place for them within the current global art development. They can be perceived as an oddity within the framework of art discourses that form the foundation of current global art development; especially since these languages are rather comparable to nineteenth-century aesthetic thought – the philosophy of beauty which questions the feeling of happiness derived from the sensations produced when encountering beauty. This sort of aesthetic thought exists outside art discourses.

The art discourses forming the basis of current global art have left this aesthetic understanding, often seen as a speculative examination on feelings (the intricacies in experiencing beauty) underlying art expressions. Art discourses have gone into what is perceived to be more definite studies, i.e., the historical examination of art works. The current forms of art discourses are comprised of these examinations.

As part of a greater sphere of philosophy, nineteenth-century aesthetics have also questioned reality and truth in reality. As such, art expressions hinging upon one's experience of beauty are a representation of reality in one's search for truth. Even this representation is not free from problems. In art discourses, this representation is seen as outdated and based upon the conviction that systems of representation evolve from one era to the next.

In the development of twentieth-century modern art, the system for representing reality based on impressions of beauty was deemed to be defunct. In its search for truth, twentieth-century art development, based on modernism, began to question the "languages" in art works found throughout history. This language – the language of art – must be differentiated from philosophy's literal language. They sought truth within the language of art, and this truth was a specific kind of truth. As such, in modernism, art expressions

were no longer representations, the central concept of philosophy. In this way, art has freed itself from philosophy.

Contemporary art has chosen to return to philosophy, thus returning to representation, although employing a system of representation that was previously unknown in art development. This system believes that there are no more boundaries between reality and representation. In his introduction of this concept, Arthur C. Danto pointed at Andy Warhol's work, an undeveloped packaging – the *Brillo Box* (1964), as an example. A thing lifted out of reality and made into a media of expression such as this one, is itself reality.[1]

However, when examining representational properties, Danto mentioned two terminologies that can be construed as "key words": *mental language*, which he went on to elaborate as needing more rigorous analysis from various points of view; and *aboutness*, being the link between description and reality. These terms are mentioned by Danto in discussing George Santayana's treatise in his famous book *The Sense of Beauty* – a classic text on the philosophy of art, which discusses nineteenth-century aesthetics; a book which Danto greatly admires.[2]

Both of Danto's terms can be seen as a possibility to understand the languages of expression found within Indonesian contemporary art works, as well as other contemporary art works outside of Europe and the United States. Another thought that can help widen this possibility further can be found in the treatise of an Indonesian philosopher, Bambang Sugiharto, on the theme of "metaphorical language".[3] Mental language can be compared to this metaphorical language, which Bambang Sugiharto sees as connected to various mental conditions – psychological symptoms, mystical experiences, flares of feeling, as well as being connected to causative logical thoughts (*aboutness*).

Bambang Sugiharto highlights the differences between "metaphorical language" and "literal language". He examines various philosophical treatises surrounding metaphorical language that have for so long been relegated to the fringes of the philosophical world due to their inability to present definite meanings.

Literal language is a simple, descriptive and systematic language (recognizing categories and classifications), and is used within an epistemological framework. Since many centuries ago, this language (in the form of texts) has been used to describe reality, in an attempt to seek truth, so much so that philosophy can no longer be separated from the development of texts. Historically, it can be said that the philosophical search for truth developed into two routes: one was to seek truth in reality, whereas the other sought truth within a collection of texts.

The search for truth along the first route was rather unsuccessful, because truth in reality is very complex, and therefore, it cannot be truly proven. Philosophy's search for truth turned to the second route: text. The language that was once used to describe reality became the object, or the venue, to seek truth. This led to the emergence of linguistic philosophy.

Linguistic philosophy was part of the dominant modernist discourse of the twentieth century. This branch of philosophy developed in parallel with scientific knowledge. Like all branches of science with their own complex language systems, philosophy also de-

veloped a system of complex literal language in its search of truth. Through these complex systems, linguistic philosophy and science claimed to have found truth.

However, the truth each of them found was a specific kind of truth: the kind of truth that existed only within the realm of each branch of knowledge. These truths were upheld in their respective fields based on commensurability (that is, they were measurable only by their own standards). This commensurability was based on the agreements reached within each "closed circle", and was not universally applicable.

Like most post-modernist thinkers, Bambang Sugiharto critically questioned the truths claimed by linguistic philosophy. How they upheld their truths was regarded as corrupt, because linguistic philosophy had attempted to link intra-linguistic truths (truth found within language) with extra-linguistic truths (universal truth). The attempt was made of structuring a complex logic into something coherent, unambiguous and separate from a text's status, in order to appear transparent, with the ability to present meaning and universal truth. This was the pinnacle of philosophical endeavours in using literal language in order to find absolute truth.

Ultimately, this attempt failed, and philosophy was thrown into disarray; a state of unrest beginning with Jacques Derrida's deconstructive treatise where he examined meaningless linguistic components within texts and found other meanings hidden behind certain commonly-accepted meanings. This became one of the catalysts in the emergence of "post-modernism", which itself was not a new -ism, even then. Rather, it was a strong sign of disorder within all dominant schools of thought of the twentieth century.

Twentieth-century modern art was equally affected. As part of modernist thinking, whose foundations were reflected in linguistic philosophy, modern art developed its own specific language, known as "visual language". As a particular visual language confined within this modernist discourse, it also led to a specific visual problem. This was what André Bazin meant when he alluded to an autonomous aesthetic problem. Parallel to the complex and incomprehensible intricacies within science, modern art works became esoteric.

Disorder within modern art led to a new development, known as "contemporary art" (though its understanding is still shaky at best, even now). With it, there was an attempt to tear down text, to free it from specific principles and to nurture more common and more open ways of reading, through semiotic and hermeneutic approaches, that were equally complex. Here, art expression was seen as a language with a common meaning. This language was readable thanks to similarities in perception and knowledge regarding signs and symbols.

In the face of this substantial change, Bambang Sugiharto was among the philosophers who tried to return to a way of thinking where thought is regarded as an attempt to understand reality. Philosophy is not the only way of thinking applied to the understanding of reality. He has acted critically towards logo-centric thoughts (the search for truth) because the wealth of thought across the history of human civilization can never grasp reality in its entirety. From this position, he began to look at the question of metaphorical language that had until then remained at the fringes of the philosophical world due to its inability to present sure and definite meanings.

Various thoughts on metaphorical language, in the evolution of philosophy, see this language to have emerged from creative imagination, aesthetic experiences, sublime feelings, critical attitude, sensitivity, even mystical experiences. This language presents metaphor that does not appear as a proposition in a hunt for truth. In Bambang Sugiharto's analysis, metaphor searches for "the ideal truth" that appears in the face of "less than ideal" conditions present in reality. Ideal truth does not pretend to find absolute truth. Thus, this truth exists in contention with other ideal truths. In addition, to various schools of thought (including philosophy) metaphor can often be found in art expressions.

Metaphors often emerge as oddities; they invite questions as they tend to collide with various categories of understanding. However, these oddities have allowed metaphors to introduce various symptoms of reality that are not widely known or understood. As such, these oddities inspire curiosity, which in turn stimulates the mind.

Metaphors are not knowledge about reality; instead, they are the *sources* of knowledge about reality. As such, all metaphors require careful reading, even radical interpretation. Their meanings can only be clear after breaking them up and translating them into literal language. This act of translation often leads to an awareness of a certain reality that was once incomprehensible. In Bambang Sugiharto's careful examination, metaphors retain a central position in human life, because they stand as language's fundamental characters in marking reality. Metaphorical patterns of understanding occur in all schools of thought, including philosophy. The usage of literal language to describe reality, in the beginning, was an attempt to translate metaphorical language.

Despite being within the domain of Western-oriented philosophy, it is clear how this examination into metaphorical language is reminiscent to fundamental symptoms found quite naturally in human existence. Thus, it does make sense that this metaphorical language flourishes outside the development of the Western world. In order to compare, we must understand the issues of representation, language and text: and the question then becomes, "can a discourse that based itself upon centuries of philosophical development in the Western world, be understood outside of it?".

In the Indonesian art world, the question of "representation" only emerged in 1993, together with a huge discussion surrounding post-modernism. Prior to this, such issues were only discussed within the closed confines of philosophical scholarship. In 1993, it was evident that even these thinkers were having a hard time in understanding the meaning of "representation". Although they did study various references – often suddenly and hastily – and even though most thinkers have gone to create abbreviated definitions for practical purposes, they could not avoid the emergence of various, and often-opposing, definitions of "representation". Whatever they did, it is impossible to understand the question of representation in post-modernism without first understanding its history.

Looking at this condition, it is almost impossible to hope for Indonesian artists – who must have kept a distance with the world of philosophy – to fully understand this question. This is despite the fact that to find the basis of thought in one's expressions, he or she must be able to understand how mastery over such an inquiry requires more than just understanding and thought. Understanding and thought, in artistic expressions, are connected to consciousness and conviction, all of which require further examination.

The nineteenth-century aesthetics discussed by Arthur Danto exists within the realm of philosophy. Various aspects of this thought (i.e., various human mental conditions) are comparable to the fundamental aspects of humanity. From these fundamental similarities, we can derive a logical conclusion that the expressions found within Indonesian contemporary art works have a certain closeness with this aesthetic view.

Like other contemporary art works found elsewhere, Indonesian contemporary art works, as seen in this book, present signs that can be collectively read as text. However, the mediated thoughts of Arthur Danto and Bambang Sugiharto demonstrate how these works cannot be understood in their entirety if we limit ourselves to semiotics. We need a way to read meanings "hidden" behind the plasticity of language, behind linguistic constructions, and behind various linguistic innovations; all of which are interpretations of a profound mental language. However, this kind of reading is fading out from within art discourses.

[1] Arthur C. Danto, *The Body / Body Problem: Selected Essays* (Berkeley: University of California Press, 2001), p. 5.
[2] Ibid., pp. 20–21.
[3] In Ignatius Bambang Sugiharto, *Postmodernisme: Tantangan bagi Filsafat* [Post-modernism: a Challenge for Philosophy] (Yogyakarta: Kanisius, 1996). This book comprehensively discusses the background of the dissonance surrounding post-modernism – itself a term that has never been universally accepted. However, this book does not stop at explaining what post-modernism is; we can also find Bambang Sugiharto's vision on metaphorical language, a theory born out of his thoughts and experiences. He has close ties with the Indonesian art world.

Eyeing Indonesian Contemporary Art

Asmudjo Jono Irianto

Within the past decade, contemporary art has sprung from every corner of the world; the expression "global contemporary art" more or less serves to mark this phenomenon. Every country can claim the existence of contemporary art within its borders. However, what *is* Indonesian contemporary art? A simple answer would be: contemporary art taking place in Indonesia. There's hope that the situation and condition in Indonesia would produce a different contemporary art than the general configuration found globally. This opinion presupposes the existence of a certain Indonesian-ness within the Indonesian contemporary art scene.

However, this has led us to have to face the problem of defining what "Indonesian-ness" is. We must admit that "national identity" is a latent problem in Indonesia, so it is not easy to interpret "Indonesian-ness". What we now call – and know – as Indonesia, is the manifestation of various ethnic groups who had freed themselves from Dutch colonization. As a post-colonial country, its rich ethnic variation and revolutionary atmosphere (in post-New Order authoritarian regime) has instigated a certain sectarian spirit in a number of societal groupings. Furthermore, in this era of globalization, with its economic and transnational information circulation, where cultural mores from stronger geo-politic and economic forces spread out and influence "weaker" regions, placing a definite meaning to the term "Indonesian-ness" is not an easy task. Indonesia, as a nation, is an apt example of what Benedict Anderson calls "imagined community".

On the other hand, contemporary art is a fluid dimension, one able to avoid the possibility of being confined within boundaries. Learning from the modern art stalemate, contemporary art has thus far avoided a unified understanding of its existence, as explained by Terry Smith: "Generalization about contemporary art has evaded articulation for more than two decades first because of fears of essentialism; followed by the sheer relief of having shaken off exclusivist theories, imposed historicism, and grand narratives; and then, recently, delight in the simple-seeming pleasure of an open field".[1]

With such an open perception and vast possibilities, contemporary art practices flourish into something that is all-encompassing, fluid and varied. Nevertheless – or, maybe because of it – contemporary art has become a common term referring to all art practices happening anywhere. Today, "in the aftermath of modernity, art has indeed only one option: to be contemporary".[2]

This fluid boundary has, by itself, caused contemporary art to operate outside rigid and stringently defined parameters and rules – quite unlike modern art, in this respect. It is often said about contemporary art that it can assume "whatever forms" as needed. "Anything goes" is a mantra used to demonstrate this effect.

The fluidity of how contemporary art is perceived has opened the path to "natural-

ization", a process of reconciliation for the lack of historical construct and modern art theories in non-Western regions. As such, contemporary art is a choice that current non-Western artists find hard to ignore. In the Indonesian context, as well as in the eyes of other developing countries, contemporary art provides the opportunity for artists to become part of the global contemporary art sphere.

Contemporary art has also freed non-Western artists from the weight of ethnic tradition – something that, in fact, has not existed in the daily lives of many Indonesians nowadays. An Orientalist outlook often defends the existence and subsistence of traditional art, as the main point of differentiation between Eastern and Western art. The exhibition, *Magiciens de la Terre* sharply illustrates this phenomenon. Here, well-known Western artists intermingled with the shamans from outside the Western world. The selection of these shamans emphasized the insignificance of individual modern artists in the non-Western world. Of course, this must have been quite disconcerting for Indonesian modern artists – who have adopted Western artistic methods – because their existences have been perceived as mere derivatives of Western modern art. Contemporary art has more or less changed the Western view of the existence of art in non-Western modern civilization. Contemporary art has provided the possibility for non-Western artists to take part in the global art scene.

It is generally agreed upon that Indonesian contemporary art began with a movement started in the 1970s by a group of young artists from Bandung and Yogyakarta, subsequently known as the "New Art Movement". However, and more in relation to the current global situation, the internationalization of Indonesian art was fostered in the 1990s, through the introduction of several Indonesian artists in international art events – especially in Asia Pacific region. These two important milestones in the history of Indonesian contemporary art are marked by works replete with socio-political content and representation. The emergence of the "New Art Movement" was triggered by the condition of Indonesian art at that time, seen by the movement's exponents as an impasse. Works by these artists showed their deep concern, not only for this stagnation (especially in the realm of art) but also as a reaction to the Indonesian socio-political situation in the 1970s, that is, the beginning of a long New Order regime.

The internationalization of Indonesian contemporary art in the 1990s saw a number of Indonesian artists invited to take part in international art events. This triggered a sort of consciousness within Indonesian contemporary artists that the spirit of post-modernism, pluralism and multiculturalism within international contemporary art could provide them with a way to become part of it. This decade marked the arrival of a number of international curators, inviting Indonesian artists to participate in various Biennials and Triennials they were staging. One of these important events is the Asian Pacific Triennial held in Brisbane since 1993, featuring a comprehensive lineup of Asia Pacific's contemporary artists. Previously, in 1992, the Japan Foundation hosted an exhibition titled *New Art of South East Asia*. Another major Triennial is the one hosted by the Fukuoka Asian Art Museum. In addition, an event organized by the Asia Society Gallery titled *Contemporary Art in Asia: Tradition/Tension*, held in various places (North America, Canada, India, Singapore and South Korea), also featured several works by Indonesian artists. And finally, a notably important exhibition, *Awas, Recent Art from Indonesia* was held in 2002. All of these large events served as im-

portant venues to present Indonesian contemporary artists to global art public, and have often influenced their decisions as to the paths their careers should take.

The inclusion of Indonesian works in various exhibitions and events and international art museums has fostered consciousness in the minds of those involved in our local art scene, on the importance of an ideal contemporary art infrastructure. This led to a certain disappointment in the lack of museums and art activities in Indonesia. The 1990s were marked by a gap between contemporary art as anti-market mainstream versus local market. At that time, the local art market was experiencing a boom in decorative art works. However, there were differences between the art works admitted into museums and international Biennials and those on sale in local art markets. At that time, a number of alternative spaces appeared in Yogyakarta, Bandung and Jakarta to accommodate contemporary art works. Cemeti Art House in Yogyakarta and Ruang Rupa in Jakarta are two of the more prominent ones.

Indonesian contemporary art works of the 1990s are heavy with socio-political and traditional representations. Socio-political contents are easy to read and have become the distinguishing feature between Indonesian contemporary art and other local art forms. The 1990s can be seen as an era filled with socio-political turmoil, ending with the fall of President Suharto, the figurehead of the New Order regime. This was followed by a period known as the Reformation Era, which brought democracy and freedom of speech. As such, works that were critical of the government gradually lost their ominous defiance. Meanwhile, reformation did not immediately lead to substantial changes in Indonesia's socio-political and economic conditions. Many became disenchanted with works containing socio-political subjects, sparking the introduction of various new tendencies within the first decade of the twenty-first century.

Indonesian contemporary art in the midst of a global art market
It is worth noting that in the beginning of the twenty-first century, the era of globalization that has influenced the Indonesian art landscape and its artists has a different face compared to previous eras. Art fairs, auction houses and commercial galleries have become important players in shaping the face of global contemporary art, influencing significantly patterns of production and consumption of Indonesian contemporary art. International Biennials and Triennials no longer hold an appeal in the eyes of Indonesian contemporary artists; art fairs and auction houses, however, do – and very much so.

Globalization is often seen as the two sides of the same coin: "For some, globalization means freedom, while others see it as a prison. For some it means prosperity, while for others it guarantees the poverty of the developing world".[3] Despite this dualism, we must acknowledge that the intensification of Indonesian contemporary art practices within the past few years has been powerfully triggered by the currents of the global contemporary art market. For the past few years, a number of young Indonesian artists have participated in various art fairs, regionally and internationally; in addition, they count themselves among the artists whose works have entered various auction houses – particularly in Asia. Of course, this condition has inadvertently helped those young artists decide their career paths. Despite the critique against an increasingly market-oriented contemporary art, we cannot

deny that the market has served as one of the main thrusts of global contemporary art practice, including in Indonesia.

If considered in a positive light, globalization can be seen as providing space for locality, accommodating cultural differences, as well as becoming a meeting point and opportunity for inter-cultural interaction. Thus, contemporary art – unlike modern art – is superior in terms of its contextualization – that is, in relation to the space and time it resides in. Thus, in this regard, it has provided a chance for Indonesian contemporary art to become unique and different from contemporary art from other locales/regions. Furthermore, the world as we know it is still showing inter-regional diversity and disparity.

"The emergence of a linked global society (linked both technologically and economically) has not resulted in international unity and worldwide equality; indeed, it is questionable whether any institution operating on a global scale can possibly represent the political, cultural, or aesthetic interests of diverse individuals in all countries."[4]

It is undeniable that the global arena is still dominated by economically-forward countries. Rich, developed countries have strong capital, aided and abetted by the flow of information technology and their mass media reaching around the world. More than anything seen in previous generations, globalization has accelerated inter-cultural interaction. In the end, we cannot avoid being dominated, in lifestyle and culture, by countries that are more advanced technologically and in possession of stronger capital. It can be said that the contemporary art practice currently spreading around the world is one of the results of globalization – through *global contemporary art*. In other words, although there are differences in the problems faced by one country to the next, from one region to the other, the current structure of world politics and economy influencing and being influenced by globalization will inevitably lead to "similarities" in the issues captured by our artists. The current development of information technology has given these artists an ease of access to basic information and latest situations in global contemporary art. This has led to similarities in themes, artistic media and visual constructions in the works of contemporary artists around the world.

The international contemporary art boom has a visible influence on the Indonesian art landscape. In 2007–08, Indonesian art market was truly dominated by contemporary art works. Naturally, works by Indonesia's old masters were still important and much sought after, but supply was extremely limited. This situation was mirrored in the global art market, which also was dominated by contemporary art works. Unlike the "booms" of previous eras – when there was a mutual disagreement between market and artistic discourse – this most recent boom has facilitated a meeting between the two. This is why artists, whose works in the 1990s were more often than not found in museums and Biennials, have finally attracted market attention. Heri Dono, Agus Suwage, FX Harsono and Dadang Christanto are but a few names we must mention. In their development post-2005, younger artists (post-Reformation) have gained the opportunity to shine in regional art markets.

Historically, the post-2005 era is often known as the post-Reformation era, with more non-political works in evidence. It will most probably be true that by "political" we mean the artists' efforts to critique the government and its powers, though, of course, external aspects will always influence them. In other words: the attitudes, themes and patterns of production and consumption of contemporary art can never be fully free from

socio-political and economic dimensions; for example, with a more democratic government in office, these artists have stepped back from works critiquing the government. One of the post-Reformation young artists' greatest influences is the industry of popular culture, because their works often highlight personal issues as a reaction to the wave of popular culture. Low-brow tendencies in the form of comics, illustrations, graffiti and advertising are quite "fashionable" with young artists now.

Even with the almost limitless media in contemporary art, painting still plays an important and dominant role on the Indonesian scene. This is not merely due to market influences, but also to the influences of contemporary culture that is extremely visual-oriented. The onslaught of digital images in the visual culture of these days has become a competitor as well as a challenge for contemporary artists, resulting in quite a number of them rising to the challenge to compete with the sophistication of digital technology. The popularity of photo-realistic and hyper-realistic paintings testifies to this. The global culture itself is strongly formed around visual aspects: "It is everywhere accepted that visuality is preeminent in news and entertainment, advertising, television, print media, fashion, commodity design, and urban architecture".[5] Representational tendencies are very much in evidence in Indonesian contemporary art works, though they are richly varied. "Skill" then becomes an important aspect, as it is especially needed to provide viewers with a convincing visual impact.

Local art markets have also become more sophisticated, indicated by the gradual inclusion of new media art works, such as digital photography and video art. A number of young video and multi-media artists, whose works have been exhibited in international museums, have enjoyed good reception in local art markets. This is demonstrated by, for instance, the Tromarama group, Angki Purbandono and Jompet Kuswidananto. In addition, most recently, and even with a general lethargy in the local art market, a number of galleries have recorded good sales in three-dimensional art works. The gradual acceptance of these oft-complicated works by local art markets has shown that local developments are no less advanced than the global art market as a whole. This has also served to strengthen claims of a convergence between discourse and market.

Whatever forms their presentations take, and despite their chosen techniques, Indonesian contemporary artists have a tendency to place importance in content or subject matter. Narration is still an important aspect of their works, though it is often difficult to explain the relationship between content and media of expression. Painting has become popular again, more or less due to its validity as an art form, leading the artists to believe that they must search for an issue, a narration or a subject matter to become the content of their paintings. In other words, content and narration are often merely alibis or justifications used when producing paintings or art works. Thus, the visual aspect of a certain piece is often the part Indonesian contemporary artists are most interested in.

[1] Terry Smith, *What is Contemporary Art?* (Chicago: The University of Chicago Press, 2009), p. 1.
[2] Ibid.
[3] Tony Schirato and Jennifer Webb, *Understanding Globalization* (London: SAGE Publications, 2003), p. 2.
[4] Jean Robertson and Craig McDaniel, *Themes of Contemporary Art. Visual Art after 1980* (Oxford: Oxford University Press, 2010), p. 24.
[5] Smith 2009, p. 249.

Suddenly, We Arrived… Polarities and Paradoxes of Indonesian Contemporary Art[1]

Leonor Veiga

The Chinese artist Ai Wei Wei's *Sunflower Seeds* commission that was showcased at the Turbine Hall of Tate Modern, in London, in late 2010, was not explicitly Chinese. Nevertheless, one could sense the Chinese identity of the installation through its sheer immensity (one hundred million seeds), a sophisticated evocation of delicacy, labour and craft that also referred to the importance of porcelain in Chinese history and heritage.

A similarly subtle approach is largely responsible for the success of contemporary art from Indonesia: works reveal their "Indonesian-ness" without necessarily being literal, relying on the viewer's own imagery of the country to complete the picture. However, we, who are not Indonesian, have come to know the country through its globalized images, primarily its beautiful beaches, its natural disasters and the disgrace that follows terrorist attacks. This image, as we all know, is a very reductive one. The result is that the specificities of the artists' message may be lost in the preconceptions of the audience. For many Indonesian artists, who are unfamiliar with the common language of the international arena, understanding how best to get their point across is a problem that remains unanswered.

Syncretism and "in-betweenness": aspects of Indonesia's current situation

The problem is not specifically territorial; in fact, what is lost in cultural transmission to the outside world – and is paradoxically the most interesting element of much of the artists' work – is the "driving force" that constitutes Indonesia's cultural energy. In my opinion, the most successful works in Indonesia are those that remain honest and truthful about the nature of the country, its heritage and what could be said to be the "inert graciousness" of its people. Their success is directly related to notions of "flattening" in Indonesian history: the country has an extremely complex legacy of external occupation (that in some senses remains ongoing) and, as a consequence, a multi-layered culture that cross-references and borrows influences from elsewhere in the world.

At this present moment, Indonesia might be one of the most highly cross-cultured of the world's societies: borrowing from North America its fast food and aspects of its material life, displaying its religiosity with the Arab garb, all pooled with Chinese goods and financial power. This on-going show in the nation's daily life creates an atmosphere of constant excitement, whilst its population struggles to absorb and integrate the new values without wiping out its already convoluted history. "Syncretism", this layering of one culture atop the other, without either being erased, can therefore be considered one of the country's strongest elements, one of the milestones of its civilization. And, as in so many moments of its past, Indonesia is again finding ways to integrate current cultural, religious, political and economic imports.

This results in a fascinating "in-betweenness" of the country, inherent in its DNA, derived from its geographical disparities and constant change; just as the country itself is volatile, so its art suffers the same fluctuating condition, with even its leading artists only intermittently represented in high-profile events such as the Venice Biennale. This condition can be seen in the work of Bandung-based artist Julius Ariadhitya Pramuhendra: in his series *Lost in…* he depicts himself at the most prestigious Western art institutions, like the Guggenheim in New York.

Indonesia's artists struggle to find a language, a voice that is respected and credited outside of their immediate homeland. The crossed culture, referred to above, permits them to speak in global terms through local conditions and experiences. Established artists including Eko Nugroho show a deep understanding of their society, whilst analysing issues such as Islamic and modern life-style changes in Java; similarly Jompet Kuswidananto reveals an extensive body of knowledge of post-colonial Java. These approaches are further exemplified by Entang Wiharso who demonstrates a "syncretic turn" regarding his surrounding culture, contaminating it with his own personal histories. Yet, despite the internationalization of their experience, it remains the case that artists and agents mostly remain busy with local concerns. Although the most local of Indonesian issues have an international dimension (some of the most important themes in contemporary art practices are notions of its national identity, tradition and how it impacts developing societies, religion and spirituality, the role of women in society, and also political, social and environmental concerns), some artists are making very literal works that don't add much to the discourse. In many cases, especially when considering younger generations, the artists remain uncertain as to what contribution their activity will make to the panorama.

In Indonesia, the art works are often polarized between "voices with native intent", such as Nasirun's and the more successful "comic art" and "neo-pop" of groups including ruangrupa. This polarity rises one question: "What is Indonesian about this art?" In fact, the country possesses as much variety in its arts and ways of expression as any other major country of the world, due not only to its traditional arts, but how it impacts its contemporary practices.

Therefore, the recent intense interest in Indonesia from the outside world should come as no surprise; this crossed-cultureness attributes potential to its art, gives a new swing to the panorama of the world's contemporary art practices. Since its local influences contain elements from different locales as far apart as India, China and the Netherlands, one or two elements of a certain work can remind the viewer of his own national references.

Even though non-Western art is vastly unrepresented in grand events such as documenta in Kassel,[2] the growing presence of these agents – especially since 2002 – is the result of several aspects: above all, great craft and refined finishing. The days of this ideological curse are long passed. The world has moved "beyond" the Orientalist view that has cornered for so long these artists. No longer does the Western world frame this art in terms of its exoticism, rather in the condition of its making.

Lack of institutions: space for freedom or a cause of weakness?
Indonesia, like many countries in the Southern world has yet to find government institutions that support its art. As a consequence, hybrid spaces have emerged. The curator

Shaheen Merali has said, in reference to India: these are "not so much museums but galleries, sometimes artist-run initiatives located within households, and one of the most alarming outcomes of such a lack of national infrastructure is that key examples of work by [the country's] greatest artists remain in homes".[3] One very famous example of such a home-grown institution is the OHD Museum of Modern & Contemporary Indonesian Art,[4] property of the renowned collector Oei Hong Djien, which has contributed widely to the maintenance of key works from Indonesian modern and contemporary artists in the country. This deficit leads institutions like the Singapore Art Museum to buy much – in fact it remains a key buyer of almost all of the most important art from Indonesia. Two contributing facts have created this reality: Singapore's geographical proximity and the interest of its commercial galleries in exhibiting art from Indonesia. In this regard, these aspects may be an extremely positive sign for the future.

Although Merali is stating the fact about India, the parallels with Indonesia are striking, and his warning has repercussions for the tropical archipelago too: "In such an impoverished condition, it seems that we are left with at best, interpretations and to a certain extent interventions that can be only guarded as private initiatives and only accessible for a given and recognized public sector".[5]

Private facilities in Indonesia have been, as in India, actively responsible for what developments there have been to this date. The CP Biennale,[6] an initiative of CP Foundation (with chairman Djie Tjianan, himself a prominent collector of contemporary Indonesian art, and curator Jim Supangkat), was closed after its second edition in 2005, named *Urban/Culture*. The reasons behind this incident related to a scandal concerning the naked exposure of two public figures in a painting by highly regarded artist Agus Suwage. Facts like this make the artist community feel disempowered.

But such obstacles have not stopped the community – from private collectors and galleries to artists – from founding and developing private art centres; as recently as 2010, Yogyakarta has been granted a new exhibition space, Langgeng Art Foundation[7] – the property of another prominent collector, Deddy Irianto – that aims, once again, to showcase new practices to the country's growing audience.

It is manifestly interesting to watch the resistance the artistic community has developed towards adversity – be it a lack of support, pressures of censorship or the ongoing indifference of society at large – for it forces them to continuously re-invent themselves.

The arrival on the global art scene

The internationalization of Indonesia's art is a recent fact; it was made through exposure at showcases such as the Asian Pacific Triennial[8] in Queensland Art Gallery, Brisbane, Australia as well as numerous exhibitions promoted by the Japan Foundation in Tokyo or New York. Amongst the first Indonesian artists who found international fame, Heri Dono, Anusapati or Nindityo Adipurnomo have acknowledged it through reflecting their identity, but only after they exited the country to study and/or exhibiting abroad. In the 1900s, these artists, as well as Arahmaiani, FX Harsono and the curator Jim Supangkat, started to offer contemporary settings, borne of the Indonesian context, to overseas audiences.

Indonesia's contemporary art currently lives in a phase of excitement: even artists who are seen as "low-key" are able to make a living from their work, by assisting the renowned ones, whilst maintaining their own art practice. This model allows them to be constantly making art, and, in turn, has contributed to high demand from collectors, and lately from auction houses. Yet this high market pressure – more evident since 2007 – is disallowing the necessary space for thought. Artists are constantly in "producing mode" and spend less time researching, looking at new discourses and solutions for their work.

One vital ingredient or trigger for the artists' success in the international arena is the possibility to study or exhibit abroad, combined with some fluency in the *lingua franca* of the art world: English. Post-modernity remains a vague experience in Indonesian society, and overseas contact facilitates an understanding of the ways to attribute further "value" to their works. Nevertheless, even if this feature is not understood by the entire art world in Indonesia, there is still a good level of comprehension about several other important aspects, especially in the relations between artists, curators and the public. What remains as yet unattained is the capacity to make the connection from these agents to those of market and the media: exhibitions are critically devalued by displays of uneven quality. Given this constant state, the task of promoting the works becomes difficult. Consequently, Indonesian art remains "in-between": impressive, yes, but not yet up to the professional standards required by the international art world.

The publication of *Indonesian Eye*, as its title suggests, will contribute to the confidence and further vision of the artists from Indonesia, it will reflect positively in their work by exposing them to a previously unknown audience and scale. What remains a necessity is the continuation of the process and maintaining a constant dialogue with the specialists from Indonesia, without forgetting to pressure the authorities.

Indonesian Eye can mark the beginning of a new era, and it is hopefully the first of many such endeavours; making the world finally look at this unique and exciting country. If the West can learn to move beyond its preconceptions, avoid the temptation to hegemonize what it finds and look at the scene through its local specificities and inherent realities, then Indonesia may finally arrive on the international scene.

[1] This essay was made possible thanks to interviews conducted on 10 March 2011 with artist Jompet Kuswidananto, FX Harsono, Ashley Bickerton and curator Jim Supangkat.
[2] http://www.tate.org.uk/research/tateresearch/tatepapers/09autumn/chin.shtm
[3] Shaheen Merali, *India Now*, paper presented at the Biennale Symposium, Beijing 798 Biennale, Yan Club Arts Center, 2009 (unpublished).
[4] http://ohd-artmuseum.blogspot.com/
[5] Merali 2009.
[6] http://biennale.cp-foundation.org/
[7] http://langgengfoundation.org/
[8] The Asia Pacific Triennial was established in 1993 in Queensland Art Gallery, Brisbane, Australia.

Expo Art: Indonesian Art and International Exhibition

Susan Ingham

Indonesian modern and contemporary art was barely known outside Indonesia before the 1990s while their traditional arts, historic crafts and sculpture, Gamelan music, the Wayang shadow plays and Batik received enthusiastic support when exhibited abroad. In the 1950s and 1960s a few modern artists received grants and travelled outside Indonesia to exhibit in Europe and America, but their work was rarely seen in major art venues. One unusual example of this was Affandi, perhaps the most famous Indonesian artist at the time, who, with other artists, presented Indonesian painting at the Sao Paulo Bienal, Brazil in 1953 and went on to exhibit in 1954 at the Venice Biennale where he received a prize.[1] His experience remained unique for some forty years until Heri Dono was invited to exhibit in the Venice Biennale in 2003. Two elements combined to encourage the exposure of Indonesian modern and contemporary art outside Indonesia. The first was a major theoretical shift in Western perceptions of non-European art and the second was an environment inside Indonesia that was not conducive to the exhibition of critically edged, experimental art.

Until the late twentieth century Asian modern art was generally treated as a peripheral copy of the modernist original that, it was presumed, was a European invention. It was considered a pastiche rather than a valid interpretation, a perspective that was reinforced by residual colonial attitudes. The first major exhibition of Indonesian modern art, a travelling show organized by the Festival of Indonesia in 1990, had difficulty finding galleries and museums in the United States that were willing to host it; in two cities the works were shown in anthropological museums. According to Joseph Fischer who co-curated the exhibition, *Modern Indonesian Art: Three Generations of Tradition and Change, 1945–1990*, this was in part "a reflection in such institutions of the lack of any real experience with anything modern from Indonesia or from other Asian countries except Japan".[2] The Indonesian curator and art historian, Dwi Marianto, had a similar experience when the exhibition was mounted in Amsterdam in 1993 by the Gate Foundation. The Dutch curators rejected some of the paintings as "mere copies" of European Surrealism when the Indonesian artists had reinterpreted a surreal style to express a sense of psychological tension and alienation in their own society.[3]

But the tide was changing. From the 1980s onwards a number of European and American cultural institutions interested in exhibiting non-Western art began to reposition their curatorial strategies, influenced by the post-colonial theories of such writers as Edward Said and Homi Bhabha. Said used the term, "Orientalism", to describe the way in which non-Western cultures were interpreted, stating that it was "a Western style for dominating, restructuring, and having authority over the Orient". He used Michel Foucault's concept of a discourse, a system of power relations linked to language and knowledge, to

define the amalgamation of ideas that constitute orientalizing.[4] More importantly, Said questioned the Eurocentric view of the Orient that perceived Euro–America as the centre and Asia (including Indonesia) the periphery. Homi Bhabha, in his work, *The Location of Culture*, carried Said's project further by indicating that Occidental and Oriental, colonizer and colonized, were not fixed positions and that a process of hybridization destabilizes the concept of a "homogenizing force". The process he called "mimicry" opened the possibility that a colonized culture could translate the dominant culture into innovative forms that constituted a "third space" of cultural resistance.[5]

Between the *Primitivism* exhibition curated by William Rubin in 1984 at the Museum of Modern Art, New York, and the exhibition, *Magiciens de la Terre,* organized by Jean-Hubert Martin at the Centre Georges Pompidou, Paris in 1989, there was a major shift in perspectives. In the 1984 exhibition non-European objects were treated as primitive artefacts for Western modern art to plunder as a source of inspiration; but by 1989, Martin was seeking to exhibit Western and non-Western art on equal terms. Both exhibitions provoked considerable debate and new ideas about non-European art were aired. The criterion for Martin's selection was that the art be connected to some perceived authentic culture and, although a problematic concept, the international survey exhibitions of non-European art that followed in the 1990s continued this preference. There were contradictory forces in operation. On the one hand selecting art that was connected to its origins recognized cultural diversity, although it reiterated the Western fascination with the exotic, while on the other hand, the demands of global display tended to homogenize the art and obscure local character. Local references may require explanation or be "lost in translation", as Asmudjo Irianto indicated when writing in connection with the *Pancaroba Indonesia* exhibition held in Oakland, California in 1999. He wrote, "Most works represent a narrative of social tragedy and have many layers of other hidden meanings; they represent specific problems and particular iconographies that are unfamiliar to American audiences, and which can only be understood through a knowledge of local conditions in Indonesia – and not only of Indonesia's social, cultural and political milieu, but also its art world".[6]

International survey exhibitions, or Biennials as they came to be known, whether they were held every two years or more, were the most visible form of globalization in the arts. More than just art, they served political and economic agendas and they were expected to grease the diplomatic channels between nations. The Venice Biennale, the first and oldest, was founded as part of the ceremonies marking the unification of Italy and to attract tourists to finance restoration projects for the city. More recently, Brisbane in Australia and Fukuoka in Japan sought to raise their profile and participate in the Asian economic boom of the 1990s by holding major art shows. The Asia Pacific Triennial mounted in the Queensland Art Gallery, Brisbane, and the Fukuoka Asian Art Show (later a Triennial) were among the first survey exhibitions to show contemporary Indonesian artists. By the late 1990s a remarkable number of Biennials were flourishing outside Europe and America. A common aim was to blur "distinctions between center and margin" and "break from the past of discrimination and exclusivity" in relation to the West, as a statement from the Gwangju Biennale held in South Korea declared.[7]

Where content was concerned, there was a marked preference for art addressing socio-political issues in the selected works. Caroline Turner, co-founder of the Asia Pacific Triennial Project and a selector of Indonesian art, said, "I would argue that much of the most interesting art that is coming out of these countries deals with issues that are very much connected to changes taking place in these societies".[8] Biennials favoured art that made a statement and provided a spectacle with a strong element of entertainment to attract the general public. Installations outweighed traditional art forms or two-dimensional works on a wall, although paintings were not excluded. Melissa Chiu, Museum Director at the New York Asia Society, wrote that artists working in local artistic traditions were "frequently overlooked by international curators interested almost exclusively in artists working in experimental media, which matched their own ideas of more progressive contemporary art".[9] As well as having socio-political content and working with experimental media, artists needed certain skills in navigating international artistic protocols such as making submissions or addressing a curatorial brief. They needed to be free to travel to take up residencies or to speak at seminars and it helped to speak English, the *lingua franca* of globalization.

A small number of Indonesian artists met these criteria, best known amongst whom were Heri Dono, Dadang Christanto, Arahmaiani, Mella Jaarsma and Nindityo Adipurnomo. Others included FX Harsono, Moelyono, Agus Suwage, Tisna Sanjaya, Krisna Murti and Marintan Sirait, although Marintan initially was identified as German.[10] Many were also painters, but it was their installations and performance art addressing Indonesian issues that was particularly sought. Heri made a series of installations and paintings that expressed criticism of the Suharto regime and the repressive society it had produced. He regularly used a variety of media and technological scrap, creating grotesque figures based on the Wayang in a playful manner that disguised his criticism of the regime which, if it had been overt, would have been dangerous. Dadang referred to victims of repression under the regime, both recently and in the past, and particularly ethnically Chinese Indonesians like himself, who have been targeted and persecuted. His installations have varied from piles of heads to full sized figures in terracotta which he often accompanies with a performance. Arahmaiani, primarily a performance artist, addressed feminist arguments familiar to Biennial selectors, she alone raising issues in her work concerning the patriarchal nature of the predominantly Muslim–Javanese society. Nindityo and his wife, Mella, focused on issues of culture. For more than ten years Nindityo explored the significance of the *konde*, the elaborate Javanese hairpiece that is an indication of status, while Mella developed the *jilbab*, or headscarf, into a series of floor-length body coverings in media from frog skins to canvas tents that raised issues of gender and ethnicity.

All five artists became part of the international art circuit in the 1990s to such a degree that they were considered expatriates at home. The introduction to the catalogue for Dadang's first exhibition in Indonesia in 1995 said: "The works of these three visual artists [Heri Dono, Eddie Hara and Dadang Christanto] are more recognised within the global art circle than in their own country. This is because they exhibit their works more frequently in foreign countries, or also because they happen to reside abroad more often."[11] Contacts led to referrals, as when the curator, Jim Supangkat, selected Dadang for the Ha-

vana Biennial in Cuba in 1994. Dadang met Apinan Poshyananda there who then selected him for exhibiting in the New York Asia Society's *Tradition and Tensions* show in 1996. Such exposure validated their work and these few artists were repeatedly selected and referred through the power lines of the art world until they became globe-trotting art stars.

While their work coincided with the curatorial preferences of the international selectors and was understood in the context of Biennials, at home the environment was not conducive to critically edged, experimental art and they received little support until "Reformasi" and the downfall of President Suharto in 1998. The Suharto regime, which had been in power since 1965, had become increasingly authoritarian and had a history of repressing dissent, sometimes forcibly, as with the imprisonment of writers such as Pramoedya Ananta Toer and artists such as Hendra Gunawan. Student activism was quashed in the 1970s and politics banned from campus life under the *NKK* programme, or "the normalization of campus life",[12] yet against this repression there was an increasing access to global information through television and the media and, by the 1990s, the Internet.[13] Teaching in the tertiary art institutions in Yogyakarta, Bandung and Jakarta remained conservative but there were protests from art students against the general predominance of conventional painting. In 1974 FX Harsono was expelled from his art institution, ASRI,[14] in Yogyakarta for being part of the "Desember Hitam", or Black December protest against prizes in the Jakarta National Biennial of Painting being awarded to conservative work. Nearly twenty years later Dadang Christanto and Heri Dono were amongst those protesting restrictions on entry to the Yogyakarta Biennial that similarly favoured established painters. They held art events on the streets and in the railway yards in 1992, Heri performing with grave diggers from the cemetery in a work titled *Kuda Binal*, or Wild Horse – wild, or *binal* being a word play on Biennial.

The regime upheld the traditional arts and provided little if any support for modern art. Even today Indonesia does not have a public museum and exhibition space for modern and contemporary art in the manner, for example, of its closest neighbours, Singapore and Malaysia.[15] The outlet for modern art was through the increasing number of commercial art galleries; still, the market favoured non contentious, decorative and abstract painting rather than installations or experimental work. It was in response to the lack of public infrastructure or support from the commercial gallery system that Mella Jaarsma and Nindityo Adipurnomo founded the Cemeti Art House in Yogyakarta in 1988 for the exhibition and sale of contemporary experimental art. Heri Dono was the first artist to hold a solo exhibition there. Cemeti was seen as an alternative to the mainstream art galleries and was the first port of call for visiting curators selecting artists for international survey exhibitions. By the late 1990s it had become a gatekeeper for contemporary Indonesian art and a launching pad for artists' careers, including their own.

Another facilitator in the process of introducing Indonesian art to global exhibition was the artist turned curator, Jim Supangkat. His curatorial career began in 1992 as a consultant to the Japan Foundation for their exhibition, *New Art from Southeast Asia* and he effectively became the writer, curator and historian for the Indonesian participants in Biennials and survey exhibitions around the world. According to Supangkat, Japanese and Australian exhibitions "started us thinking, here in Indonesia, who are we? It's the first

time we encountered the so-called art world and started to understand art discourse. It is from that I developed the tools to debate Indonesian art".[16] The lack of public infrastructure for modern art or curatorial training in Indonesia contributed to Supangkat's lone status in the 1990s: so he became the public face of Indonesian contemporary art in international conferences, seminars and symposiums.

This local/global exchange has increased the understanding of Indonesian art and culture outside, and raised the profile of contemporary art inside, Indonesia. There are though, attendant problems, not least among them being the repeated selection of these same artists while other Indonesian art rarely sees the light of day in global exhibitions. The modernist painters, so successful in the local art market, and traditional arts and crafts tend not to be selected. It seemed Biennials incorporated traditional art only when it was transformed by contemporary practice, as, for example, with Heri Dono's use of the Wayang. Tradition tends to be associated with repetition while contemporary art is associated with invention and experimentation.[17] The art of activist youth and collective groups, so prevalent in Indonesia, is also rarely seen in international survey exhibitions. Multimedia community events are difficult to stage within the format of a static, large-scale exhibition and, when shown, can appear dry documentation drained of energy.[18]

Biennials have been criticized for these exclusions and the tendency towards a homogenous contemporary art form with the same artists and curators forming an international club. These criticisms must be balanced against the opportunity to give global exposure to local issues and increased international appreciation and understanding of diverse cultures.

[1] As reported by Claire Holt in *Art in Indonesia: Continuities and Change* (Ithaca, NY: Cornell University Press, 1967), pp. 321–22. Claire Holt and the Indonesian Studies Group at Cornell University were active in gaining some grants for Indonesian modern artists in the 1960s. These seemed to gain support on the basis that they encouraged anti-communist sentiments during the Cold War.

[2] *Modern Indonesian Art: Three Generations of Tradition and Change, 1945–1990*, edited by Joseph Fischer (Jakarta and New York, 1990); see "Introduction", p. 12.

[3] Martinus Dwi Marianto, *Surrealist Painting in Yogyakarta*, University of Wollongong PhD thesis, unpublished version, 1995, pp. 11–13.

[4] Edward W. Said, *Orientalism* (New York: Penguin, 1995).

[5] Homi K. Bhabha, *The Location of Culture* (London and New York: Routledge, 1994).

[6] The *Pancaroba Indonesia* exhibition was held in 1999 at the Pacific Bridge Contemporary Southeast Asian Art Gallery in Oakland, California. The quotation is from an article by Asmudjo Jono Irianto titled, "An Unsettled Season. Political Art of Indonesia", *Art AsiaPacific*, no. 28, 2000, p. 83.

[7] See http://www.universes-in-universe.de/car/gwangju/english.htm accessed 26 February 2007; and also the websites of the Fukuoka Triennial and Shanghai Biennial, accessed 8 July 2005.

[8] Caroline Turner, then Deputy Director of the Queensland Art Gallery, co-founder of the Asia Pacific Triennial Project and a selector of Indonesian art for the Asia Pacific Triennial, interviewed by Jennifer Moran for Pandanus Books, *Newsletter*, Spring 2005, no. 6, Research School of Pacific and Asian Studies, The Australian National University, for the publication of the book, *Art and Social Change: Contemporary Art in Asia and the Pacific*, edited by Caroline Turner.

[9] Melissa Chiu, Museum Director and Curator for Contemporary Asian and Asian–American art, Asia Society, New York, "Asian Contemporary Art: An Introduction" (Oxford University Press, 2005), *Grove Art Online*, http://www.groveart.com/grove-owned/art/asiancontintro.html accessed 30 April 2007.

[10] Eventually the effects of globalization were recognized in identifying artist's country of origin. Both Mella Jaarsma, Dutch-born and educated, and Marintan Sirait of German–Indonesian parentage, live permanently in Indonesia and make work that is identified as Indonesian. This is not intended to be a comprehensive list and, for example, certain Balinese artists were also selected for different exhibitions.

[11] Bentara Budaya Administration's introduction for the catalogue of the exhibition by Dadang Christanto, titled *Kengerian tak Terucapkan*, or The Unspeakable Horror, curated by Hendro Wiyanto in 2002 at the Bentara Budaya exhibition space, Jakarta, 4–14 July, p. 23.

[12] *NKK, Normalisasi Kehidupan Kampus,* or the normalization of campus life, required students to concentrate on reading, writing and conducting research, according to the Minister of Education and Culture, Daoed Joesoef. *Badan Koordinasi Kemahasiswaan,* or bodies for the co-ordination of student affairs, known as *BKK,* enforced the policy with censorship, harassment and informers on campus.

[13] Public access through *Warnet,* or Internet cafes was provided in Yogyakarta, for example, by September 1996; see Hill David T and Sen Krishna, "Wiring the Warung to Global Gateways", *Indonesia,* no. 63 1997, p. 68.

[14] ASRI, Akademi Seni Rupa Indonesia, the Indonesian Art Academy in Yogyakarta was later renamed Institut Seni Indonesia or ISI, the Indonesian Art Institute. The other two major art academies are the Fine Arts department of Institut Teknologi Bandung, Bandung Technological Institute or ITB, and the Institut Kesenian Jakarta, Jakarta Art Institute or IKJ, part of the complex that includes the TIM Culture Centre in Jakarta.

[15] The Galeri Nasional Indonesia is a space for hire. It holds exhibitions financed by private interests and sells the works from the floor. The Singapore Art Museum, in contrast, aims to be a repository for Southeast Asian art and part of the international art circuit. It has held significant exhibitions of Indonesian art history as well as solo shows of Indonesian artists.

[16] Interview to Jim Supangkat, Bandung, 24 April 2005.

[17] The innovative Batik art of Brahma Tirta Sari, for example, was seen in the Asia Pacific Triennial, *APT/3* in 1999 but on the whole their work is shown in media specific exhibitions for textiles. See http://www.brahmatirtasari.org/cv2.html

[18] The diversity of these groups makes it hard to generalize. Some groups don't consider themselves artists and art is only part of a range of activities supporting their activism, as in the case of Tanam Untuk Kehidupan (TUK), whereas ruangrupa and Taring Padi prioritize art making; ruangrupa were exhibited in the Gwangju Biennale in 2002.

Indonesian Contemporary Art Across and in Relations

Amanda Katherine Rath

In his landmark, *What is Contemporary Art?*, Terry Smith contends that the "intense, expansionist, proliferating global subculture"[1] that is contemporary art carries within it the tensions and crucial marks of both a globalized interactive space and post-colonial positions of sovereignty. This relationship and continuous process of entanglement and disentanglement is integral to any understanding of contemporary art in Indonesia and the region of Southeast Asia (a political construction and constructed idea, as well as a location). Contemporary art in this/these contexts is "poised somewhere between worldly and homely interests, universal but by no means post-national in [its] artistic inspirations and motivations".[2] Contemporary art as a subculture assumes a criticality and self-reflexivity that in the various and proximate locations in Southeast Asia carry different weight and risks. Much of Southeast Asia's post-colonial experience has entailed authoritarian regimes or other forms of government that enforce modernity-as-development, and attempt to control cultural and political expression through methods of coercion and censorship. Hence, contemporary art as a critical voice in this region has often found itself speaking first in, to, and through the international community before it would be heard in the artist's own country. As such, in certain respects, contemporary art in Southeast Asia initially posited a critical marginality – a post-colonial articulation with democratic socio-political ambitions. It was also, as in the case of Indonesia, a critique of modernity-as-development.

Government intervention and scrutiny of the arts has to varying degrees in the region made it difficult for artists to gain the necessary permits to exhibit. Artists wanting to make a counter-argument to official policy or to make social commentary often have had little choice but to work outside official and national institutions. An artist-run alternative arts infrastructure developed parallel to the mainstream. Cemeti Art House (established in 1988 in Yogyakarta) is exemplary in this regard as the first and longest running alternative art space in Indonesia. It was formed to accommodate alternative modes of art such as installation, mixed media, video and performance. Prior to the explosion of the contemporary art market in Indonesia especially in the last decade, alternative art spaces like Cemeti functioned as indispensable bridges between artists in Indonesia and the international circuit of exhibitions and art world professionals.[3] They became part of an anti-mainstream Mainstream.

In the following, I suggest some of the initial conditions and historical matrices that gave rise to contemporary art in Indonesia, and situate it within a regional context, particularly that of Malaysia. While Indonesia and Malaysia share a number of commonalities, not least of which linguistic, due to different trajectories and experiences of colonialism and processes of decolonization, and to their respective ethnic compositions, contemporary art has taken discernibly different contours and features in both countries.

Contemporary art in both countries emerged out of deep changes in cultural policy and the political landscape in the late 1960s and early 1970s, changes that had deep implications for the development of alternative narratives, modes of representation and critical artistic practices thereafter. In the case of Indonesia, a main turning point was the political fall of the Republic's first president in 1965–66, and the ideological sea change that accompanied the physical and ideological purge of the communists, their affiliates and supporters in 1965 after an attempted coup supposedly carried out by the communist faction in the military. The transition from the so-called Old (1949–66) to the New Order (1966–98) in Indonesia entailed the move from a radical anti-Western nationalism and socialist ideology to a more pro-Western focus on development and modernization. Indonesia was to be modern, technologically advanced, while rooted in traditional culture and spiritually grounded. National culture, identity and unity were stressed over social, economic, religious and ethnic diversity and inequalities in the country. The "ethnic" was replaced by constructions of regional culture. This began a revival of conservative, hierarchical values of especially Javanese culture and traditions.

Art in the New Order quickly took on an enforced ideology of autonomy-as-set-apart. The separation of art from the sphere of politics became the primary ideological basis of the cultural institutions including the academies. Modern art in Indonesia took on the trappings of anti-communist Cold War ideology promoted through an international modernism combined with traditional cultural motifs, and Javanese aesthetic assumptions of order, harmony and beauty.

Contemporary art in Indonesia arose out of such conditions and clash of discourses and the practices they authorized. In other words, it erupted as a rebellion and an alternative art called the Gerakan Seni Rupa Baru, or New Art Movement. This small group of mainly academy students joined the larger debate over the uses of culture in the New Order as legitimating elements of national culture. Not only did the artists involved in this movement call for a rejection of poorly translated Western modernism that had not been fully internalized. They also called for art to take on socio-political issues, and recuperate lost narratives refused by both modernism and the discourse of national culture. This entailed incorporating into their art materials and technologies of traditional culture of the poorer classes.

Developments in contemporary art as alternative art during the 1980s were sporadic and took place parallel if not marginal to the discourses delineated above, particularly to the dominance of abstract, decorative and lyrical painting. However, unlike Malaysia, in Indonesia it developed its own infrastructure. Part of the decline in critical and socio-political art in Indonesia was due to increasing scrutiny and a booming painting market. Yet, unlike the situation in Malaysia, a number of artists in Indonesia continued to engage artistic practice as a form of activism.

Malaysia also experienced a cataclysmic change to its cultural and political landscape in the 1960s that continues to have implications for issues of contemporary art in the country. The change was sparked by the May 13 Incident of 1969, or the Chinese–Malay Sectarian violence in Kuala Lumpur following general elections. The riots resulted in hundreds of deaths. In the aftermath, the Prime Minister resigned as a result of the political

struggles within the ruling party, UMNO. The new government forged and implemented the Malaysian New Economic Policy (NEP). This was designed to redress economic and education imbalances in the country by favouring so-called *bumiputera* (Malays and other indigenous Malaysians). Limits of public dissent also narrowed.

Sweeping shifts in the political landscape were coupled with measures in implementing a new cultural policy following the 1971 National Culture Congress. As the late artist and art writer, Redza Piyadasa, explains: "The need for a more cohesive and unifying cultural vision for the nation was deemed necessary, and the Congress brought together Malaysians [from various cultural fields, including artists] to work out the basis for the new national culture. The outcome of this historic gathering was the resolution that the new cultural vision must be founded upon the Malay language and Malay cultural values. The government accepted the resolution and almost immediately afterwards began the difficult task of implementing it in a multi-racial society".[4]

To be Malay is also to be Muslim. Hence, the new cultural policy also placed Islamic principles at the centre of developments in culture and society. The new cultural policy forced Malaysian artists of all races and ethnic backgrounds to reorient their aspirations and practices accordingly. This does not mean that previously existing streams in art ceased, or that the new policy forbade other forms to non-Malay-Muslim artists. It does mean, however, that racial and religious divisions in the country truncated avenues for artists to discuss these heady issues artistically and in a critical way.

In addition to a revivalist movement focusing on traditional Malay culture and its incorporation into modern modes of artistic practice, the Iran revolution of 1979 and the pan-Islamic movement had a great impact on Malay sentiments. "The result was a systematic requestioning of Western-centred values founded upon humanistic and secularized values. Much of modern culture and modernity was suddenly viewed as essentially decadent and founded upon existential and materialistic values".[5] A dominant stream in art emerged to accommodate this new attitude. This included the decline of the figurative and expressive in painting.

After nearly a decade of "sober" painting, a new generation of artists, many of whom were from the all-Malay Institut Teknologi Mara, began expressing what has been called "angst", "a response to a society which is becoming more repressive and narrow". The angst inherent in Neo-expressionism lent itself well to what curator and artist Wong Hoy Cheong describes as "voices form the periphery seeking to be heard, questioning the hegemony of the dominant ideology and culture".[6] The figure in painting also returned with this new expressiveness. This new kind of visible emotion was in itself an act of rebellion for a society that discourages dissenting voices. By the early 1990s, mixed media, installation and video art were increasingly viable options for art with social content. Some artists began deconstructing the nation's colonial past through autobiographical works, many utilizing purloined images. This critical stream continues today.

For historical reasons Indonesian contemporary art, unlike that of Malaysia, carries within its DNA notions of dissent and cultural radicalism. This did not change even though it became quite risky to engage in overt criticism throughout the 1990s. Artists had to continuously change tactics and adjust their visual language accordingly. They contin-

ued to place emphasis on aesthetic and cultural plurality and art's potential as a critical force against assumed universal referents of a dominant Western discourse, as well as of national culture. Many emphasized particularly on the cultural context and the different experiences and temporalities of modernity that then were incorporated into a critical art practice.

During the New Order, contemporary artists worked against a common foe, and contemporary art transcended issues of race and religion in favour of issues such as social justice and democracy. After Suharto's downfall in 1998 and the racial and religious violence that ensued, contemporary artists fell into a period of vitriolic paroxysms bent on exorcising the ghost of Suharto's authoritarian rule. Today, some Indonesian artists of Chinese descent, such as FX Harsono and Dadang Christanto, use their artistic practice as a means of reclaiming their Chinese identities that were erased during and after the violent purges of the mid-1960s and the enforced sublimation of Chinese–Indonesian culture thereafter. This is part of a larger move in contemporary art in Indonesia and Malaysia as well, namely the deconstruction and reconstruction of identity/ies, reclamations of Self, and the pouring forth of the personal in a fragmented collective as a place to instigate new and meaningful exchanges and dialogue.

[1] Terry Smith, *What is Contemporary Art?* (Chicago: The University of Chicago Press, 2009), pp. 241–42.
[2] Michele Antoinette, "Deterritorializing Aesthetics: International Art and Its New Cosmopolitanism, from an Indonesian Perspective", in *Cosmopatriots: On Distant Belongings and Close Encounters*, edited by Edwin Jurriëns and Jeroen de Kloet (Amsterdam and New York: Rodopi, 2007), pp. 205–35; quote on p. 213.
[3] Amanda Rath, "Alternative Art and Alternative Spaces. Altered-Natives and Altered-Spaces", *Karbon*, no. 5, Alternative/Alternative Spaces, 2003, pp. 4–15; Idem, "Concerning the 'Work' of Art", in *Exploring the Vacuum*, edited by Saut Situmorang, Elly Kent, Mella Jaarsma and Nindityo Adipurnomo (Yogyakarta: Cemeti Art House, 2003), pp. 94–102.
[4] Redza Piyadasa, "Modern Malaysian Art, 1945–1991: A Historical Overview", in *Traditions and Change: Contemporary Art of Asia and the Pacific*, edited by Caroline Turner (Queensland: University of Queensland Press, 1993), pp. 58–71; quote on p. 175.
[5] Ibid., p. 176.
[6] Niranjan Rajah, "Antara Amok dengan Adab: Ekspresi dan Ekspresionisme dalam Seni Moden Malaysia", in *Bara Hati Bahang Jiwa*, exhibition catalogue (Kuala Lumpur: Nation Art Gallery, 2002), pp. 47–48.

Indonesian Eye

Nindityo Adipurnomo

I am interested in how a culture is created and develops through different influences. I look at Indonesia as a constantly shifting socio-cultural history. Through a process of interrogation, I start from a specific object that I turn through my art into an idiom that comments on issues such as power, tradition, values, gender and religion. I have worked intensively with the Javanese hair, chairs, doors and megaphones, in order to reconfigure our perception towards the accepted interpretations of society and culture.

Post Tolerance Trophy, 2011
Tripod, teak wood, gouache on paper, video projection,
146 x 104 x 150 cm
Collection of the artist
Courtesy of the artist

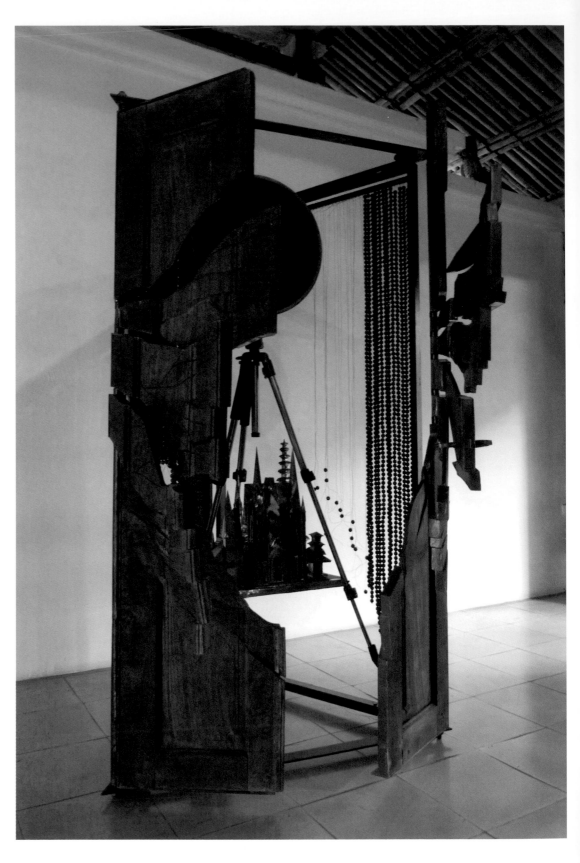

Techno Idiot, 2005
Iron, granite stone,
100 x 45 x 45 cm
Collection of the artist
Courtesy of the artist

Step on Heirloom, 2007
Granite stone, variable
dimensions
Collection of the artist
Courtesy of the artist

*Have You Been to Madura,
Mam*, 2008
Teak wood, brass, glass,
aluminium, iron, glass paint,
370 x 125 x 125 cm
Collection of the artist
Courtesy of the artist

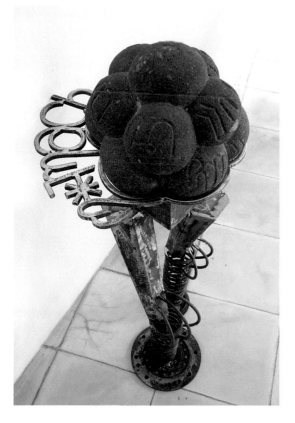

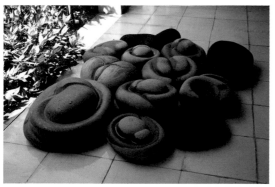

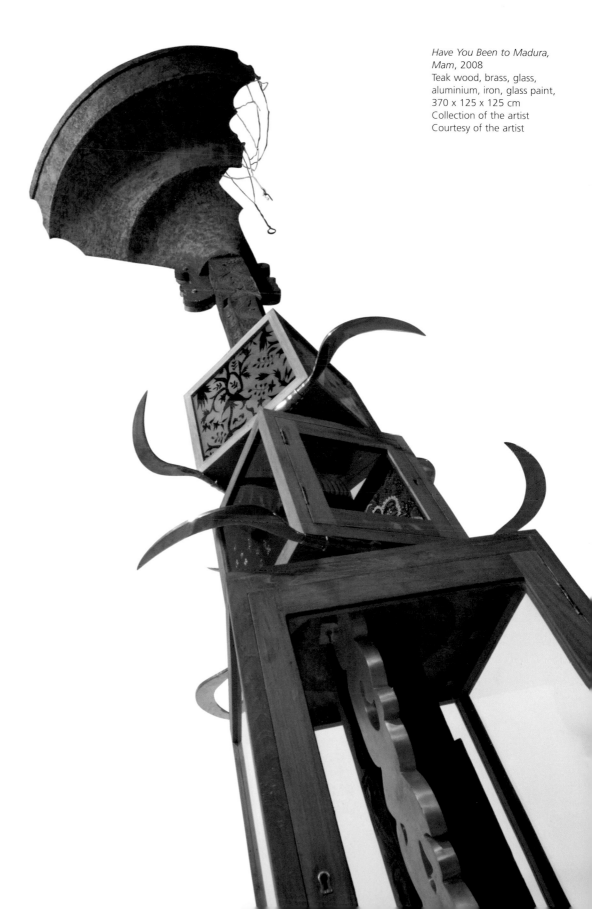

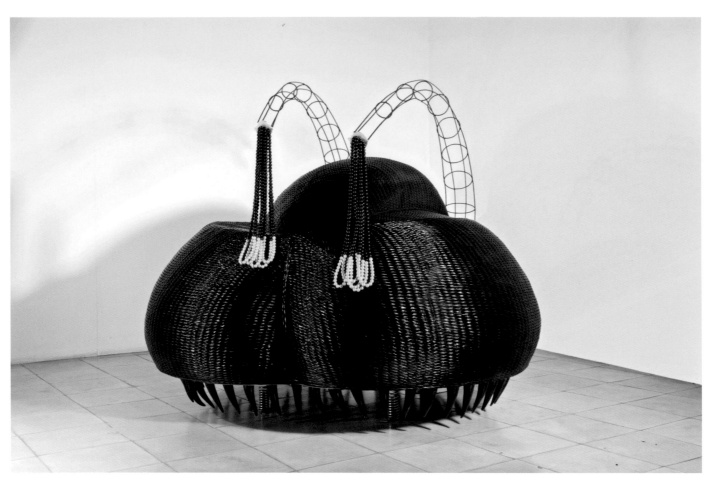

Dhikr, 2008
Rattan, buffalo horn, beads,
iron, 120 x 145 x 145 cm
Collection of the artist
Courtesy of the artist

*My Ancestors Were
Traders*, 2010
Gouache on paper,
49 x 134 cm
Collection of the artist
Courtesy of the artist

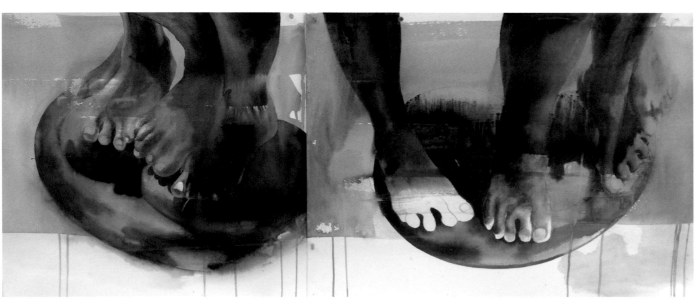

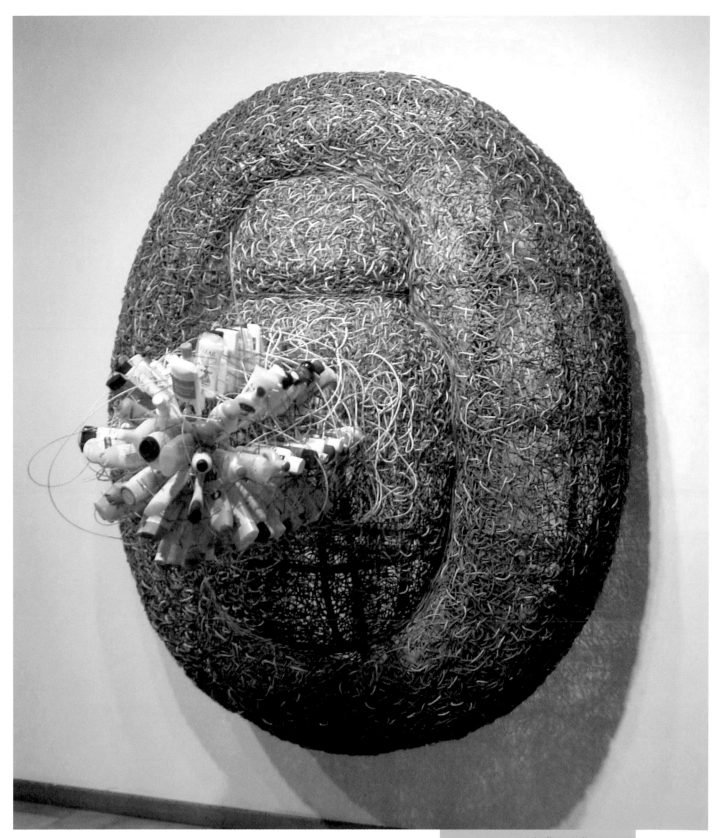

Tradition and Tension, 2005
Rattan, shampoo bottles,
iron, 300 x 180 x 150 cm
Collection of the artist
Courtesy of the artist

Bob Yudhita Agung

Agung created the name "Sick" for himself in reference to concepts in his paintings, and is widely known by this name in the Yogyakarta art world. The name "Sick" was manifested not only from his reputation as a painter, but also from activities in other parts of his life between the years 1993–96, when he tattooed his whole body, founded the "Java Tattoo Club" with Athonk and put up a band called "Steak Daging Kacang Ijo" with S. Teddy D., Tony Voluntero and Edo Pillu.

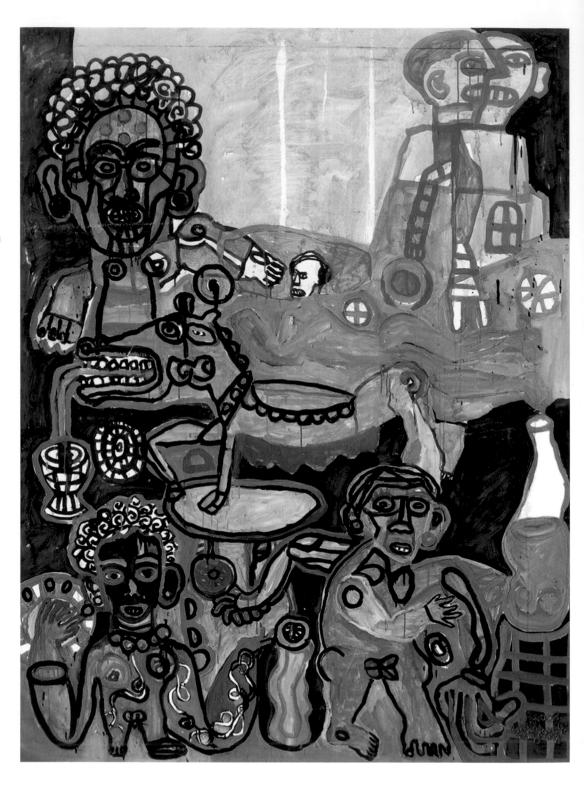

Juice Thirsty, 2008
Acrylic on canvas,
200 x 150 cm
Private collection
Courtesy of Galeri
Semarang

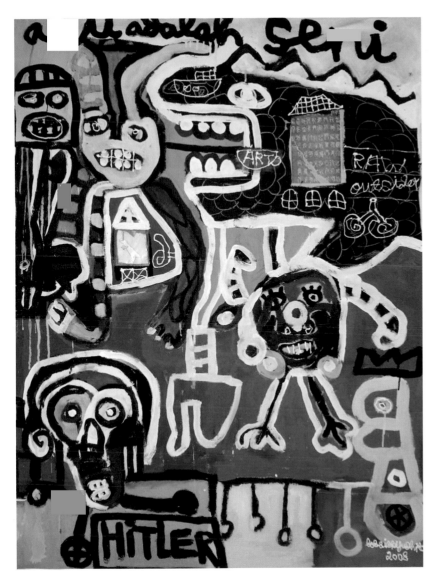

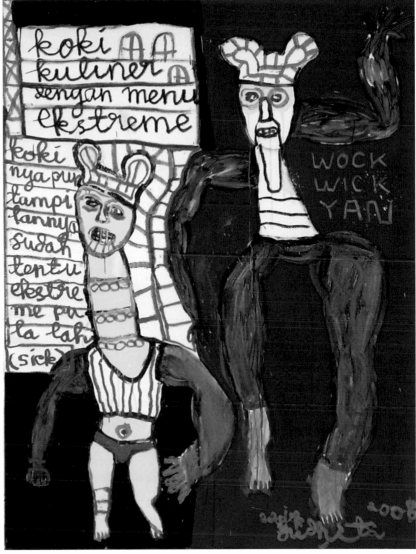

Hitler, I Am Art, 2008
Acrylic on canvas,
120 x 100 cm
Private collection
Courtesy of Galeri
Semarang

*Culinary Chef with
Extreme Menu*, 2008
Acrylic on canvas,
200 x 150 cm
Private collection
Courtesy of Galeri
Semarang

p. 50
*The Modern Anatomy
of Cleopatra*, 2008
Acrylic on canvas,
150 x 150 cm
Private collection
Courtesy of Galeri
Semarang

p. 51
*Vincent Van Gogh
vs Rembrandt*, 2008
Acrylic on canvas,
150 x 150 cm
Private collection
Courtesy of Galeri
Semarang

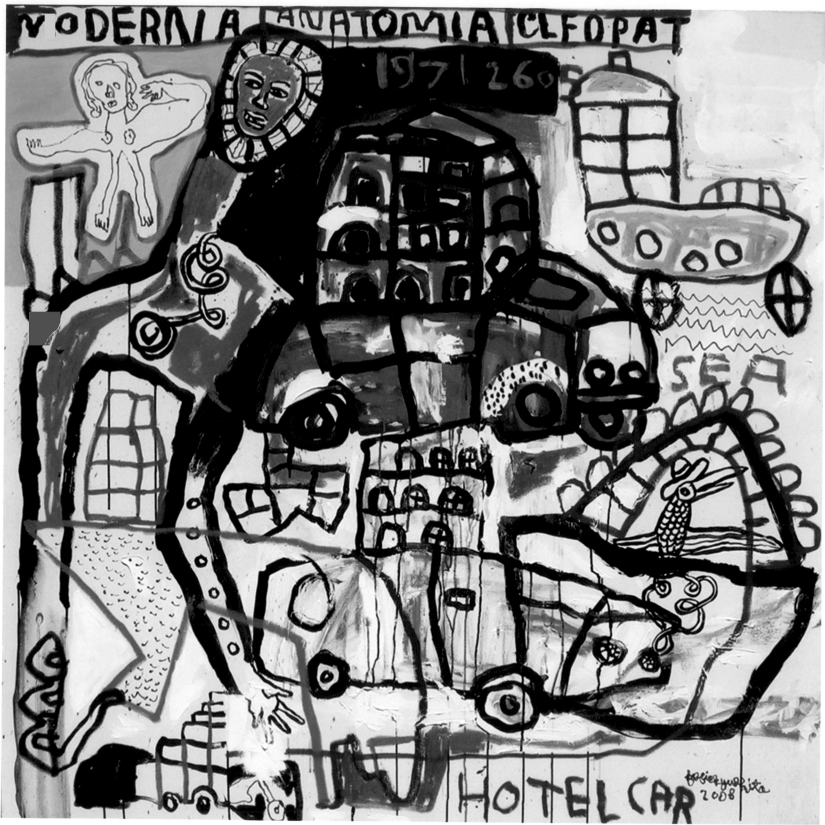

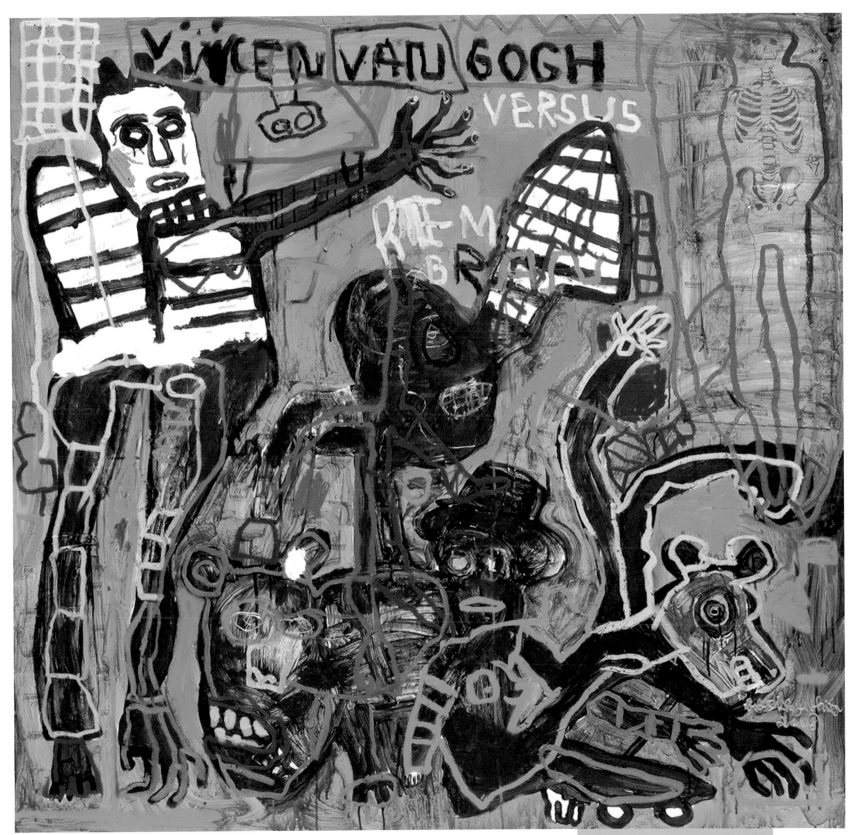

Made Aswino Aji

Born to a family of wood carvers, painters and sculptors, Aji's art reflects phenomenons of modern life, depicting themes such as ostracization, isolation and loneliness. It reflects a world where some individuals no longer see others as a community, but rather as competitors, not just on a personal level but in a global arena without boundaries. To struggle on a global scale, each person must have certain qualities. Modern-day technological advances are viewed as stairs that can lead upward to success, but they can also lead backwards. New choices and opportunities are like doors leading us down unknown paths. This insecurity is compounded by increasingly competitive economies and work, which leave us feeling cornered and hopeless. When we look a little closer to Aji's work, we will find hope in a common longing for something more. Compassion, beauty and human solidarity can be seen by simply looking out the window of our modern-day box.

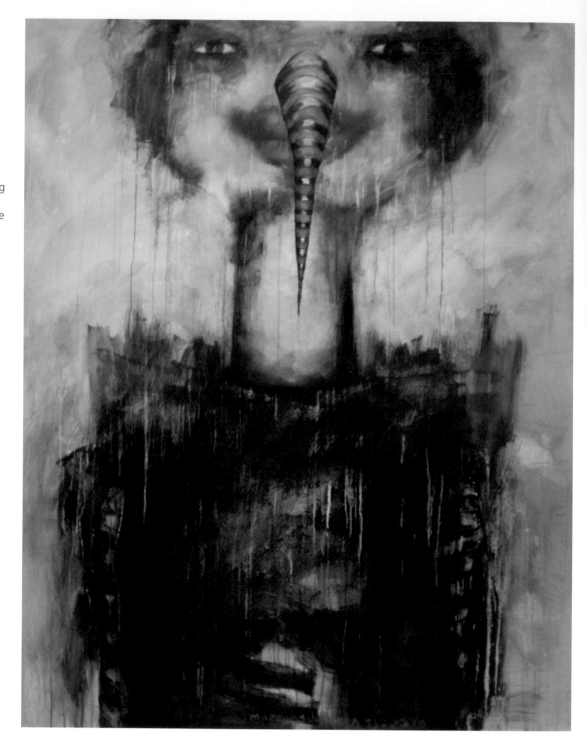

Wicked, 2010
Acrylic on canvas,
180 x 140 cm
Private collection
Courtesy of the artist and
Kersan Art Studio

Between the Paper Bird,
2010
Oil on canvas, 180 x 140 cm
Private collection
Courtesy of the artist and
Kersan Art Studio

Glamorous Pride, 2010
Acrylic on canvas,
180 x 140 cm
Private collection
Courtesy of the artist and
Kersan Art Studio

Being Huge, 2010
Oil on canvas, 150 x 100 cm
Private collection
Courtesy of the artist and
Kersan Art Studio

Faded Emotion, 2010
Acrylic on canvas,
180 x 140 cm
Private collection
Courtesy of the artist and
Kersan Art Studio

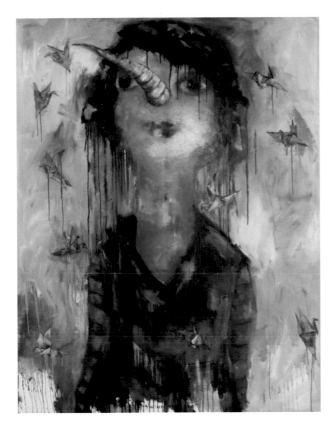

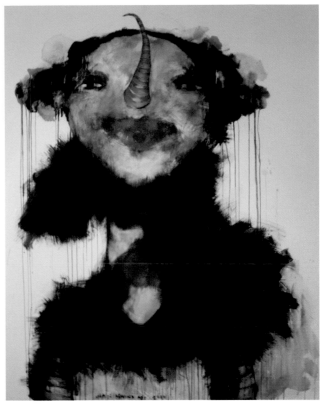

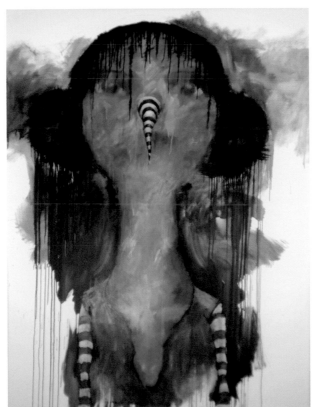

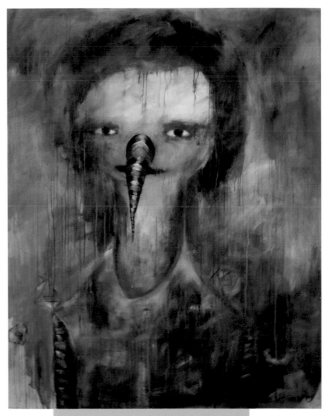

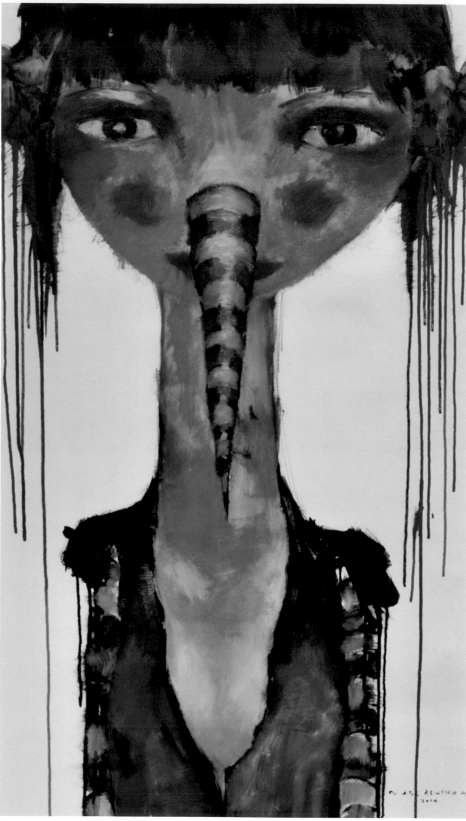

Portrait, 2010
Oil on canvas, 257 x 93 cm
Private collection
Courtesy of the artist and
Kersan Art Studio

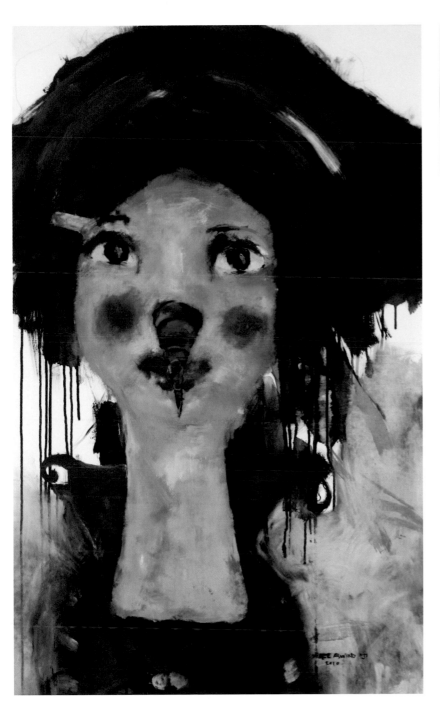

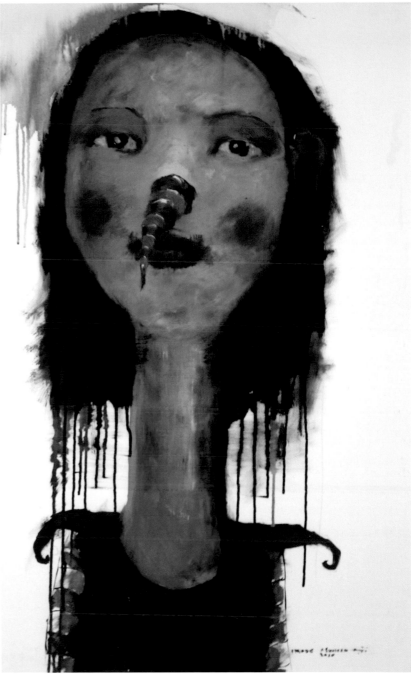

Portrait, 2010
Oil on canvas, 157 x 93 cm
Private collection
Courtesy of the artist and
Kersan Art Studio

Portrait, 2010
Oil on canvas, 157 x 93 cm
Private collection
Courtesy of the artist and
Kersan Art Studio

Muhammad Reggie Aquara

My work is generally about belief. I try to verify the power of visual language and the verbal text. I believe that each language has a different reference in everybody's mind. In my work, I use an image from a movie scene or a Western artist biography movie, for example Basquiat, Rembrandt, Klimt or Vermeer. I capture the image and input Indonesian subtitles; then I transfer it to canvas in oil painting. What is created is a scene that deals with a provocative text, and an image that has a different meaning in time, medium, duration, changing the viewer's empathy as well as the themes of personal and historical memory. Recently my work has used movie stills as a template, "the image and the text". I use the abstract image by recreating it into a large scale of blot painting with translated subtitles that read "Berdasarkan kisah nyata" on the front, and "Based on true story" on the reverse. In this work I tried to represent the act of Action Painting as a movie scene. The mirrored image of the impasto painting and the translated text were combined to form a kind of essay on the limits of memory and immateriality. This work tries to show how the cultural influences on the scene have unlimited possibility of perception, in the same way as an abstract painting.

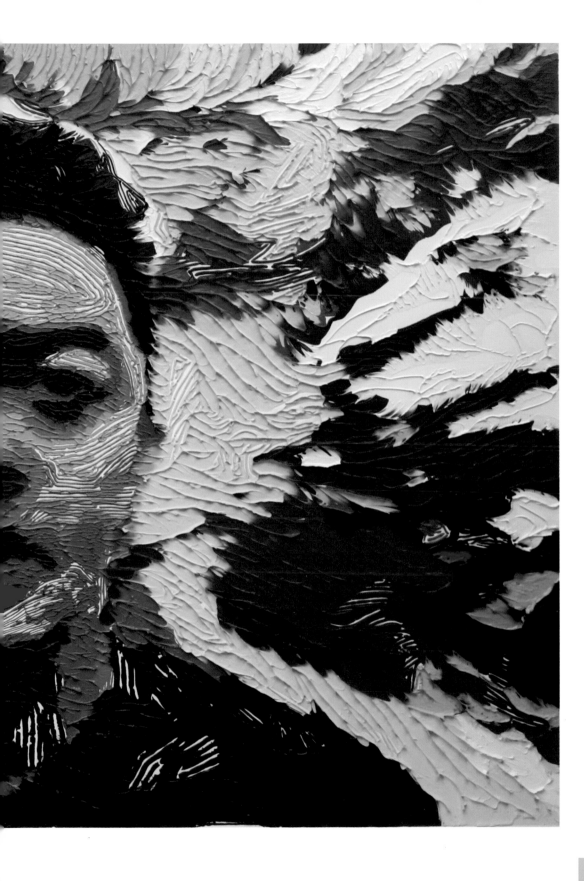

Between Beauty and Ugliness, 2010
Oil on canvas on wood
panel, 132 x 195.5 cm
(2 panels: 132 x 98 cm each)
Private collection
Courtesy of the artist

Muhammad Reggie Aquara **57**

*What You See Is What
You Guess #1*, 2009
Oil on canvas with black
gloss varnish frame,
106 x 150 cm
Collection of the artist
Courtesy of the artist

*What You See Is What
You Guess #2*, 2009
Oil on canvas with black
gloss varnish frame,
110 x 155 cm
Collection of the artist
Courtesy of the artist

*How to Understand
the Highly Abstract Painting
Shown in Wide Screen*,
2010
Oil on canvas on wood
panel, 135 x 390 cm
(2 panels: 135 x 195 cm each)
Collection of Mrs Nanny
Widjaja
Courtesy of the artist

Berdasarkan kisah nyata

Where the Light Is #1, 2009
Oil on canvas with black
gloss varnish frame,
112 x 158 cm
Collection of the artist
Courtesy of the artist

Where the Light Is #2, 2009
Oil on canvas with black
gloss varnish frame,
110 x 155 cm
Collection of the artist
Courtesy of the artist

Muhammad Reggie Aquara

Dewa Ngakan Made Ardana

In his work *Anonymous Projects* Ardana creates a number of photographs of the faces around him, treats the photographs and combines a number of facial pictures into composition. He seems to be playing with the characters by removing everything that may give characteristic signs of existence as an actual person. In *History [Bleak Depiction]* Ardana illustrates one dimension of Javanese culture and tradition in Yogyakarta Royal Palace, Indonesia in 1812.

Bleak Depiction, 2010
Oil on canvas, 110 x 120 cm
Private collection
Courtesy of the artist and
Galeri Semarang

Image no. RA VI H, 2010
Oil on canvas, 200 x 150 cm
Private collection
Courtesy of the artist and
Galeri Semarang

History [Bleak Depiction],
2010
Oil on canvas, 200 x 300 cm
Private collection
Courtesy of the artist and
Galeri Semarang

Abstract Pseudo, 2010
Oil on canvas, 104 x 120 cm
(2 panels: 104 x 60 cm each)
Private collection
Courtesy of the artist and
Galeri Semarang

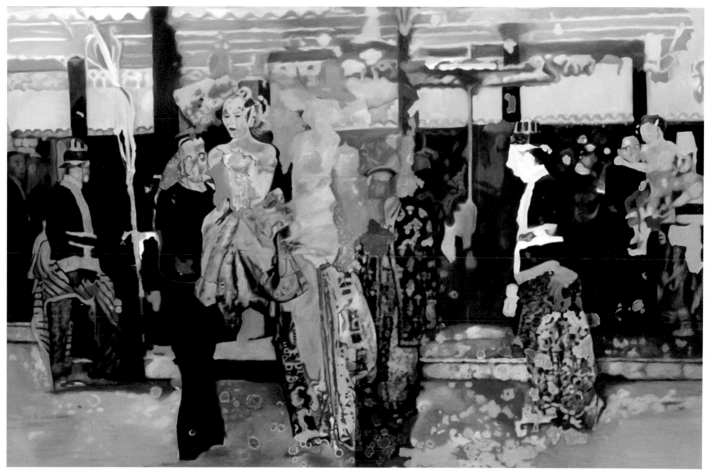

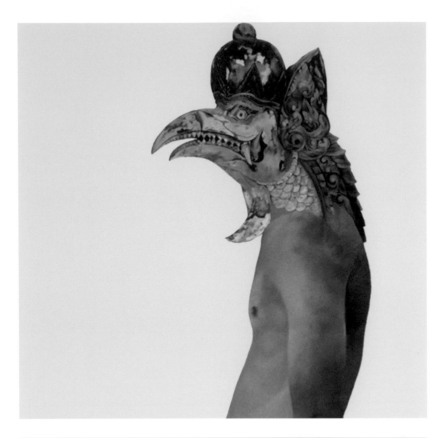

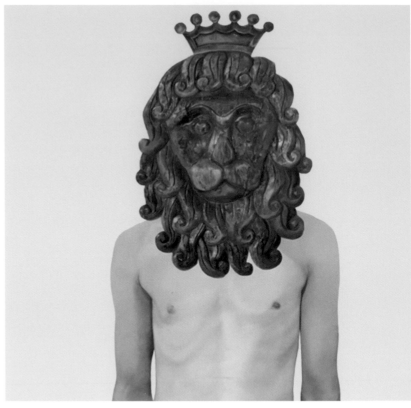

Being Another One no. 2, 2010
Oil on canvas, 200 x 200 cm
Private collection
Courtesy of the artist and
Galeri Semarang

Reproducing Symbol, 2010
Oil on canvas, 200 x 200 cm
Private collection
Courtesy of the artist and
Galeri Semarang

Being Another One, 2010
Oil on canvas, 200 x 200 cm
Private collection
Courtesy of the artist and
Galeri Semarang

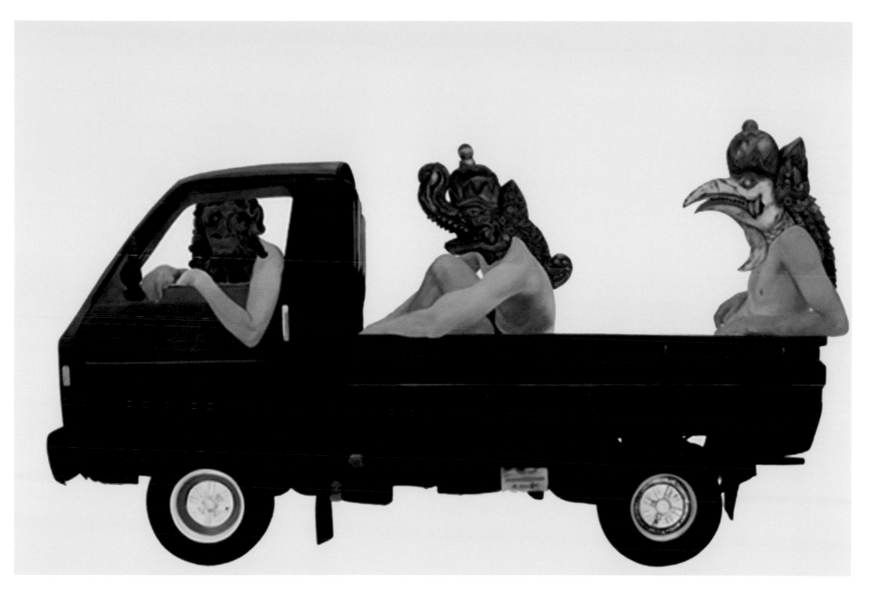

The Irony, 2010
Oil on canvas, 200 x 300 cm
Private collection
Courtesy of the artist and
Galeri Semarang

Samsul Arifin

The collective memories of education are images of chairs, pencils and erasers, pens and papers that must be written. To Samsul these depicted objects, the Staedtler 2B blue pencils and Boxy erasers are familiar visual icons to the generations who schooled in the 1980s and 1990s, and possibly up until today. These objects are icons for young people who haven't been colonized by the digital technologies that are starting to dominate the life development of children from the urban upper classes.

You Can See (white), 2010
Fabric, dacron, life size
Collection of the artist
Courtesy of the artist and
Galeri Semarang

You Can See (black), 2010
Fabric, dacron, life size
Collection of the artist
Courtesy of the artist and
Galeri Semarang

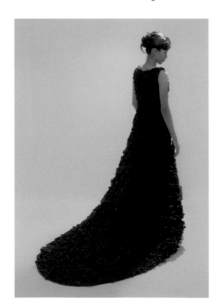

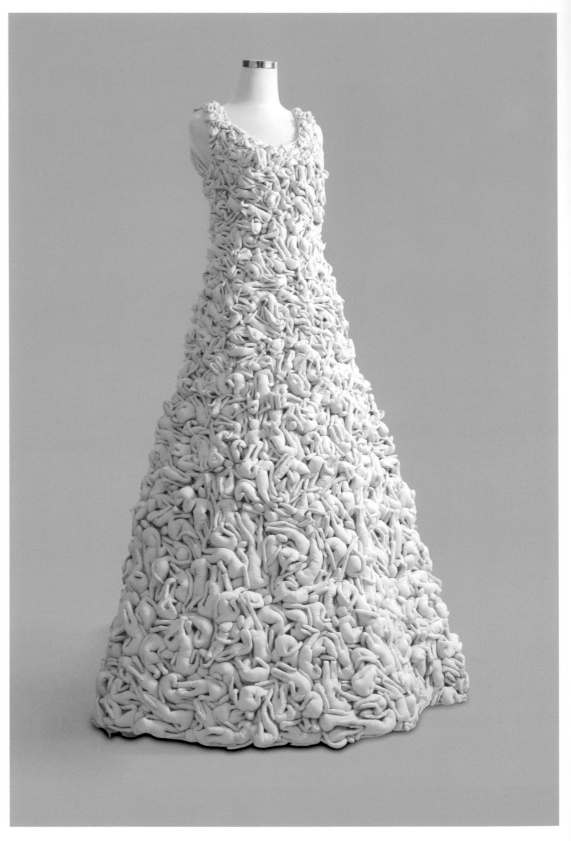

Between Life and Game,
2010
Fabric, dacron, string,
polyester, diameter 170 cm
Private collection
Courtesy of the artist and
Galeri Semarang

Samsul Arifin **65**

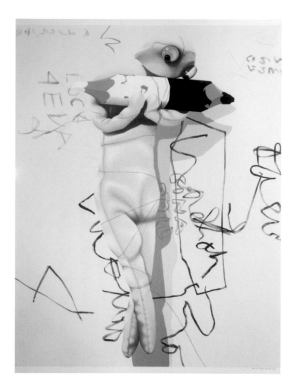

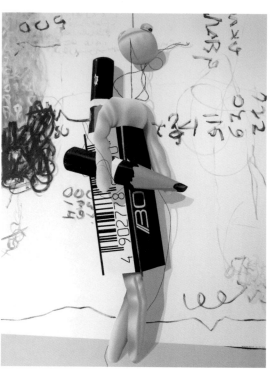

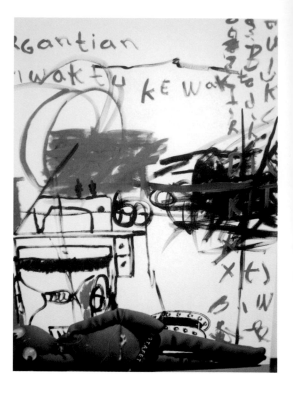

Between Black and White,
2010
Acrylic on canvas,
200 x 150 cm
Private collection
Courtesy of the artist and
Galeri Semarang

Offhand Scribble 2, 2010
Acrylic on canvas,
200 x 150 cm
Private collection
Courtesy of the artist and
Galeri Semarang

Time After Time, 2010
Oil on canvas, 200 x 150 cm
Private collection
Courtesy of the artist and
Galeri Semarang

Goni's Voice, 2008
Ricesack, wood, installation,
variable dimensions
Private collection
Courtesy of the artist and
Galeri Semarang

Goni's Voice 2, 2008
Ricesack, wood, installation,
variable dimensions
Private collection
Courtesy of the artist and
Galeri Semarang

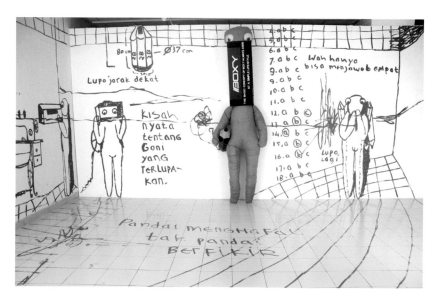

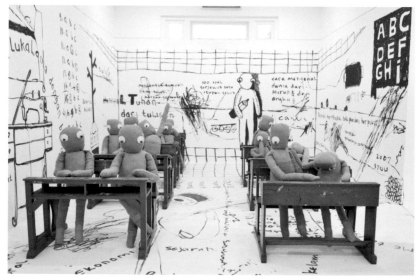

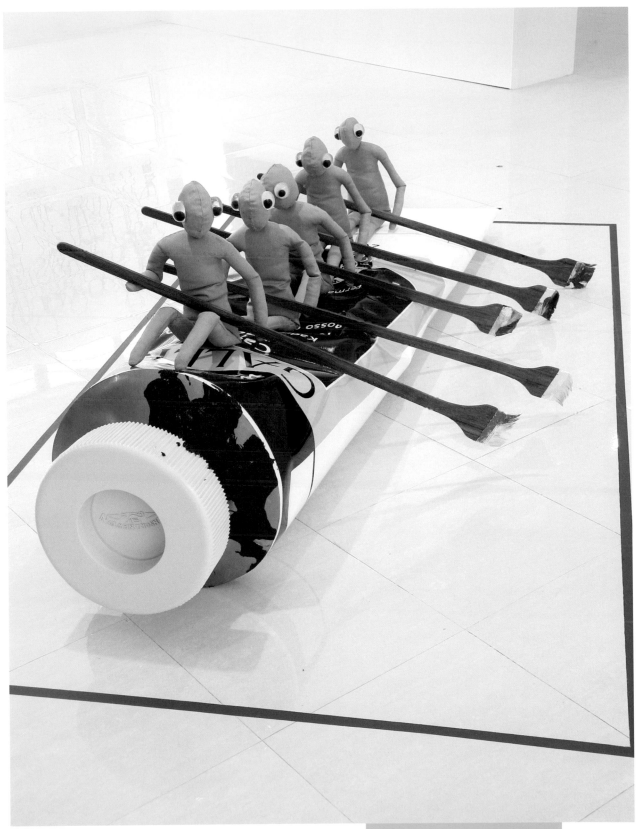

Collective Success, 2010
Painted steel plate, polyester,
wood, 90 x 260 x 100 cm
Private collection
Courtesy of the artist and
Galeri Semarang

Ay Tjoe Christine

The work has transformed the theological relations into interhuman relations, with all their banality, bitterness and tragic aspects. Christine's artistic idea is an allegorical one, alluding to religiosity and even referencing to the religious texts that she has so far believed in and simultaneously reinterpreted. The impressions and images of destruction, frailty and collapse give rise to perceptions about tragic emotions that serve as the basis of her allegorical works. We can see lines that appear winding, fractured or scrawny in places, going in all directions. Under the shadow of the nails, guillotine, strings, balls, and the type machine's sharp arms, the work conjures a special atmosphere reminiscent of Eva Hesse: a space between absurd and collapsed lives. (*Hendro Wiyanto*)

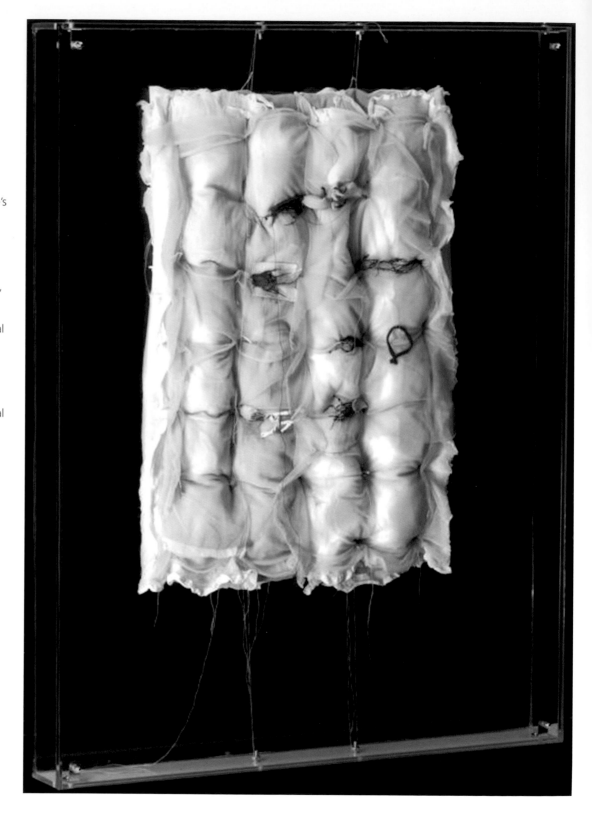

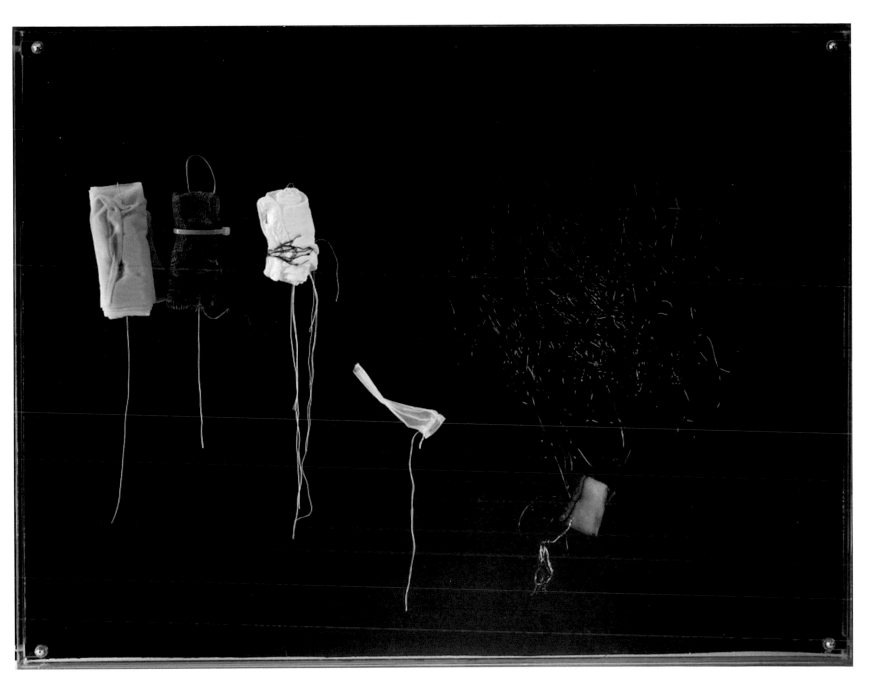

24 of Us, 2006
Mixed media and glass box,
65.5 x 50 x 6 cm
Collection of Edwin's Gallery
Courtesy of the artist

Foursome, 2006
Mixed media and glass box,
50 x 65 x 3 cm
Collection of Edwin's Gallery
Courtesy of the artist

3 > 2 #07, 2010
Oil on canvas, 170 x 200 cm
Christiana Gow Gallery
Courtesy of the artist

Our Undercover #01, 2008
Acrylic on canvas,
135 x 170 cm
Collection of Langgeng
Gallery
Courtesy of the artist

Removable Party, 2007
Acrylic on canvas,
135 x 135 cm
Umahseni Collection
Courtesy of the artist

Growing Fish #01, 2008
Acrylic on canvas,
170 x 135 cm
Private collection
Courtesy of the artist

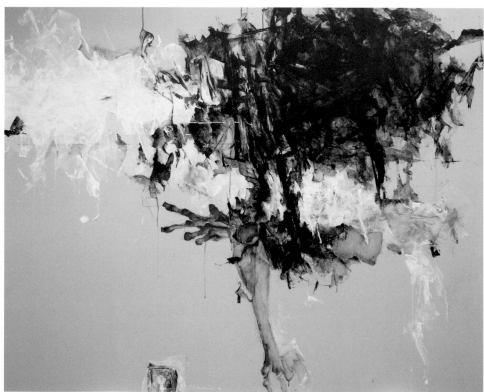

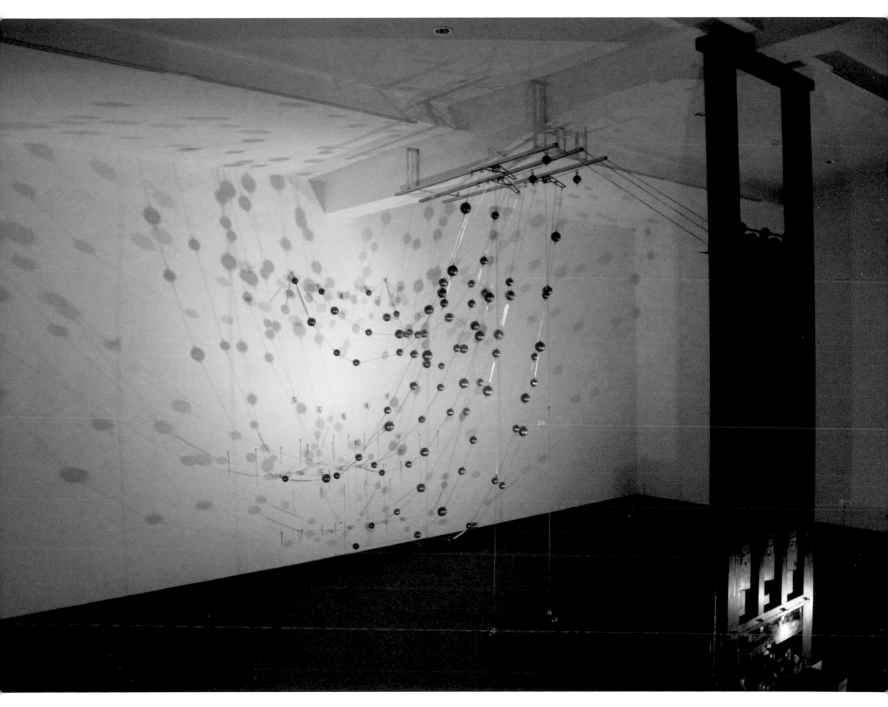

Lama Sabakhtani #01, 2010
Wood, metal, wire, brass
balls, 4.3 x 2.5 x 4 m
Private collection
Courtesy of the artist

Wimo Ambala Bayang

Wimo Ambala Bayang works mostly with photography and video. As a photographer, Bayang plays with the idea of how a camera and the digital image have changed our perception of visual reality. He juxtaposes what is real and what is unreal to create a whole new reality. He uses various artistic approaches, acting and inviting the audience to be part of the process of making collages with images. Bayang is interested in issues of urban life including youth culture and daily expression, and in studying the power dynamics among people in this context. He presents ideas about power in interpersonal relationships, where the personal becomes political. In his works we can find an alternative and subversive definition of the meaning of power and politics. (*Alia Swastika*)

The 8th Force, 2008
Series *The Dutch is coming soon!*
Digital-c print mounted on aluminium, 120 x 120 cm
5 edition + 2 AP
Courtesy of the artist and Cemeti Art House

The 6th Force, 2008
Series *The Dutch is coming soon!*
Digital-c print mounted on aluminium, 120 x 120 cm
5 edition + 2 AP
Courtesy of the artist and Cemeti Art House

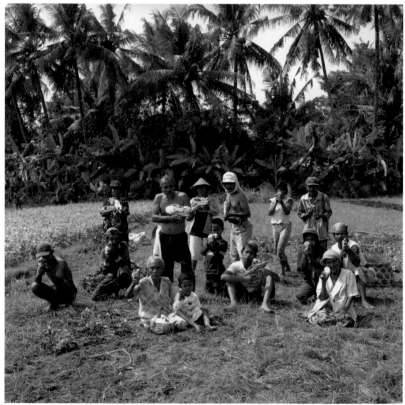

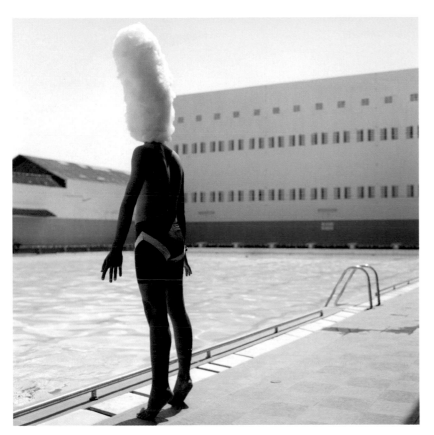

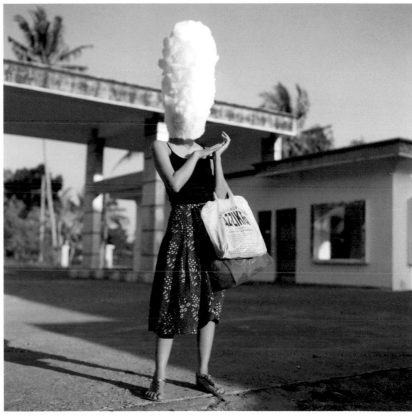

*Anang is Seeking for
Happiness*, 2009
Series *High Hopes*
Digital c-print mounted on
aluminium, 120 x 120 cm
2 edition 100 x 100 cm,
inkjet print on Hahnemühle
Monet canvas
3 edition + 1 AP
Courtesy of the artist and
Ark Galerie

*Julia Wants to be
Successful*, 2009
Series *High Hopes*
Digital c-print mounted on
aluminium, 120 x 120 cm
2 edition 100 x 100 cm,
inkjet print on Hahnemühle
Monet canvas
3 edition + 1 AP
Courtesy of the artist and
Ark Galerie

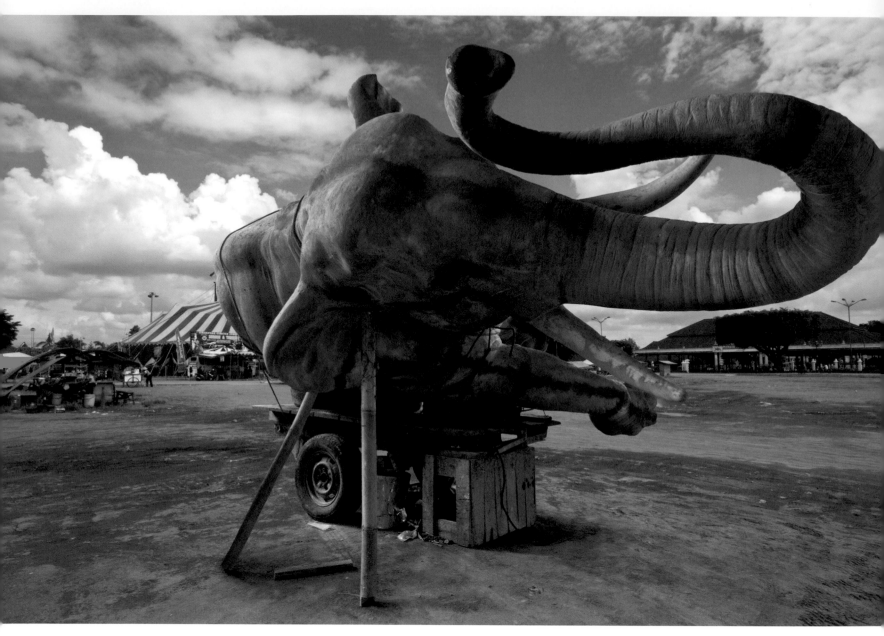

Yogyakarta Monument,
2010
Series *Sleeping Elephants in
the Axis of Yogyakarta*
Digital c-print mounted on
aluminium, 110 x 165 cm
3 edition + 2 AP
Courtesy of the artist and
Ark Galerie

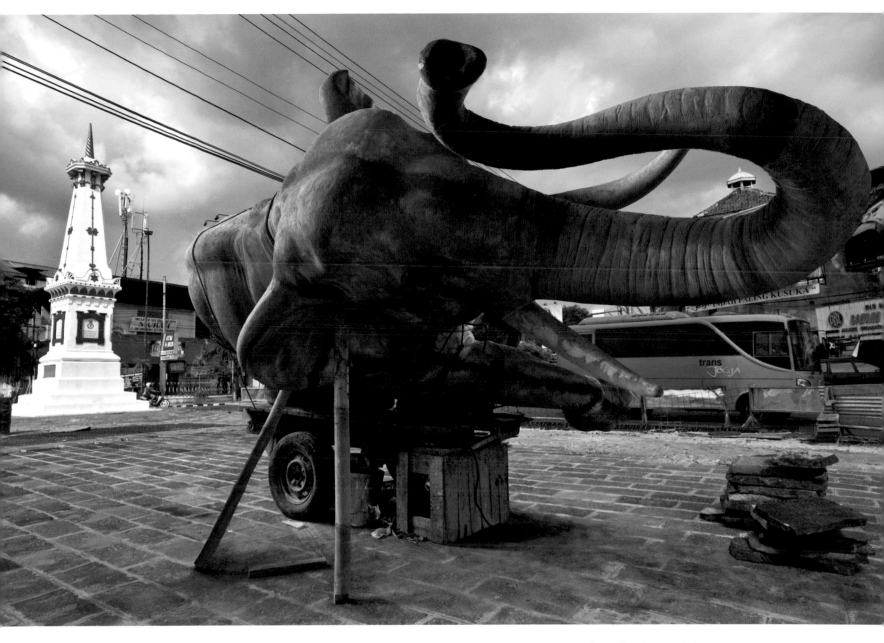

Sultan Palace Square, 2010
Series *Sleeping Elephants in the Axis of Yogyakarta*
Digital c-print mounted on aluminium, 110 x 165 cm
3 edition +2 AP
Courtesy of the artist and Ark Galerie

Wimo Ambala Bayang

Dadang Christanto

From the very beginning, Christanto's work has been about human tragedy. The pieces relate to the artist's personal experience with a political trauma that was also one of the worst humanitarian crises in the history of modern Indonesia. The symbols of trees, seeds and other plants have a personal meaning for him. They are formed with paint, charcoal and inside minimalist spaces lined with brownish linen. There is a special attention to tension the balance colour in his work, which evokes a carefully woven game of polarity. These elements become symbols, spread out and fragmented, reminiscent of the ornamental images in primitive painting or the dot images of Australian Aborigines.

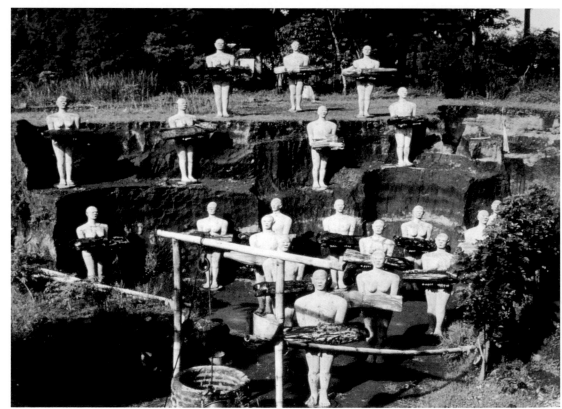

Voice from Underworld
(detail), 1998
Variable dimensions
Collection of the artist
Courtesy of Indonesian
Visual Art Archive

Voice from Underworld,
1998
Variable dimensions
Collection of the artist
Courtesy of Indonesian
Visual Art Archive

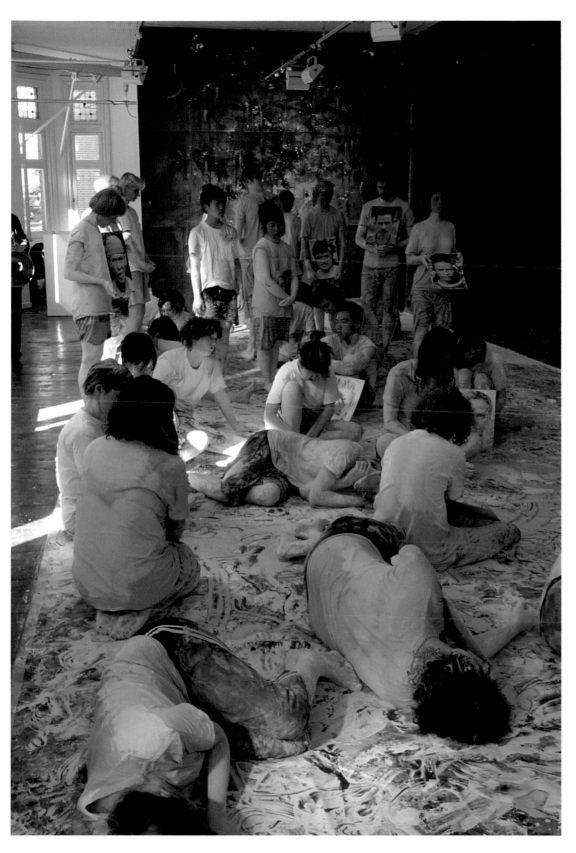

Survivors, 2008
Performance
Courtesy of the artist

Never Ending Stories
(front ground), 2007
Acrylic on used cardboard,
installation, variable
dimensions
Courtesy of the artist and
Jan Manton Gallery

Violence III: Land Case
(detail), 1995
Terracotta powder,
52.5 x 245 x 164 cm
Courtesy of Jogja Gallery

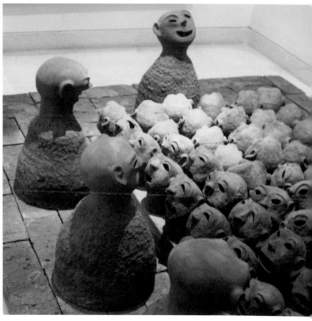

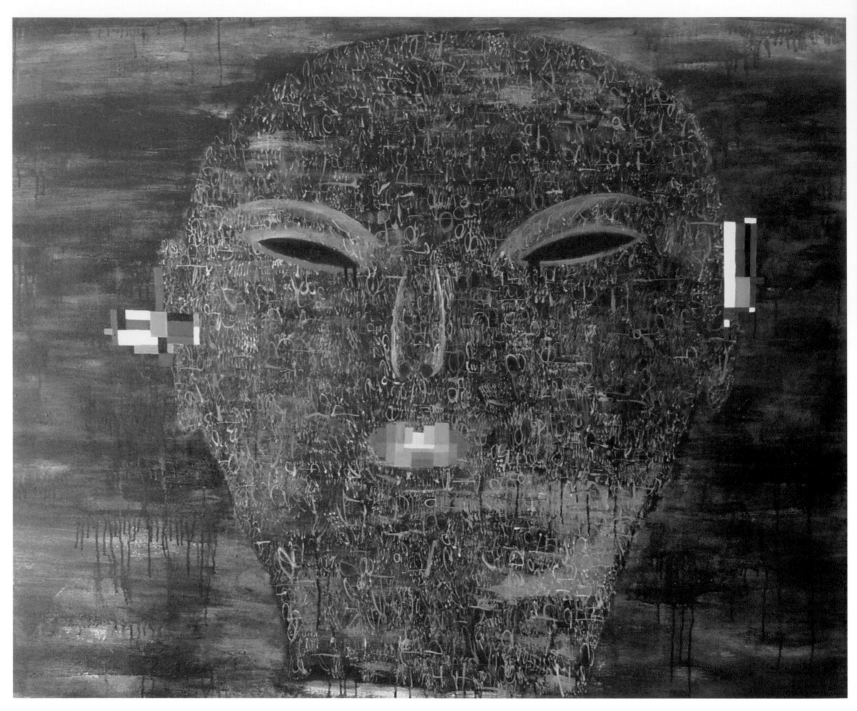

Face with Black Tears, 2010
Acrylic on Belgian linen,
136 x 168 cm
Collection of the artist
Courtesy of the artist

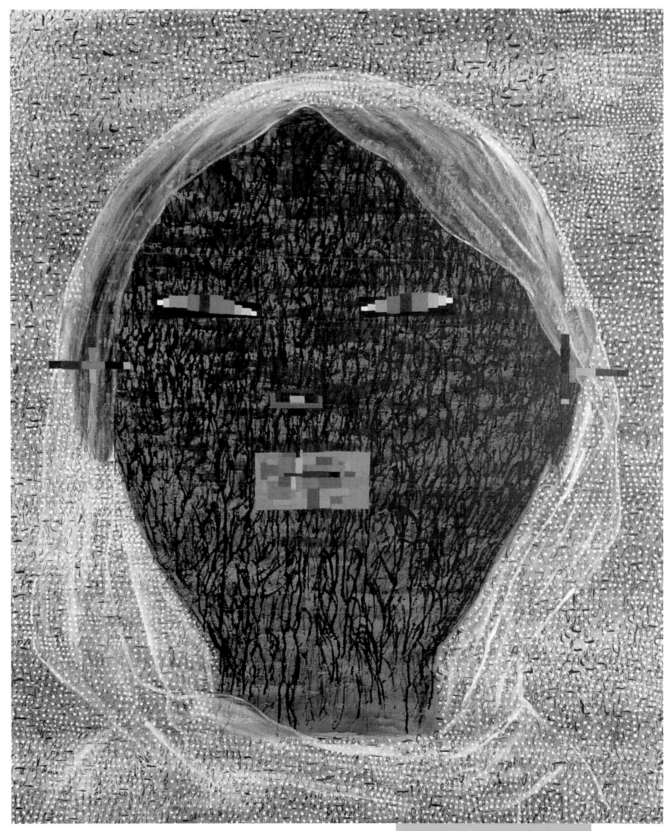

When My Censorship Coming, 2010
Acrylic on Belgian linen,
136 x 110 cm
Collection of the artist
Courtesy of the artist

S. Teddy D.

S. Teddy D.'s work is tied up with conversations about social problems. His creative ideas strike at all kinds of issues and statements that narrate the realities of history, society and other popular topics. He keeps his options open by not seeing everything in purely black or white, for what matters most to him is the emergence of a cultural dialogue and facing reality sensibly. He says, "Humans have a preference for giving freedom to the thoughts and fantasies in their hands". By this he means that people can take action to liberate their imagination, conflicts and desires from their daily lives. These ideas have led to his preference for fantasy in his works, that often show signs that other artists avoid. These visual thoughts give meaning to social symptoms. (*Mikke Susanto*, excerpted from *Modern Indonesian Art from Raden Saleh to the Present Day*, 2010)

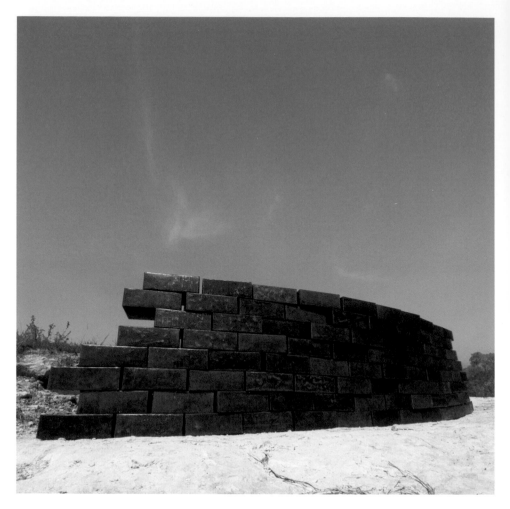

Do Not Touch (Not except for the artist), 2003
Zinc, 100 x 200 x 200 cm
Collection of the artist

Funatic, 2008
Painted fibreglass,
80 x 40 x 40 cm each
Collection of Langgeng Art Foundation

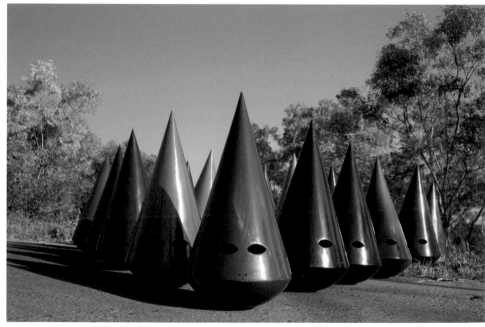

Love Tank (The Temple),
2009
Plywood, fibreglass, fabric,
830 x 400 x 600 cm
Collection of the National
Museum of Singapore

Pink Tank, 2009
Fibreglass,
400 x 200 x 350 cm
Collection of
Mrs Jais Darga Wijaya

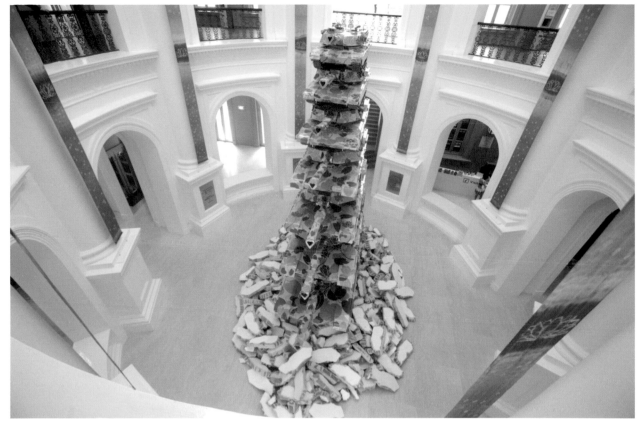

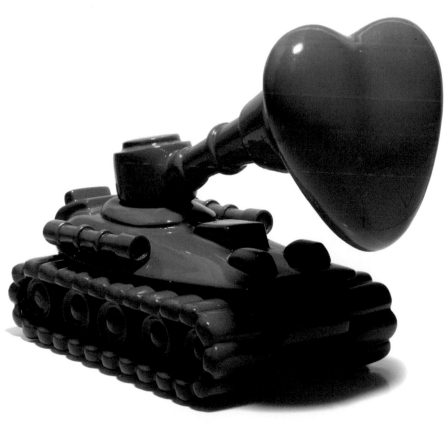

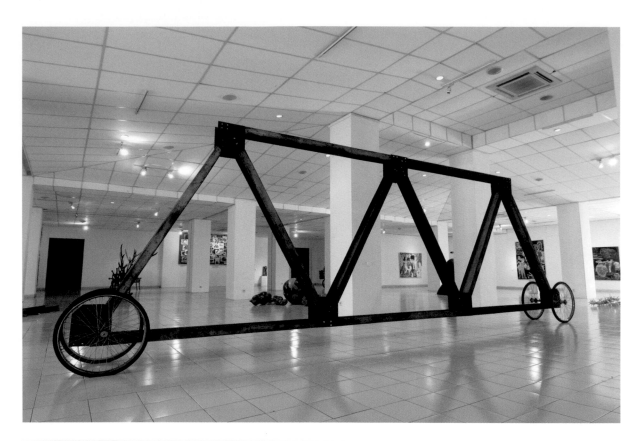

*Show Me the Way to the
Next Bridge*, 2002
Steel, 270 x 800 x 80 cm
Collection of the artist

Hope, 2009
Fibreglass, glass, mirror,
paddy, 400 x 350 x 300 cm
Collection of the artist

*Parody of Circle of Life
(Circle of Death)*, 2008
Wood, aluminium, acrylic,
60 x 50 x 15 cm
Collection of
Mr Eddy Hartanto

S. Teddy D.

83

Andy Dewantoro

Abandoned, 2010
Fibreglass, resin, paint,
variable dimensions
Private collection
Courtesy of the artist and
Galeri Semarang

As he explored the museums of Europe in 2006, Dewantoro witnessed great works from diverse eras, from classical to modern and contemporary. He found that he was attracted to landscape paintings developed in nineteenth-century England, especially works by William Turner and John Constable. Since then, Dewantoro began applying landscape painting as the frame to his art. Remembering his experience on seeing the painted English landscapes, he explained how his feeling about them heightened a sense of drama that was captivating, as he had initially thought that landscapes showed only natural beauty. But looking more closely inside those paintings he witnessed an almighty storm, a menacing winter sky and a natural disaster bringing down stone mountains. Through this drama Dewantoro came to a kind of religious experience.

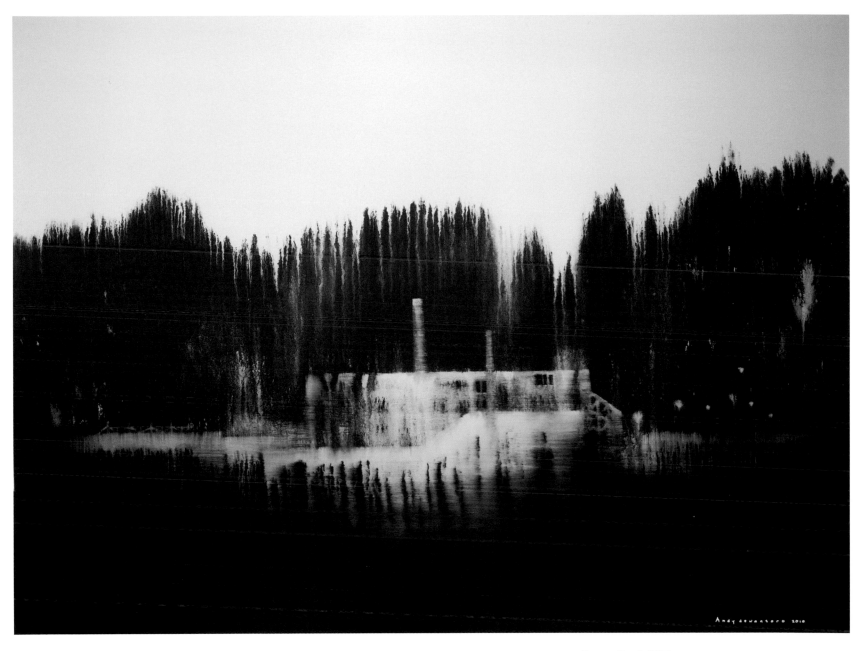

Strange Day 3, 2010
Acrylic on canvas,
180 x 240 cm
Private collection
Courtesy of the artist and
Galeri Semarang

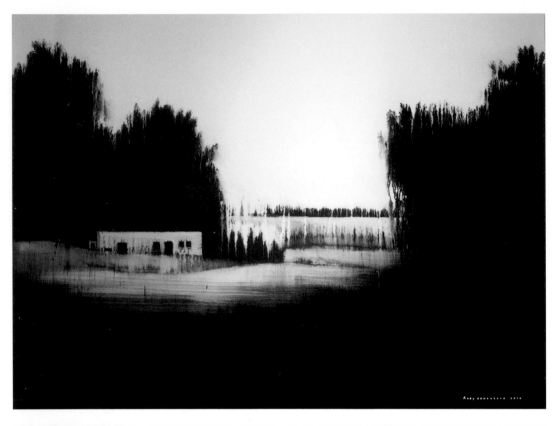

Forest Unknown 3, 2010
Acrylic on canvas,
180 x 240 cm
Private collection
Courtesy of the artist and
Galeri Semarang

Forest Unknown 11, 2010
Acrylic on canvas,
18 panels: 40 x 40 cm each
Private collection
Courtesy of the artist and
Galeri Semarang

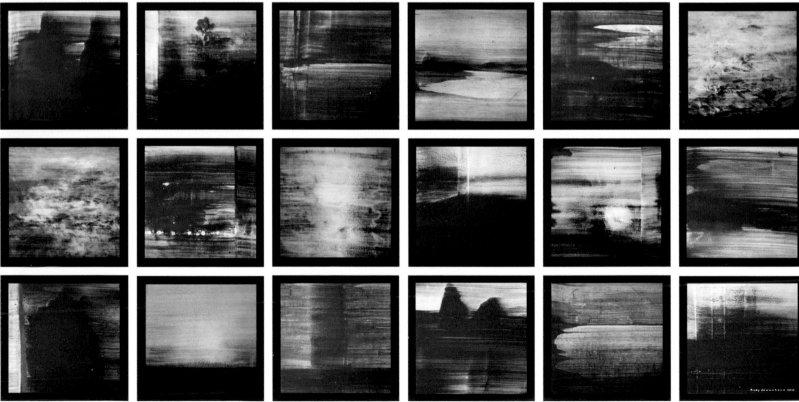

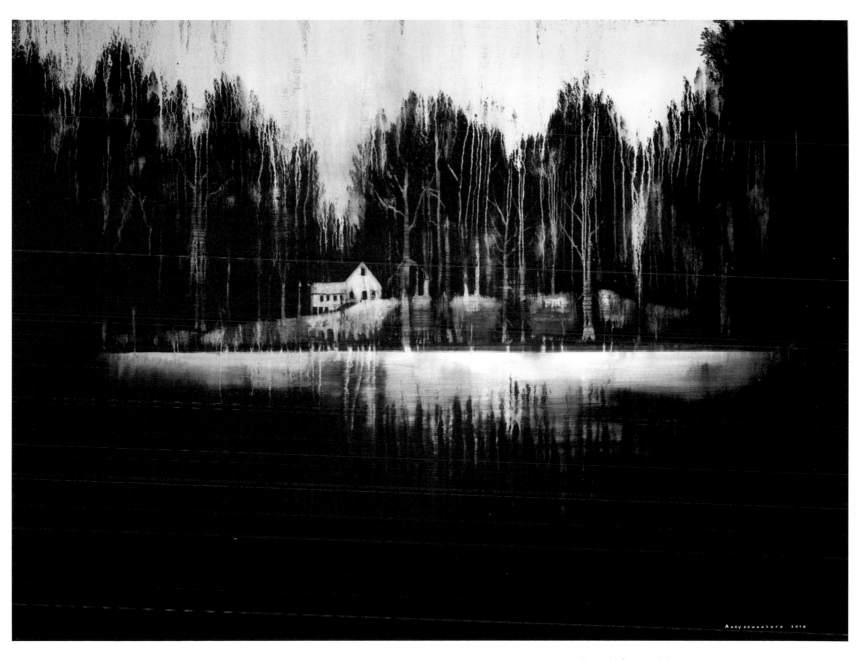

Forest Unknown 4, 2010
Acrylic on canvas,
180 x 240 cm
Private collection
Courtesy of the artist and
Galeri Semarang

Andy Dewantoro 87

I Made Widya Diputra

I express my feelings and desires through my work by transforming the materials. A work of art is a self-reflection of the artist.

Fetish #3, 2010
Dacron, silicon, textile, socks, shoes,
75 x 95 x 190 cm
Collection of the artist
Courtesy of the artist

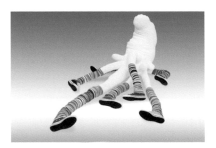

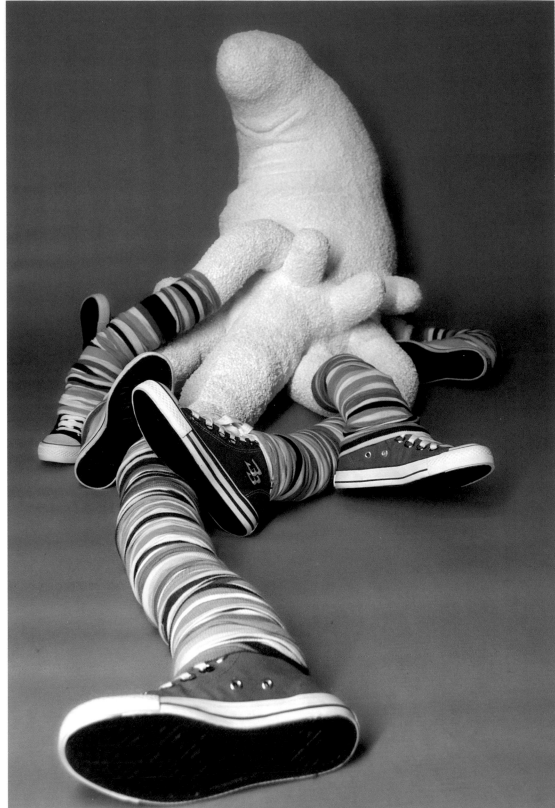

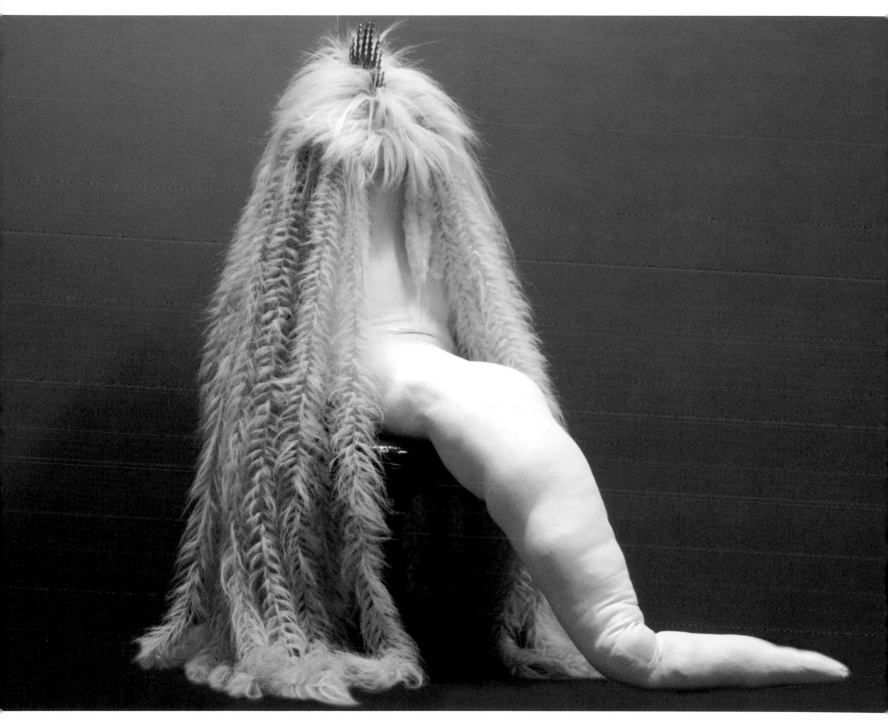

Mother, 2009
Resin, polyurethane paint,
horse hair, chair,
120 x 80 x 100 cm
Collection of the artist
Courtesy of the artist

I Made Widya Diputra

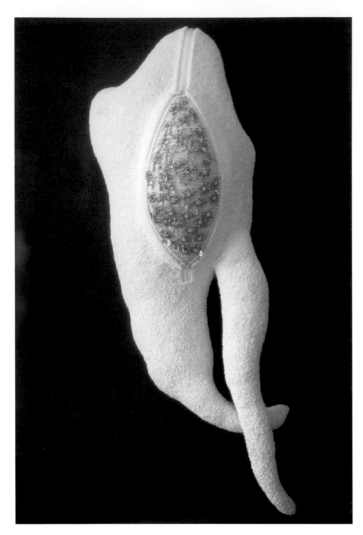
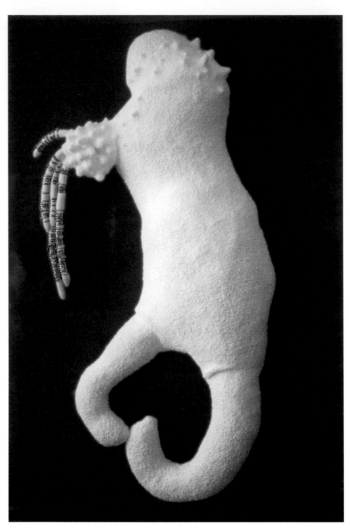

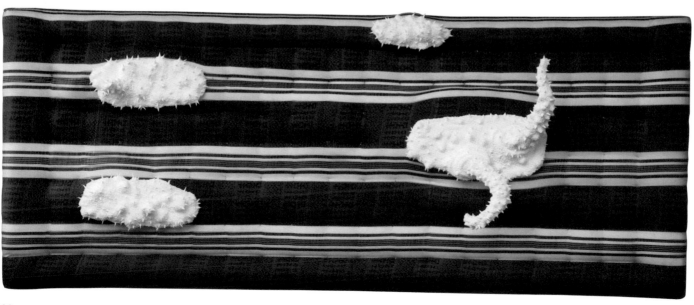

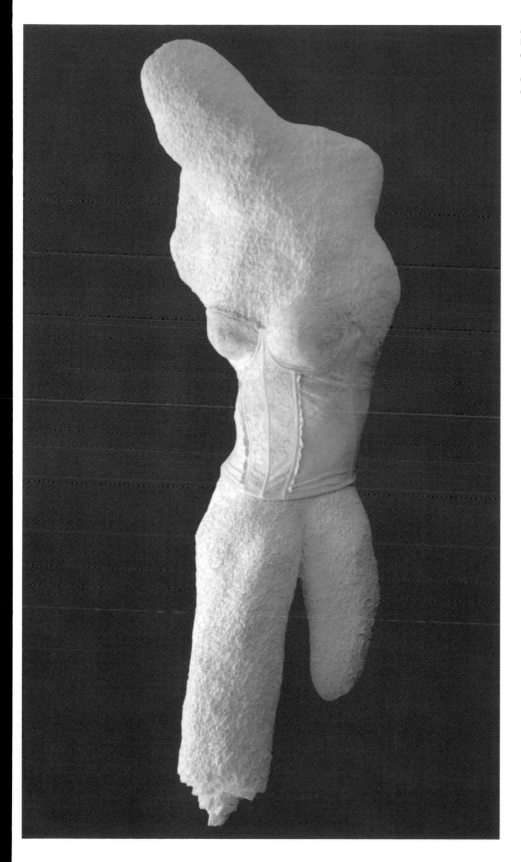

Microcosm, 2010
Metal, gauze, silicon,
corset, acrylic paint,
150 x 54 x 38 cm
Collection of the artist
Courtesy of the artist

*There Are Still Many Empty
Rooms*, 2009
Resin, stone, polyurethane
paint, 100 x 100 x 10 cm
Private collection
Courtesy of the artist

Heri Dono

Heri Dono uses elements from folk traditions known to everyone in Indonesia: Wayang plays and the life of the common man. He combines these elements with images from the collective consciousness. He likes to play with words, which is also a part of Javanese culture, and images. Here we can see people represented as puppets, angels and clowns. Common subjects in his work are the state of the education system in Indonesia, corruption, mass media, power and politics. Aside from paintings and installations, Dono also makes multimedia performances in which current affairs are explored, although politics is not the most important element in his work. (Excerpted from the *Introduction* of the exhibition catalogue, Tropenmuseum, Amsterdam)

Flower Diplomacy, 2000
Acrylic, collage on canvas,
154 x 207 cm
Private collection
Courtesy of the artist and
Nadi Gallery

*The King Who is Afraid of
Approaching Barong*, 2000
Acrylic, collage on canvas,
153 x 205 cm
Private collection
Courtesy of the artist and
Nadi Gallery

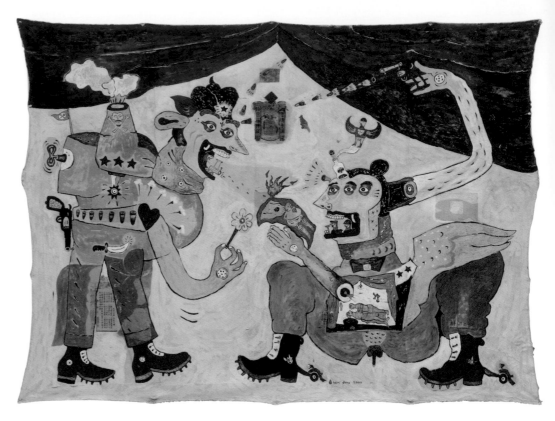

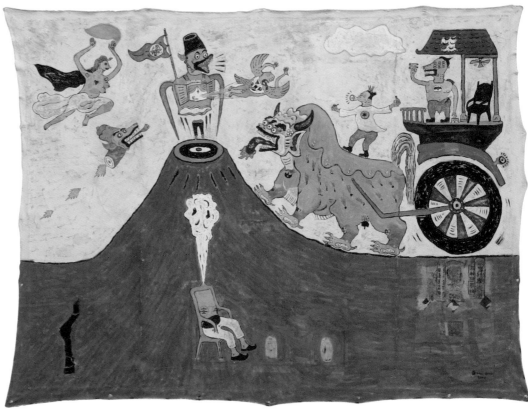

Flying Angels, 1996
Fibreglass, mechanical
system, acrylic, electronic
parts, cotton, bamboo,
overall c. 500 x 500 cm
(100 x 60 x 25 cm each)
Private collection
Courtesy of the artist
and Nadi Gallery

Born and Freedom, 2004
Fibreglass, acrylic, radio,
metal, 5 pieces on the floor
90 x 65 x 36 cm each,
5 pieces on the wall
105 x 50 x 30 cm each
Private collection
Courtesy of the artist
and Nadi Gallery

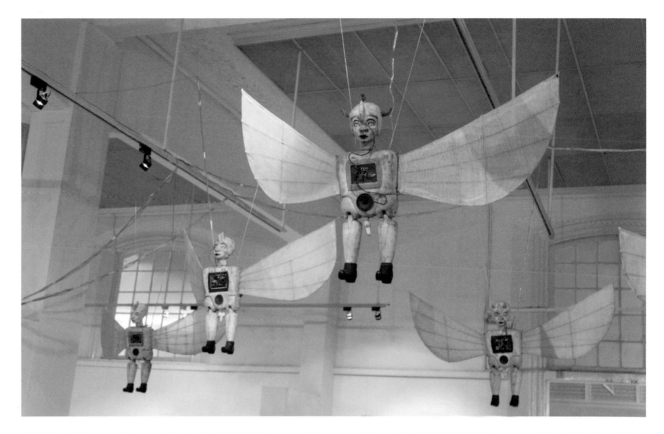

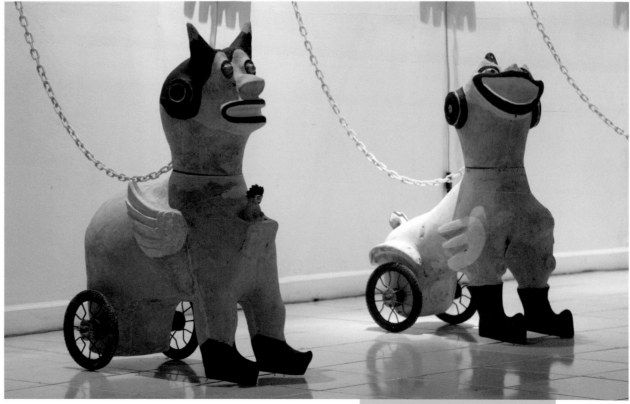

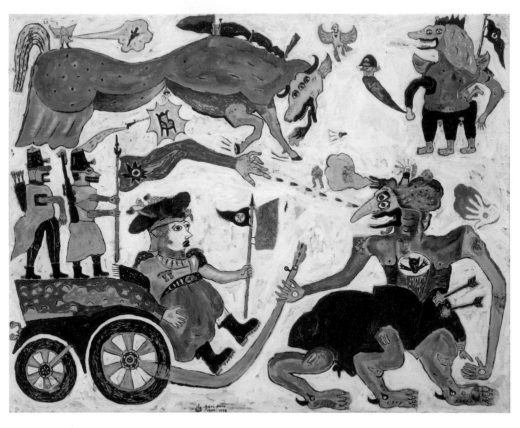

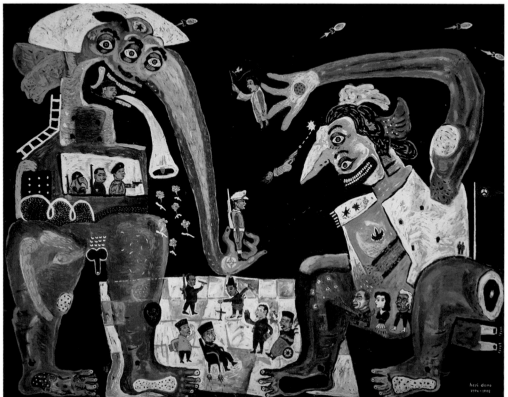

Looking for a Fake President, 1994–98
Acrylic, collage on canvas,
119 x 149 cm
Collection of Eddie Hartanto
Courtesy of the artist and
Nadi Gallery

Playing Chess, 1994–98
Acrylic, collage on canvas,
118 x 148 cm
Private collection
Courtesy of the artist and
Nadi Gallery

Fermentation of Mind, 1994
9 wooden desks, 18 nodding
heads with mechanical
system, 9 loop tape
recorders, cable, adaptor,
overall c. 500 x 500 cm
Private collection
Courtesy of the artist and
Nadi Gallery

Political Clowns, 1999
Fibreglass, bulbs, bottles
of jar, metal, cable, tape
recorders, tin cans, acrylic,
plastic pipes, vegetable
oil, 15 pieces,
120 x 50 x 50 cm each
Private collection
Courtesy of the artist and
Nadi Gallery

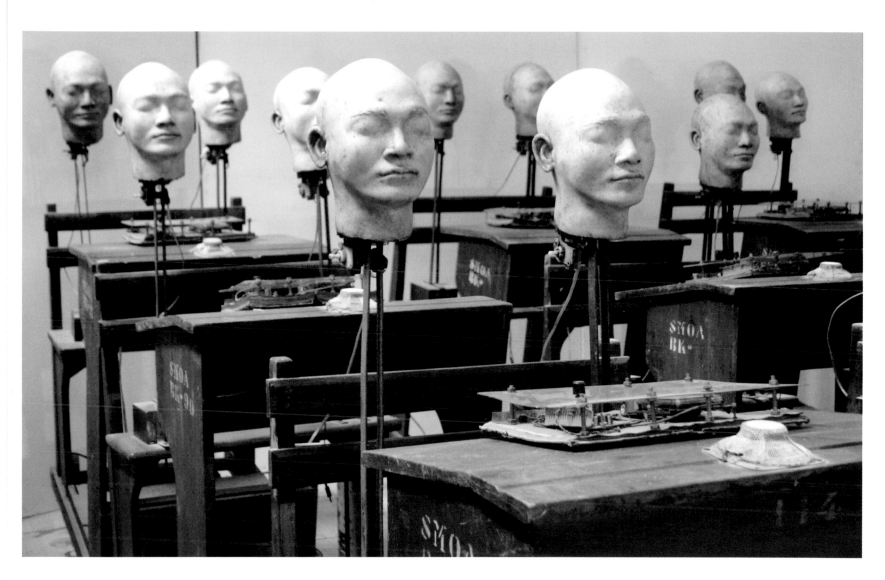

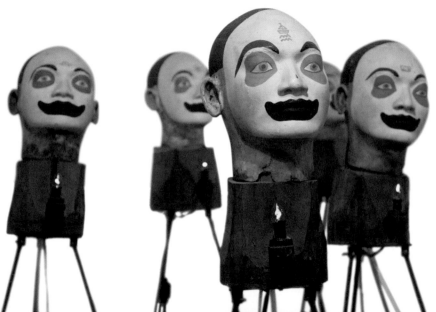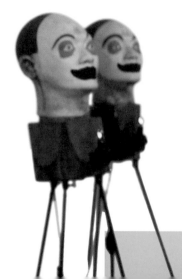

Heri Dono 95

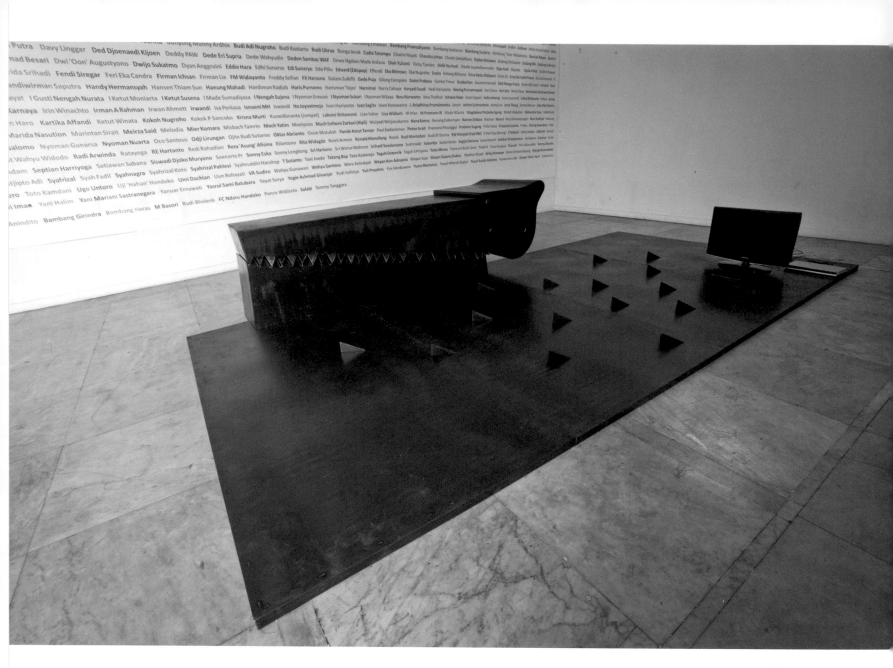

Manifesto, 2008
Iron, video,
400 x 300 x 90 cm
Collection of the artist
Courtesy of the artist

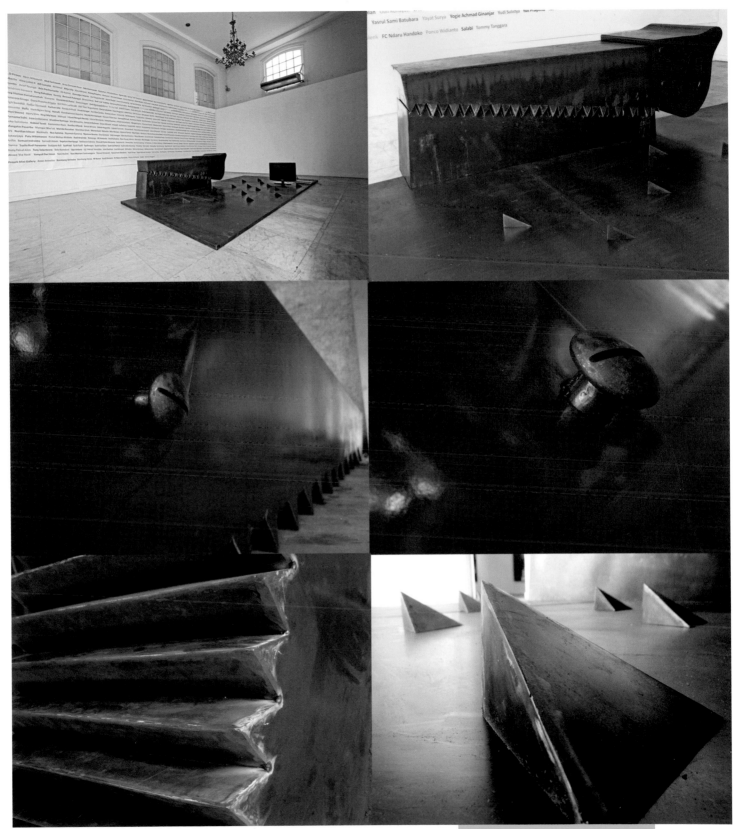

Eddie Hara

Eddie Hara's images posses a naïve, almost childlike quality. With an abundance of bright colours and filled with intense humour, the mood of Eddie Hara's art is always cheerful, joyful and easygoing, albeit exuding a bizarre impression. It reflects a festive atmosphere, a carnival, or even a crazy orgy. Nevertheless, some of his works portray very serious issues, involving the difficult periods of life, which can be dramatic and tragic.

Brothers in Arm, 2009–10
Acrylic on canvas,
180 x 100 cm
Collection of the artist
Courtesy of the artist and
Tonyraka Art Gallery

I've Got the Crown, 1999
Watercolour on paper,
40 x 55 cm
Collection of Tonyraka Art
Gallery
Courtesy of the artist

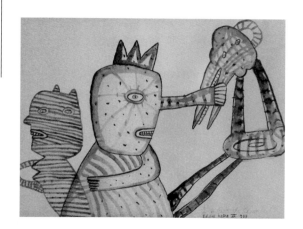

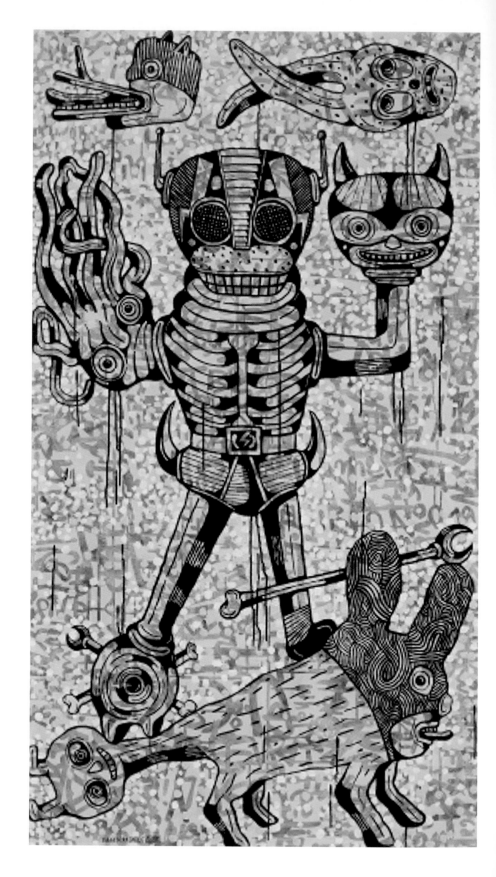

Big Brother's Playground,
2010
Acrylic on canvas,
150 x 205 cm
Collection of the artist
Courtesy of the artist and
Tonyraka Art Gallery

Lost in Wasteland, 2010
Acrylic on canvas,
150 x 240 cm
Collection of
Mr Tihin Tjonq Yen
Courtesy of the artist and
Tonyraka Art Gallery

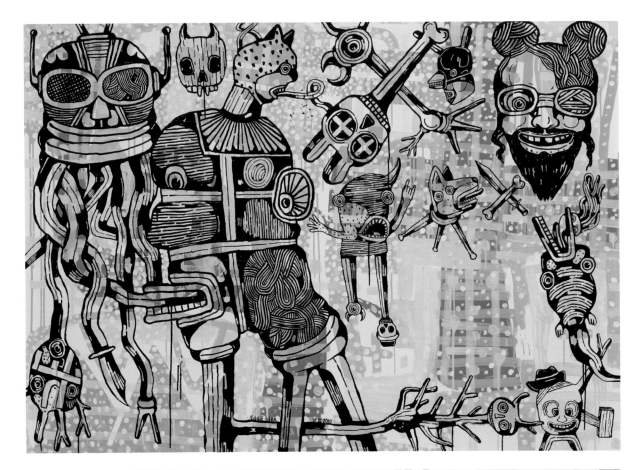

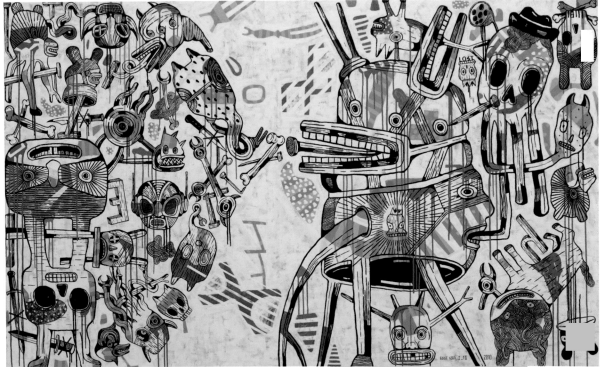

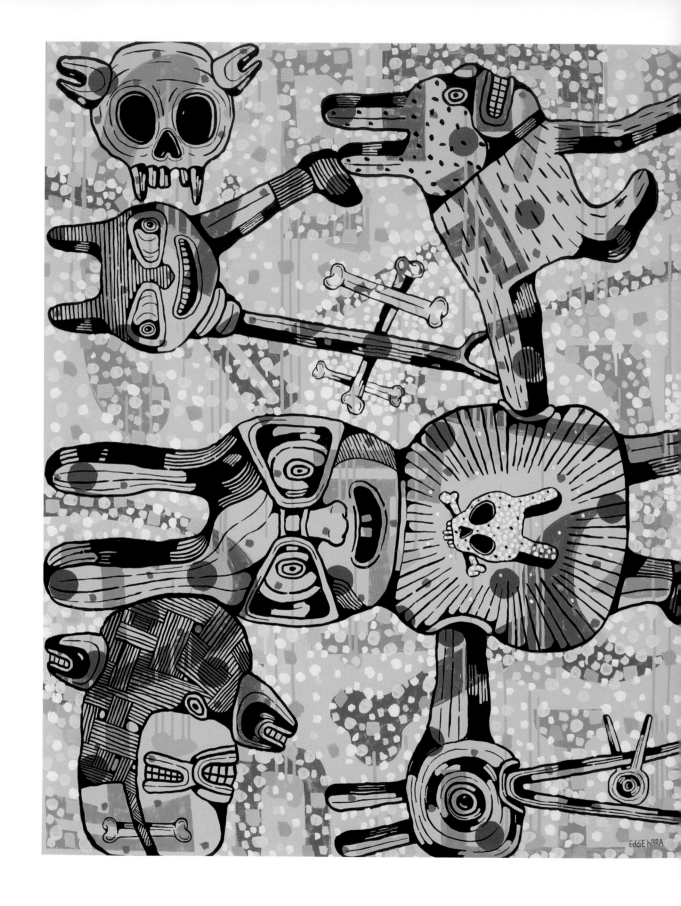

Almost Spring Fever, 2010
Acrylic on canvas,
150 x 240 cm (2 panels)
Collection of
Mr Sutanto Joso
Courtesy of the artist
and Tonyraka Art Gallery

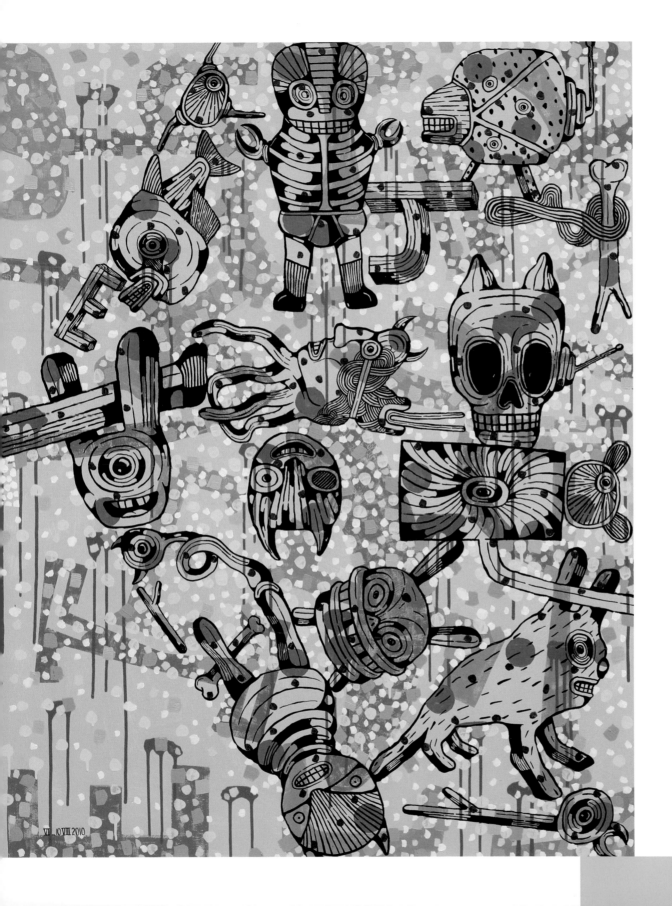

VII 10 VIII 2010

FX Harsono

Harsono's work is remarkable, and spanning four tumultuous decades in Indonesian art and history it has witnessed a multitude of changes and upheavals in Indonesian politics, society and culture. By the 1990s, he had established himself as a force in Indonesian contemporary art, creating powerful installations with strident social commentary. These compelling works, which critiqued the regime of power and oppression in Indonesia, gained critical attention and were widely exhibited abroad. The closing years of the 1990s were marked by a series of social shockwaves that reverberated throughout the nation; in particular, the economic meltdown of the 1997 Asian Financial Crisis generated a groundswell of public anger. In 1998, this culminated in days of brutal street violence and the fall of Suharto's New Order. Indonesian–Chinese artists like Harsono experienced a profound sense of disillusionment, as the events of May 1998 revealed that the very "people" he had fought for through his art were just as capable of brutality as the political regime – and worse, these people would turn on each other. With the veneer of control under "strongman" Suharto removed, the fractures in Indonesian society revealed themselves more painfully than ever, particularly along ethnic lines. It was then that Harsono's art began to look inwards, as the artist intensively scrutinized his identity and place in society. To date, Harsono has continued to raise troubling questions about the position of minorities and the disenfranchised in Indonesia. His most recent body of work draws on his family history, in an investigative journey that reveals the intersection of the personal with the political. (*Tan Siu Li*, from the exhibition catalogue *FX Harsono: Testimonies*)

Rewriting the Erased Name, 2009
Wooden and rattan chair, wooden table with marble, Chinese ink on paper, performance video, variable dimensions, edition of 3
Installation view at Centre for Contemporary Asian Art, Sydney
Courtesy of Susannah Wimberley

Rewriting the Erased Name #1, 2011
C-print on photo paper, 110 x 180 cm, edition of 5
Collection of the artist
Courtesy of the artist and Langgeng Gallery

Rewriting the Erased Name #2, 2011
C-print on photo paper, 110 x 180 cm, edition of 5
Collection of the artist
Courtesy of the artist and Langgeng Gallery

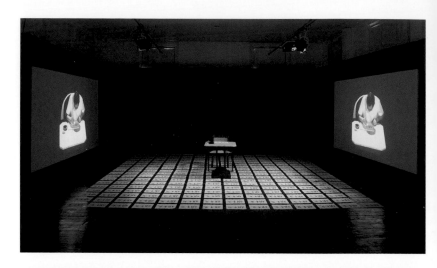

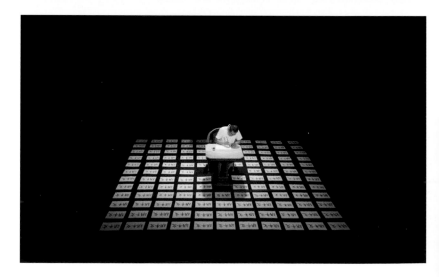

Burn Victims, 1998
Burned wood, steel, burned
shoes and video, variable
dimensions
Collection of the Singapore
Art Museum
Courtesy of the artist and
Langgeng Gallery

Darkroom, 2009
C-prints on photo paper,
acrylic sheet, steel, plywood,
red lamp, variable dimensions
Collection of the artist
Courtesy of the artist and
Langgeng Gallery

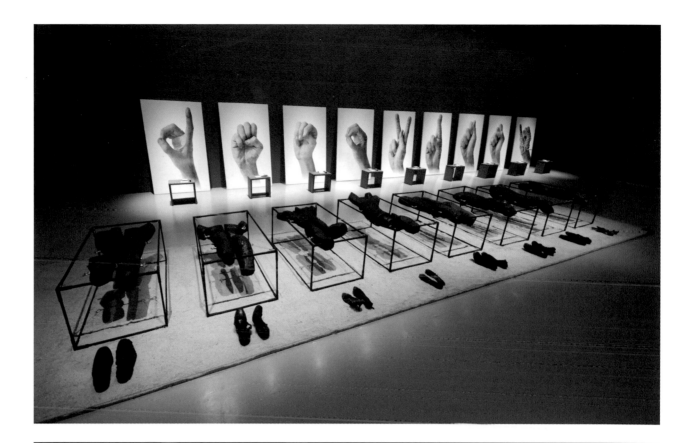

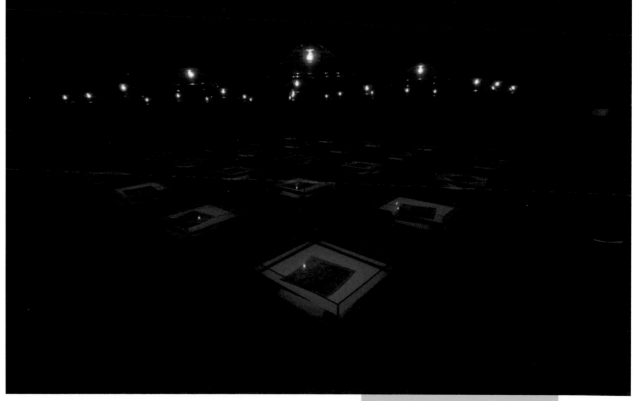

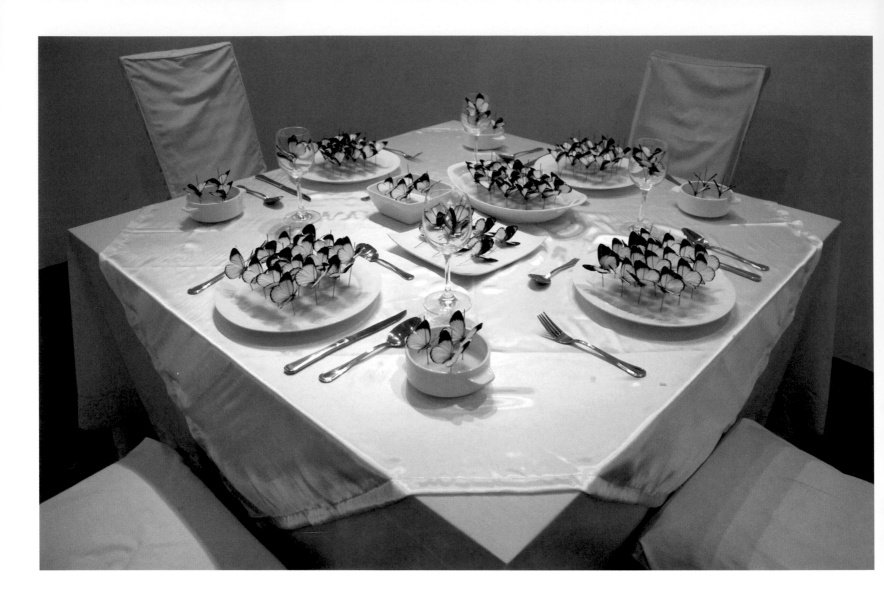

Bon Appetit, 2008
Table, cloth, chairs,
tableware, needles and
butterflies, variable
dimensions
Collection of the artist
Courtesy of the artist and
Langgeng Gallery

*Preserving Life, Terminating
Life #4*, 2011
Diptych, c-print on
Hahnemühle canvas,
100 x 175 cm
Collection of the artist
Courtesy of the artist and
Langgeng Gallery

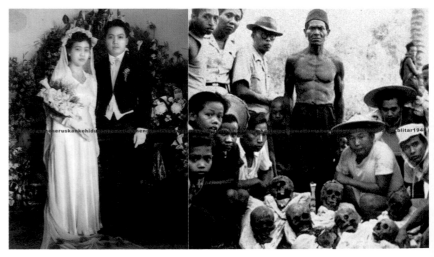

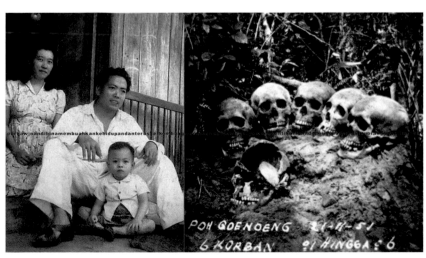

Preserving Life, Terminating Life #5, 2011
Diptych, c-print on Hahnemühle canvas, 100 x 175 cm
Collection of the artist
Courtesy of the artist and Langgeng Gallery

Monument Bong Belung, 2009
Screen print on textile, needles, electric lamp and c-print on photo paper, variable dimensions
Collection of the artist
Courtesy of the artist and Langgeng Gallery

Iswanto Hartono

Iswanto Hartono, who is also an architect, conceived his work to be inserted into institutionalized spaces. This is not without any risk, and the dilemma between sculptural art and installation lingers upon his work. Yet the chosen institutionalized spaces allow awareness that the context of his work, highlighting the hybrid quality of his pieces as something between sculptural and installation art, is itself an interpretation. His work confronts the gallery space, but also challenges the whole unconscious leitmotif of all the establishment of Indonesian galleries. A further quality to his work is in the meticulous measurement and the construction of his objects. His work tends to be three-dimensional as a way of bringing attention to the scale of the space and thus how the space has been treated. He does not simply put something into a gallery as is commonly the case with modern sculptural works. Instead he tries to knit together cooperation between space and object, yet within this cooperation he stubbornly offers his artistic concepts. It is at this point that provocation and confrontation against space become possible. (*Aminuddin TH Siregar*)

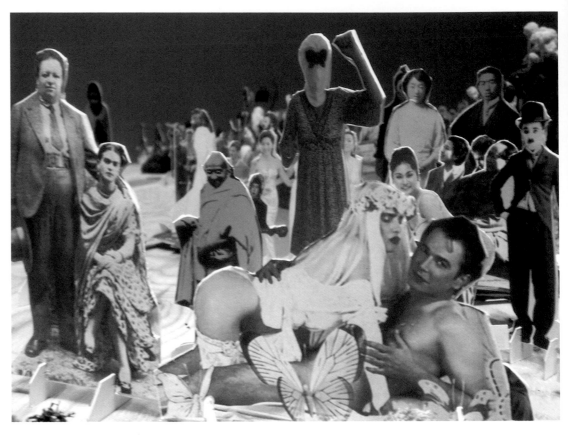

Flower, 2008
Inkjet print, cardboard, wood, CCTV camera, LCD projector, roses, CD player, toys, 3.5 x 3.5 m
Collection of the Tokyo Wonder Site
Courtesy of the artist

Mellow (Zacht), 2009
Galvanized plate, wood, water pump, boat toys, digital print on vinyl, water, 5 x 8 m
Collection of the artist
Courtesy of the artist

Kaleidoscope, 2009–still in progress
Inkjet print on paper, tobacco, cigarette filter, pencil, oil, tape, approx. 200 pieces of A4 paper
Collection of the artist
Courtesy of the artist

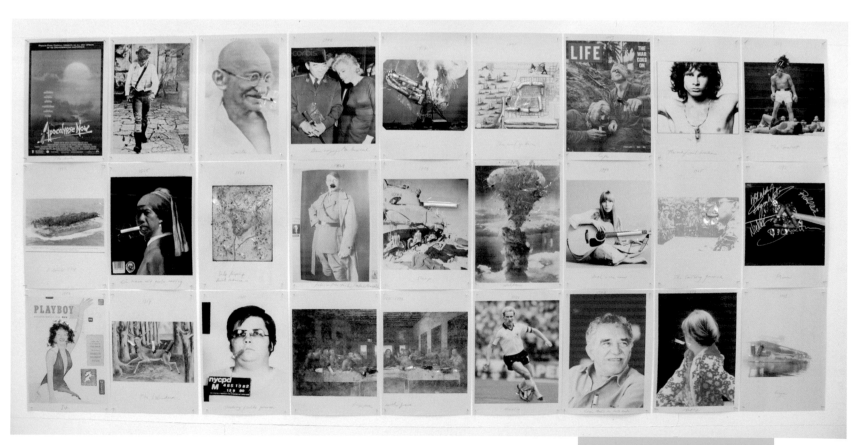

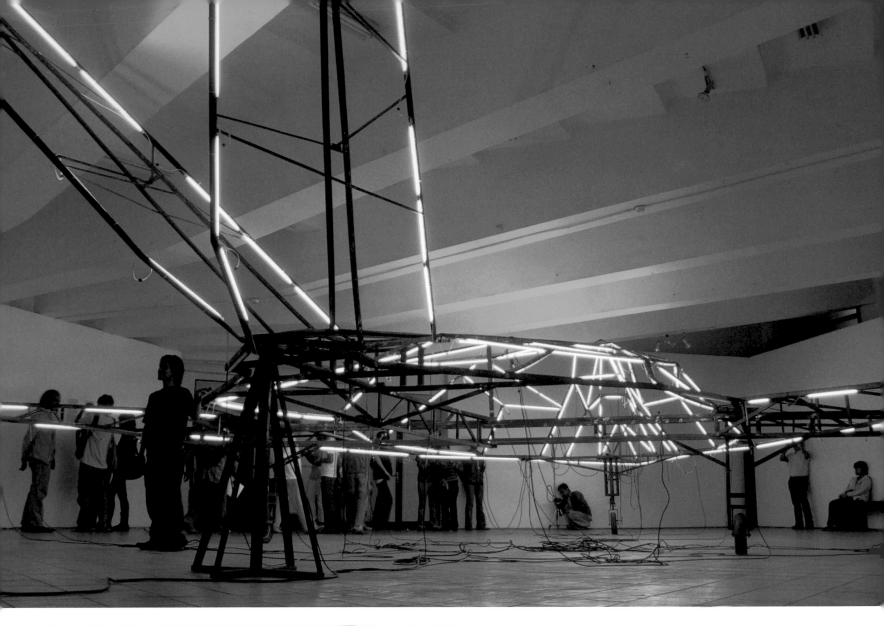

Untitled, 2005
Cardboard, neon, wood,
5 x 4 x 4 m
Collection of the artist
Courtesy of the artist

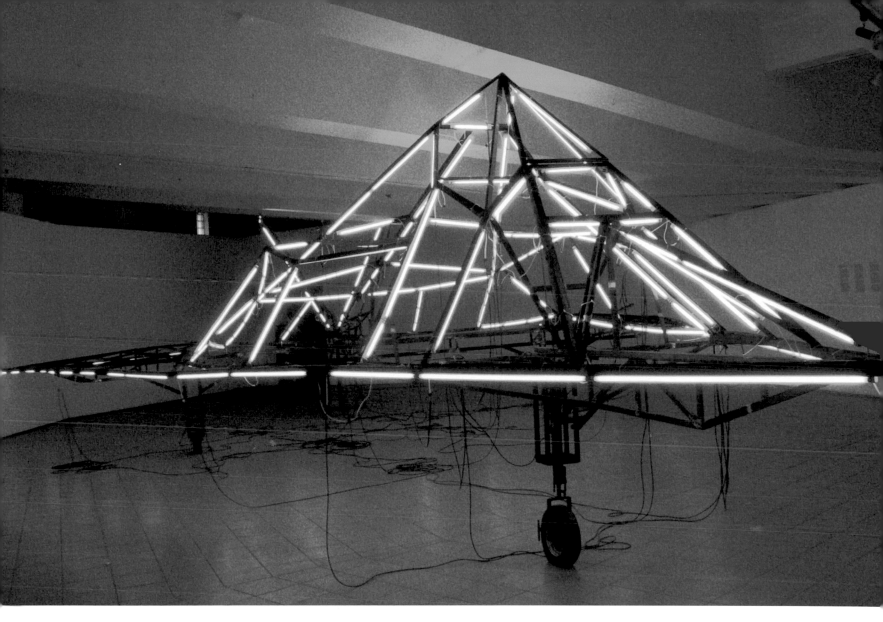

Blue, 2007
Steel, neon, 8 x 12 x 4 m
Collection of the artist
Courtesy of the artist

Hayatudin has effortlessly merged his clear concepts with his proficiency in dealing with colours and his keen imagination to create highly artistic works. In his hands the images of cities become dynamic, curving and binding in alluring visual games rendered in well-toned pastels.

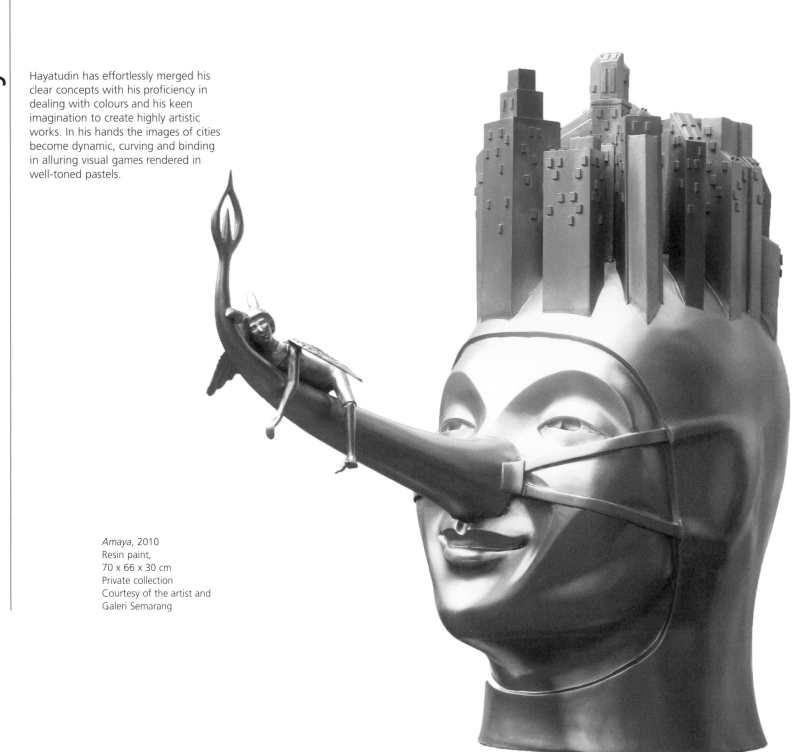

Amaya, 2010
Resin paint,
70 x 66 x 30 cm
Private collection
Courtesy of the artist and
Galeri Semarang

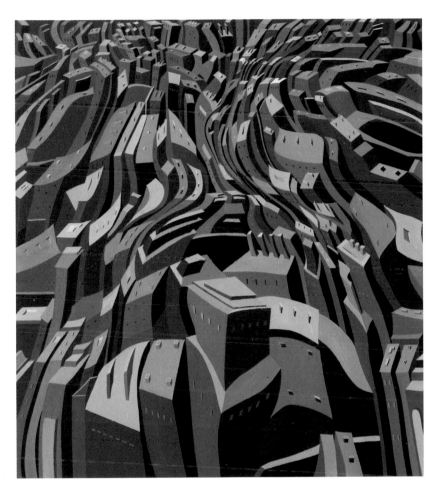

Future Shock, 2008
Acrylic on canvas,
200 x 180 cm
Private collection
Courtesy of the artist and
Galeri Semarang

Wriggle, 2008
Acrylic on canvas,
200 x 180 cm
Private collection
Courtesy of the artist and
Galeri Semarang

Back to the Centre, 2008
Acrylic on canvas,
200 x 180 cm
Private collection
Courtesy of the artist and
Galeri Semarang

Contraction, 2008
Acrylic on canvas,
200 x 180 cm
Private collection
Courtesy of the artist and
Galeri Semarang

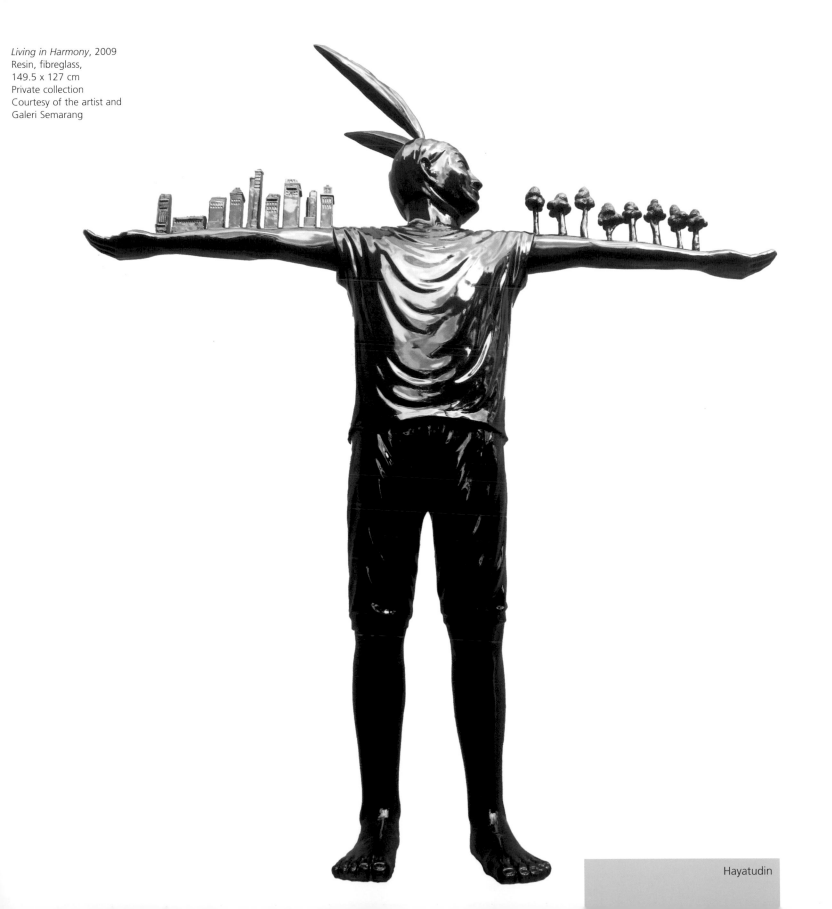

Living in Harmony, 2009
Resin, fibreglass,
149.5 x 127 cm
Private collection
Courtesy of the artist and
Galeri Semarang

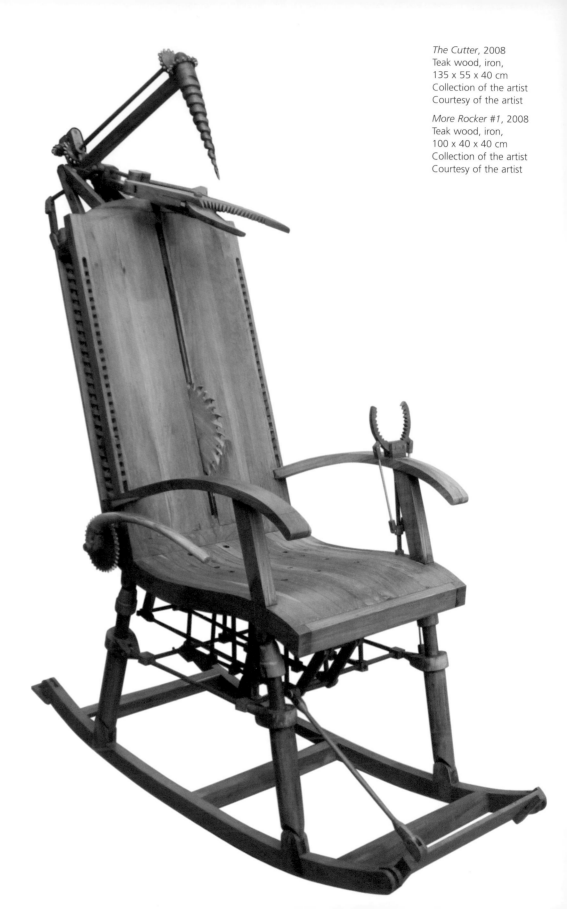

Rudi Hendriatno

I materialize modernistic concepts in the form of machines and tools that signify our cultural change. I have also developed a traditional "hand skill" in order to work with teak wood. In this way I combine modern and traditional thoughts and practices, and this causes my work to be an experimental craft.

The Cutter, 2008
Teak wood, iron,
135 x 55 x 40 cm
Collection of the artist
Courtesy of the artist

More Rocker #1, 2008
Teak wood, iron,
100 x 40 x 40 cm
Collection of the artist
Courtesy of the artist

Beautiful Dead, 2010
Teak wood,
173 x 53 x 176 cm
Collection of the artist
Courtesy of the artist

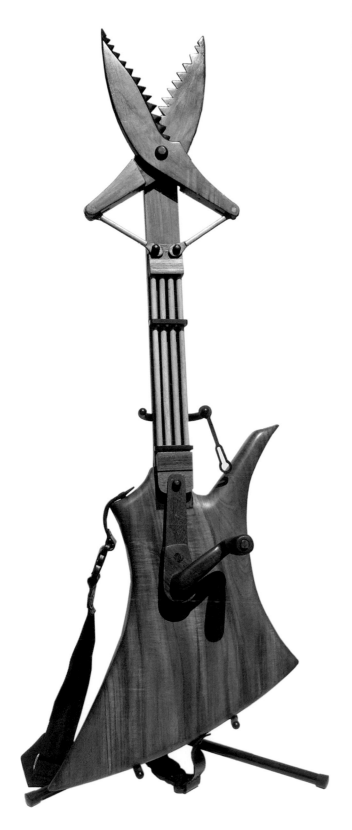
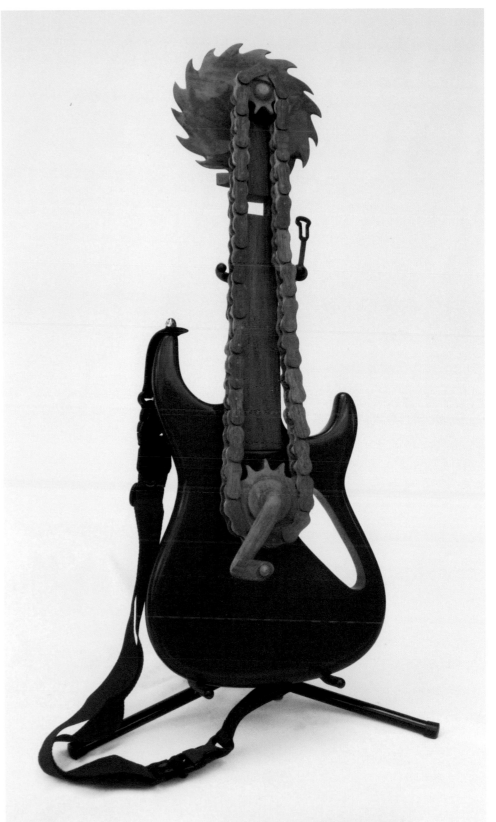

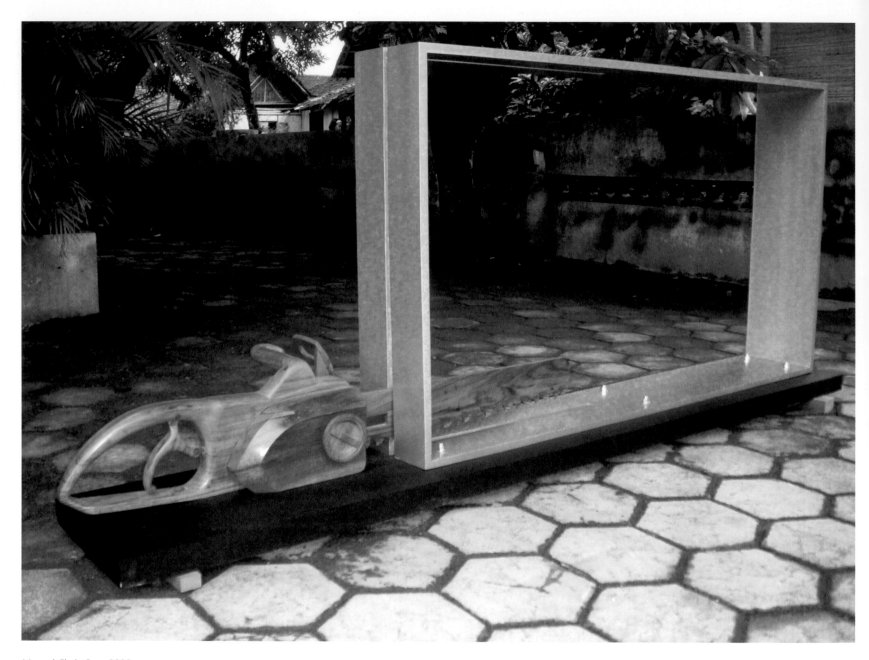

Manual Chain Saw, 2008
48 x 115 x 22 cm
Collection of the artist
Courtesy of the artist

Manual Chain Saw, 2008
48 x 115 x 22 cm
Collection of the artist
Courtesy of the artist

Noor Ibrahim

Noor has worked with bamboo, resin and wood and now finds metal the most attractive material for his work, feeling he has the spiritual capacity to handle it. He says, "Humans are the controllers of metal". In his work he is energetic, strong and incredibly skilled at showing how far humanity can be "controlled" by manually hammering and soldering this material. Experimenting with metals such as iron and stainless steel, the physical forms in his sculptures show exposed figures or human bodies with various gestures that are connected to his chosen themes. His works are studies of tradition, mythology, events and problems of individuals and spirituality. Most of these themes are isolated, adapted, elaborated and modified to suit his contemporary ideas. (*Mikke Susanto*, excerpted from *Modern Indonesian Art from Raden Saleh to the Present Day*, 2010)

Among Rogo, 2009
Bronze, life size
Collection of Dr Melani
W. Setiawan
Courtesy of the artist

Huni Uni, 2010
Iron and acrylic,
310 x 310 x 203 cm
Collection of the artist
Courtesy of the artist

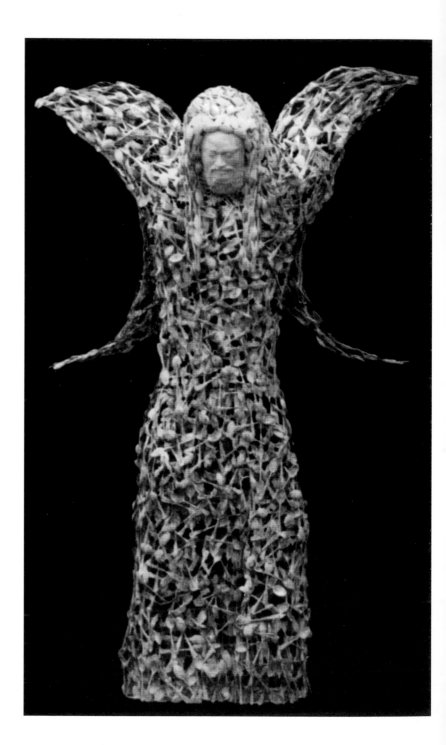

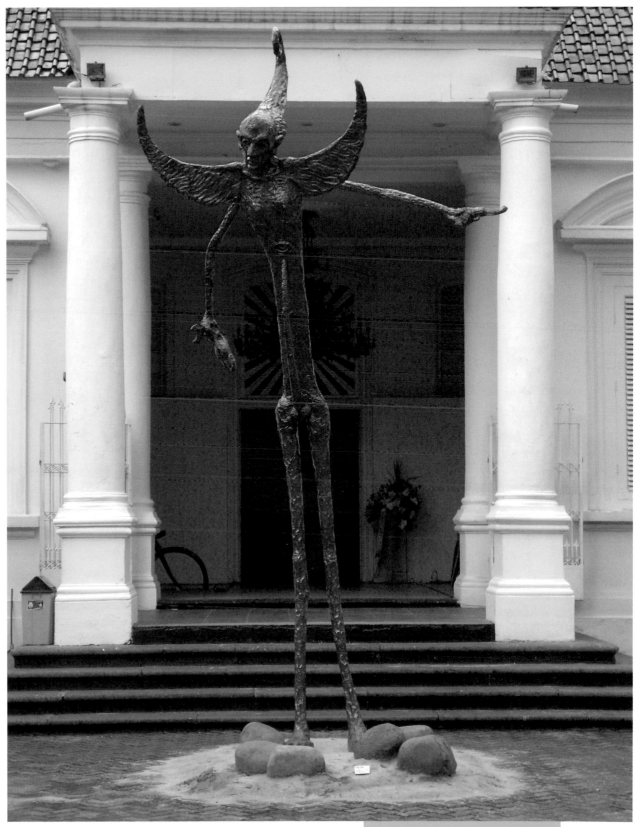

Angel from Pasar Kembang,
2005
Brass and bronze,
550 x 260 x 75 cm
Collection of Mr Willy Walla
Courtesy of the artist

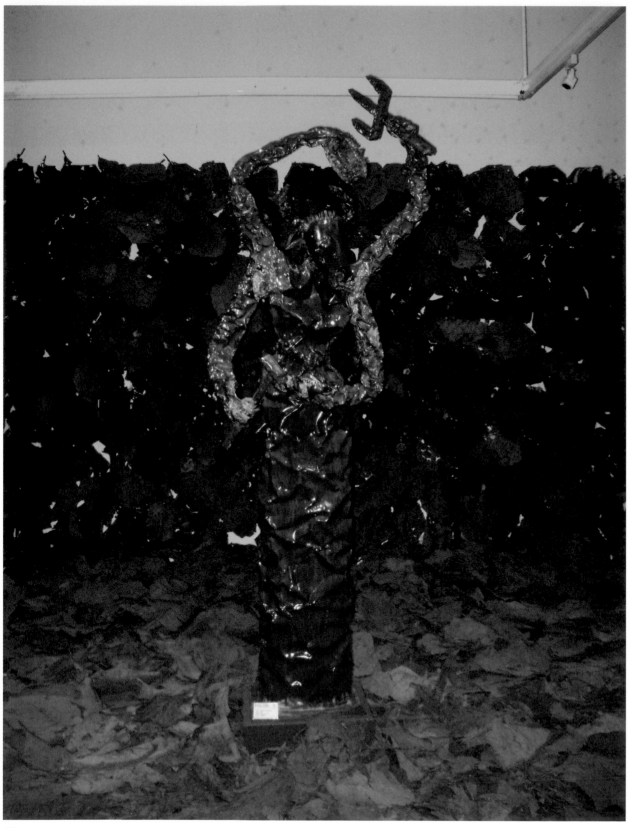

Angel of Justice, 2006
Bronze, 254 x 90 x 75 cm
Collection of Mr Sarjana
Sumichan
Courtesy of the artist

Nasirun in USA, 2002
Brass, 180 x 95 x 45 cm
Collection of Mr Sunarjo
Sampoerna
Courtesy of the artist

Bird in INRI, 2010
Bronze, 400 x 230 x 60 cm
Private collection
Courtesy of the artist

Knight of Country 1–7,
2009
Bronze, life size
Private collection
Courtesy of the artist

Thank You Mr D, 2010
Stainless steel,
73 x 122 x 53 cm
Collection of Mr Eko
Courtesy of the artist

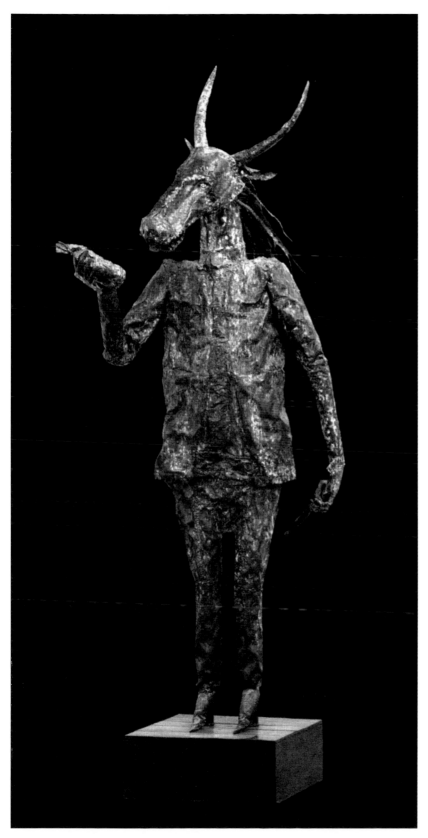
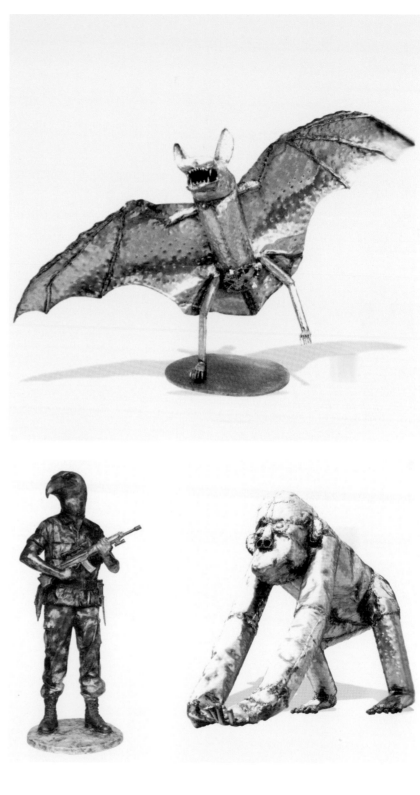

Soni Irawan

Irawan's painting and music influence each other. He has tried to combine visual language, taken from underground comics, with cassette tape covers, as the visualization of his favourite songs. His paintings speak wildly and free.

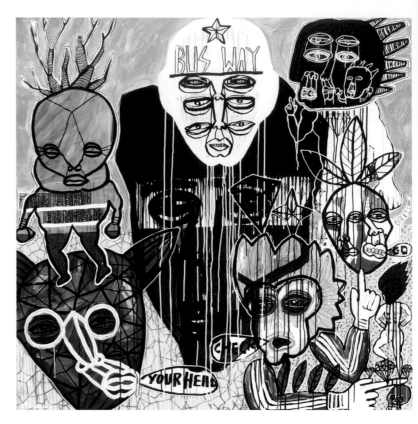

Head between Heads, 2009
Mixed media on canvas,
150 x 150 cm
Private collection
Courtesy of the artist and
Galeri Semarang

Keep on Running, 2009
Mixed media on canvas,
150 x 150 cm
Private collection
Courtesy of the artist and
Galeri Semarang

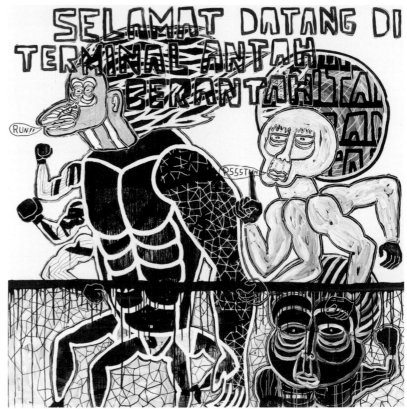

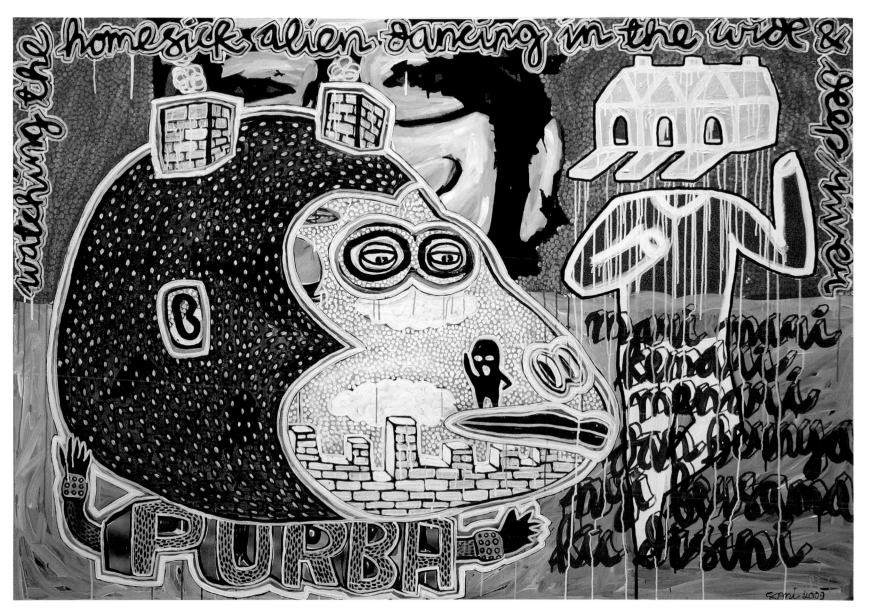

Neanderthal Disco, 2009
Oil on canvas, 150 x 200 cm
Private collection
Courtesy of the artist

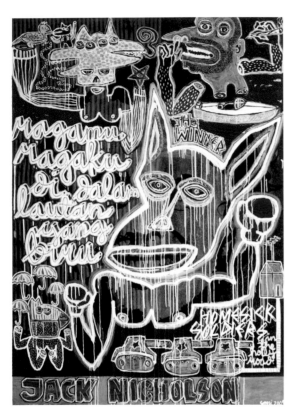

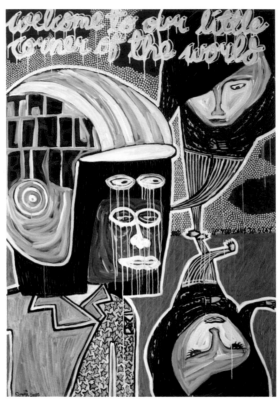

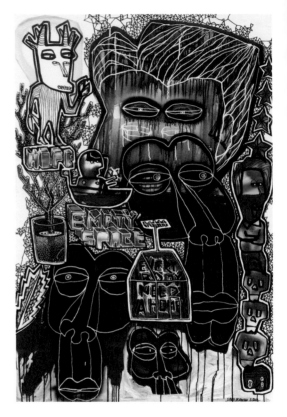

My Idol Jack Nicholson,
2009
Ol on canvas, 200 x 150 cm
Private collection
Courtesy of the artist

Stay, 2009
Oil on canvas, 200 x 150 cm
Private collection
Courtesy of the artist

A Hope for Empty Space,
2010
Mixed media on canvas,
150 x 100 cm
Private collection
Courtesy of the artist and
Galeri Semarang

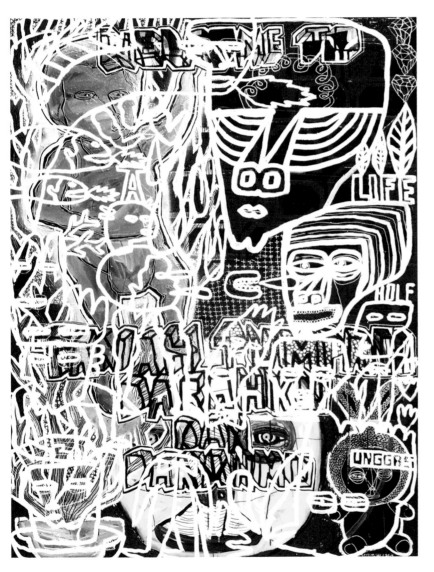

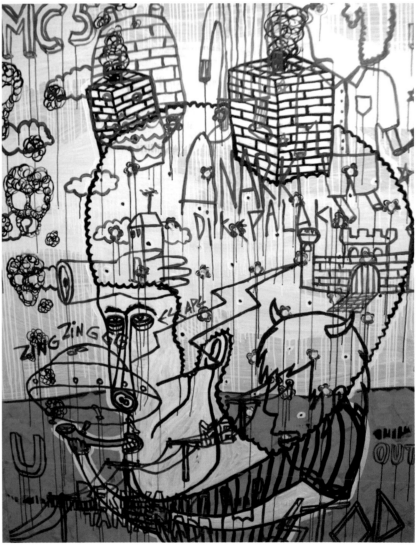

Welcome to My Homeland and Yours, 2009
Mixed media on canvas,
200 x 150 cm
Private collection
Courtesy of the artist and
Galeri Semarang

The Afros Pipe, 2009
Mixed media on canvas,
200 x 150 cm
Private collection
Courtesy of the artist and
Galeri Semarang

Soni Irawan **127**

Mella Jaarsma

My works are bodily modifications of the social space in between the layers of skin, clothing, sartorial inhibition and architecture. Through my work, I question origin and deconstruct identities by producing renewable ones, seeing identity as a transient invention.

We are like impermanent buildings with a façade from which the inside is changeable. The second skin that we are wearing is like a house in which we can appear and hide; we have to be ready to leave or inhabit it. Everyone who confronts my work is coming at it from different backgrounds and cultures, dealing with highly personal sets of taboos and therefore experiencing the work in different ways. I want my work to relate to these specific audiences, to deal with some of their taboos and interpretations. This takes great sensitivity, and therefore I try to find ways to open up dialogue, rather than work in a more confrontational way. I question my own existence in the hybrid feudal society in Java, where every day I have to deal with the stereotyped roles of a foreigner as post-colonialist and explorer.

My work is also about positioning "the native" and "the ethnic" and the acknowledgement that these groups could be reversed, depending on their surroundings.

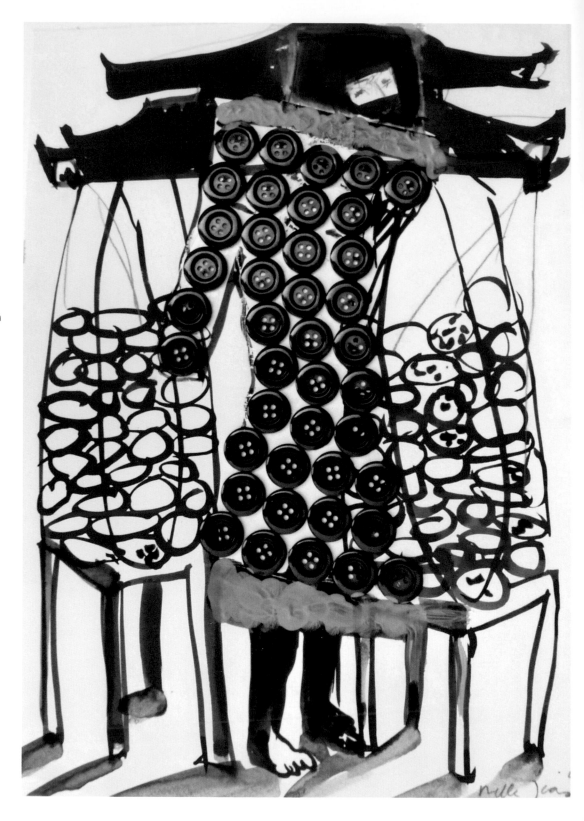

Traders of the Visible 1,
2009
Gouache, ink, buttons on paper, 38 x 28 cm
Private collection
Courtesy of the artist

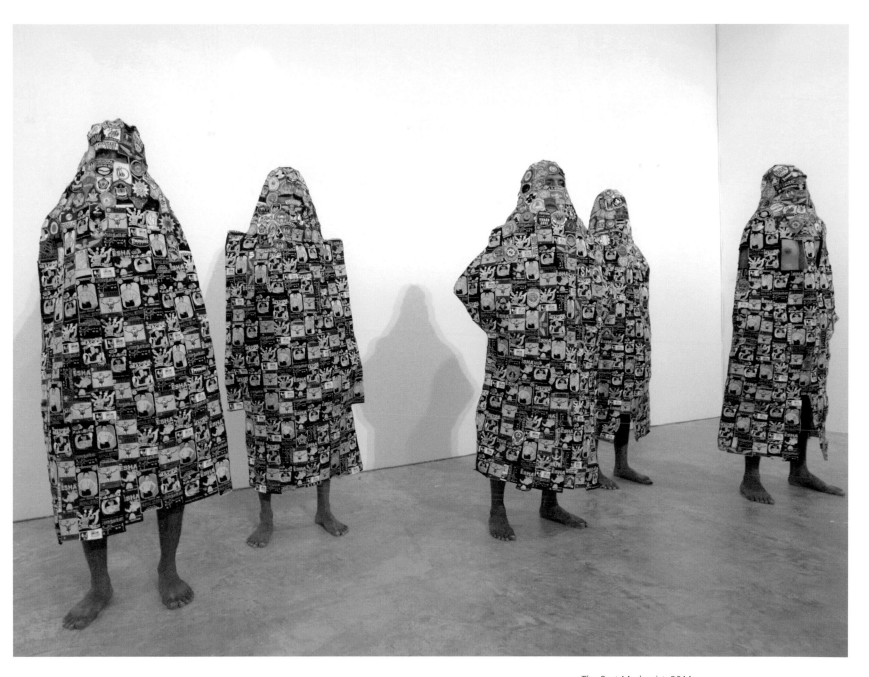

The Post Modernist, 2011
5 cloaks of embroidered
emblems
Collection of the artist
Courtesy of the artist

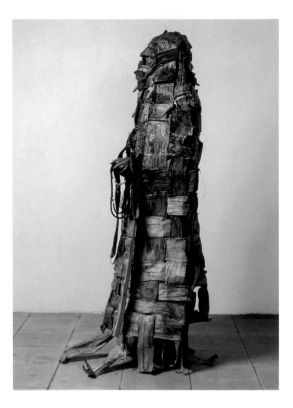 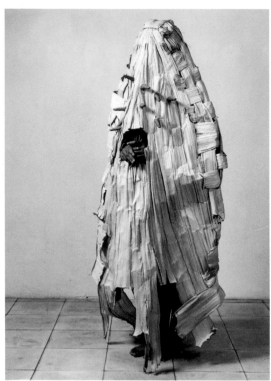

SARA–Swati I and II, 2000
Dried banana tree trunks,
fibreglass, photographs
Collection of the Singapore
Art Museum
Courtesy of the artist

Shaggy, 2008
Hair, hair curlers,
160 x 60 x 50 cm
Collection of the artist
Courtesy of Mie Cornoedus

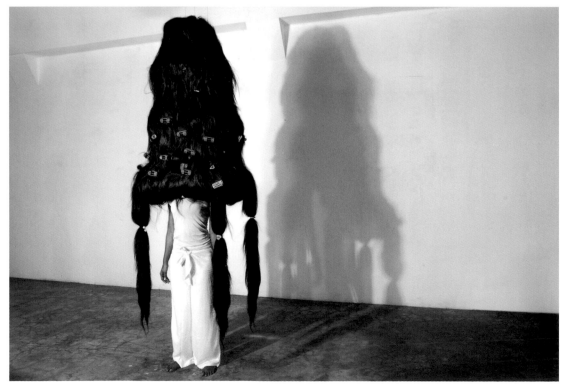

Sketches for
The Talisman, 2009
Ink on paper,
36 x 26 cm each
Collection of Serenella
Ciclitira
Courtesy of the artist

The Talisman, 2009
Chains and old jewellery,
190 x 100 and 70 x 50 cm
Collection of the artist
Courtesy of Mie Cornoedus

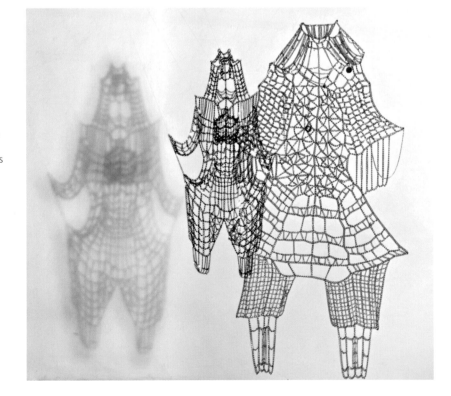

Agapetus A. Kristiandana

Agapetus has chosen animals to convey his satiric messages, with norms and educational ideas also worked into the pieces. In this sense, these sculptures are parodies and critical narratives of human lives. The main principle informing these animals derives from a statement contained in George Orwell's celebrated allegorical novel *Animal Farm*: "four legs good, two legs bad!" The artist uses this idea to make his own allegorical expression to show how every human habit is bad. What differentiates humans from animals are the hands; and it is exactly by using our hands, which seem as if they can substitute human intelligence, that we commit all our crimes, including crimes against animals. Animals do not possess such destructive attributes. In these pieces we see our social world mapped into the random spots of a cow, as a sum of random fragments. Humans are necessarily in a rut, trapped between two options of freedom, forever tempted by banaity and grandiose.

Tall Cow, 2006
Bronze, 65 x 36 x 29 cm
Private collection
Courtesy of Galeri
Semarang

Conked Out Pig, 2005
Bronze, 50 x 79 x 22 cm
Private collection
Courtesy of Galeri
Semarang

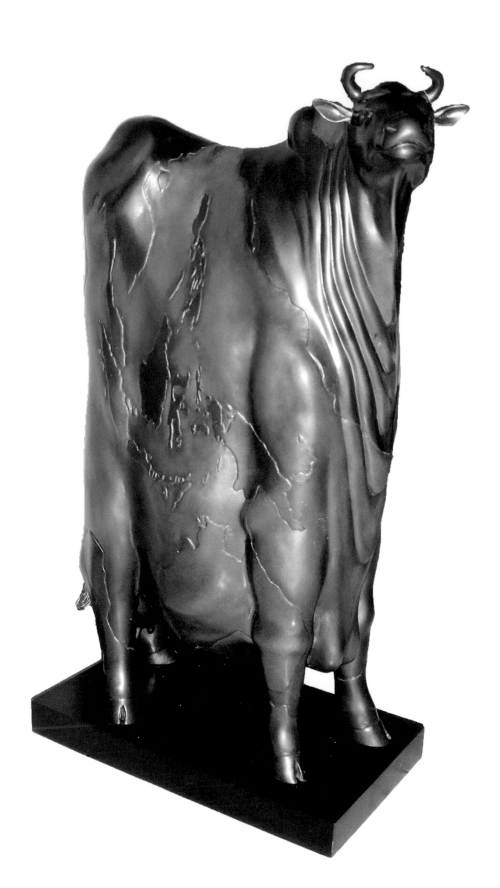

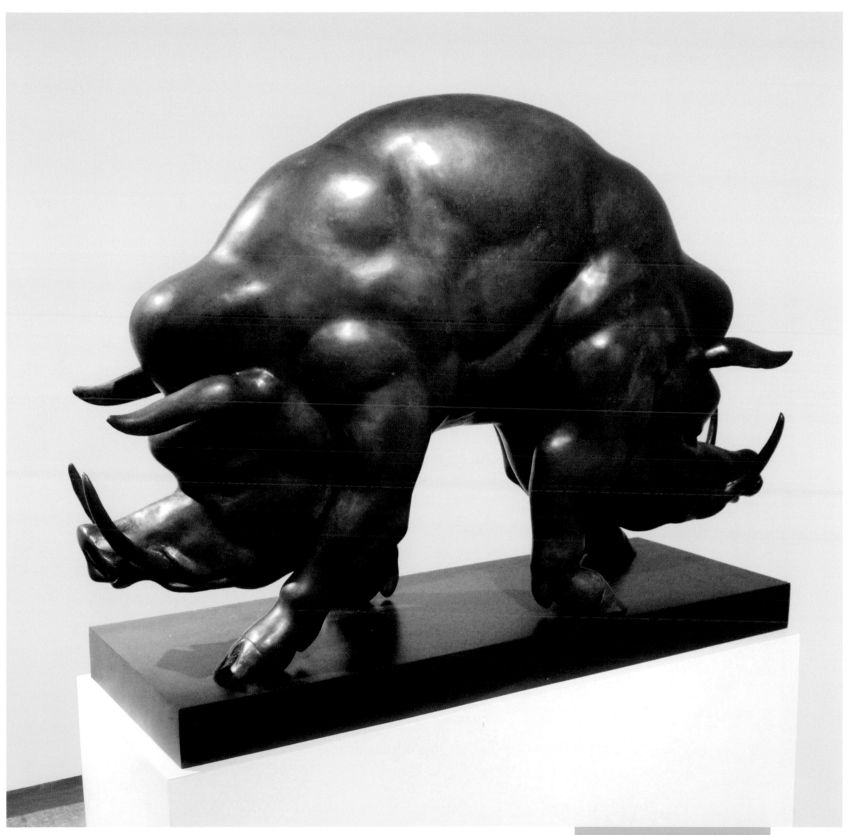

Professional, 2005
Bronze, 45 x 55 x 25 cm
Private collection
Courtesy of Galeri
Semarang

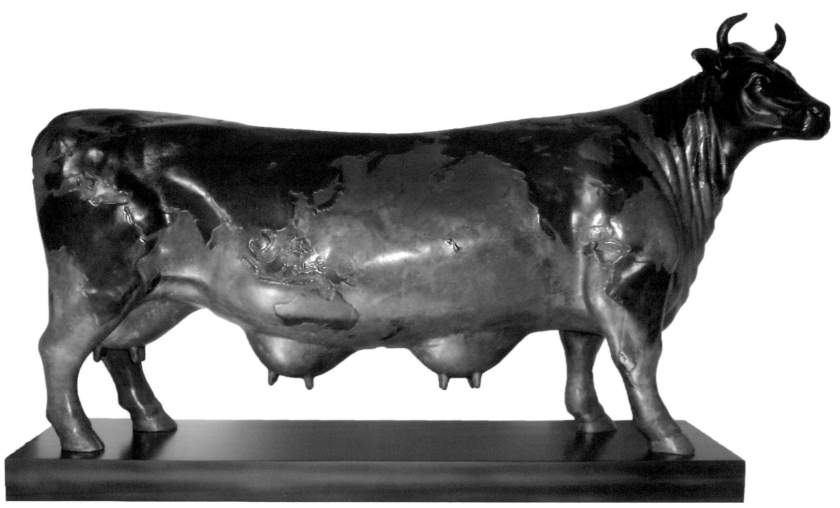

Little Marhaen, 2005
Bronze, 61 x 61 x 31 cm
Private collection
Courtesy of Galeri
Semarang

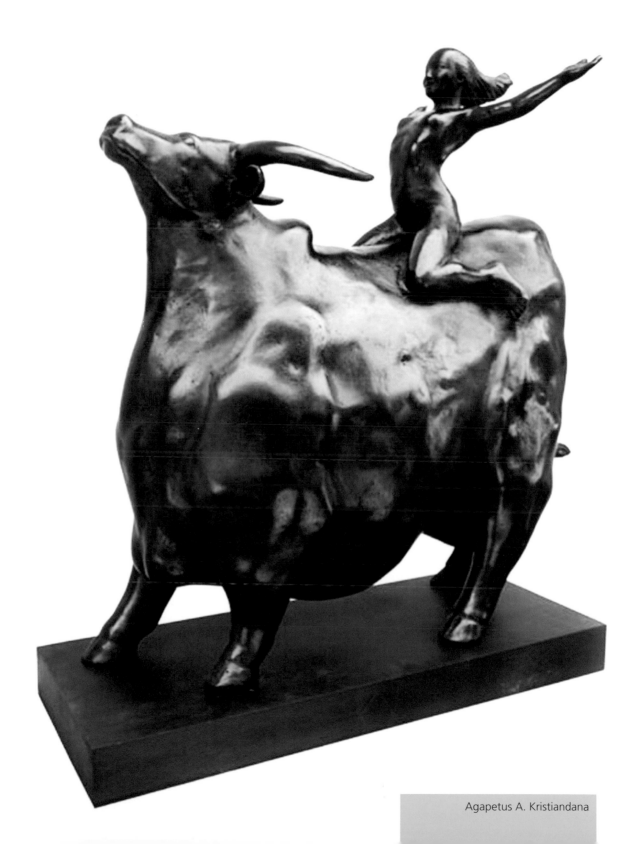

Agung Kurniawan

My work is always dealing with the idea of inconsistency. Inconsistency is formed in the choices of media I work with, in the theme and the operation model.

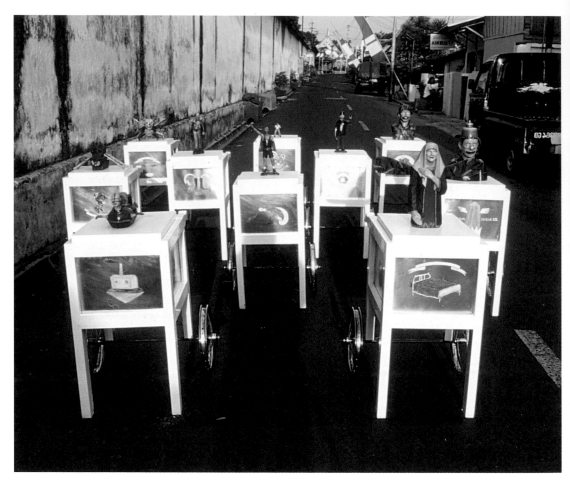

Souvenirs from the Third World, 1998
20 pieces of acrylic, wood and fibre boxes and figurines
Collection of the artist
Courtesy of the artist

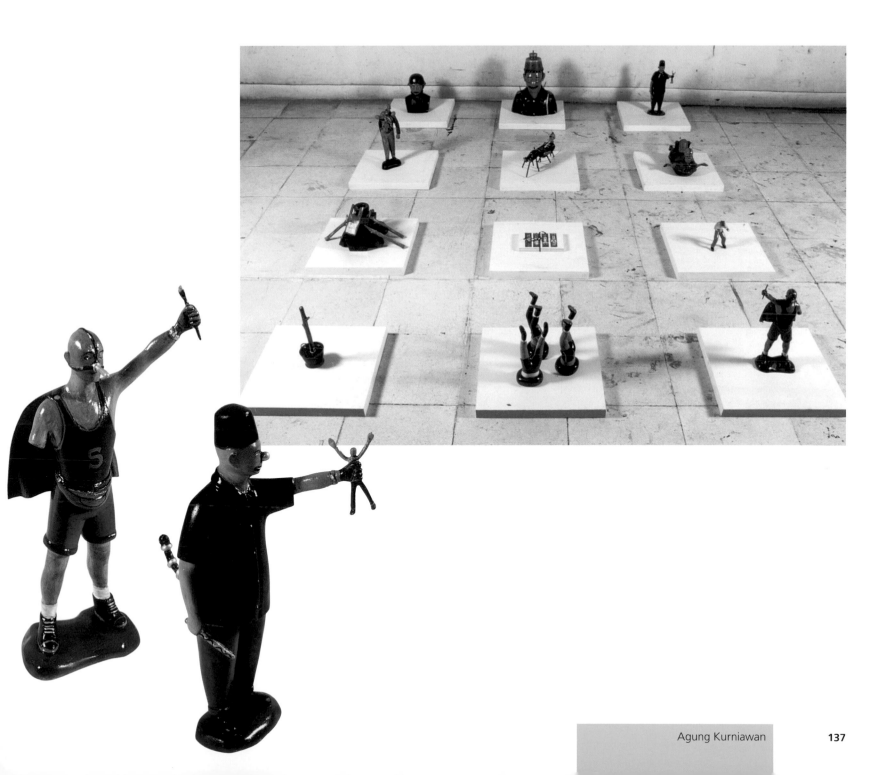

My First Parade, 2010
Steel and paint,
138 x 158 cm
Collection of the artist

The Capture of Saddam,
2010
Steel and paint,
167 x 233 cm
Collection of the artist

Budi Kustarto

In my work, there is the "I" that has been imaged through my body and face. This is a signifier, in which "I", in my social form, is looking for "myself" in my private form, and vice versa. I am looking for the true "I" between the objects that I recognize, without full awareness of the power behind imaging. It is exactly through the representation of such objects that the "I" is pretending to become "not I", or a "not I" pretends to be "I".

Ice Cream Cake, 2008
Oil and acrylic on canvas,
200 x 200 cm
Private collection
Courtesy of the artist

Never Ending, the Knotted Gun, 2009
Oil on canvas, 200 x 250 cm
Private collection
Courtesy of the artist

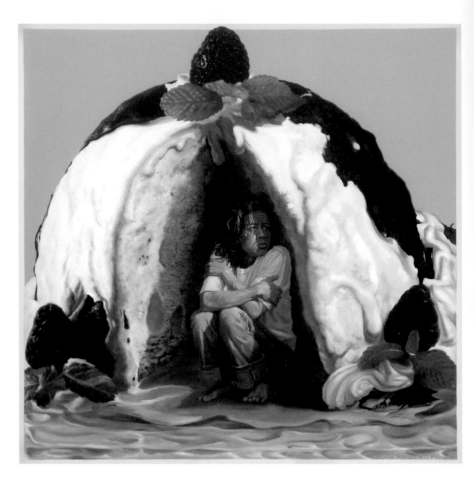

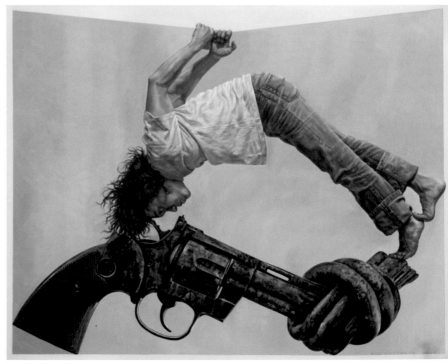

Take Me to Heaven, 2005
Oil on canvas, 200 x 150 cm
Private collection
Courtesy of the artist

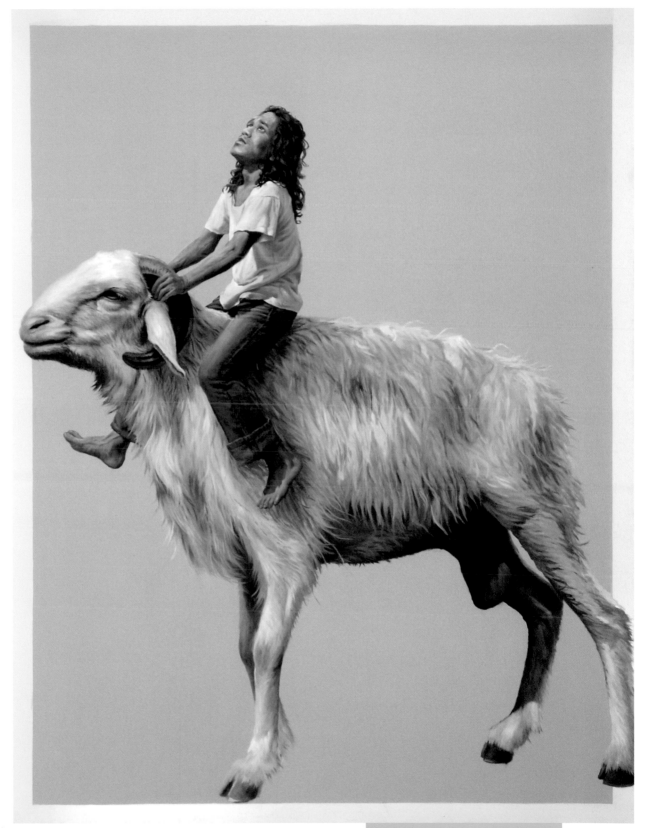

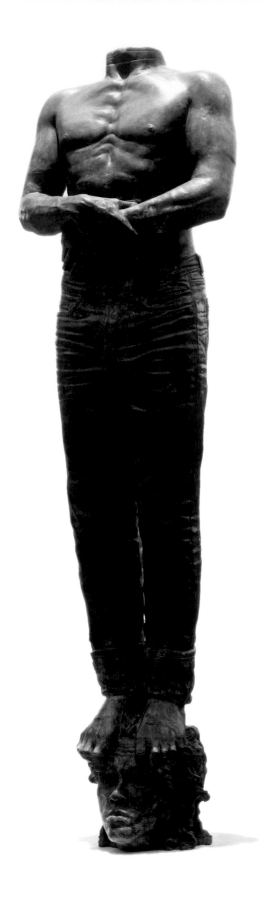

Staying Still with the Body,
2010
Bronze, 150 x 40 x 30 cm
Private collection
Courtesy of the artist

On the Move, 2010
Fibreglass, wood,
styrofoam and plastic,
183 x 135 x 133 cm
Collection of the artist
Courtesy of the artist

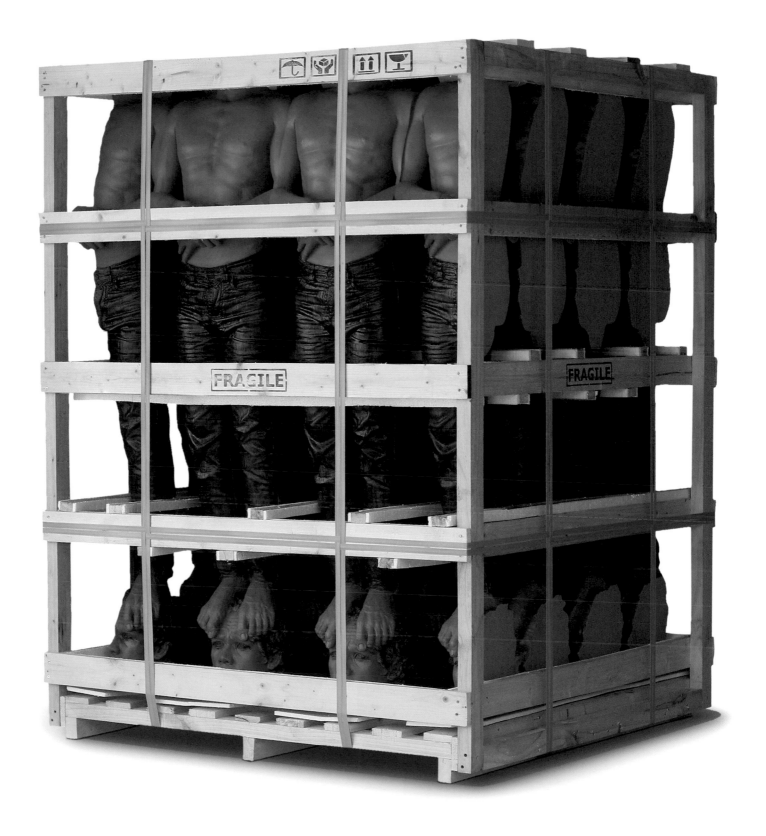

FRAGILE

FRAGILE

Budi Kustarto 143

Jompet Kuswidananto

I learnt about practicing arts from my community rather than attending art school. The community network is a fountain of knowledge and played an important role in my development because there was the support of the state. This fountain connected me to music, moving picture, theatre and visual art. Within my work I travel, shuttling from traditional to contemporary styles. My work is sometimes experimental, but not always, and I work both independently and collaboratively. As I believe that art is a way to understand and to communicate reality, I believe an artist is both a self-explorer and a social actor. My work is mostly inspired by the connection between oneself and others, in different dimensions and contexts. I have worked with various methods, mediums and materials.

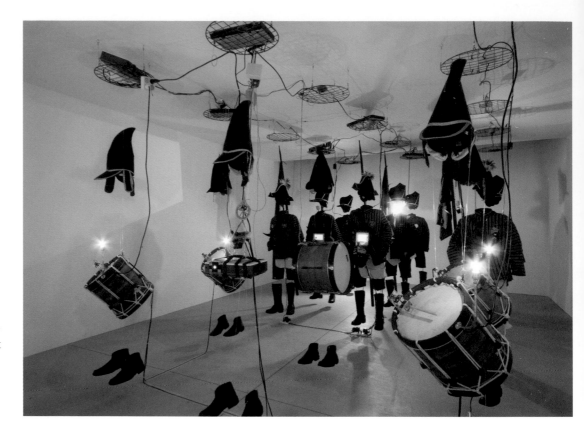

Java's Machine: Phantasmagoria, 2008
Installation,
15 human-size figures
Collection of the Singapore
Art Museum
Courtesy of the artist

Java, the War of Ghosts,
2009
Installation,
15 human-size figures
Collection of Osage Gallery
Courtesy of the artist

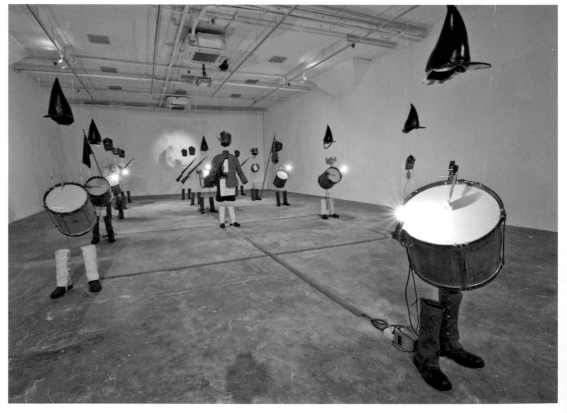

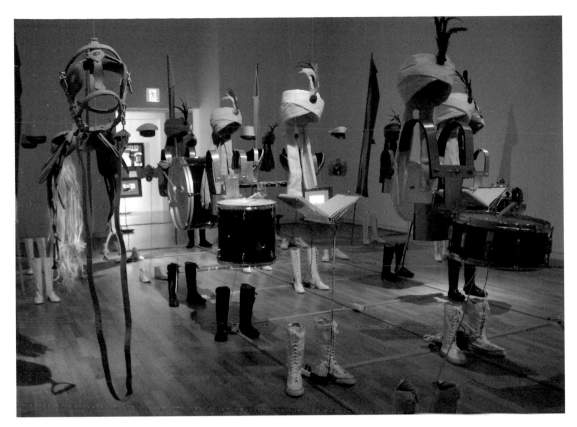

Cortege of the Third Realm, 2010
Installation,
24 human-size figures
Collection of Ark Galerie
Courtesy of the artist

New Myth for the New Family, 2009
Installation,
200 x 150 x 300 cm
Collection of Osage Gallery
Courtesy of the artist

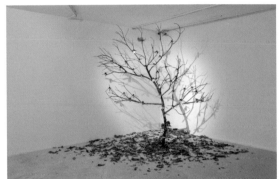

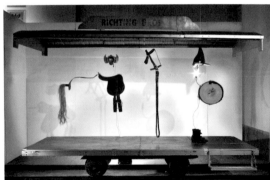

Sleep Kingdom Sleep, 2009
Installation
Collection of the artist
Courtesy of the artist

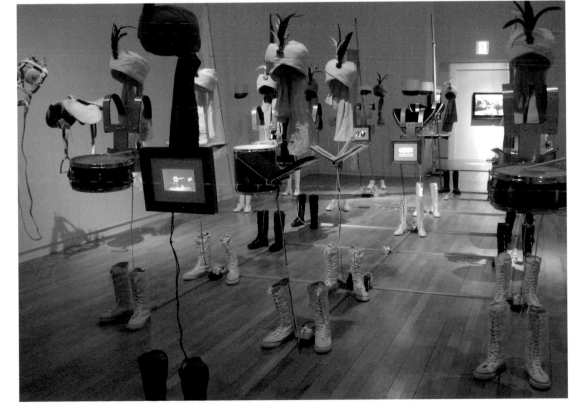

Jompet Kuswidananto **145**

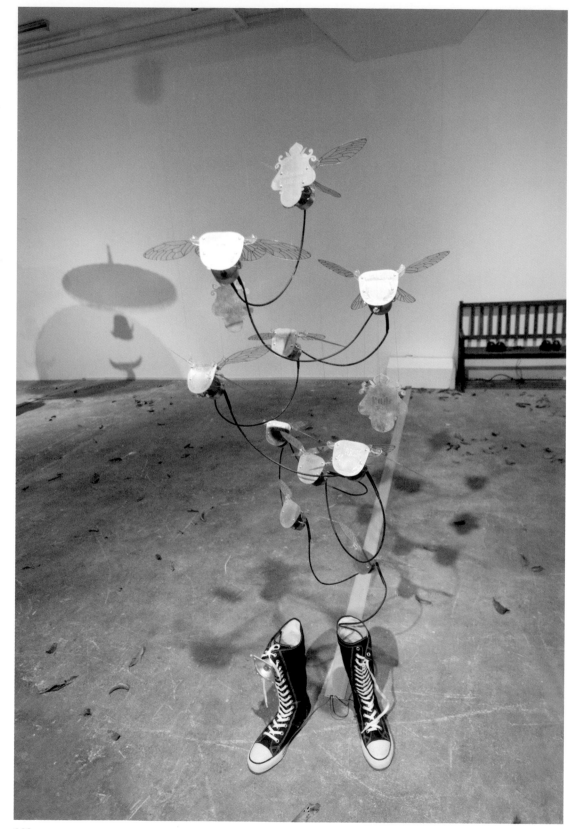

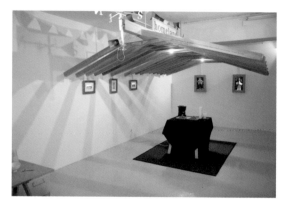

Third Body, 2010
Installation, life size
Collection of Osage Gallery
Courtesy of the artist

Third Realm, 2010
Installation
Collection of the artist
Courtesy of the artist

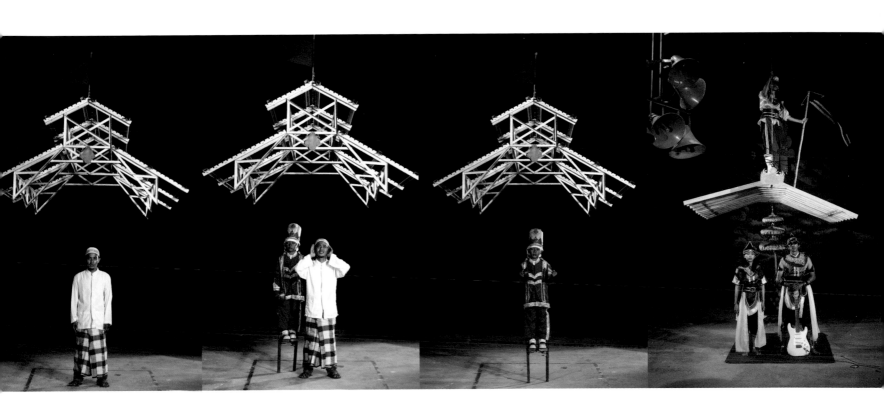

Narrative Genealogy, 2010
Videos and photographs
Collection of the artist
Courtesy of the artist

War of Java. Do you remember? #1, 2008
Installation,
5 human-size figures
Collection of the artist
Courtesy of the artist

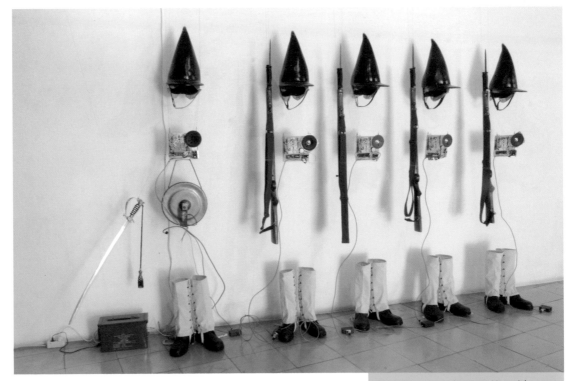

Jompet Kuswidananto **147**

Rudi Mantofani

Rudi Mantofani is an Indonesian contemporary artist worth keeping an eye on. His work involves presenting elements of surprise in formal and visual terms and his creativity in exploring the world of ideas with a variety of materials and forms, always shines through. Rudi succeeds in introducing unexpected aspects into his pieces, things that he always sees from a positive viewpoint. This is because he believes that positive energy transmits positive values and auras to people experiencing art.

These positive aesthetics of the artworks derive from particular aspects of the chosen objects. To look at them, they are "a sight to behold", while in terms of meaning they "challenge the intellect" to examine and interpret. His work grows from weighty ideas, that are only possible with an artist who is constantly striving to expand his or her intellectual power, in order to disclose the crucial side of a given theme. The strength of these pieces is that the artist has successfully invented a suitable "language" to convey the new side of the theme. Mantofani keeps exploring ideas, spotting specific topics and then merging them, and in the process produces works that mark three essential points: "conquering", the ability to make materials serve as appropriate and effective media; "animating", the formal and visual power that cause created objects to have new narrative lives; and "positive energy", the power endowed into the artwork to stir and suggest to the audience a positive spirit and energy.
(*Suwarno Wisetrotomo*)

The Earth and the World,
2006
Polyester resin, stainless steel, paints,
130 x 110 x 130 cm
Collection of the artist
Courtesy of Agung Sukindra

Boundary of the Earth, 2007
Acrylic on canvas,
170 x 250 cm
Collection of the artist
Courtesy of the artist

The World Falling into Earth,
2007
Acrylic on canvas,
150 x 200 cm
Collection of the artist
Courtesy of the artist

Rudi Mantofani **149**

Lost Notes, 2007
Wood, electric guitar
components, paints,
120 x 80 x 115 cm
Collection of the artist
Courtesy of Agung Sukindra

Lost Notes, 2007
Wood, electric guitar
components, paints,
176 x 145 x 55 cm
Collection of the artist
Courtesy of Agung Sukindra

Lost Notes, 2006
Wood, electric guitar
components, paints,
280 x 45 x 15 cm (9 pieces)
Collection of the artist
Courtesy of Agung Sukindra

Lost Notes, 2007
Wood, electric guitar
components, paints,
75 x 41 x 60 cm (9 pieces)
Collection of the artist
Courtesy of Agung Sukindra

Ronald Manullang

We have often come across statements saying how history cannot be forgotten, and will never even elapse. This often applies to terrible events such as genocide, war crimes or mass murders. However, we rarely read statements about punishments. Many perpetrators of such evil deed are even considered heroes, such as Mao, Stalin, Hirohito and, to some people, Hitler. Having read many books and seen many films as well as pictures about such cruelty, particularly regarding Hitler, I had an idea about a fitting punishment for him. It will be an artistic punishment, the art of expiation, to atone for all the souls that he had taken away, which he would repay with his own soul. The heavens would make him, as that man of power, leader, Führer of the Third Reich, become a woman, who would fall pregnant. He would carry the foetus that would eventually become the person he hates most, give birth to it, breastfeed it and nurture the child with all his love: he would become a mother.
He would fulfil his ideal views about the perfect mother with many children. He would even be awarded with the German Mother's Cross of Honour. But this time, the child would not be Aryan.

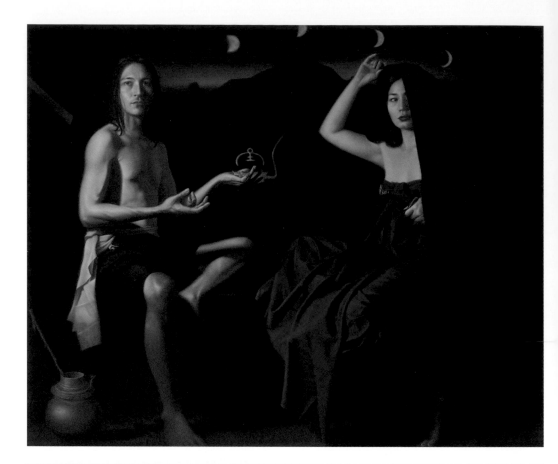

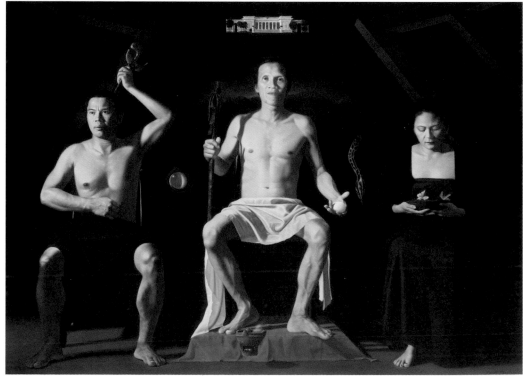

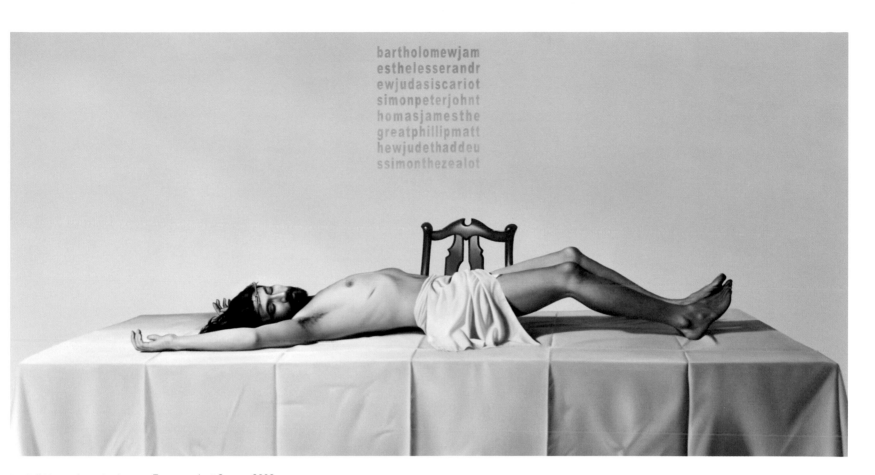

In image, text on wall reads:

bartholomewjam
esthelesserandr
ewjudasiscariot
simonpeterjohnt
homasjamesthe
greatphillipmatt
hewjudethaddeu
ssimonthezealot

No Full Moon above Aceh, 2004
Oil on canvas, 100 x 120 cm
Collection of the artist
Courtesy of the artist and
Langgeng Gallery

Ritual before the Election Day, 2004
Oil on canvas, 105 x 145 cm
Collection of the artist
Courtesy of the artist and
Langgeng Gallery

Transpose Last Supper, 2009
Oil on canvas, 125 x 240 cm
Umahseni Collection
Courtesy of the artist and
Langgeng Gallery

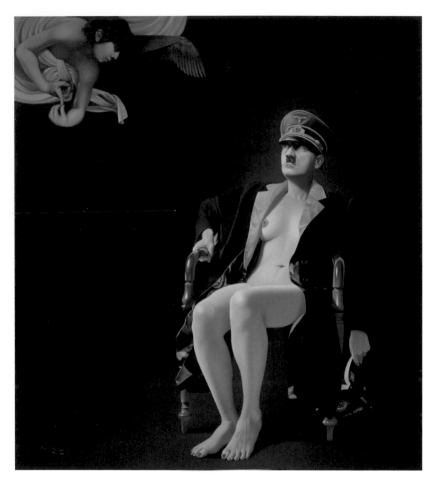

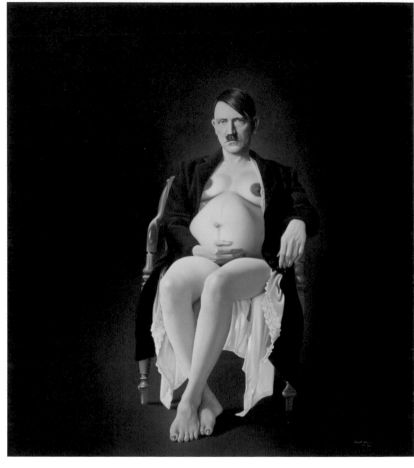

The Annunciation, 2009
Oil on canvas, 200 x 180 cm
Umahseni Collection
Courtesy of the artist and
Langgeng Gallery

Expecting New Born Child,
2009
Oil on canvas, 200 x 180 cm
Umahseni Collection
Courtesy of the artist and
Langgeng Gallery

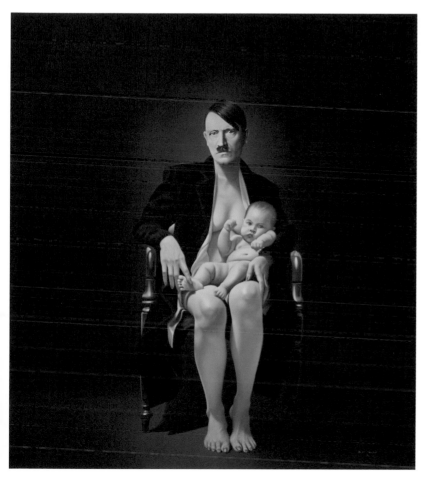

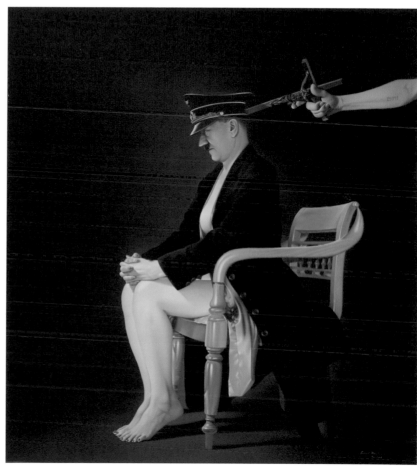

The Führer and Child, 2009
Oil on canvas, 200 x 180 cm
Umahseni Collection
Courtesy of the artist and
Langgeng Gallery

The Crucifixion, 2009
Oil on canvas, 200 x 180 cm
Umahseni Collection
Courtesy of the artist and
Langgeng Gallery

Yusra Martunus

Yusra Martunus creates three-dimensional works that play on the sensory language of the materials. He tackles the heart of materials in his works by highlighting their essence as a particular substance – whether liquid or solid, organic or industrial, wild or structured. He then adapts their characteristics and processes them to create new symbols and metaphors.

09201
(soft-hard series), 2009
Oil on canvas, 150 x 150 cm
Collection of the artist
Courtesy of the artist and
Valentine Willie Fine Art

09202
(soft-hard series), 2009
Oil on canvas, 150 x 150 cm
Collection of the artist
Courtesy of the artist and
Valentine Willie Fine Art

07108N
(flexible series), 2007
Aluminium casting and
sheets, polyurethane
painted, 120 x 30 x 30 cm
Collection of the artist
Courtesy of the artist and
Valentine Willie Fine Art

07112N
(hold series), 2007
Aluminium casting and
sheets, polyurethane
painted, 117 x 37 x 40 cm
Collection of the artist
Curtesy of the artist and
Valentine Willie Fine Art

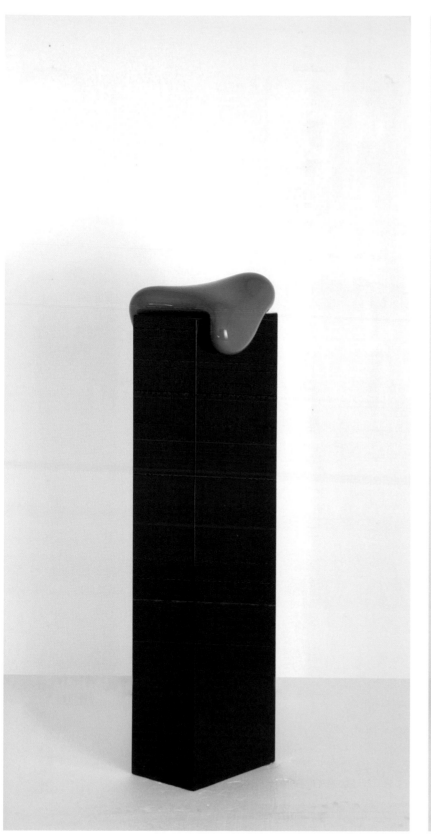

Yusra Martunus **157**

09101
(flexible series), 2009
Towel bar, fibreglass,
polyurethane painted,
15 x 53 x 27 cm
Collection of Nadi Gallery
Courtesy of the artist and
Valentine Willie Fine Art

07115U
(soft-hard series), 2007
Aluminium casting and
sheet, polyurethane painted,
120 x 120 x 10 cm
Courtesy of the artist and
Valentine Willie Fine Art

Wiyoga Muhardanto

I like to replicate an object or space to the scale of 1:1. When I do this, I combine the replica with an object that has contrasting meaning. Through combining two contrasting meanings, I create a new meaning of the object. I am also interested in playing with the context of space and like to focus on the commoditization of space. For example, turning the sacred space into a commercialized space.

Fork Chandelier, 2008
Plexiglas bent and neon bulb, 150 x 60 x 10 cm
Collection of the artist
Courtesy of Cemeti Art House

The Latest, 2007
Painted resin, wooden case
and neon lamp, variable
dimensions
Courtesy of Langgeng
Gallery

Ciao Bella, 2008
Painted resin, plywood and
steel pipe, 109 x 214 x 90 cm
Collection of Andi's Gallery
Courtesy of the artist

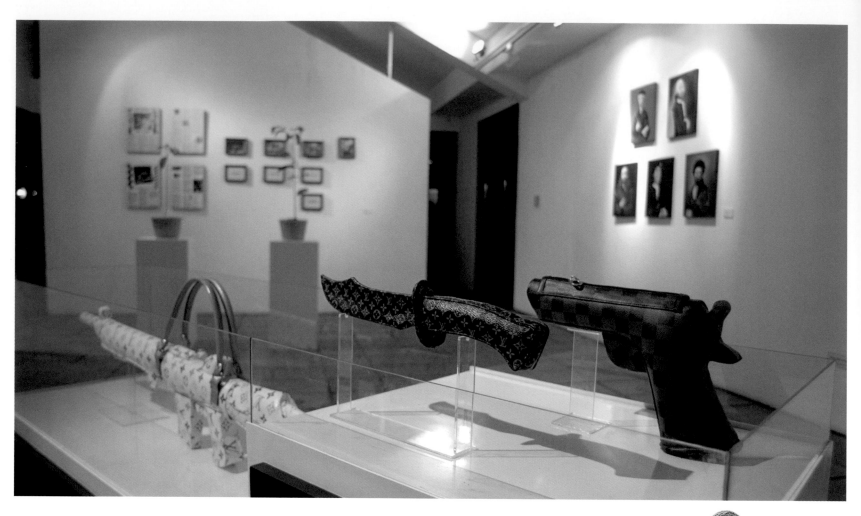

LV Violence Series, 2006
Imitation leather and
plexiglas, variable dimensions
Collection of
Ms Deborah C. Iskandar
Courtesy of the artist

Disposable Gucci, 2007
3 syringes wrapped
with canvas,
2.5 x 2.5 x 17 cm each
Private collection
Courtesy of the artist

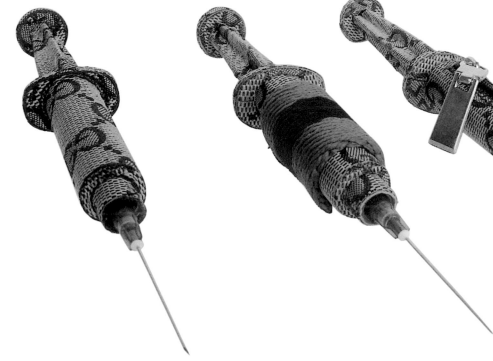

Multi-part Vehicle, 2008
Painted plywood, iron
structure and motor,
160 x 480 x 220 cm
Collection of Galeri Canna
Courtesy of the artist

iType, 2005
Vintage typewriter, painted
plywood, plexiglas,
88 x 39.5 x 39.5 cm
Collection of the artist
Courtesy of the artist

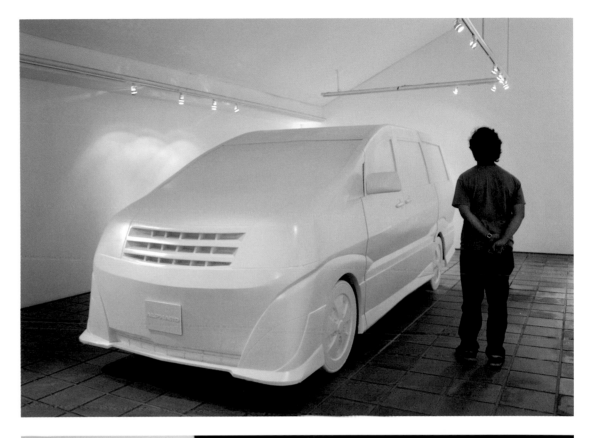

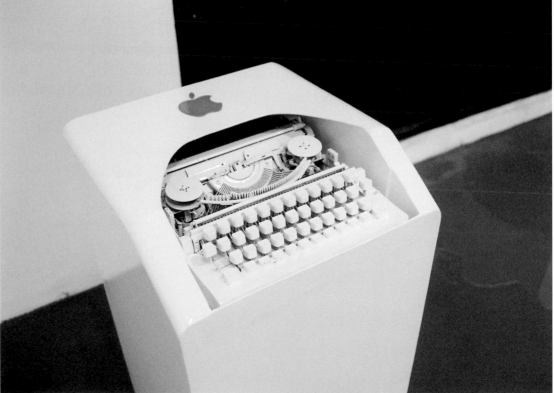

Krisna Murti

Krisna Murti rarely directly portrays himself or performs in his art. The artist serves as a conduit through which activity is perceived. In these light installations he plays with modes of self-presentation, employing the critical strategies of masquerade and impersonation, whilst depicting himself as various characters of the dance. These images record attributes of his exterior, instead of exploring the interior of the self. The work as a whole is simultaneously autobiographical and allegorical, speaking of a shared experience of modernity. In this regard, it demonstrates a widespread ambivalent relationship to legacy and tradition. Krisna re-narrates these shared experiences and ambivalence through themes such as detachment, disconnection, impassivity, loss and distance. (*Amanda Katherine Rath*)

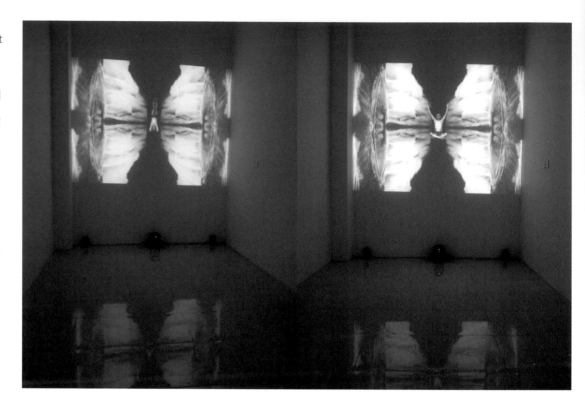

Video Poem, 2011
DVD player, beam projector,
speaker, variable dimensions
Collection of the artist
Courtesy of the artist

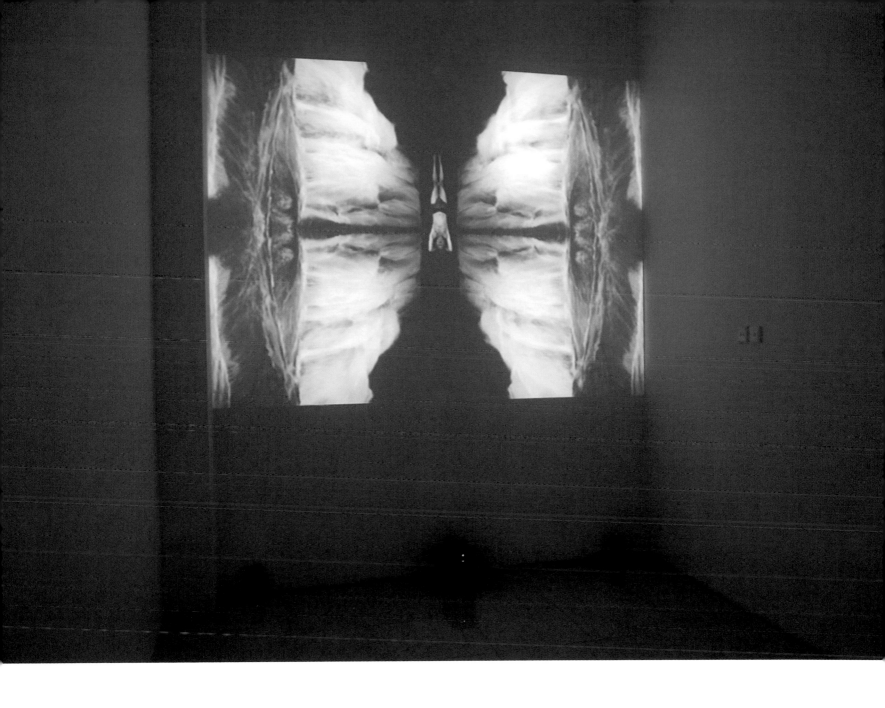

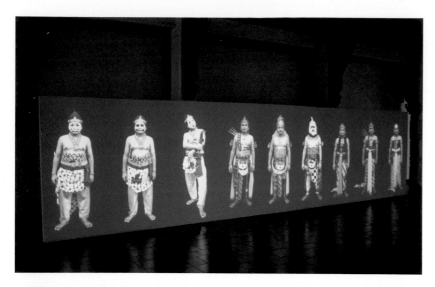
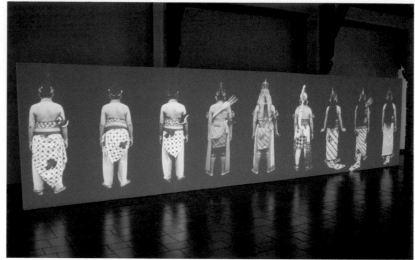
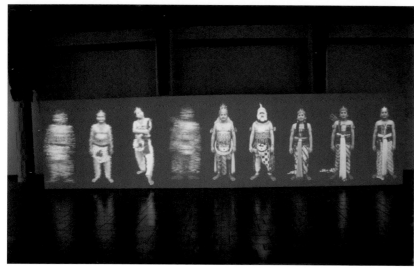

Empty Theatre, 2010
DVD player, beam projector,
speaker, variable dimensions
Collection of the artist
Courtesy of the artist

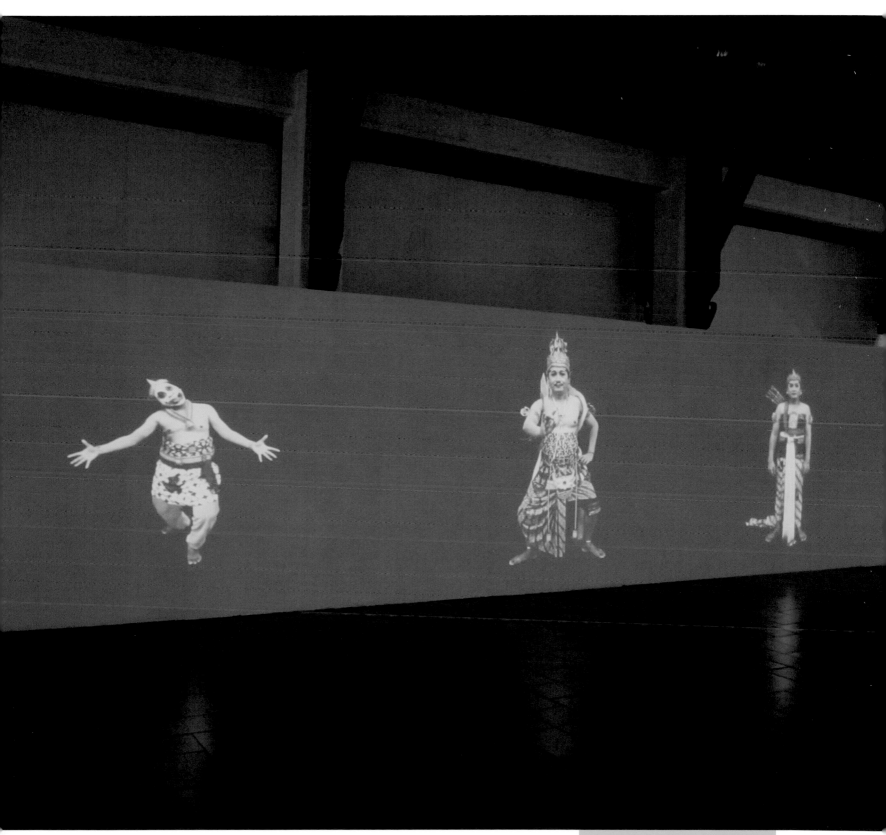

Nasirun

Fairy with a Rainbow Scarf,
2009
Oil on canvas, 145 x 400 cm
Private collection
Courtesy of the artist

The Fairy's Lost of Tears,
2009
Oil on canvas, 145 x 400 cm
Private collection
Courtesy of the artist

Art is an expression of my inner soul
that cannot be touched but can be felt.
My opinion is that an artist or a painter
only serves to express the outcome
of a moment that is seen and felt.
These moments are ideas close
to spirituality, that inspire the world's
most inner consciousness, and this
eventually becomes a work of art.
"My pieces are the children of my
work": in this sense they are the result
of vision, reflection, digestion and
the manifestation of a worthy soul,
which is finally presented to the public.

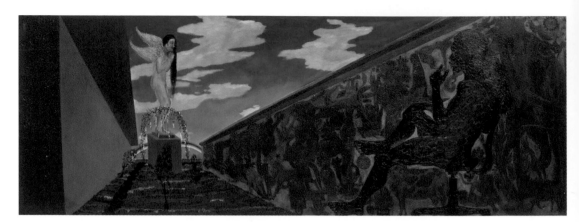

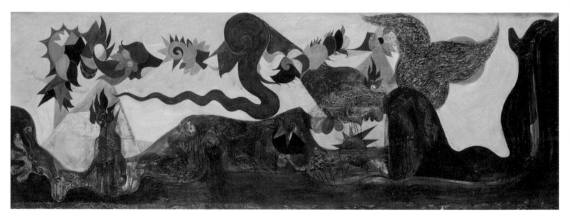

Bajaj Always Pass, 2010,
Mixed media,
250 x 250 x 150 cm
Private collection
Courtesy of the artist

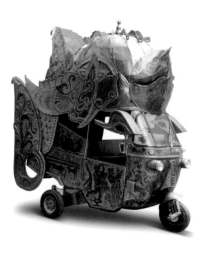

Yin Yang, 2010
Mixed media,
100 x 100 cm each
Private collection
Courtesy of the artist

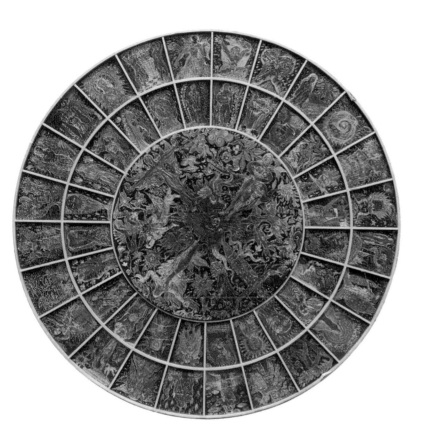

That's the Way It Is, 2010
Mixed media
Private collection
Courtesy of the artist

The Throne for Citizens,
2010
Oil on canvas, 145 x 400 cm
Private collection
Courtesy of the artist

Period Puppets, 2007
Acrylic on cardboard with
bamboo spine, 9 figures,
200 x 100 cm
Collection of the artist
Courtesy of the artist

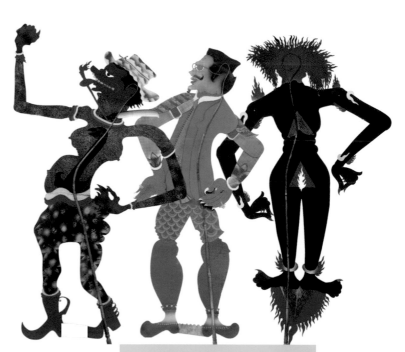

Aditya Novali

These are interactive paintings, offering the audience the freedom to choose the make-up of the image presented in the work. Each piece is made up of four-sided aluminium bars covered with canvas, which rotate to create different configurations and images. I focus and challenge our perception of the "comfort zone". Since this is a personal concept, the offered variations allow multiple personal understandings. In the *Mooi In(Die)* series, I specifically question our memories of the landscape *Mooi Indie* with a painting style of the colonial era, a tribute to our magnificent environment that we can testify as being destroyed nowadays, which I illustrate through a play on words in the title. So, it is a choice: the viewer's eye and will are supposed to decide what he experiences.

Silent Traces, 2010
Series *Mooi In(Die)*
Wood, metal, plexiglas,
ink and acrylic paint
on 12 rotatable four-sided
aluminium bars
covered with canvas,
83 x 66 x 14.5 cm each
Private collection
Courtesy of the artist and
Kersan Art Studio

White Ashes, 2010
Series *Mooi In(Die)*
Hand cut paper on 12
rotatable four-sided
aluminium bars,
83 x 66 x 14 cm each
Private collection
Courtesy of the artist and
Kersan Art Studio

Lost Green, 2010
Series *Mooi In(Die)*
Oil and ink on 21 rotatable
four-sided aluminium bars
covered with canvas,
88 x 61 x 12 cm each
Private collection
Courtesy of the artist and
Kersan Art Studio

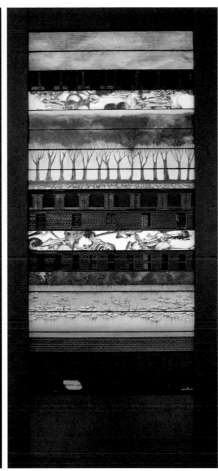
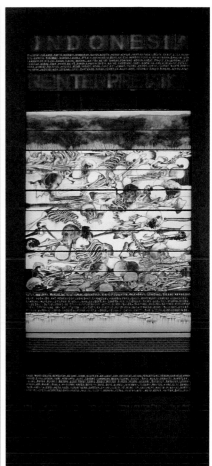

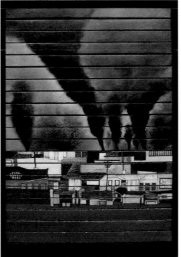
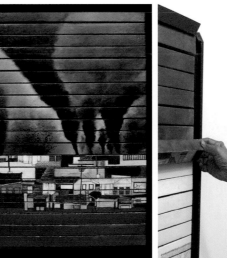

Unity in Diversity, 2011
Series *Mooi In(Die)*
Oil and ink on canvas,
wood, metal and plexiglas
on 18 rotatable four-sided
aluminium bars,
220 x 100 x 20 cm each
Private collection
Courtesy of the artist and
Kersan Art Studio

Comfort Zone, 2010
Series *Mooi In(Die)*
Oil on 16 rotatable four-
sided aluminium bars
covered with canvas,
70 x 70 x 5 cm each
Private collection
Courtesy of the artist and
Kersan Art Studio

Aditya Novali **173**

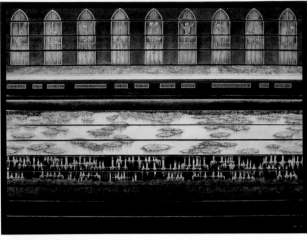

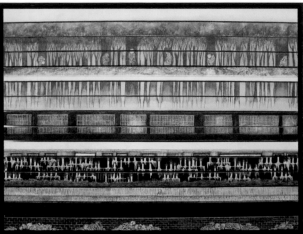

The Last Resort, 2010
Series *Mooi In(Die)*
Ink, charcoal and acrylic on
15 rotatable four-sided
aluminium bars covered
with canvas,
61 x 105 x 14 cm each
Private collection
Courtesy of the artist and
Kersan Art Studio

Tomorrow, 2010
Series *Mooi In(Die)*
Oil and ink on 18 rotatable
four-sided aluminium
bars covered with canvas,
80 x 80 x 12 cm each
Private collection
Courtesy of the artist and
Kersan Art Studio

Rebellious Silence, 2010
Series *Mooi In(Die)*
Oil and ink on 17 rotatable
four-sided aluminium bars
covered with canvas,
82 x 120 x 14 cm each
Private collection
Courtesy of the artist and
Kersan Art Studio

(My) Comfort Zone, 2010
Series *Mooi In(Die)*
Oil and ink on 21 rotatable
four-sided aluminium bars
covered with canvas,
61 x 88 x 12 cm each
Private collection
Courtesy of the artist and
Kersan Art Studio

Eko Nugroho

Working with thick dark outlines, Eko Nugroho's comic-inspired work is a storytelling journey with a different audience at different sites. He works across disciplines, from murals and paintings to drawings, book projects, animation, large-scale embroideries, and even sculptures. Most recently he created a piece using a contemporary interpretation of *Wayang kulit* or shadow puppets, and performed in his hometown of Yogyakarta. His part-man and part-machine characters are often accompanied by bizarre and ironic statements in the form of speech bubbles or t-shirt slogans. They symbolize the de-humanization of Man, as we become increasingly apathetic and amoral, more machine-like and regimented, bound by the pressures and expectations of society at large. (*Adeline Ooi*)

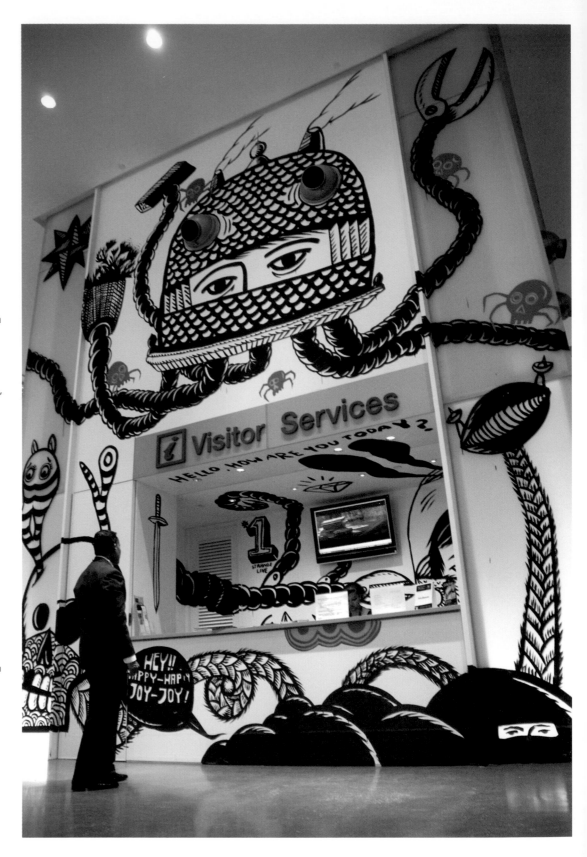

It's All About Coalition, 2008
Acrylic on the wall
Singapore National Museum
Courtesy of Mita Ratna Harjanti

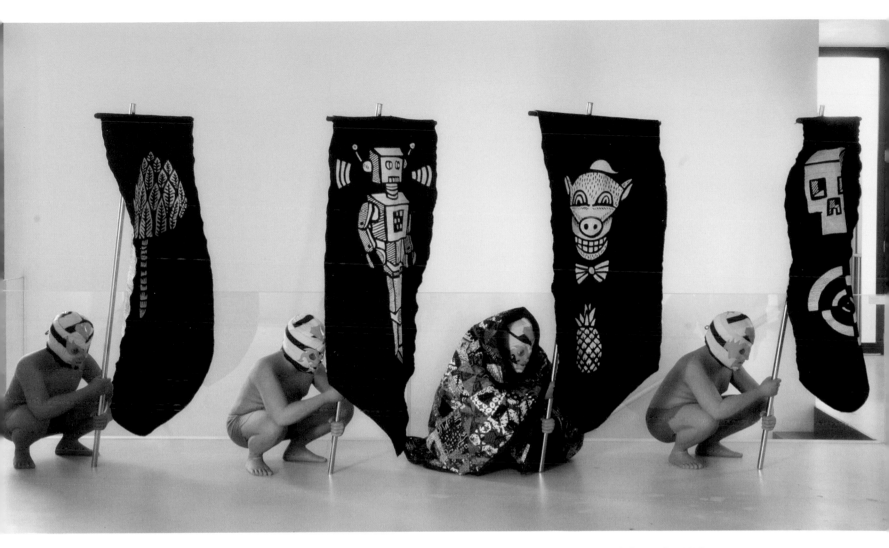

Be Proud of Your Flag, 2009
Resin painted with acrylic,
stainless steel, machine
embroidered rayon thread
on fabric backing, masks,
192 x 82 x 110 cm each
Collection of the artist
Courtesy of Desi Suryanto

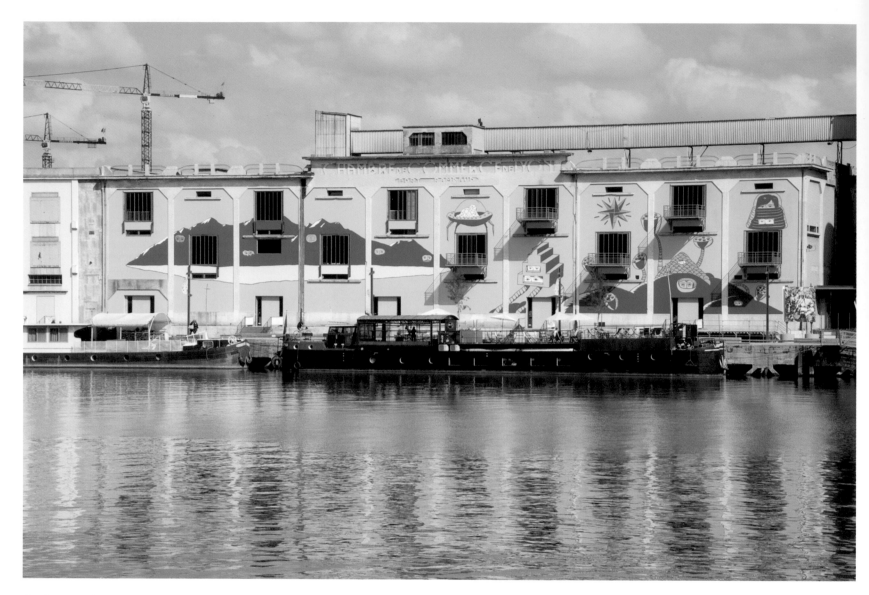

*Cut the Mountain
& Let It Fly*, 2010
Acrylic on the wall
The 10th Lyon Biennale
Collection of the artist
Courtesy of the artist

Puppet Series "Hidden Violence", 2008
Buffalo skin painted with acrylic, bamboo, variable dimensions
Puppet edition 1/3
Collection of the Tropen Museum, The Netherlands
Courtesy of Cemeti Art House and Dwi "Oblo" Praestyo

Stranger Always Look Strange, 2010
Machine embroidered rayon thread on fabric backing, 250 x 156 cm
Collection of the artist
Courtesy of the artist and Desi Suryanto

Yellow Soldier #1, 2009
Machine embroidered rayon thread on fabric backing, 62 x 48 cm
Collection of the artist
Courtesy of the artist and Desi Suryanto

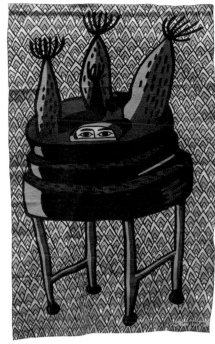

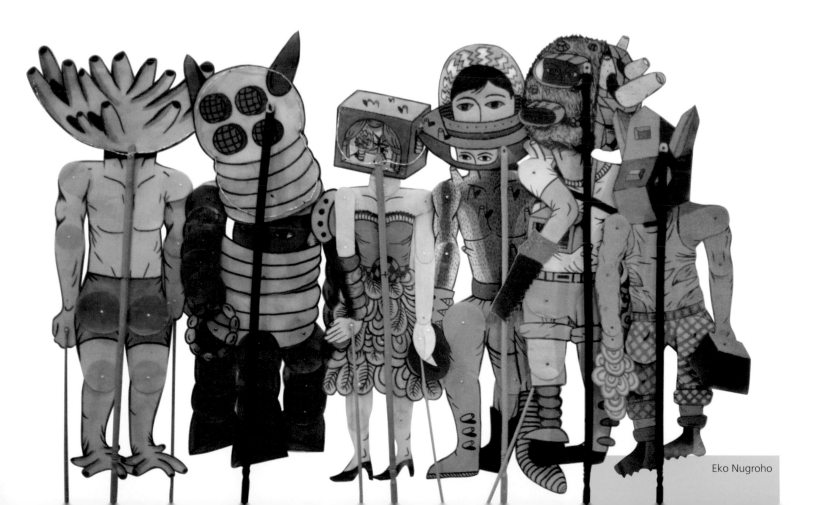

Eko Nugroho

179

Arya Pandjalu

Crazy Wheels
(pentacycle), 2007
Bicycle, felt, zinc, acrylic
paint, 120 x 195 x 95 cm
Collection of Susanna Perini,
Biasa Art Space
Courtesy of the artist

Birdprayers is an ongoing multi-site and interdisciplinary project that combines performances, exhibitions and talks by artists Sara Nuytemans (The Netherlands) and Arya Pandjalu (Indonesia). It is a creative response to the weighty and seemingly impossible issue of how to resolve the religious conflict we witness in the world. By representing four major world religions, Judaism, Catholicism, Hinduism and Islam, the artists react and challenge the competing religious hegemonies, which appear locked in a never-ending debate of often bloody and polarizing drama. However, although *Birdprayers* expresses the need for unity and peace in place of the often-divisive so-called utopian ideologies, it also highlights the difficult realities of achieving this goal, illustrated through playful and sombre pieces.

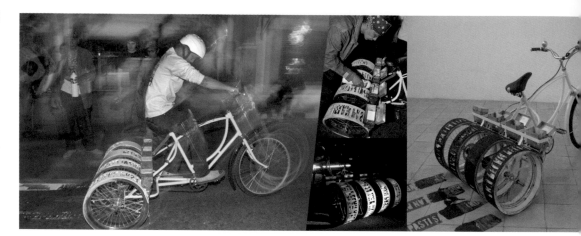

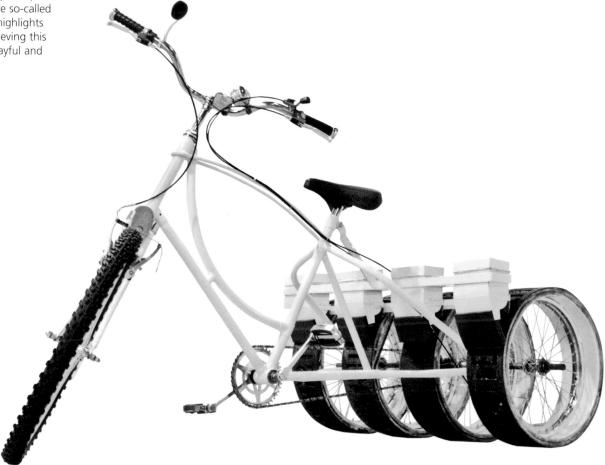

Birdprayers, 2007
Ubud, Bali
Video performance project
with Sara Nuytemans
Photograph on lambda
print, 60 x 80 cm
Edition of 10
Collection of the artist
Courtesy of the artist

Birdprayers #3, 2008
Ubud, Bali
Video performance project
with Sara Nuytemans
Photograph on lambda
print, 60 x 80 cm
Edition of 10
Collection of the artist
Courtesy of the artist

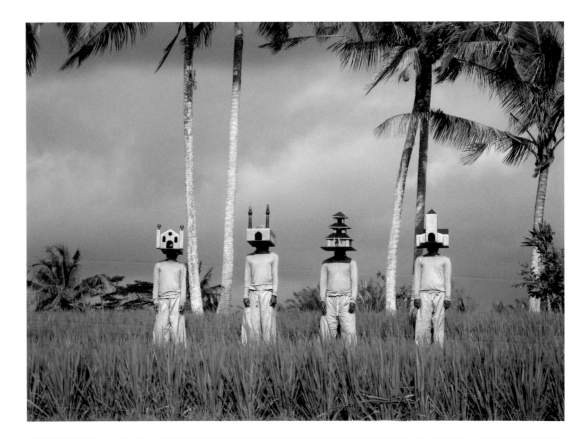

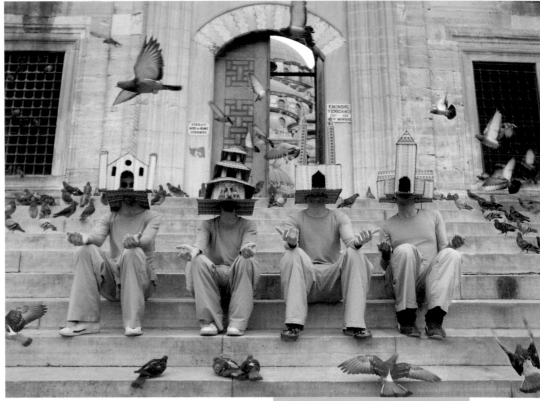

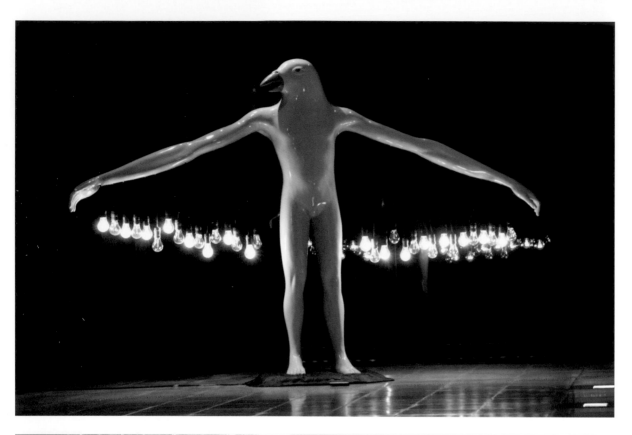

Keep the Light on, 2008
Polyester resin, light bulbs,
auto paint, 170 x 250 x 63 cm
Collection of Biasa Art Space
Courtesy of the artist

Keep this Land, 2008
Polyester resin, wood, auto
paint, 120 x 53 x 93 cm
Collection of the artist
Courtesy of the artist

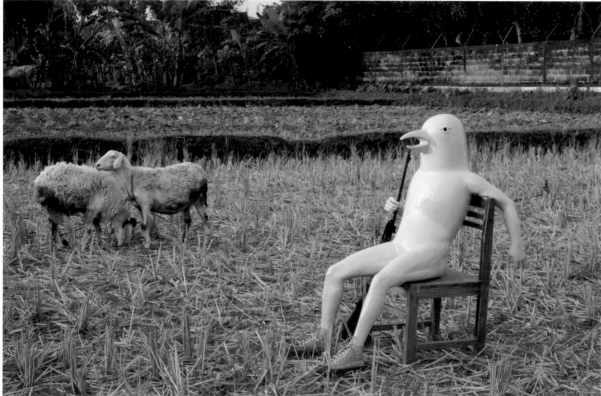

Tribute to Jogja, 2009
Video performance
Photograph on lambda
print, 60 x 80 cm
Collection of the artist
Courtesy of the artist

*This Little Bird Goes to
Market, this Little One Stays
at Home*, 2008
Polyester resin, wood, glass,
autopaint, 62 x 305 x 51 cm
Collection of the artist
Courtesy of the artist

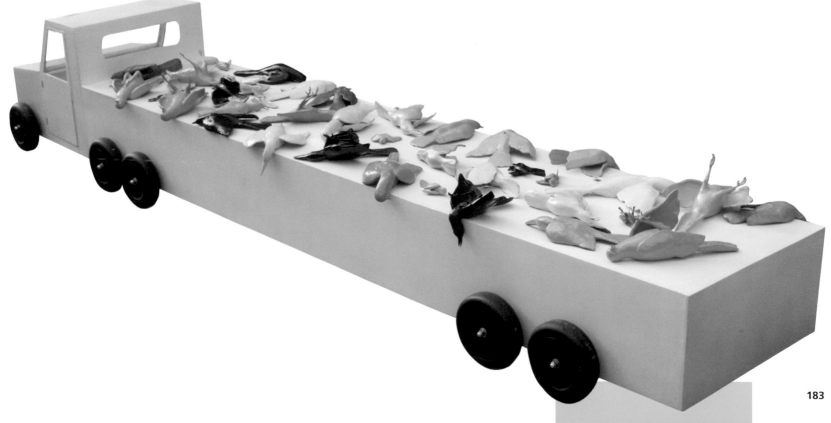

Edo Pillu

Almost all my work is subjective, personal views and opinions exploring ideas of existence and mankind as social beings. I want to show a dynamic shift from traditional societies and the fight for a modern existence. In these pieces, I am interested in religious awareness, the conflicting social space, the utopian longing for peace and the overwhelming volume of information in contemporary society, shown here as a simultaneous burst into the minds: what I call chaos.

Javanese Mystical Notes, 2010
Acrylic on canvas,
150 x 200 cm
Private collection
Courtesy of the artist and Vanessa Artlink

Dynamics towards the Truth, 2010
Acrylic on canvas,
150 x 200 cm
Pivate collection
Courtesy of the artist and Vanessa Artlink

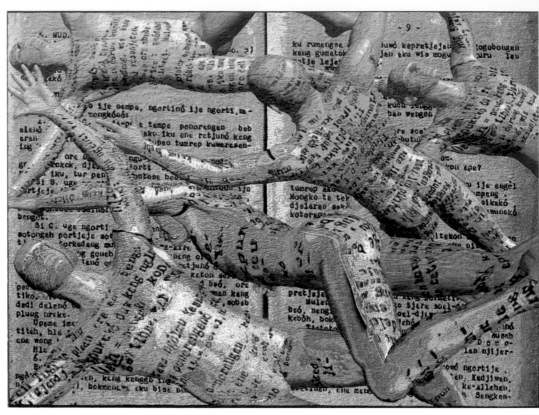

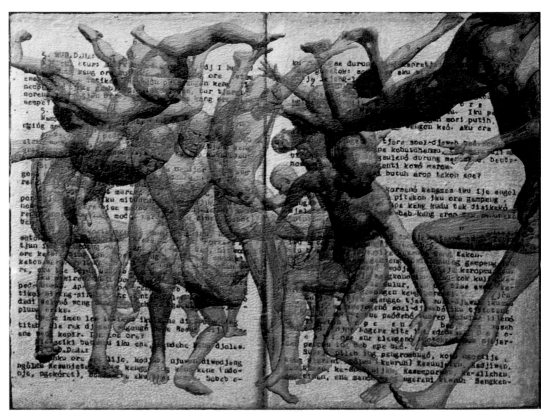

Ascetic, 2010
Acrylic on canvas,
150 x 200 cm
Collection of Vanessa Artlink
Courtesy of the artist

*Carrying the Air – A Gift
from the Plants*, 2010
Acrylic on canvas,
150 x 200 cm
Collection of Vanessa Artlink
Courtesy of the artist

People at a Yard, 2010
Acrylic on canvas,
150 x 200 cm
Private collection
Courtesy of the artist and
Vanessa Artlink

About Cosmology, 2010
Acrylic on canvas,
150 x 200 cm
Private collection
Courtesy of the artist and
Vanessa Artlink

Eddi Prabandono

I use art as a tool. My work appears playful, humorous and I present it for entertainment. Underneath the initial silliness, I want to show elements of frustration and figures crying out in protest.

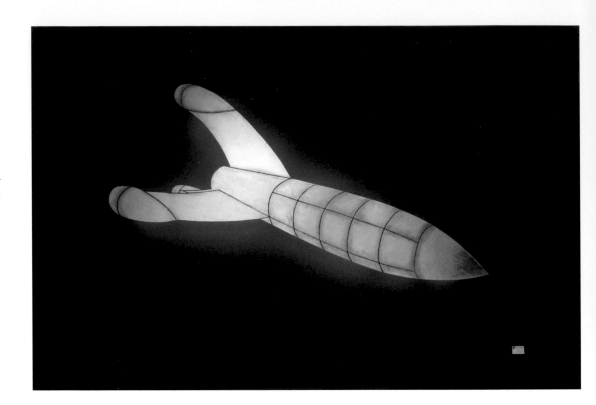

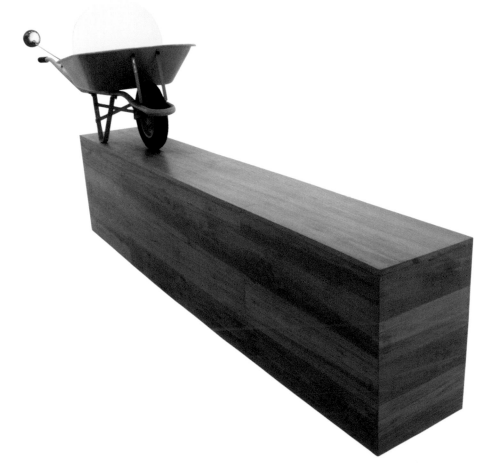

Luminous Crown, 2008
Aluminium plate, electrical lamp, 300 x 150 cm
Collection of the artist
Courtesy of the artist

Let the Daughter Take the Lead, 2008
Trolley, electricity, variable dimensions
Collection of the artist
Courtesy of the artist

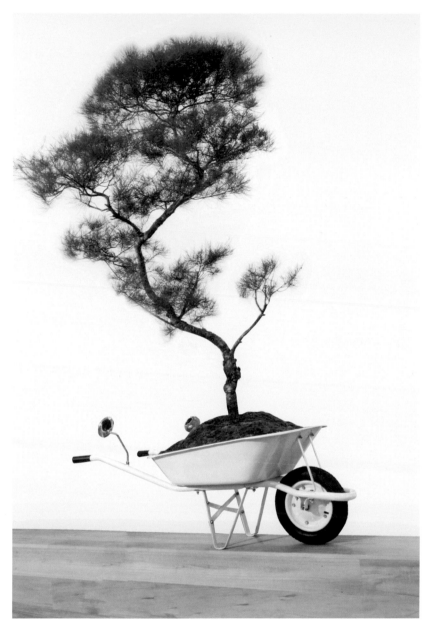

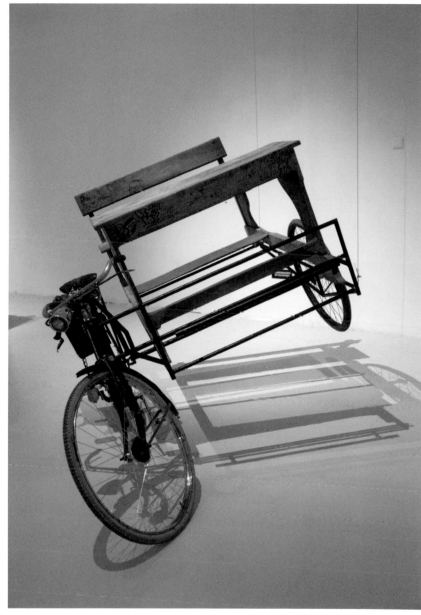

*Green, Green, Green
Go Ahead*, 2009
Trolley, bonsai,
600 x 120 x 250 cm
Collection of the artist
Courtesy of the artist

Scandal Table, 2008
Bicycle, school table,
300 x 200 x 130 cm
Collection of the artist
Courtesy of the artist

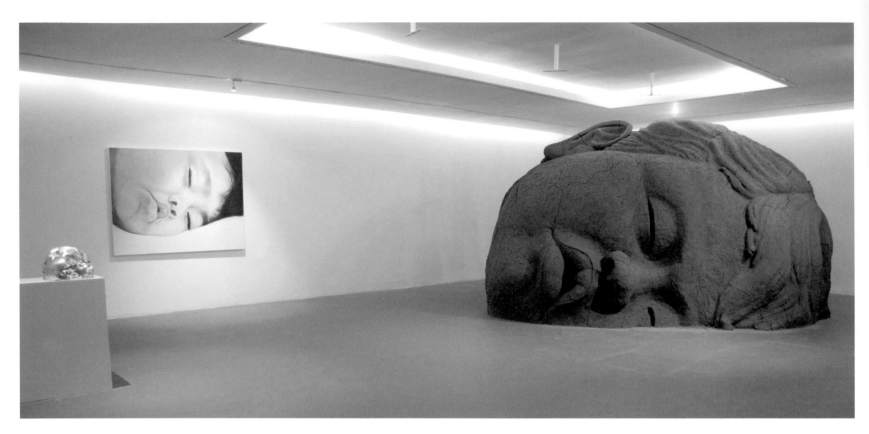

Luz Series, 2009
Aluminum, 40 x 40 x 40 cm
Collection of the artist
Courtesy of the artist

Mbak Sri is Admitted
to Hospital, 2009
Toy, glass, paddy,
50 x 20 x 50 cm
Collection of the artist
Courtesy of the artist

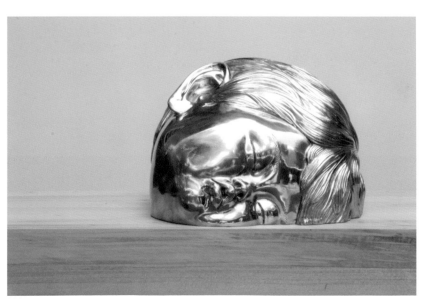

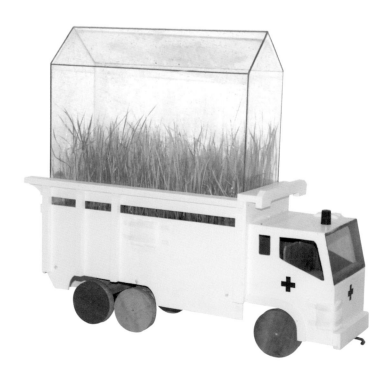

Wish Me Luck, 2009
Closet pipe, 20 x 900 cm
Collection of the
Municipality of Yogyakarta
Courtesy of the artist

Star Park, 2010
Iron, neon, 600 x 600 cm
Collection of the artist
Courtesy of the artist

Bambang Pramudiyanto

The Changes of a Value,
2001
Oil on canvas, 2 panels,
60 x 45 cm each
Collection of Mr Cristianto
Courtesy of the artist

For me, art is a way to express feelings and thoughts that reflect society and culture. Art grows and progresses as a civilization evolves, through time and through its achievements.
My work is made of the steps I have taken on my life journey, and I consider it a strategy to keep my creative soul growing. I prevent myself from sticking to one artistic style because I want to constantly innovate, push and develop myself.

192

The Rose, Who Are You,
2001
Oil on canvas, 3 panels,
60 x 45 cm each
Collection of the artist
Courtesy of the artist

*Paper Puppets #2:
Three Seasons*, 2001
Oil on canvas, 100 x 150 cm
Collection of Mr Hogi Hyun
Courtesy of the artist

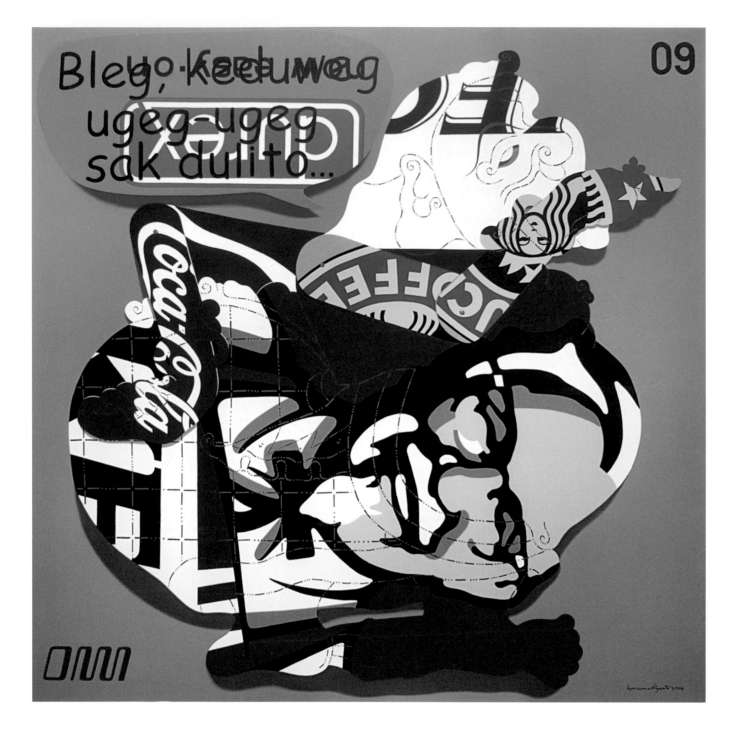

Paper Puppets #1:
The Acculturation
Acrylic on canvas,
200 x 200 cm
Collection of Mr Hogi Hyun
Courtesy of the artist

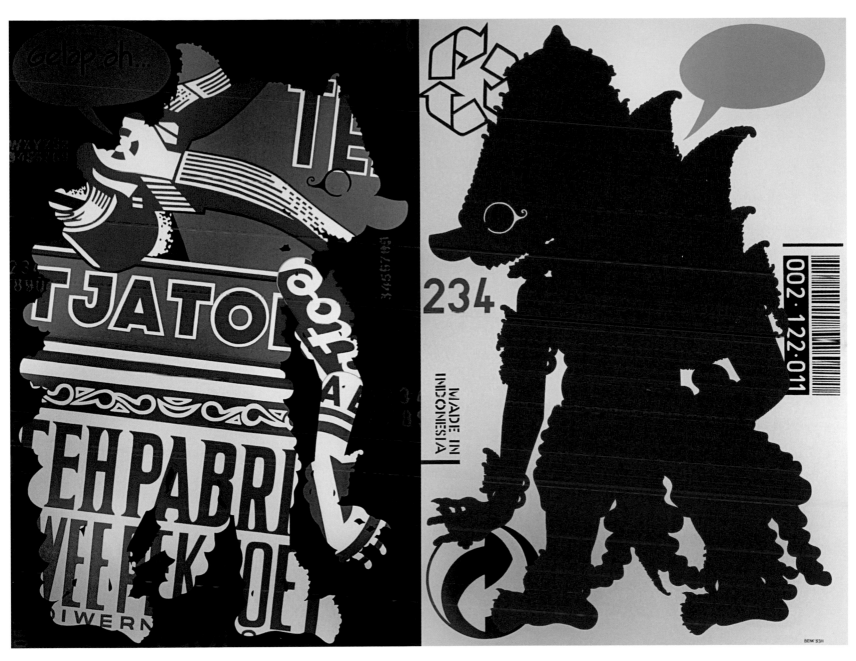

Paper Puppets #2:
The Border Struggle, 2011
Acrylic on canvas, 2 panels,
180 x 120 cm each
Collection of the artist
Courtesy of the artist

Julius Ariadhitya Pramuhendra

In his early career, Pramuhendra's work was already dominated by a large number of self-portraits in various poses. His years of struggle with printmaking have etched an artistic character on him and he continues to use dry media, such as pencil and charcoal on paper or canvas. Almost all of his two-dimensional works are laden with rich and intense grey scales. On closer inspection you can see careful use of light and volumes, and the play of contrast often results in a poetic as well as dramatic visual impact.

In the context of the development of contemporary art in Indonesia, Pramuhendra is one of the few young artists who work on religiosity in a unique way. Born into a devout Catholic family, he has a firm grasp on the cultural tensions that one might experience only in Indonesia as a multi-ethnic and multi-religious country, where religious forces play an important role in the life of society. Pramuhendra's deep understanding of his own religious belief provides him with inspiration for his thoughts and insight, especially in relation with the existence of symbols and rituals, which in turn give him an aesthetic experience. He also understands how the history of religious life in Indonesia was born out of a "syncretism" between the local cultures, with their specific understanding of the function of symbols and rituals, and the teachings that came with the European colonization. (*Agung Hujatnikajennong*)

Careful where You Stand, 2007
Charcoal on canvas,
180 x 130 cm
Courtesy of the artist

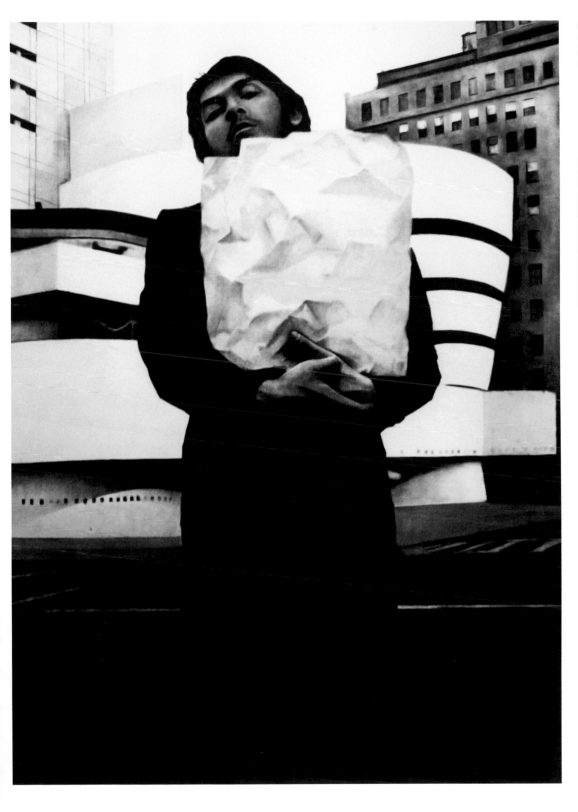

Lost in New York, 2008
Charcoal on canvas,
250 x 145 cm
Courtesy of the artist

One Day in Bilbao, 2009
Charcoal on canvas,
122.5 x 200 cm
Courtesy of the artist

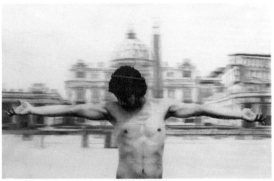

Crucifixion in Vatican, 2008
Charcoal on canvas,
180 x 300 cm
Courtesy of the artist

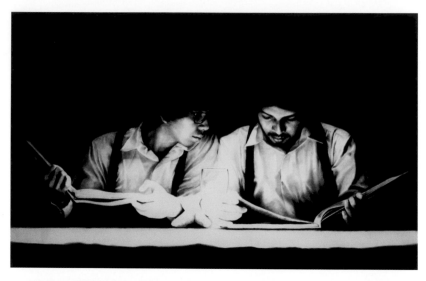

He says, "I live in a third-world country, Indonesia. As an artist, I always ask, 'Who am I?' within myself and in the larger context of the religious, social and even artistic constellation. This question and discussion therein has become the base of my work. It's this very question that I believe will always be a discussion matter, now and forever: 'Who am I?'. Art subjects are not always to be sought out. I believe that every matter, and not only in art, begins from inside ourselves. That is why I draw an image of myself in most of my work, the face representing the most important part of my body in a process of self-identification".

The Companion, 2010
Charcoal on canvas,
190 x 300 cm
Courtesy of the artist

The Reunion (Ashes to Ashes), 2010
Charcoal on canvas,
190 x 400 cm
Courtesy of the artist

Divided and Fold, 2008
Charcoal on canvas,
190 x 400 cm
Courtesy of the artist

Last Supper, 2008
Charcoal on canvas,
145 x 700 cm
Courtesy of the artist

I See Me, 2007
Charcoal on canvas,
150 x 250 cm
Courtesy of the artist

The Way of Gravity, 2007
Charcoal on canvas,
150 x 250 cm
Courtesy of the artist

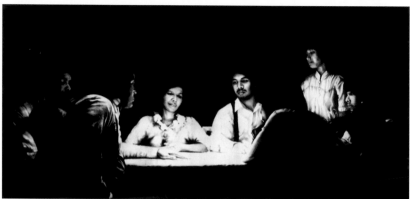

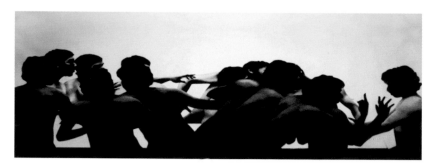

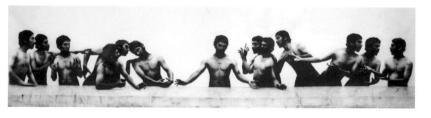

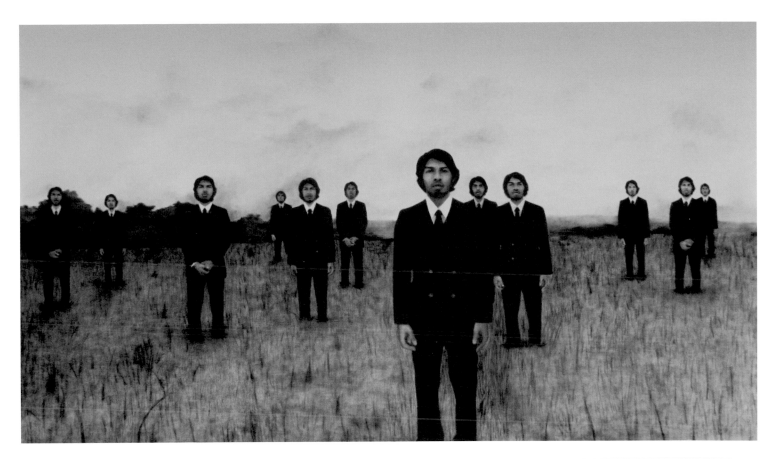

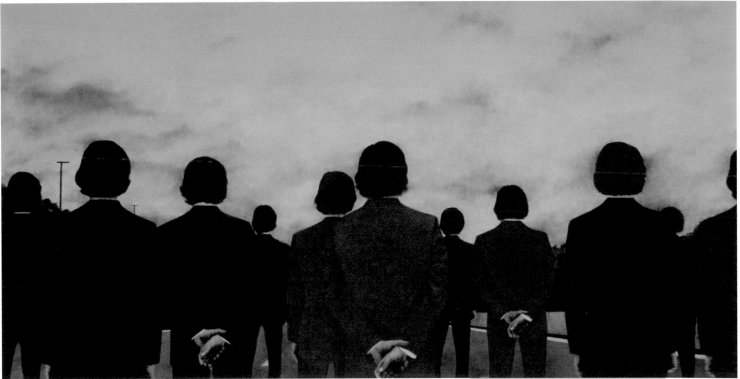

Anggar Prasetyo

For me, the subject matter of visual art is in its own elements. Hence, working on the visual elements is a way to emphasize the visual arts for the pleasure of the eye.

Drapery Texture VII, 2010
Mixed media on canvas,
190 x 145 cm
Private collection
Courtesy of the artist

Drapery Texture XII, 2010
Mixed media on canvas,
145 x 190 cm
Collection of Tembi
Contemporary
Courtesy of the artist

Drapery Texture XVII, 2010
Mixed media on canvas,
200 x 300 cm
Collection of Tembi
Contemporary
Courtesy of the artist

Anggar Prasetyo

*Line Color Composition
VIII*, 2010
Mixed media on board,
190 x 190 cm
Collection of Tembi
Contemporary
Courtesy of the artist

Drapery Texture XIV, 2010
Mixed media on canvas,
190 x 190 cm
Collection of Tembi
Contemporary
Courtesy of the artist

Drapery Texture XVI, 2010
Mixed media on canvas,
190 x 190 cm
Collection of Tembi
Contemporary
Courtesy of the artist

Wood Texture III, 2010
Mixed media on canvas,
190 x 190 cm
Collection of Tembi
Contemporary
Courtesy of the artist

Angki Purbandono

Photography's enemy is rigidity, that is, fixed rules about how photography should be done. Experiment is what saved photography. With a scanner flatbed, I try to seek and save attention in the contemporary photography scene. By provoking a conventional perception about the photographic medium itself, I capture new ways and moments of interaction with my surroundings, without using a camera as my tool.

Golden Dragon, 2010
Series *Noodle Theory*
Scanography, print on paper, framed by aluminium composite, dibond, 100 x 150 cm, 3 pieces
Collection of Mr Tom Tandio
Courtesy of the artist and Vivi Yip Art Room

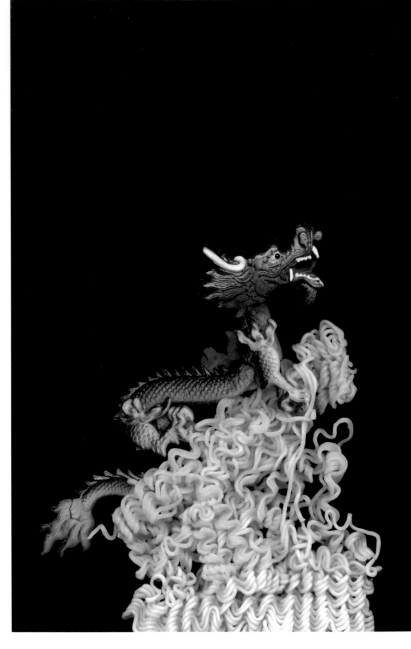

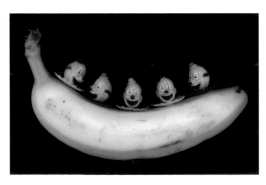

The Clown, 2009
Series *The Earth*
Scanography, print on transparency, 80 x 125 cm
Collection of the Singapore Art Museum
Courtesy of the artist and Vivi Yip Art Room

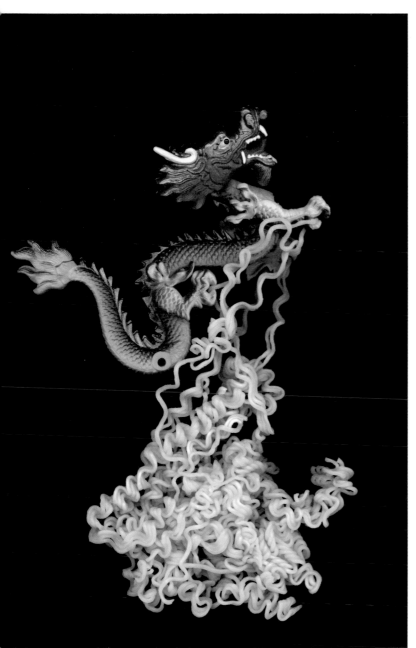

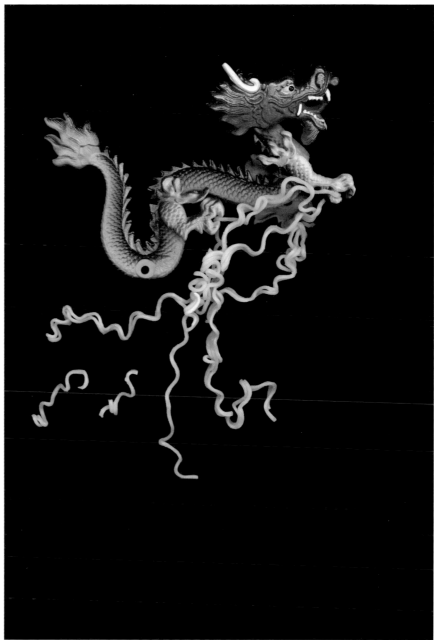

Yoga in Singapore, 2011
Series *Miss TOP POP*
Scanography, print on
transparency, neon
box installation,
100 x 100 cm, 6 pieces
Collection of the artist
Courtesy of the artist and
Vivi Yip Art Room

General, 2009
Series *Folder from Fukuoka*
Scanography, print on
transparency, neon box
installation, 100 x 100 cm
Collection of Mrs Sri Rahayu
Courtesy of the artist and
Vivi Yip Art Room

Soldier, 2009
Series *Folder from Fukuoka*
Scanography, print on
transparency, neon box
installation, 100 x 168 cm
Collection of Mr Igor Rahmanadi
Courtesy of the artist
and Vivi Yip Art Room

Fighter, 2009
Series *Folder from Fukuoka*
Scanography, print on
transparency, neon box
installation, 90 x 200 cm
Collection of Mrs Jane Ittogi
Courtesy of the artist and
Vivi Yip Art Room

Brush!, 2008
Scanography, print on
transparency, neon box
installation, 80 x 200 cm
Collection of the artist
Courtesy of the artist and
Vivi Yip Art Room

Katana, 2009
Series *Folder from Fukuoka*
Scanography, print on
transparency, neon box
installation, 100 x 100 cm
Collection of Ms Vivi Yip
Courtesy of the artist

Stay Hungry, 2008
Series *The Earth*
Scanography, print on
canvas, 100 x 150 cm
Collection of the Fukuoka
Asian Art Museum
Courtesy of the artist and
Vivi Yip Art Room

Angki Purbandono 207

Agus "Baqul" Purnomo

Agus "Baqul" Purnomo has been exploring abstract painting using numbers as his basic element. Through this technique, he responds to natural and cosmic themes and has developed his own unique style of "abstract impressionism". Besides his numeric paintings, he also explores calligraphy, depicting holy verses or words from Qur'an and endowing them with a dynamic contemporary look.

Bougainville, 2009
Acrylic on canvas,
200 x 300 cm
Private collection
Courtesy of the artist and
Valentine Willie Fine Art

Rose #3, 2009
Acrylic on canvas,
200 x 300 cm
Collection of Tembi
Contemporary
Courtesy of the artist

Prayer Before Bedtime, 2009
Acrylic on canvas,
150 x 200 cm
Collection of Valentine
Willie Fine Art
Courtesy of the artist

Prayer After Meal, 2009
Acrylic on canvas,
180 x 200 cm
Private collection
Courtesy of the artist and
Valentine Willie Fine Art

Agus "Baqul" Purnomo **209**

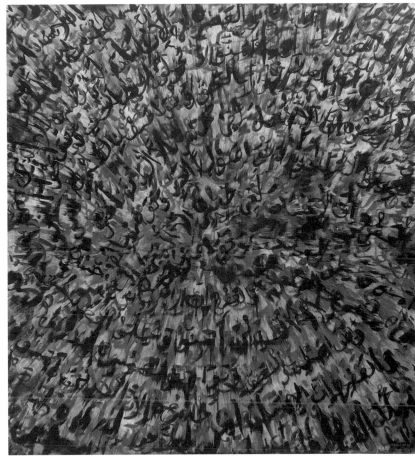

Kursi Verse, 2009
Acrylic on canvas,
200 x 180 cm
Private collection
Courtesy of the artist and
Valentine Willie Fine Art

The Time, 2010
Acrylic on canvas,
200 x 180 cm
Private collection
Courtesy of the artist and
Valentine Willie Fine Art

Haris Purnomo

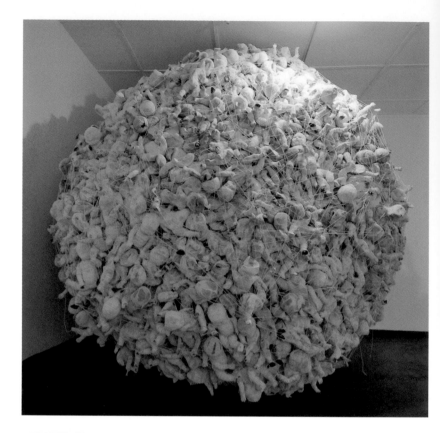

Haris Purnomo is back now. From his current works we notice that the Garuda bird has been whirling in his mind and preoccupying him since the bird flew off his hand more than twenty years ago. His devastating bandaged baby dolls have gone away. However, he perhaps still visits their mass grave. They are back or called back, some turning to human infants, having removed the bandages over old wounds that leave no mark, yet showing new blemishes of the current era stamped over their whole soft-skinned bodies.

But these babies seem to want to be powerful like Garuda, with tattoos all over the face and body, small wings growing here and there, and creeping as if in battle fields prior to the birth of the Republic, while living in the shadow of the overwhelming image of the mythical being with its scary gaze and claws. (*Hendro Wiyanto*)

Globaby, 2010
Mixed media, variable dimensions
Courtesy of the artist

Nation and Character Building 1, 2007
Mixed media, variable dimensions
Courtesy of the artist

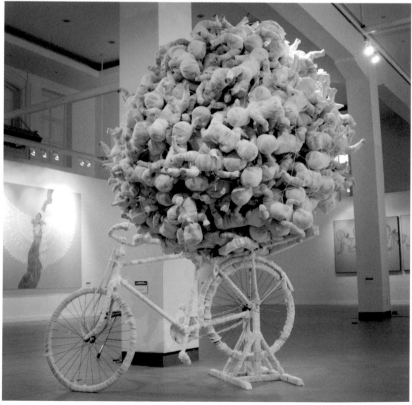

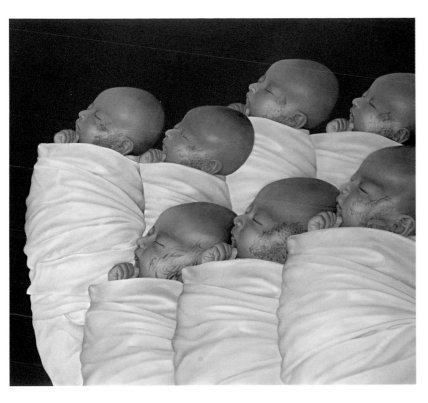

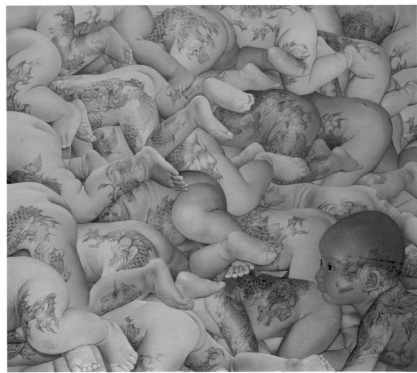

Blanket of Hope, 2008
Oil and acrylic on canvas,
180 x 200 cm
Courtesy of the artist

Green Baby 2, 2009
Oil and acrylic on canvas,
180 x 200 cm
Courtesy of the artist

Baby Process 2, 2007
Oil and acrylic on canvas,
200 x 250 cm
Courtesy of the artist

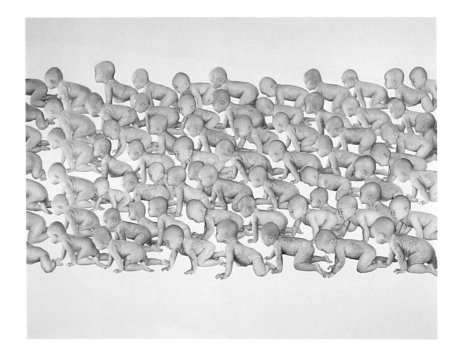

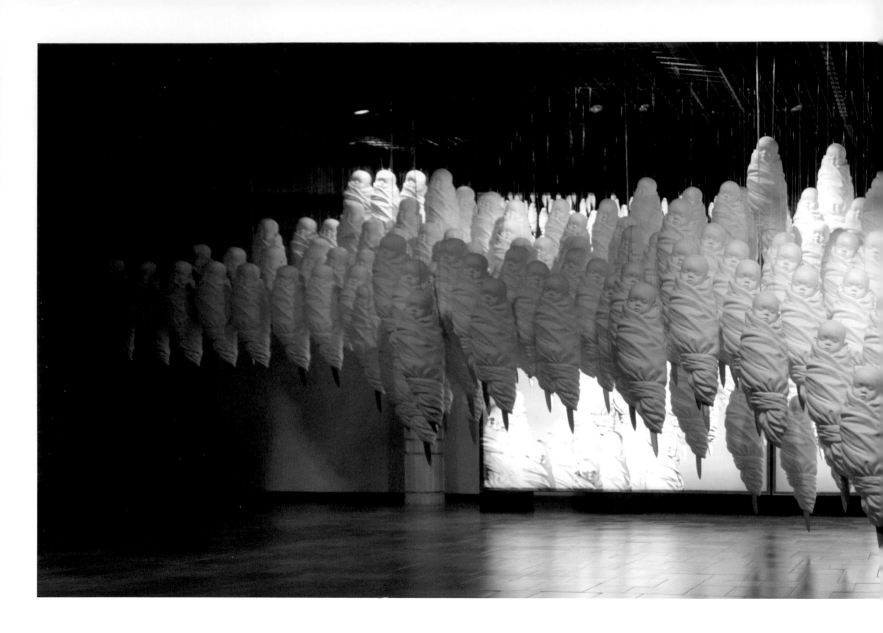

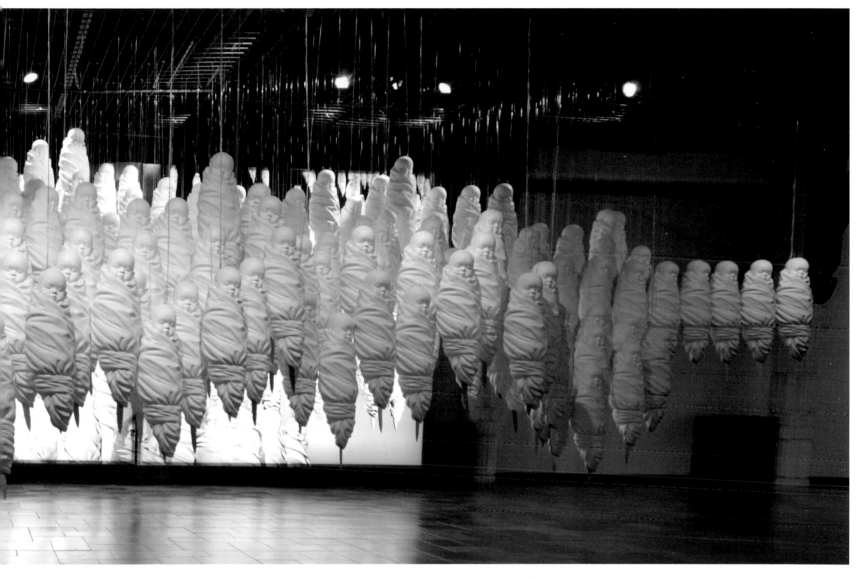

Waiting for the Signal,
2008–09
Mixed media, variable
dimensions
Courtesy of the artist

Alienated, 2008
Mixed media, variable
dimensions
Courtesy of the artist

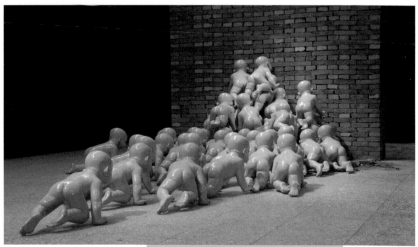

Haris Purnomo 215

Pupuk Daru Purnomo

Almost all of my paintings are the expression of my feelings in response to life in happy times and hard times that bring pressures and troubles. I wish I could put all my pain into my work, and smile.

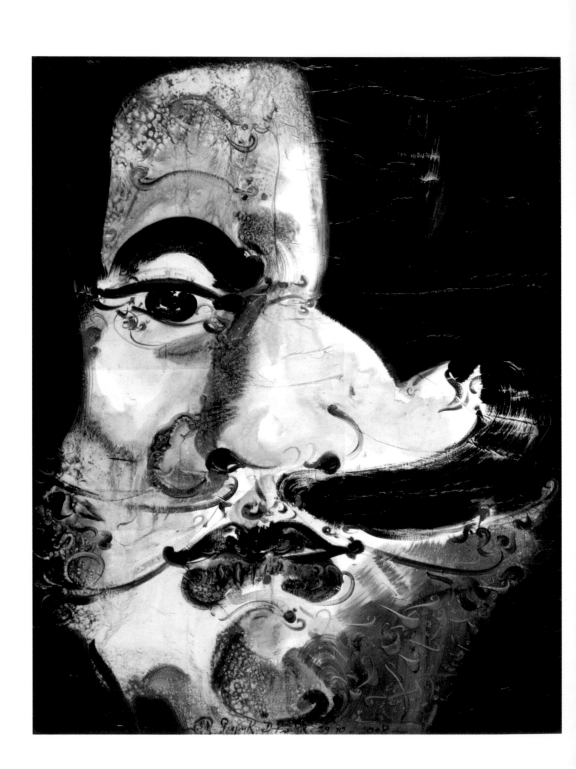

The Celebrities, 2008
Acrylic on canvas,
146 x 115 cm
Collection of the artist
Courtesy of the artist

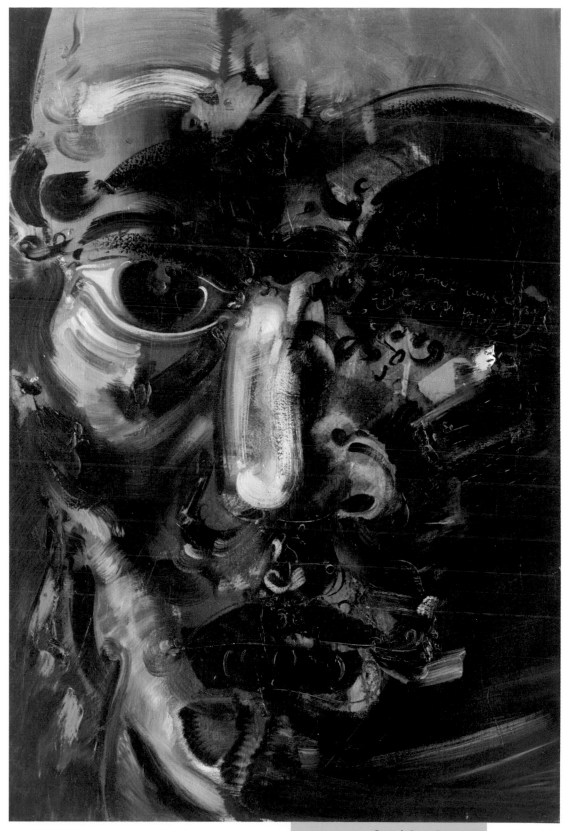

Self Portrait, 2009
Oil on canvas, 215 x 145 cm
Collection of the artist
Courtesy of the artist

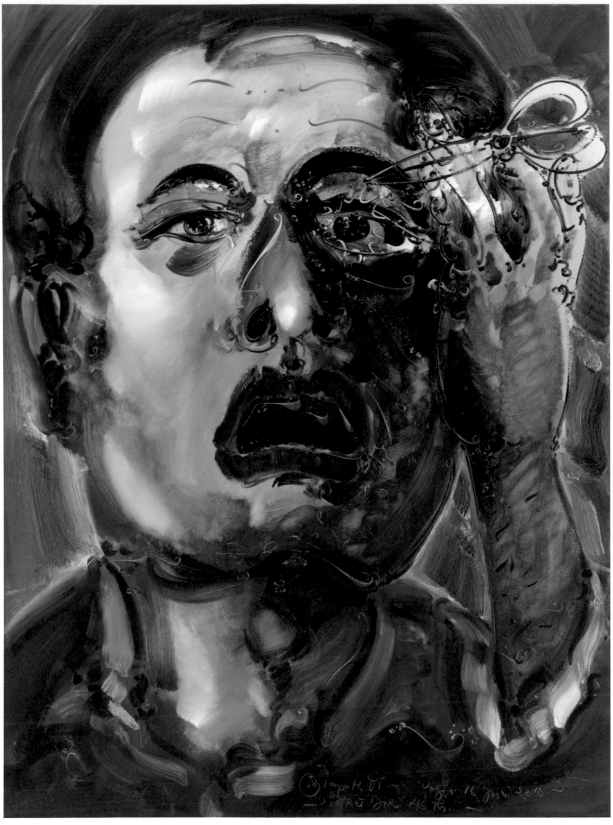

Self Portrait, 2010
Series *Catarac II*
Acrylic on canvas,
200 x 150 cm
Collection of the artist
Courtesy of the artist

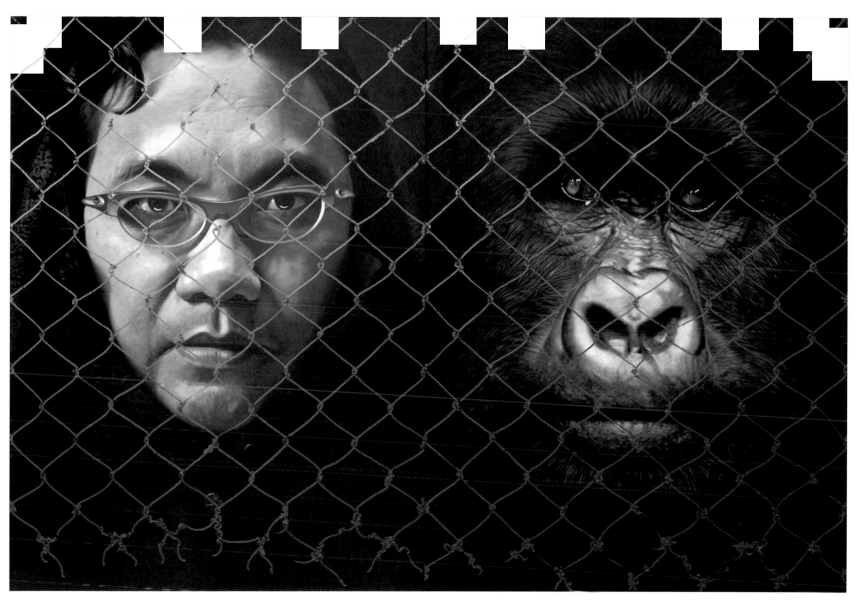

Fixed Price, 2009
Oil on canvas,
230 x 334 cm, 2 panels
Collection of the artist
Courtesy of the artist

Agung Mangu Putra

Agung Mangu Putra's art maintains a delicate balance between passionate imagination and cold calculation, between formal interest and moral commitment. In his works, he articulates his concerns about the disturbing condition of contemporary society: from the exploitation of nature to the devastating impact of pauperization; from the search for the spiritual in the materialistic world to the place of nationalism in the global era. Environmental issues such as pollution, the killing of animals and global warming are among the main subjects of his paintings.

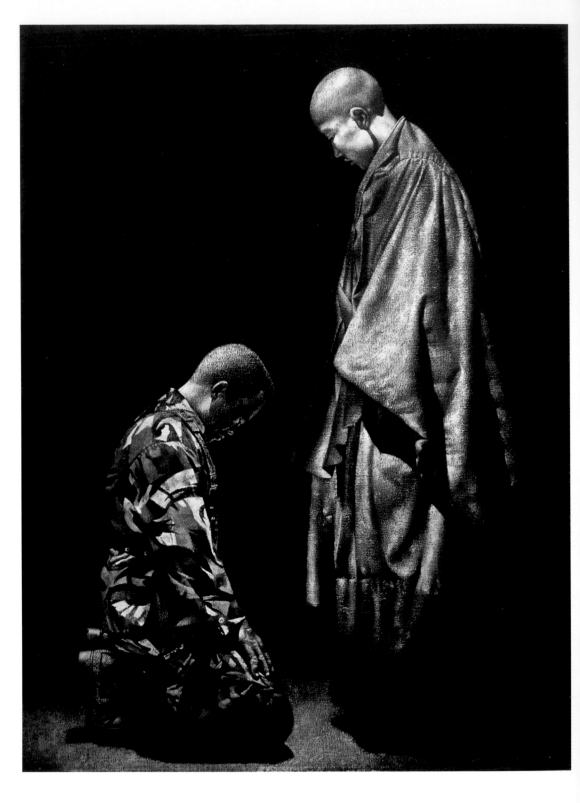

There Will Always Be Maa F, 2007
Oil and acrylic on canvas, 195 x 145 cm
Collection of the artist
Courtesy of the artist and Tonyraka Art Gallery

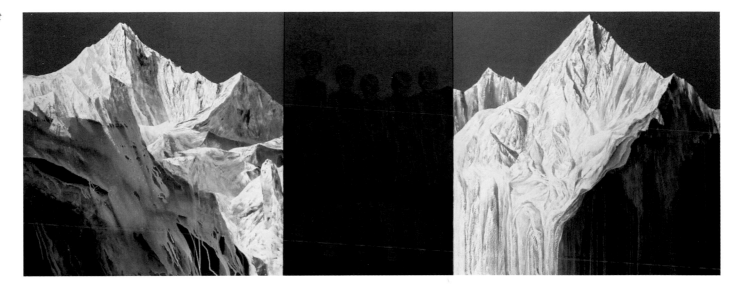

*Global Warming III: The Left
and Melted Ones*, 2007
Acrylic on canvas,
200 x 525 cm, 3 panels
Collection of Tonyraka
Art Gallery
Courtesy of the artist

Independence Day, 2008
Oil and pastel on linen,
140 x 200 cm, 2 panels
Collection of the artist
Courtesy of the artist and
Tonyraka Art Gallery

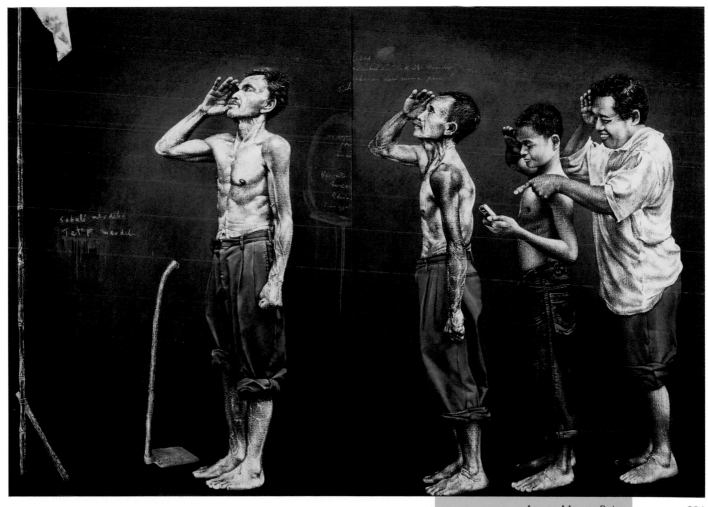

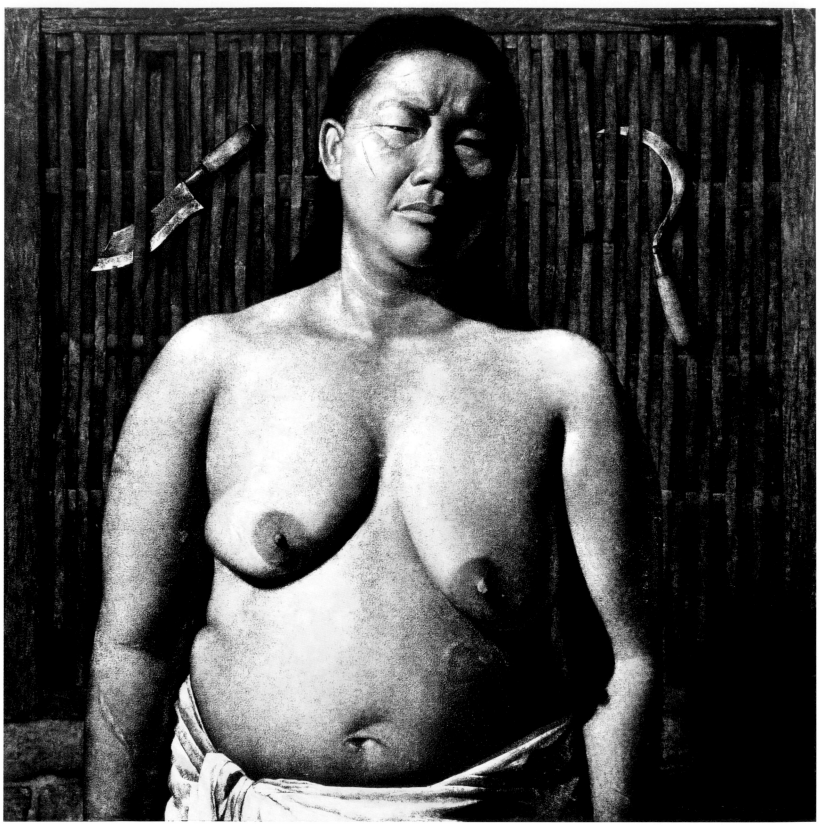

Portrait, 2009
Oil on canvas, 150 x 150 cm
Collection of Tonyraka
Art Gallery
Courtesy of the artist

Mr Teacher, 2010
Oil and pastel on canvas,
140 x 200 cm
Collection of the artist
Courtesy of the artist and
Tonyraka Art Gallery

Police line #5, 2010
Oil on linen, 200 x 200 cm
Collection of the artist
Courtesy of the artist and
Tonyraka Art Gallery

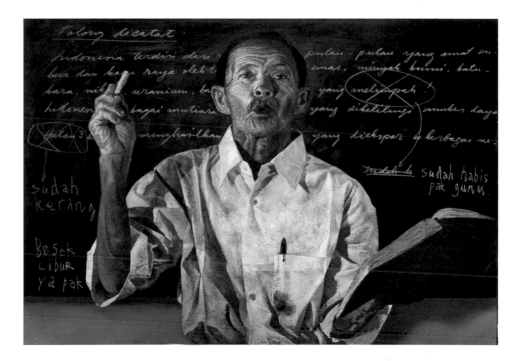

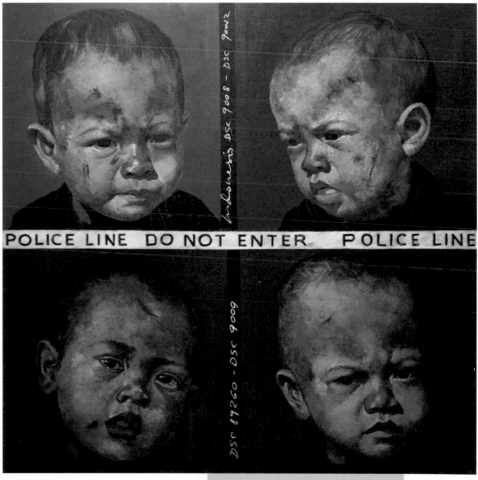

I Wayan Sudarna Putra

I Wayan Sudarna Putra is gifted with a rich and playful spirit that is the driving force behind his creativity, inspiration, ideology and method. His images comment on reality through parody and give fresh meaning to common views by shifting the context or direction of logic. The absurdity of life is revealed through images that seem both familiar and odd at the same time, causing confusion between the representation and the represented, the signifier and the signified.
His works are intentionally created to invoke feelings in the hope of opening new horizons of consciousness and reality.

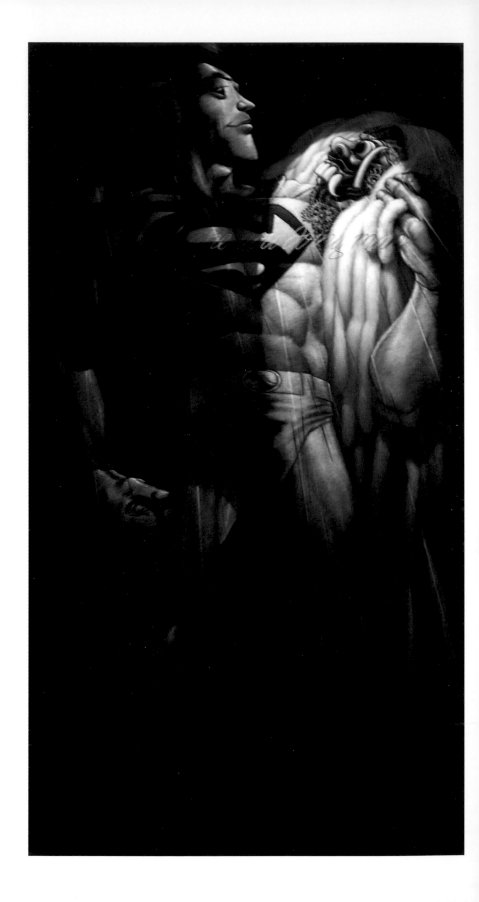

What Are You Doing Man,
2008
Oil on canvas, 280 x 145 cm
Collection of Tonyraka
Art Gallery
Courtesy of the artist

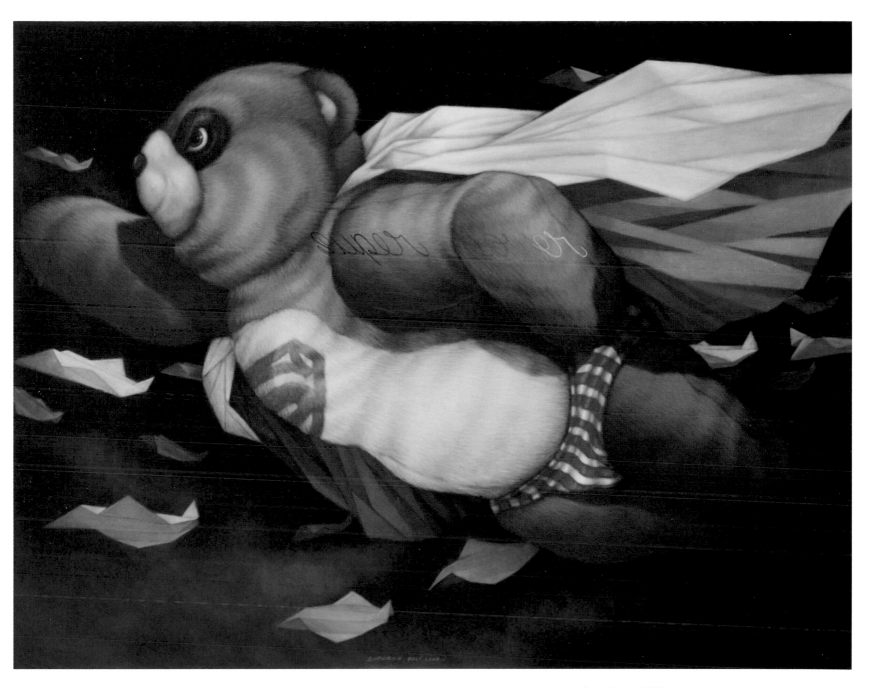

Super Power, 2008
Oil on canvas, 140 x 180 cm
Collection of Tonyraka
Art Gallery
Courtesy of the artist

Genuine Fighter, 2010
Acrylic on canvas,
140 x 825 cm
Collection of the artist
Courtesy of the artist and
Tonyraka Art Gallery

Tasteless, 2009
Oil on canvas, 290 x 140 cm
Collection of the artist
Courtesy of the artist and
Tonyraka Art Gallery

Everybody Knows, 2010
Oil on canvas,
280 x 420 cm, 3 panels
Collection of Tonyraka
Art Gallery
Courtesy of the artist

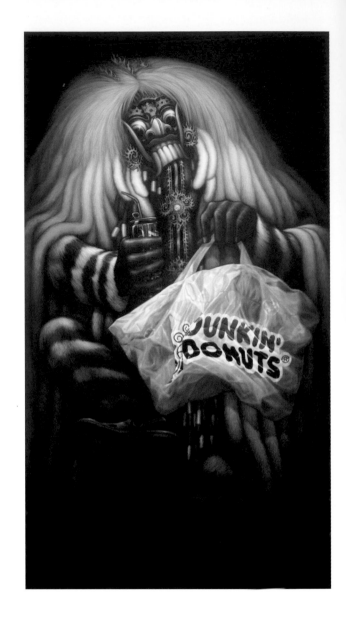

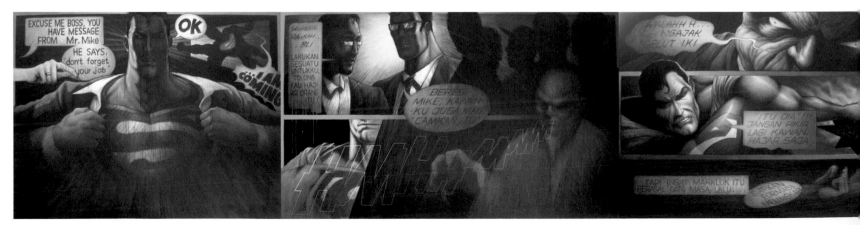

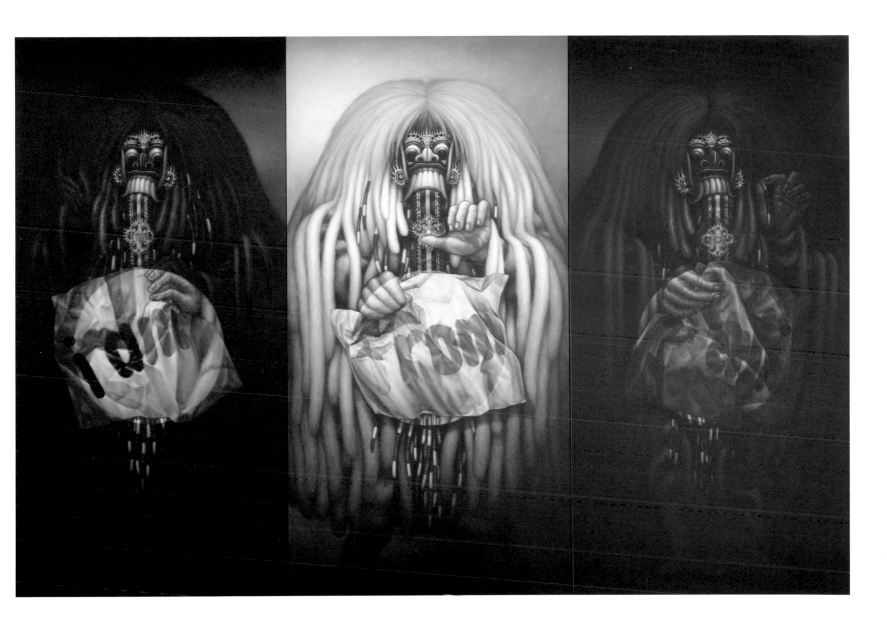

Wedhar Riyadi

I spent my childhood surrounded by Java's culture, whilst consuming a lot of television shows including cartoons, sci-fi, horror and action shows, as well as imported comics, anime and manga. When I was a teenager, these fed into hobbies, which were widely influenced by popular culture, subculture and music. I am part of a generation that grew up with the development of mass media and the Internet, experiencing an abundance of popular images and icons always scrambling for our attention. In my work, I try to channel and incorporate these images and spirits that influenced me as a teen into a range of media such as painting, drawing and sculpture, to capture and translate that human experience and environment.

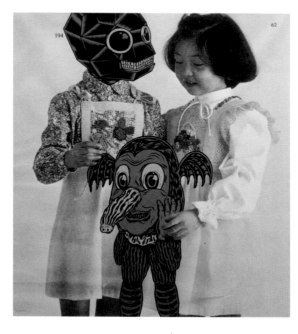

New Neighbour from the Outerspace, 2009
Acrylic, digital print on canvas, 120 x 90 cm
Collection of the artist
Courtesy of the artist and Ark Galerie

Give Me Your Best Flavour and I Will Bite You, 2008
Acrylic, digital print on canvas, 110 x 80 cm
Collection of the artist
Courtesy of the artist and Ark Galerie

Old Version, 2009
Pencil colour on black paper, 37 x 27 cm
Collection of the artist
Courtesy of the artist and Ark Galerie

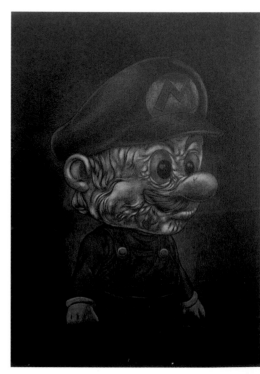

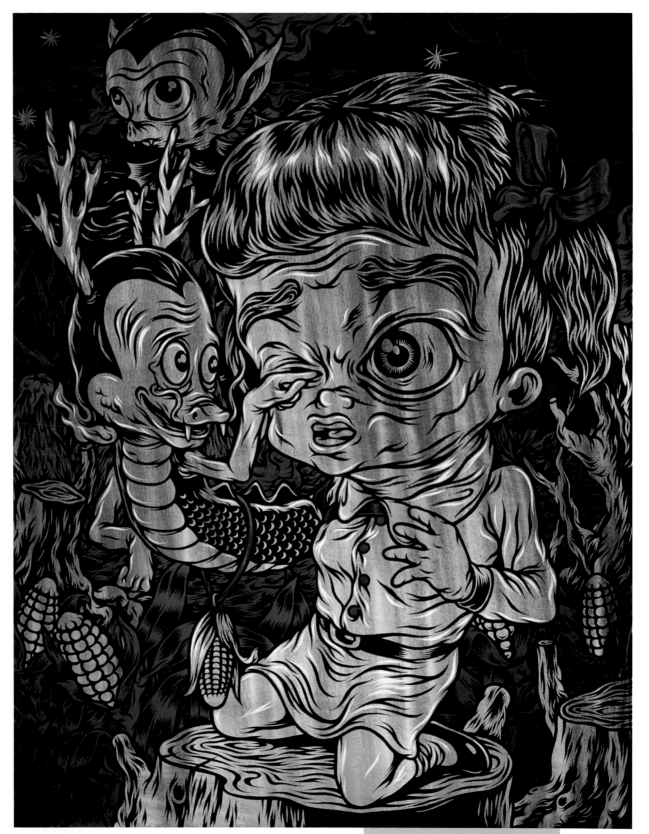

Under Attack, 2009
Acrylic on canvas,
200 x 150 cm
Collection of the artist
Courtesy of the artist and
Ark Galerie

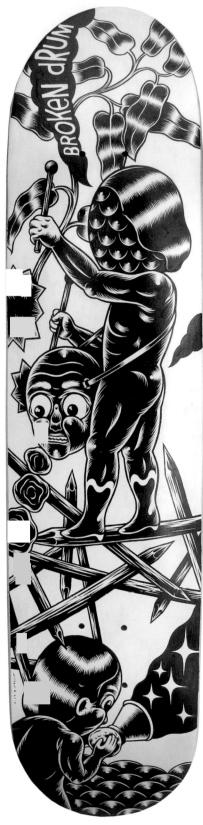

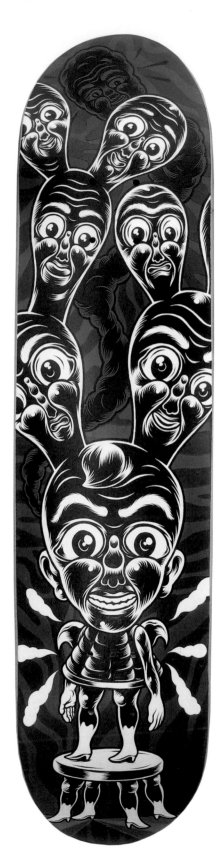

Broken Drum, 2010
Acrylic on skateboard deck,
72 x 30 cm
Collection of the artist
Courtesy of the artist and
Ark Galerie

Stand Up, 2010
Acrylic on skateboard deck,
72 x 20 cm
Collection of the artist
Courtesy of the artist and
Ark Galerie

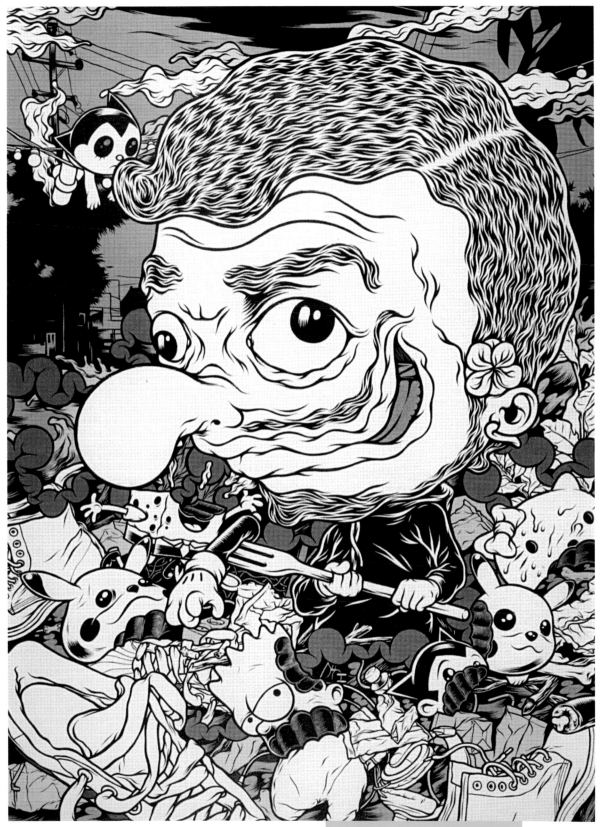

Hungry and Riot, 2008
Acrylic on canvas,
250 x 180 cm
Collection of the artist
Courtesy of the artist and
Ark Galerie

Wedhar Riyadi **231**

To Give and Expect Nothing in Return is a performance exhibition and a simulation stating artist collective ruangrupa's stance towards the interaction artists have with their public. In this project, ruangrupa invited 35 artists who have been involved in diverse ruangrupa's activities for a collaborative, travelling exhibition series held in Bandung, Yogyakarta and Jakarta. All the works contributed were reproducible pieces that the audience could have for free, but in an interactive and participative way. The work took the form of posters, t-shirts, photocopied books, postcards, calendars, flyers, silk-screen prints, badges and stickers.

Kaos focuses on the t-shirt (*Kaos* in Indonesian) as a form of popular culture. In Jakarta, t-shirts are used for propaganda, statements or ways to represent an ideology or identity in a public space. The individual wearing it might express a collective or personal identity through the t-shirt, or simply want to pose. In particular, many t-shirts featured the heads of world-famous figures such as Einstein, Che Guevara, Jim Morrison, Superman and Osama Bin Laden, which were collaged with the face of Jakarta's local hero, the famous musician and actor Benyamin Sueb (1939–1995). Sueb represents the social reality of Jakartan people in funny, honest, pure yet critical ways. Jakartan people of every

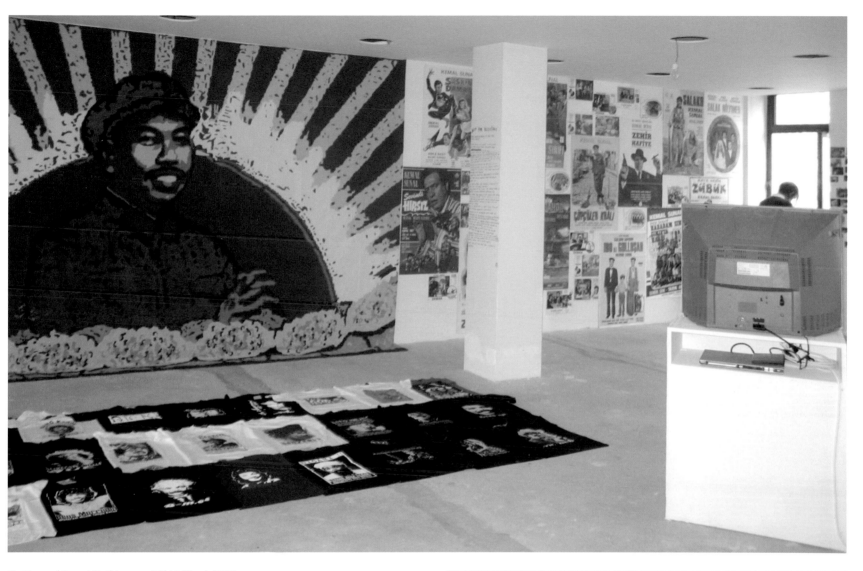

To Give and Expect Nothing in Return, 2010
Mixed media

Transaction (Lonely Market), 2009
Map of temporary market in Jakarta, market, film screening

T-Shirt (Kaos), 2005
T-shirts, banner, posters, stickers, video, installation
Project for the 9th Istanbul Biennale, 2005

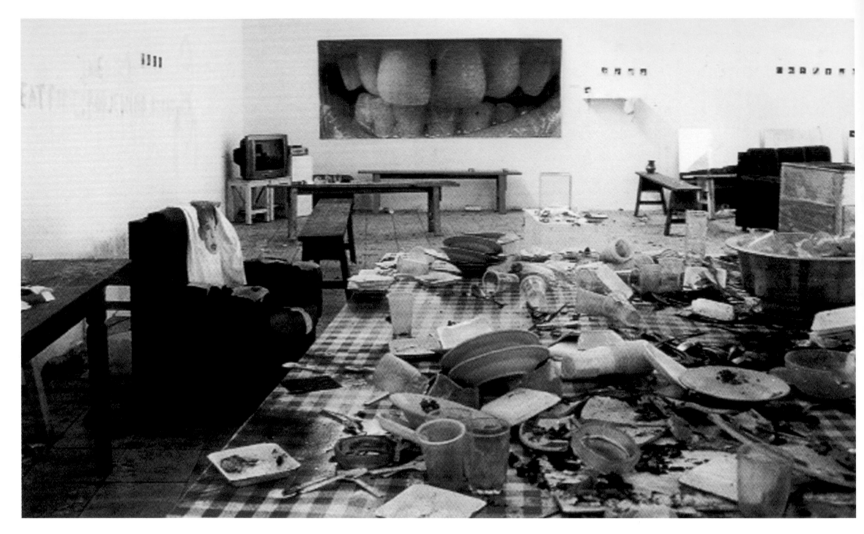

class admire his work and he became a major icon for the city, influencing everything from the language to the local football club. This project reflects to what extent an iconic figure represents his or her society, and plays on the relations of power between local icons and international celebrities. A local figure is not only an object of adoration, but can also be part of a personal statement by those who collectively form this local community. Running parallel to this, ruangrupa have researched the status of similar heroes in Istanbul, to uncover insights into the different roles and possibilities of popular culture in the two cities. (*Esra Sarıgedik Öktem*)

The art project *Transaction (Lonely Market)* investigates the influence of

figures and economic transaction values in society on the mobilization of specific groups of people in the city. It highlights the importance of non-mainstream economic transaction in particular communities, for example transactions in illegal gambling, pirated DVD kiosks or garbage collectors. As part of this, the collective have created simulations of small markets and bazaars at their premises, involving outdoor film screenings for the local community.

A Dinner and Party presents the leftovers and chaotic trashed remnants of a big dinner and wild party that has taken place. In this situation piece the spectators are also performers. Instead of being the final product of creative process, this specific work is

understood as a start for interaction, encounters, and experiences. The experience is key, as it is built around something that is common: a dinner during the opening night. In Indonesian culture, dining together plays an important role, by mediating the energy of birth or even life, until we reach death. In this case, there was a dinner at an opening, and it was in itself a medium in bringing about interactions and meetings between individuals, as well as the items presented.

Delicious Food without Paying, A Dinner and Party (DJ set and live band) Cemeti Art House, Yogyakarta, 6–30 March 2003

Singapore Fiction, 2011 Mixed media Project for the 2011 Singapore Biennale

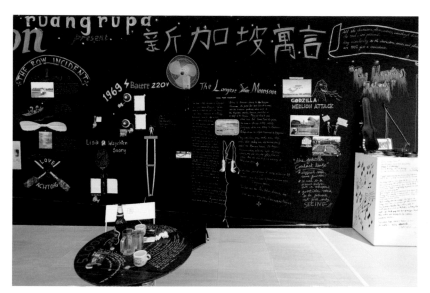

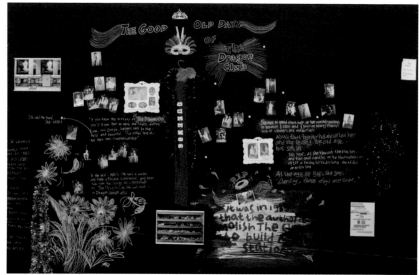

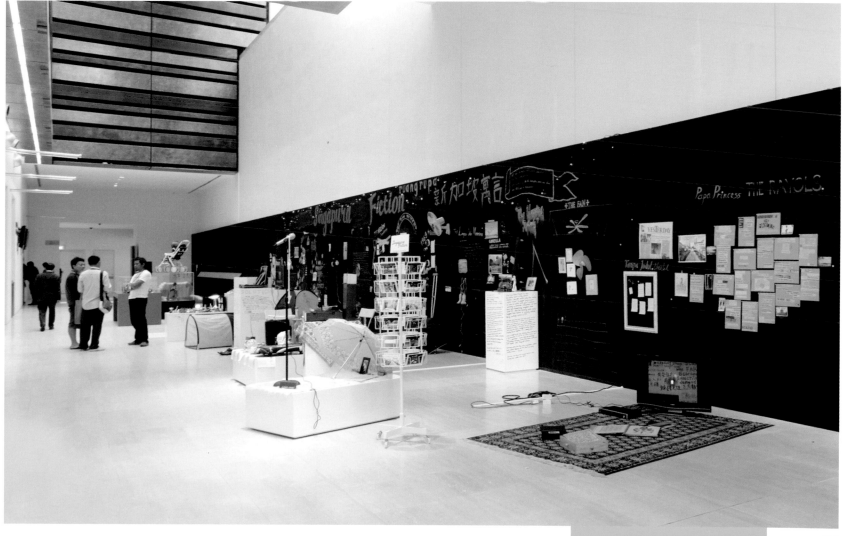

Tisna Sanjaya

The creative process of my work is inspired by the interactions of everyday life. It is from the intensity of life and the everyday environment that I find and select my materials. As a result, the theme of my artwork is a process of appreciation and contemplation of the flowing stream of life and the daily rhythm of my breath.

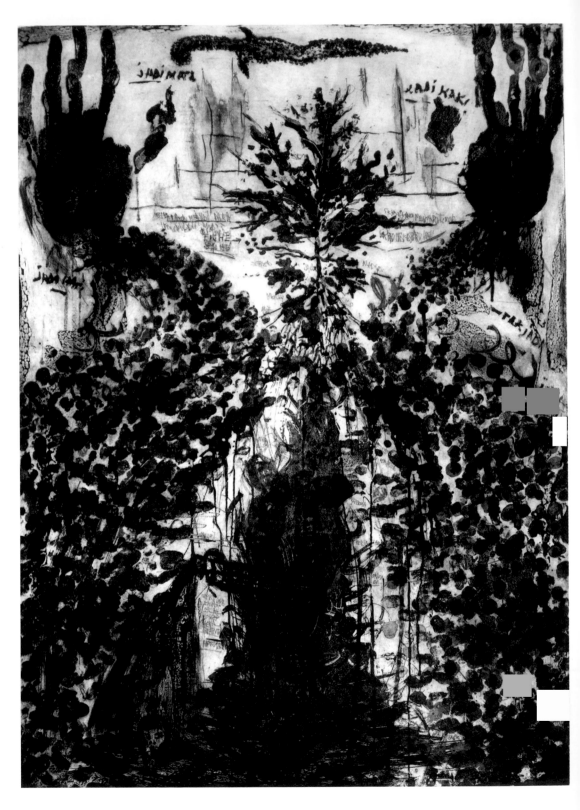

Theatre, 1993
Etching on paper,
plat 75 x 75 cm,
paper 110 x 80 cm
Collection of ArtSociates
Bandung
Courtesy of the artist

Palasari, 2007
Burnt books, ashes on
canvas, 300 x 600 cm,
4 panels
Collection of the artist
Courtesy of the artist

Absurd Theatre, 2008
Watercolour on canvas,
350 x 600 cm
Collection of the artist
Courtesy of the artist

236

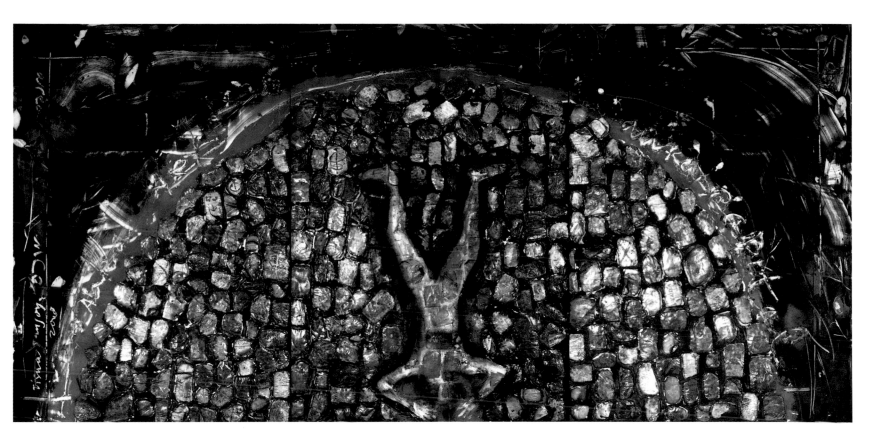

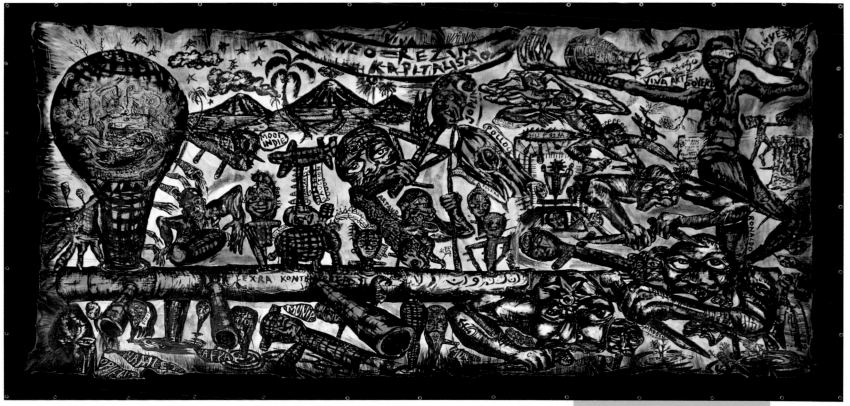

Beating up Picasso, 1988
Etching on paper,
plat 50 x 50 cm,
paper 64 x 69 cm
Collection of ArtSociates
Bandung
Courtesy of the artist

Amnesia Cultura, 2008
Ash body print on military
fabric, 250 x 130 cm,
series of 14
Collection of the artist
Courtesy of the artist

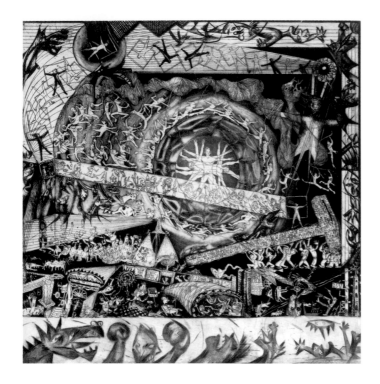

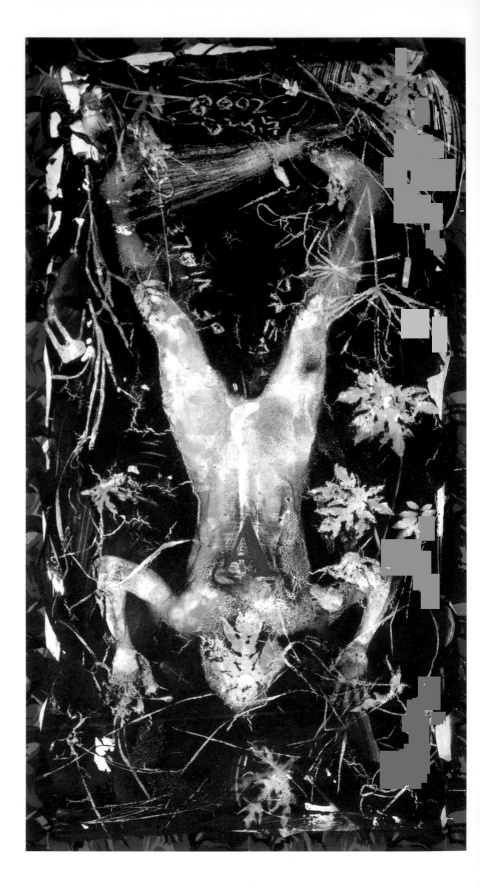

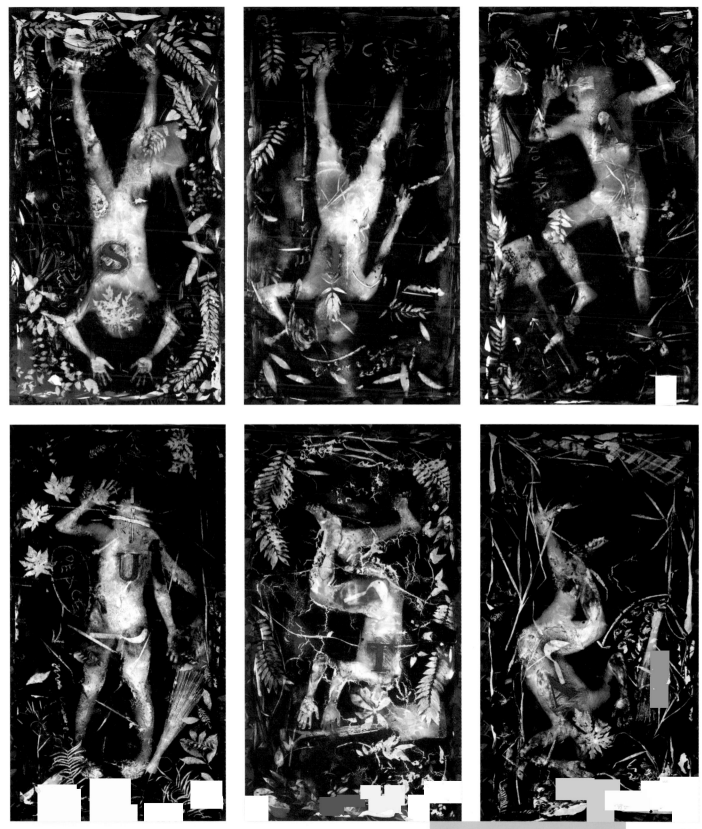

Handiwirman Saputra

Tak Berakar, Tak Berpucuk –
no. 1, 2010–11
Steel plate, tree's root,
paraffin lamp, autopaint,
305 x 560 x 260 cm
Private collection
Courtesy of the artist
and Nadi Gallery

Tak Berakar, Tak Berpucuk –
no. 6, 2010–11
Resin fiber, screen print puff
ink, cloth, steel, acrylic
paint, 394 x 270 x 186 cm
Private collection
Courtesy of the artist
and Nadi Gallery

Handiwirman is cofounder and member of "Jendela Art Group". He was initially known for his installations of objects and found objects he composed without almost any artistic pretension. The objects – thread, wire, bits of paper, plastic lumps, hair – were presented practically just as they were. Such anti-aesthetic tendency also appeared in his painting.

Only in mid-2000 did he present several surprising works endowed with neatness and fascinating realist techniques. The same thing occurred for his installation work, that showed a careful selection of materials and technical rigour. What remained the same was Handiwirman's view of "beauty". He searches to offer beauty out of simple things around him. This means his paintings are an extension of the still-life genre. The thematic emphasis in Handiwirman's painting is on the issue of perception, the way of seeing. So the forms seen in his painting are often two-dimensional shapes, representations of the objects he himself has made and assembled. With careful consideration he selects materials and colours to be presented in configurations of "objects" that provoke us to associate the perceived forms with things that are familiar in our daily life. Any definitive meanings or conclusive narratives are almost always cancelled out by the vast possibilities of association on the viewers' part.

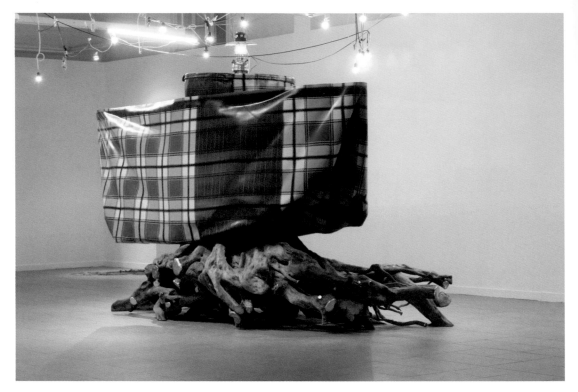

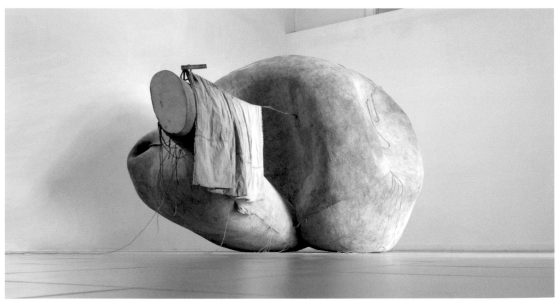

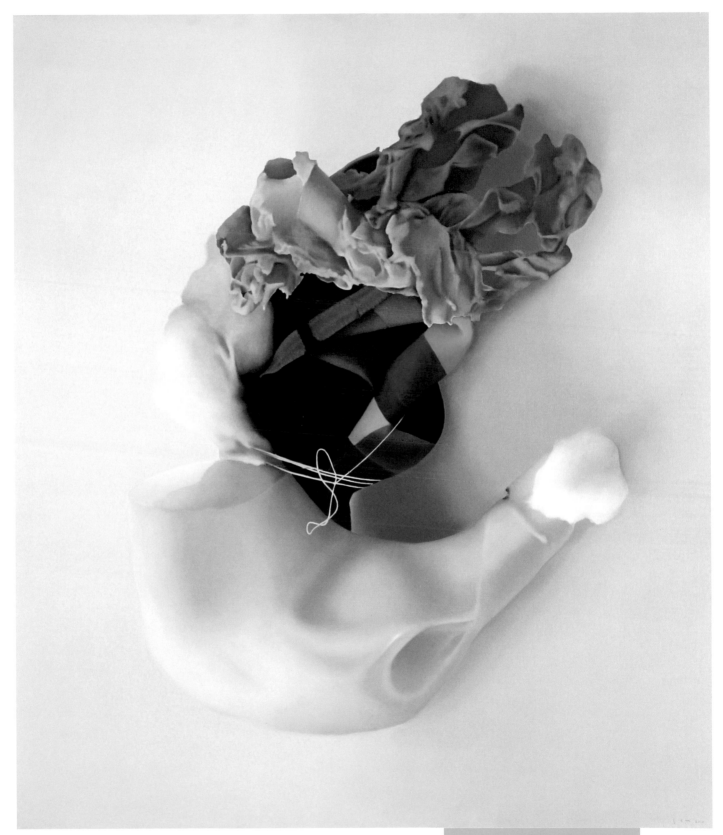

Sejumput Sehelai Seutas,
2010
Acrylic on canvas,
220 x 195 cm
Private collection
Courtesy of the artist
and Nadi Gallery

Mental Series, 2006
Sponge, thread, cotton,
40 x 30 x 20 cm
Private collection
Courtesy of the artist and
Nadi Gallery

Salon Series – no. 5, 2006
Acrylic on canvas,
190 x 145 cm
Private collection
Courtesy of the artist and
Nadi Gallery

Sama Sama Sama, 2010
Fiber resin, candy painted,
plastic PE, stainless steel,
polyurethane,
120 x 230 x 80 cm
Private collection
Courtesy of the artist and
Nadi Gallery

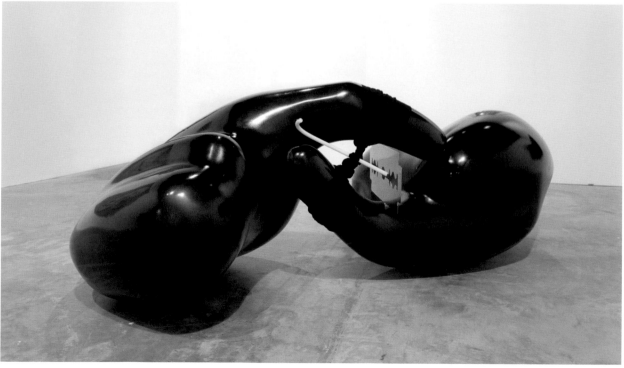

Bentuk, 2008
Series *Tuturkarena*
Acrylic on canvas,
195 x 150 cm
Private collection
Courtesy of the artist and
Nadi Gallery

Nelan, 2008
Series *Tuturkarena*
Acrylic on canvas,
195 x 150 cm
Private collection
Courtesy of the artist and
Nadi Gallery

Dadi Setiyadi

In his multimedia work, Dadi refers to his childhood home, one that was filled with books on aliens and science fiction. These books, belonging to his elder brothers, activated his interest in fantasy and art. He later, in 2004, studied the symbols of the Archipelago, – as Garuda from Java and Lembuswana from Borneo – through a project on Indonesian folklore called *Kisah Nusantara*. This is when he discovered he felt a connection to this fantastical and mythical world. All these influences create a peculiar syncretism in his art by combining traditional local elements inspired from his environment, full of living traditions, with modern and contemporary subjects.

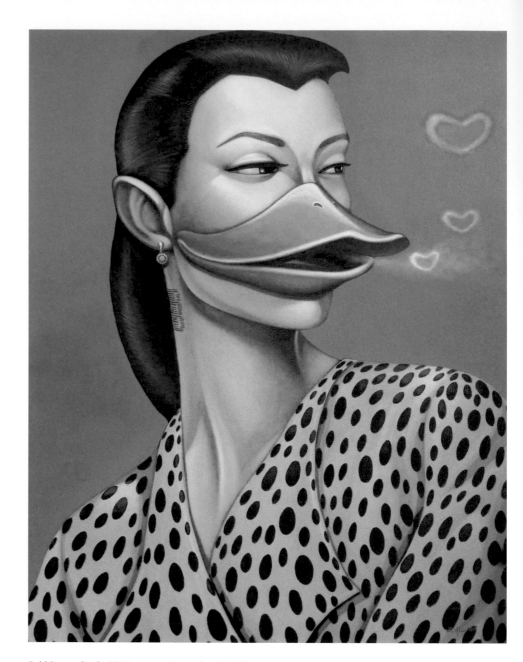

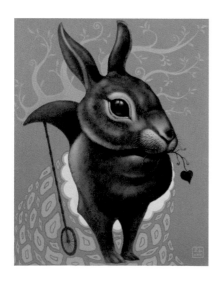

Rabbit on wheels, 2010
Series *Folklore from Java*
Acrylic on canvas,
50 x 40 cm
Private collection
Courtesy of the artist and
Kersan Art Studio

Beautykwek, 2008
Acrylic on canvas,
200 x 150 cm
Private collection
Courtesy of the artist and
Kersan Art Studio

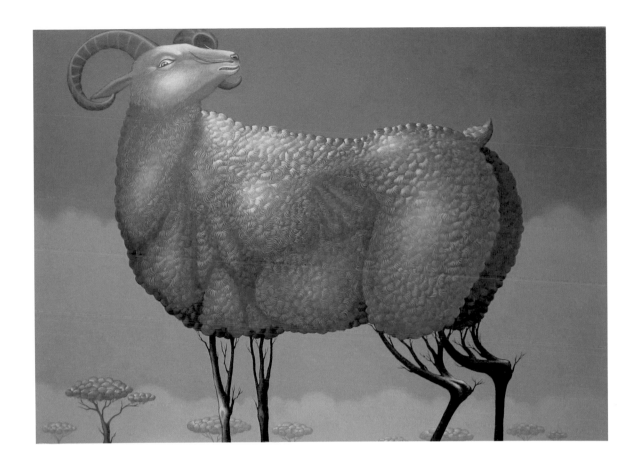

Green Dali, 2007
Acrylic on canvas,
120 x 160 cm
Private collection
Courtesy of the artist and
Kersan Art Studio

Story from Melayu, 2007
Acrylic on canvas,
160 x 120 cm
Private collection
Courtesy of the artist and
Kersan Art Studio

Raining Ants, 2009
Acrylic on canvas,
137 x 130 cm
Private collection
Courtesy of the artist and
Kersan Art Studio

pp. 246–47
Lines God Hands, 2009
Acrylic on canvas,
153 x 168 cm
Private collection
Courtesy of the artist and
Kersan Art Studio

The Flame Player, 2009
Acrylic on canvas,
153 x 168 cm
Private collection
Courtesy of the artist and
Kersan Art Studio

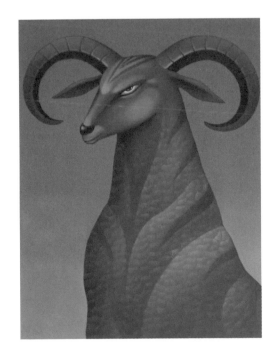

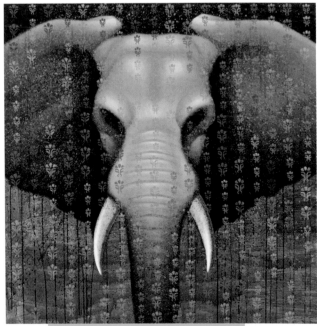

Dadi Setiyadi **245**

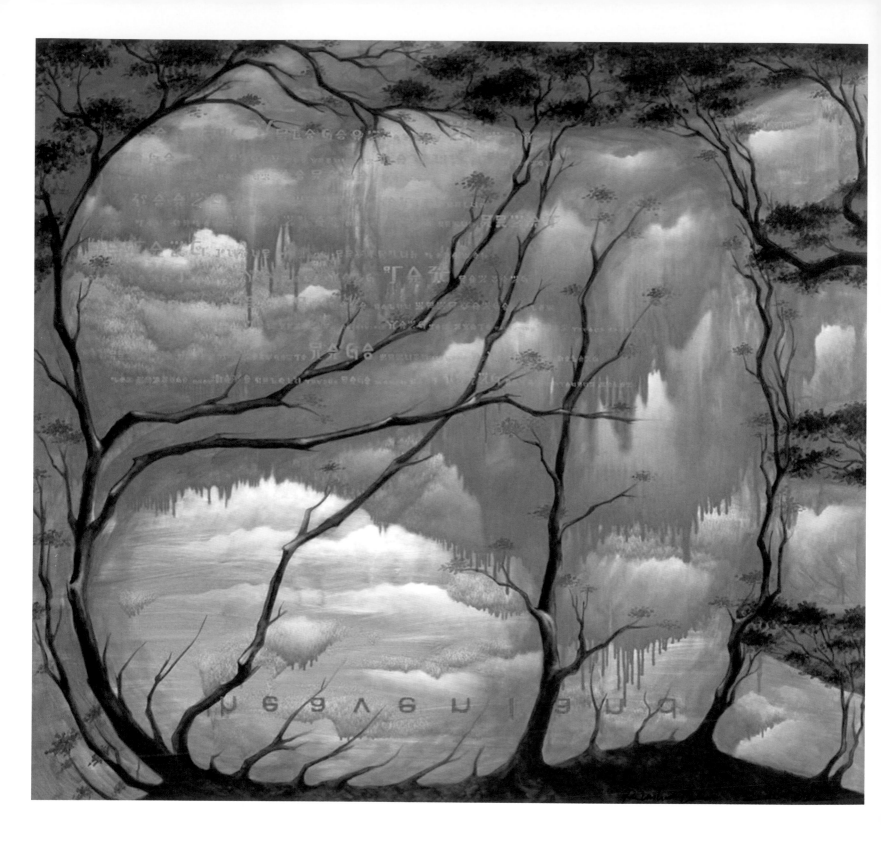

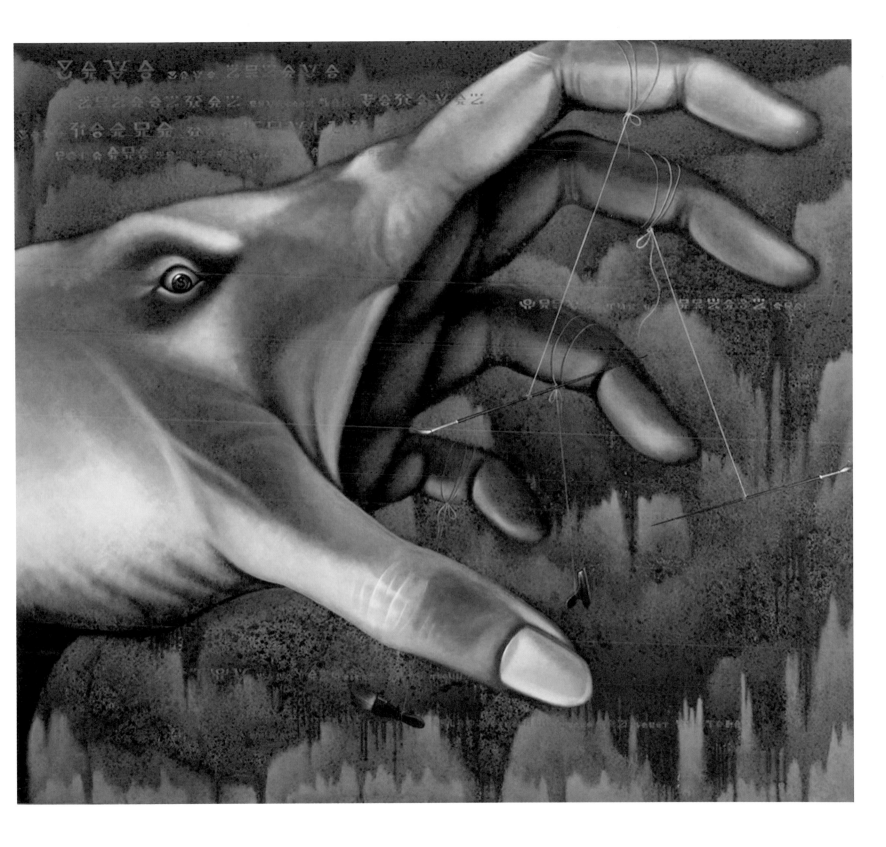

Farhan Siki

Farhan Siki is a street artist and an activist who works intensively on issues facing the urban community. He is therefore strongly influenced by this environment and in his work visualizes the spirit of street. He displays a set of unreadable letters and wild melting, splattering paint.

I Have the Answer, 2008
Spray paint on canvas,
145 x 200 cm
Private collection
Courtesy of the artist and
Galeri Semarang

Assistance, 2008
Acrylic on canvas,
180 x 150 cm
Private collection
Courtesy of the artist and
Galeri Semarang

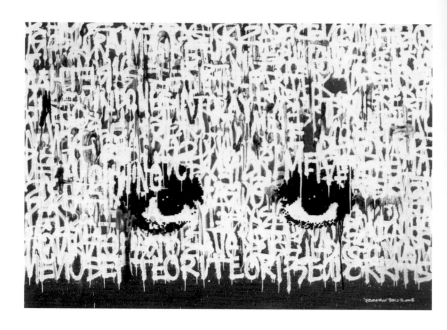

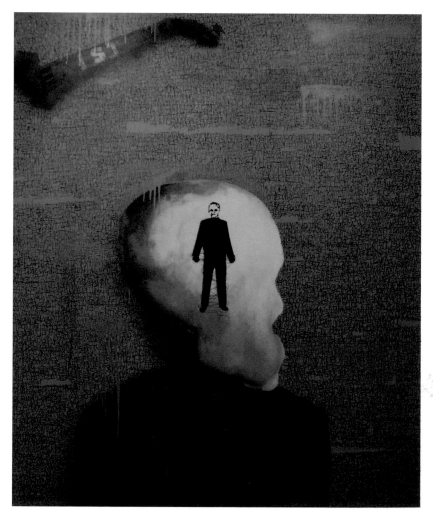

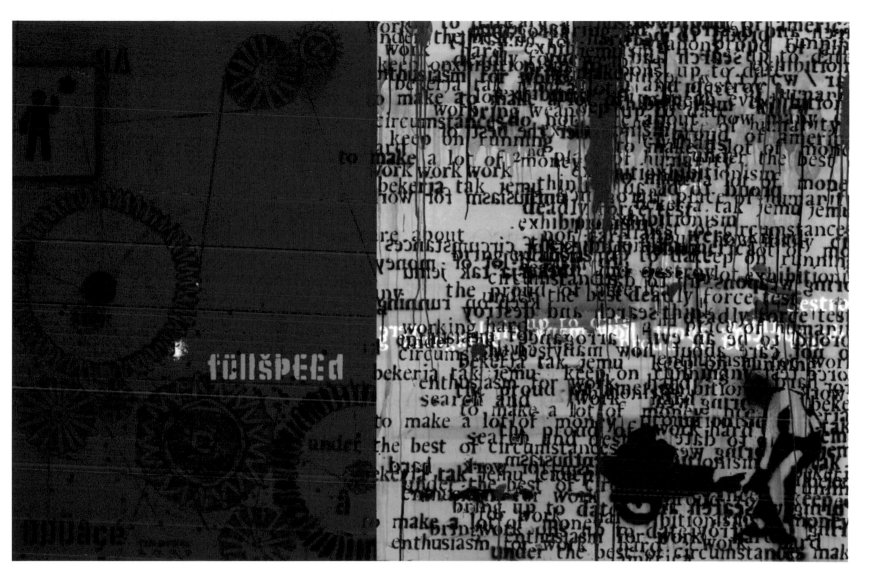

Work, Work, Work, 2009
Acrylic and spray paint on
canvas, 130 x 200 cm
Private collection
Courtesy of the artist and
Galeri Semarang

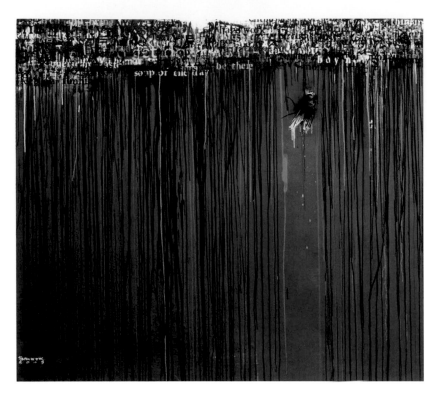

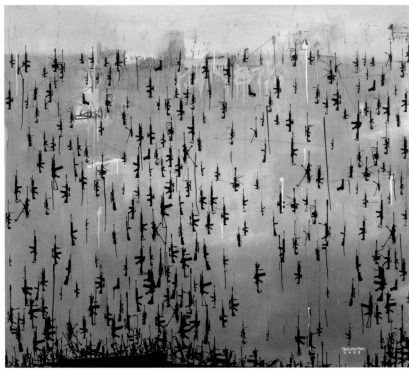

Junk Verses, 2009
Acrylic and spray paint on
canvas, 180 x 200 cm
Private collection
Courtesy of the artist and
Galeri Semarang

*The Most Popular
Instrument 1*, 2009
Acrylic and spray paint on
canvas, 180 x 200 cm
Private collection
Courtesy of the artist and
Galeri Semarang

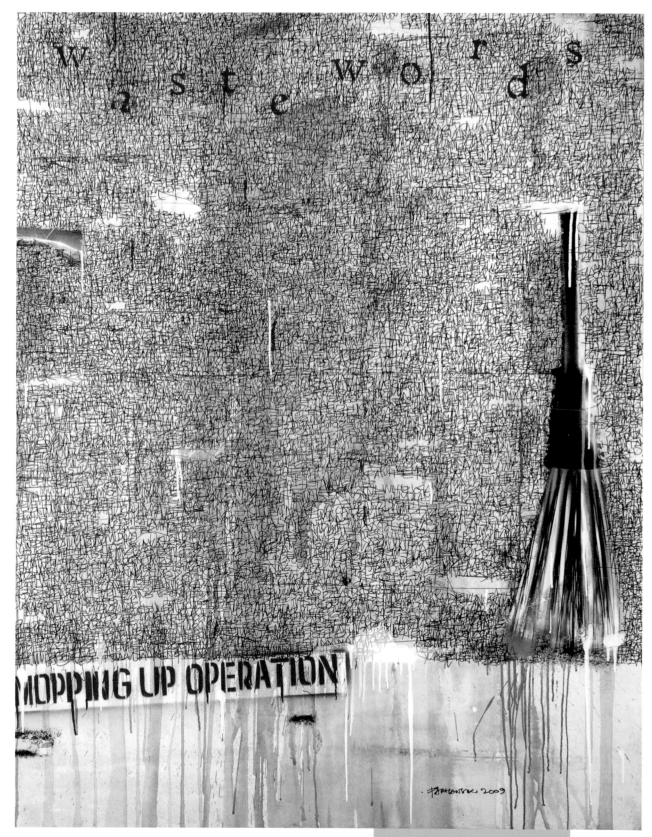

Wastewords 2, 2009
Spray paint and marker on
canvas, 170 x 130 cm
Private collection
Courtesy of the artist and
Galeri Semarang

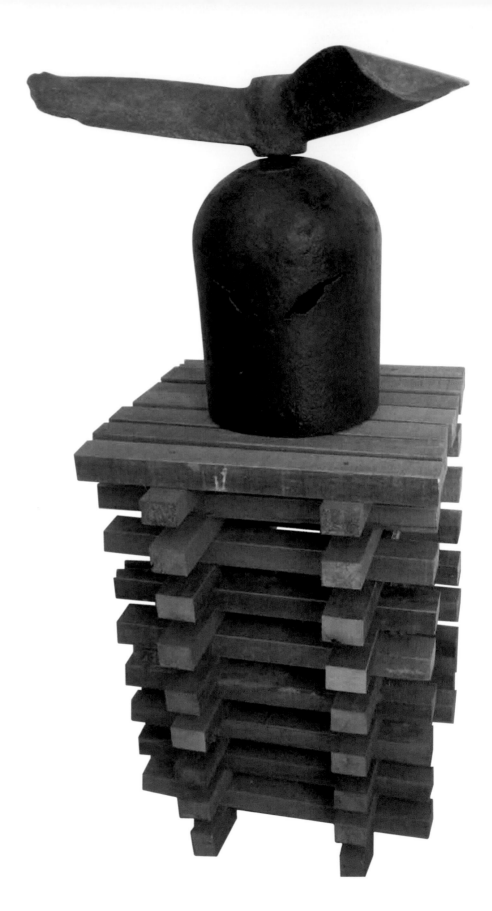

Awan Parulian Simatupang

Awan Simatupang's work reflects a search for stability and eternity behind fragility and transience. Sculptural monumentality is exchanged for playful objects that mix illusion and reality, steadiness and instability, silence and motion. As an artist, he is concerned with the difficult condition of contemporary human life and the environment. His work reveals our desires and the problems we have to face in the search for pleasant physical and metaphysical spaces where we could feel safer.

No Fear, 2004
Bronze, steel, electric motor,
58 x 70 x 70 cm
Collection of the artist
Courtesy of the artist and
Tonyraka Art Gallery

7 Nights, 2009
Seven stainless steel pillows,
variable dimensions
Collection of the artist
Courtesy of the artist and
Tonyraka Art Gallery

Hydrants, 2007
Fibreglass, 76 x 108 x 22 cm,
27 pieces
Collection of the artist
Courtesy of the artist and
Tonyraka Art Gallery

June, 2009
Stainless steel,
32 x 45 x 10 cm
Collection of the artist
Courtesy of the artist and
Tonyraka Art Gallery

Mula, 2009
Stainless steel,
41 x 29 x 11 cm
Collection of the artist
Courtesy of the artist and
Tonyraka Art Gallery

Pratama, 2009
Stainless steel,
45 x 32 x 10 cm
Collection of the artist
Courtesy of the artist and
Tonyraka Art Gallery

"The Other Life"

Awan 09

Sketch for *The Other Life*,
2009
White pencil on black paper
Collection of the artist
Courtesy of the artist and
Tonyraka Art Gallery

Lekung Sugantika

Lekung Sugantika depicts the tension between global and local cultures. The images of pigs on his canvases symbolically represent the local culture that suffers from the cultural violence imposed by globalization. By means of irony and parody, Sugantika suggests the need to create a smart cultural strategy to face the threats of cultural imperialism. His work articulates the aspiration towards a cultural balance to prevent cultural chaos in the contemporary world.

Flying without Wings, 2009
Pencil and oil on canvas,
120 x 160 cm
Collection of the artist
Courtesy of the artist and
Tonyraka Art Gallery

Guard, 2008
Oil on canvas, 160 x 180 cm
Collection of the artist
Courtesy of the artist and
Tonyraka Art Gallery

Flying Pig, 2008
Series *Emotional Pig*
Oil and pencil on canvas,
200 x 180 cm each,
3 panels
Collection of Tonyraka
Art Gallery
Courtesy of the artist

Much Milk, 2009
Pencil and oil on canvas,
4 panels, 200 x 150 cm each
Collection of the artist
Courtesy of the artist and
Tonyraka Art Gallery

Playing, 2011
Pencil, oil on canvas,
200 x 70 cm, 3 panels
Collection of the artist
Courtesy of the artist and
Tonyraka Art Gallery

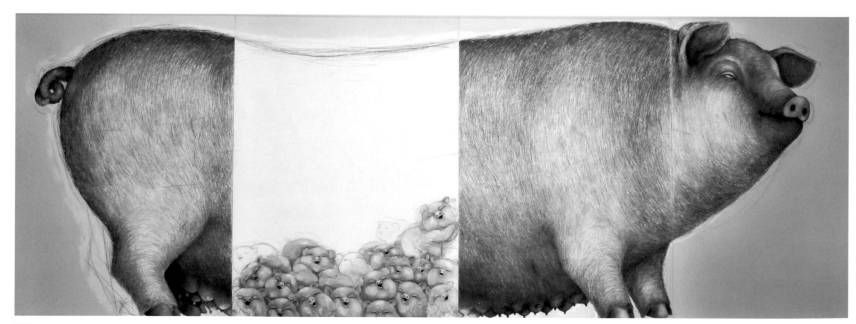

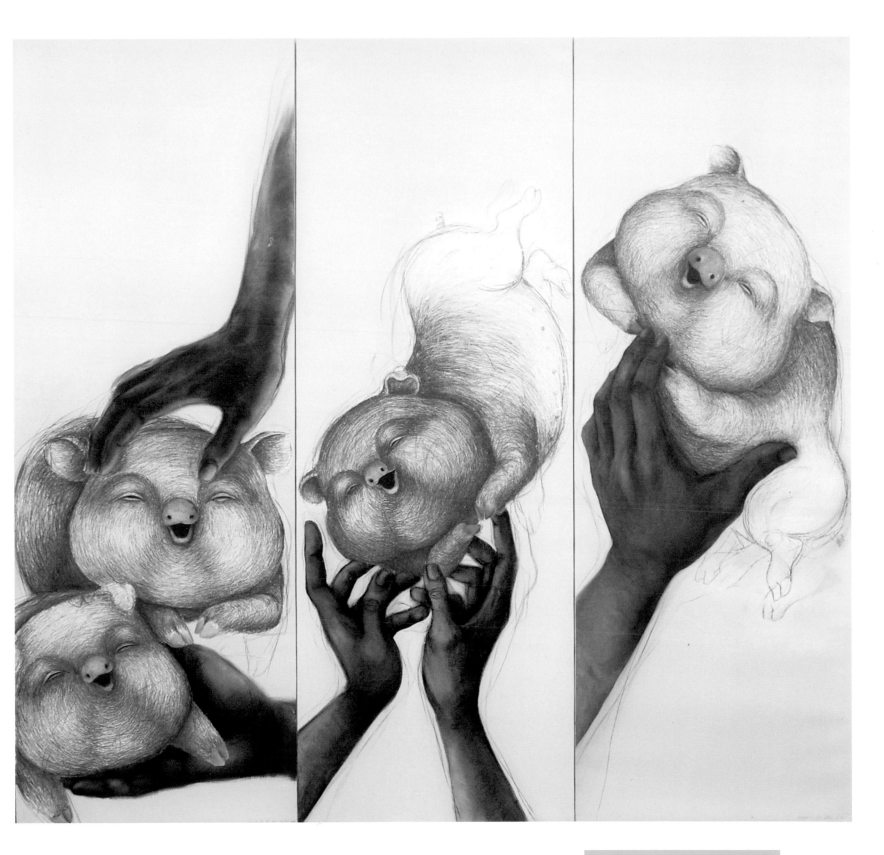

Joko "Gundul" Sulistiono

Gundul's work depicts the on-going transformation that takes place in contemporary urban settings, one that involves a variety of aspects. His paintings refer to an imagery of decadence found on walls that are constantly manipulated by city dwellers. He delivers several elements of post-modern culture through the depiction of cultural idols and expressions that intimate universal ideals of freedom. The depiction of John Lennon and Jimi Hendrix refers to the possibility of communicating global values and to the impact of their actions on the past, the current and the future generations. They serve as symbols beyond their own personal quests and offer a possibility of universalism.

Young Power, 2010
Mixed media on canvas,
120 x 140 cm
Collection of the artist
Courtesy of the artist and
Galeri Apik

Anything, 2011
Mixed media on canvas,
150 x 175 cm
Collection of the artist
Courtesy of the artist and
Galeri Apik

Young Spirit, 2010
Mixed media on canvas,
150 x 175 cm
Collection of the artist
Courtesy of the artist and
Galeri Apik

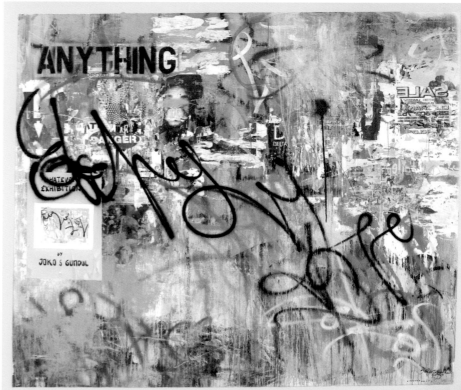

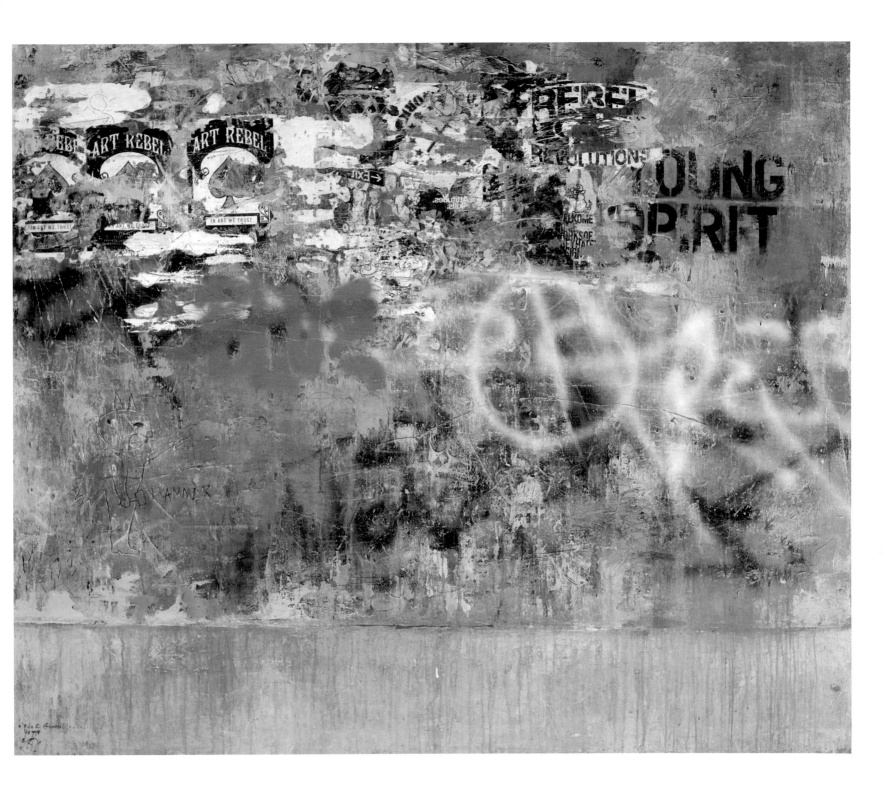

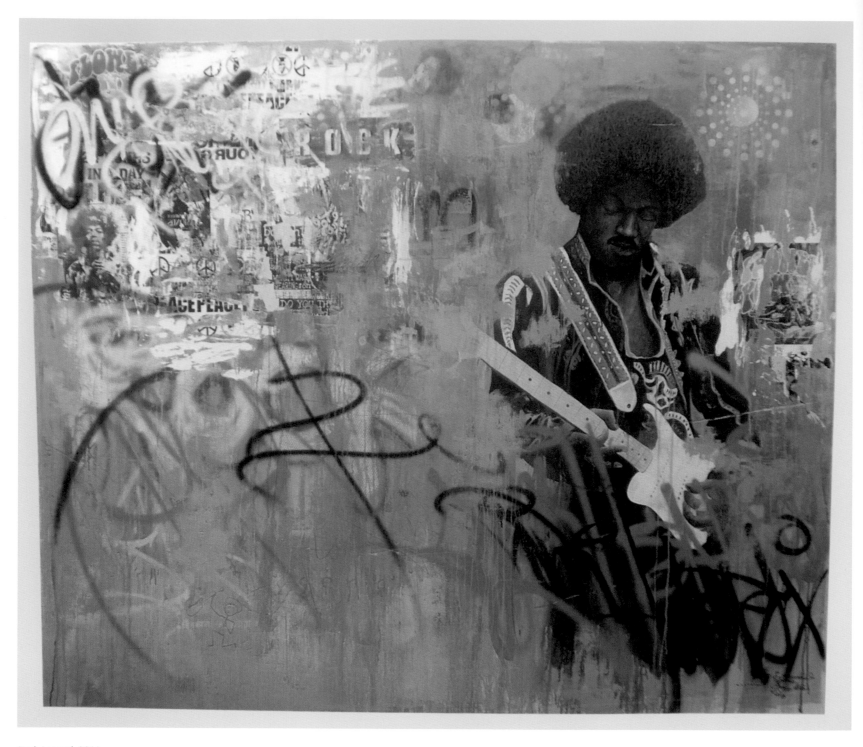

Rock Legend, 2011
Mixed media on canvas,
150 x 175 cm
Collection of the artist
Courtesy of the artist and
Galeri Apik

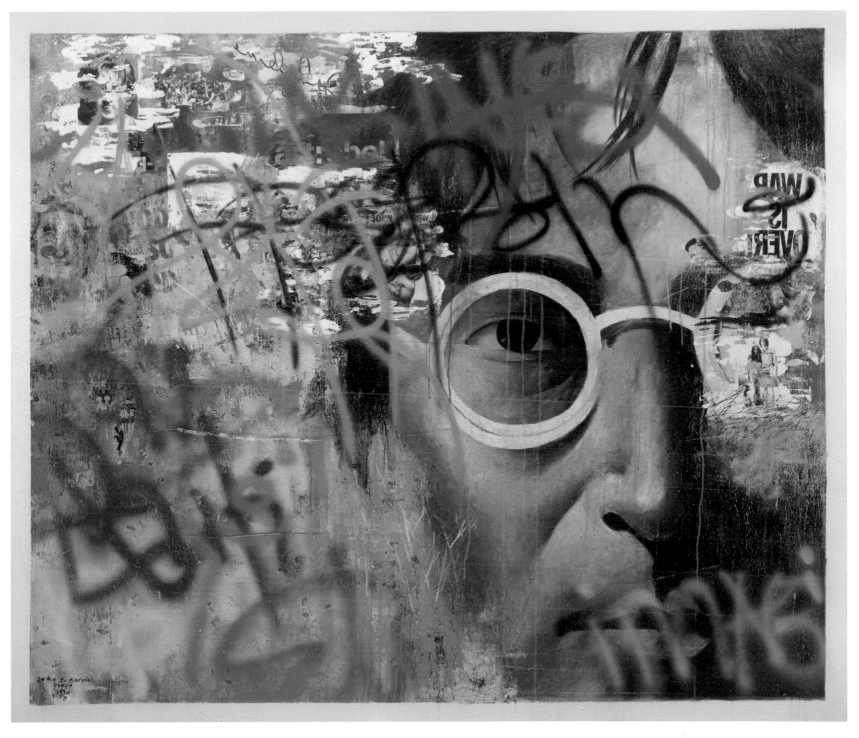

War Is Over, 2010
Mixed media on canvas,
150 x 175 cm
Collection of the artist
Courtesy of the artist and
Galeri Apik

Joko "Gundul" Sulistiono **263**

Yudi Sulistyo

"Mission Failed" is a term used mostly in video games, signalling the termination of game after the player fails to carry out a specific mission. But in Yudi's world, "mission failed" simply means a number of repeated reattempts until he succeeds in carrying out his mission. Yudi's diligence and enthusiasm in this virtual world mimics his reality in the creation of his art. His message is that when we live a life with endless enthusiasm, of reattempts, and we are not afraid to fail, then life itself will become a very interesting game.

Mission Failed, 2011
Paper and mixed media,
70 x 65 x 65 cm
Courtesy of the artist

When Train Is Coming #2,
2005
Paper, 50 x 50 x 50 cm
Courtesy of the artist

My Plane, 2009
Cardboard, plastic, wire,
cable, spay-paint and
acrylic, 135 x 300 x 300 cm
Collection of OHD Museum
Courtesy of the artist

When Train Is Coming #2,
2010
Paper, 50 x 50 x 50 cm
Courtesy of the artist

My Defense 10, 2010
Paper, 160 x 200 x 130 cm
Courtesy of the artist

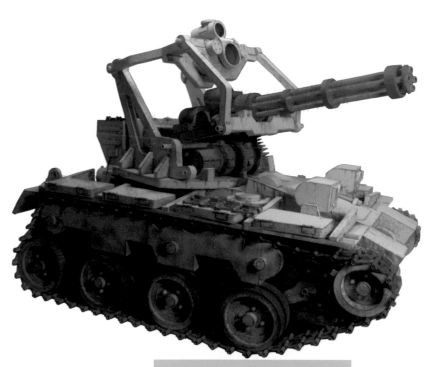

Yudi Sulistyo

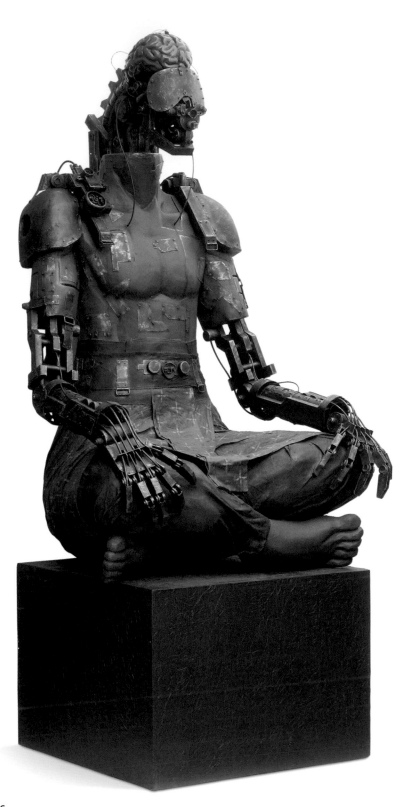
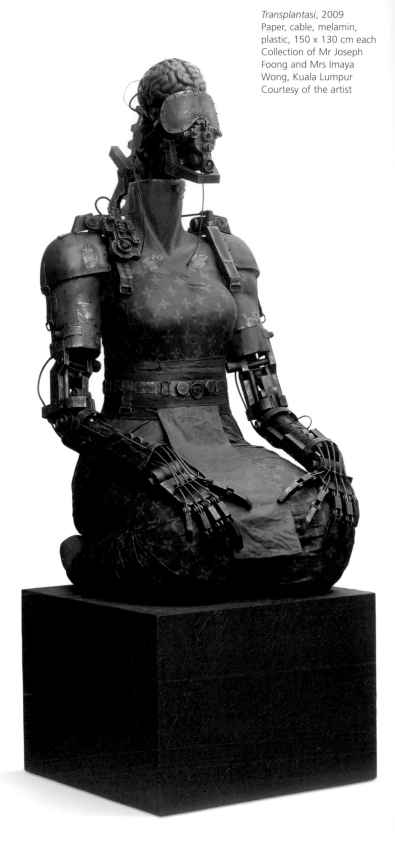

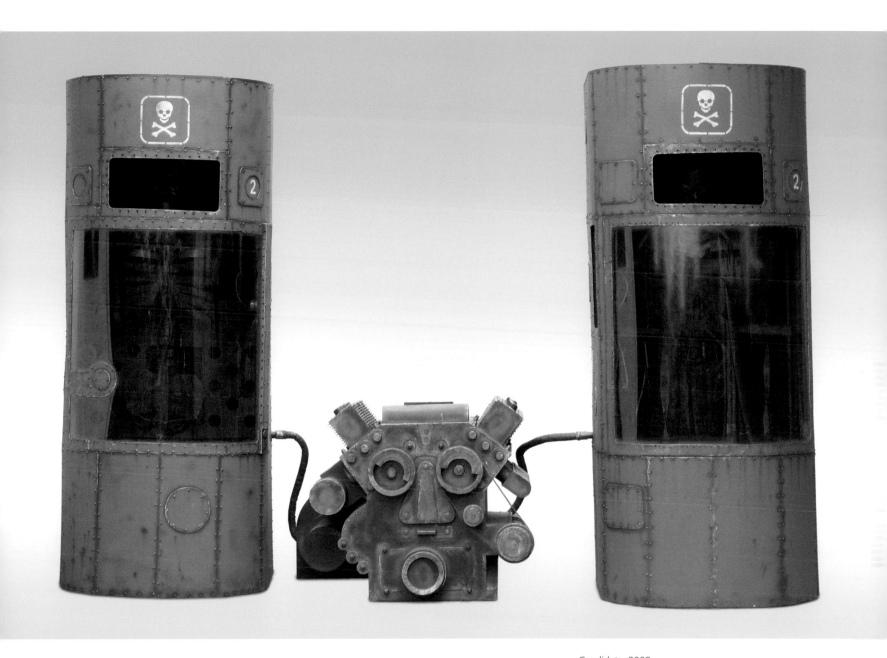

Candidate, 2009
Cardboard,
400 x 200 x 80 cm
Collection of Mr Hermanto
Soerjanto
Courtesy of the artist

I Made Supena

The artwork echoes human feelings such as restlessness, anxiety and excitement. It also reflects social interaction among people belonging to different societies and cultures. My work visualizes the feelings that cross my mind and the social and cultural issues that surround me.

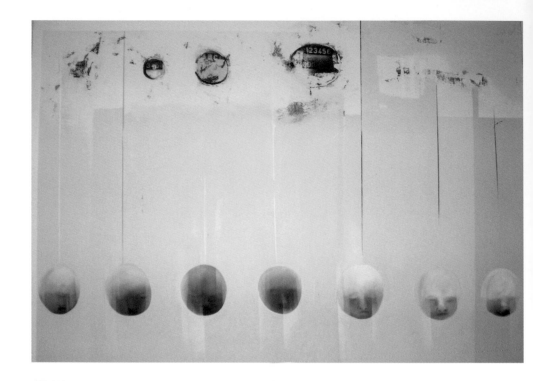

Placing Hope I, 2008
Acrylic on canvas,
150 x 200 cm

Jargon, 2009
Acrylic on canvas,
185 x 200 cm
Collection of the artist
Courtesy of the artist

The Truth about Totality,
2010
40 wooden sculptures
and fibre, 200 x 100 cm

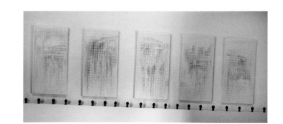

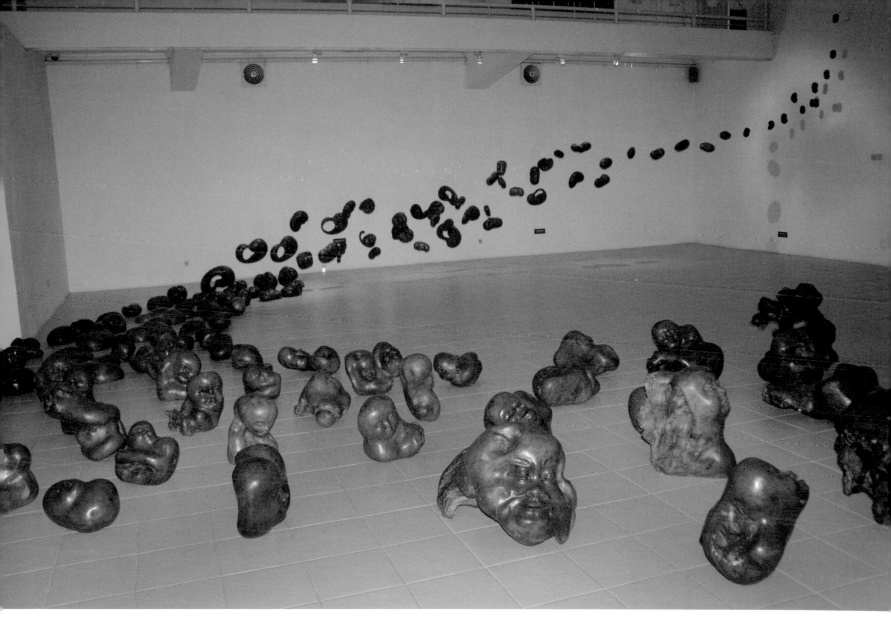

Emotion, 2005
Indian rosewood, frangipani,
variable dimensions,
160 pieces
Courtesy of the artist

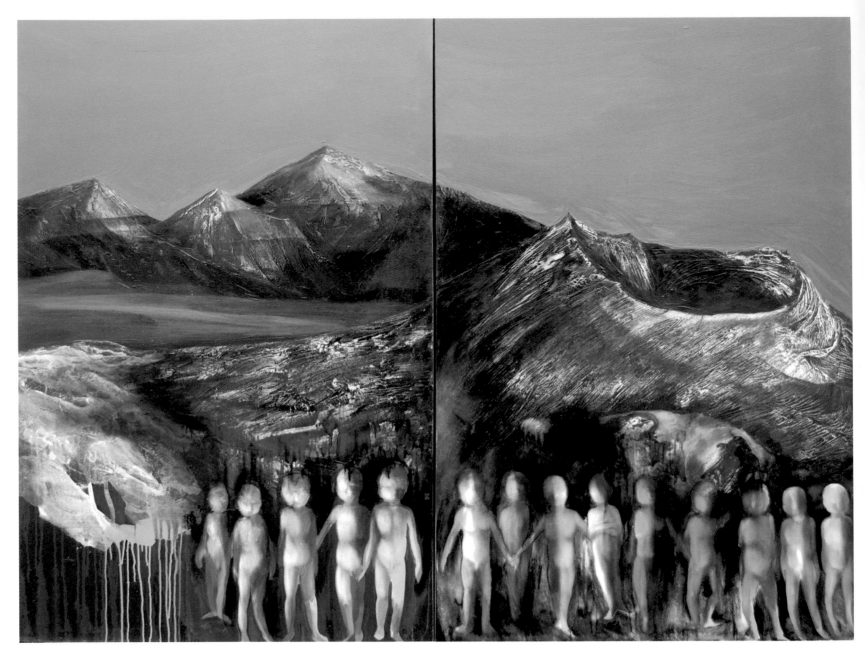

Episodes for the Locals,
2010
Mixed media on canvas,
180 x 240 cm
Courtesy of the artist

Mountain Rite 1, 2010
Mixed media on canvas,
150 x 145 cm
Courtesy of the artist

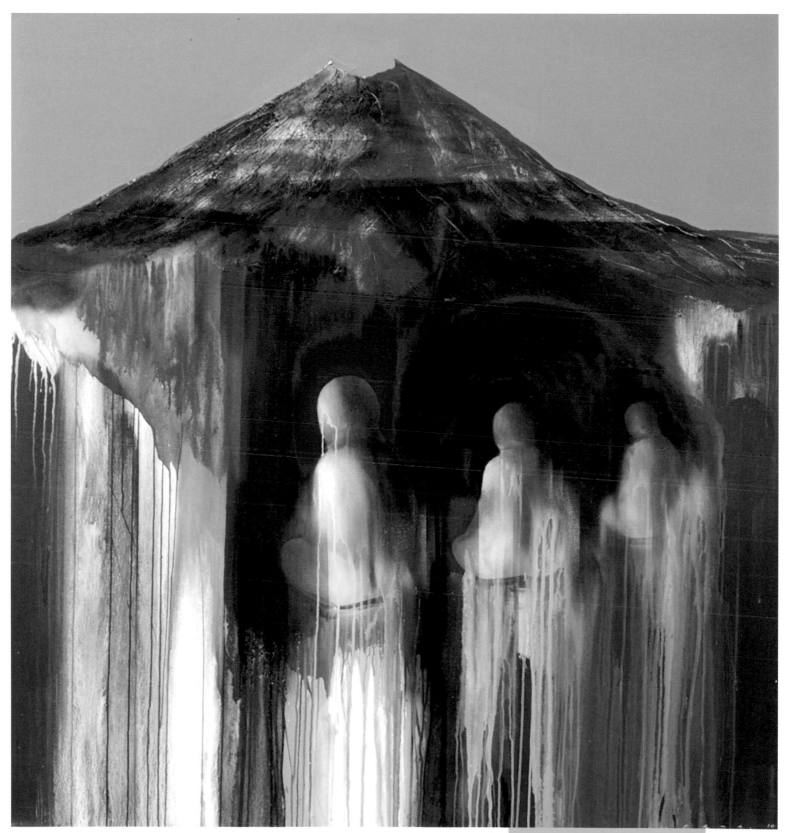

Melati Suryodarmo

My Fingers Are the Triggers,
2007
Mini DV on DVD-PAL, 6 min.
Edition of 3
Collection of the artist
Courtesy of the artist

The Ballad of Treasures,
2007
Lambda print on Endura
paper, 15 x 25.5 cm,
4 pieces
Edition of 7
Collection of the artist
Courtesy of the artist

As a performance artist I am inspired and motivated by my inner world. The body is like a home, a container of memories as well as a living organism. The psychological system inside the body changes constantly and this has enriched my idea to develop and provoke new attitudes in my work. I try to open the door to perception and interpret the facts of my surroundings in the present, whilst considering the path of its history, and understand what remains unspoken. I respect the freedom in our minds to perceive things coming through our individual sensory system. Crossing the boundaries of cultural and political encounters in this way is a challenge that stimulates me to discover new identifications, yet these efforts to find identity risk losing the ground of origin. For me, the process of making artwork is a life-long search that never stops, and places me at the centre of an inner metamorphic constellation. In my work, I try to touch upon the fluid border between the body and the environment with an intensity that is free of narrative structures. The work speaks of how politics, society and psychology are meaningless without nerves to perceive and digest information. I love it when a performance reaches a level of factual absurdity.

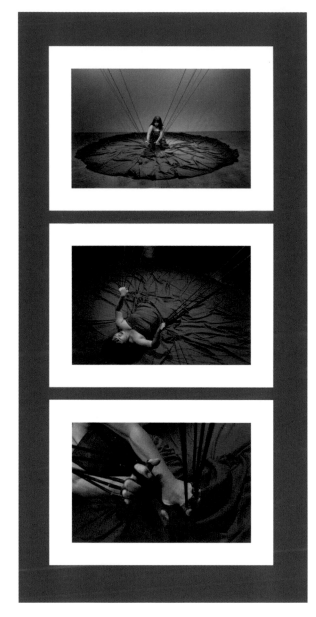

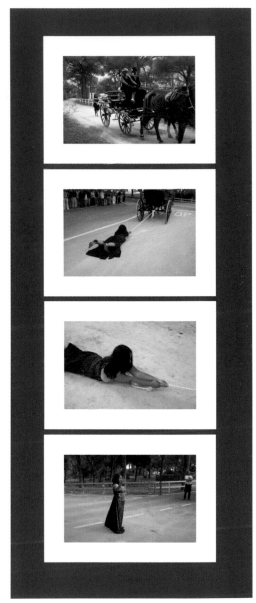

Exergie – Butter Dance,
2000
Mini DV on DVD-PAL, 6 min.
Edition of 3
Collection of KIASMA
Helsinki, Singapore Art
Museum
Courtesy of the artist

The Seed, 2008
Lambda print on Endura
paper, 60 x 90 cm, 3 pieces
Edition of 5
Collection of the artist
Courtesy of the artist

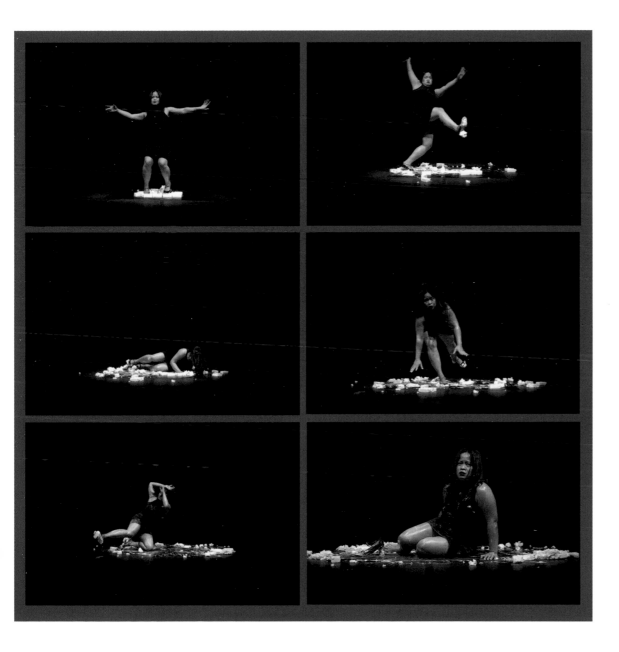

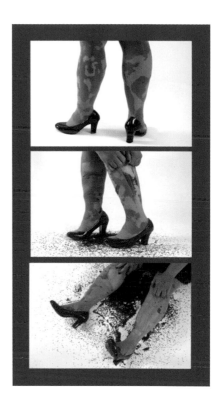

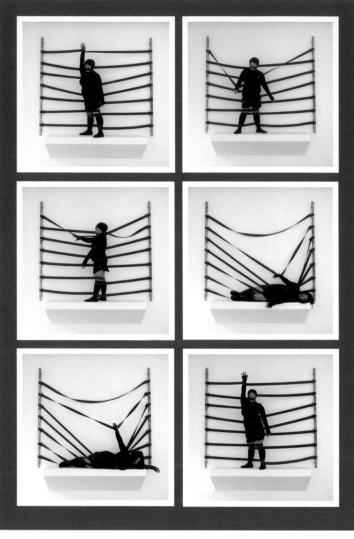

The Dusk, 2010
HD film, 26 min. 30 sec.
Edition of 5
Collection of the artist
Courtesy of the artist

Boundaries that Lie, 2006
Lambda print on Endura
paper, 40.5 x 40.5 cm,
6 pieces
Edition of 7
Collection of the artist
Courtesy of the artist

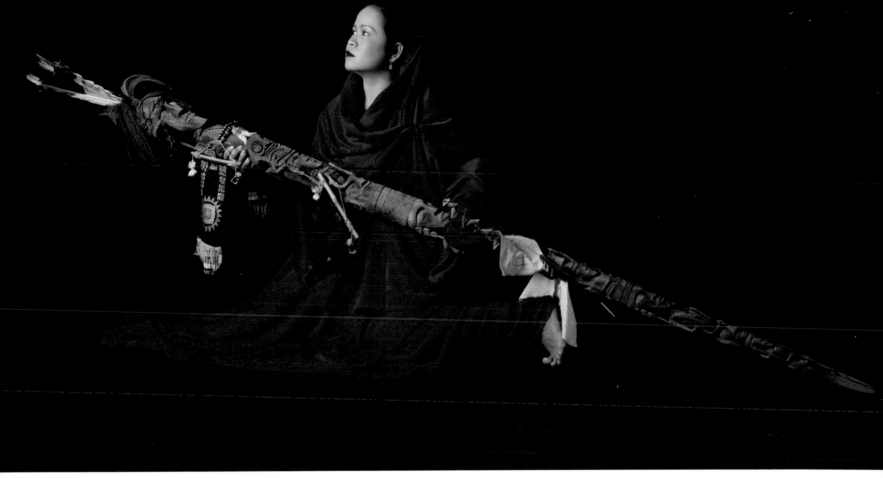

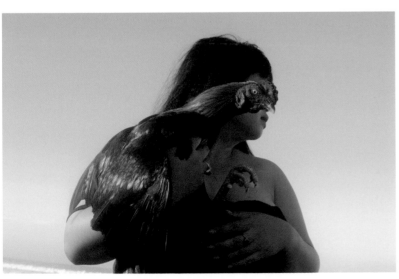

Father I'm Ready, 2008
Lamhda print on Endura
paper on Alu-Dibond,
60 x 80 cm
Edition of 5
Collection of UBS
Switzerland
Courtesy of the artist

Memorabilia, 2008
Lambda print on Endura
paper, 60 x 90 cm
Edition of 5
Collection of the artist
Courtesy of the artist

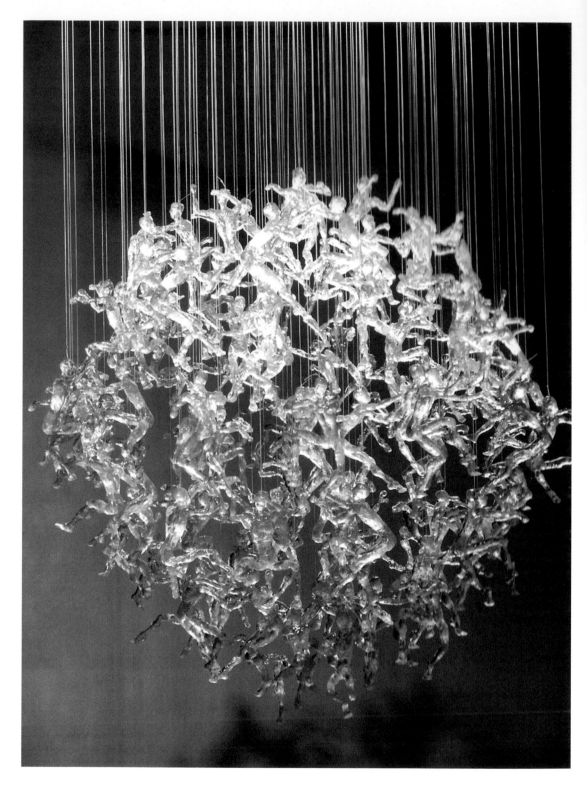

Putu Sutawijaya

Various movements of the human body give life to Putu's works. He internalizes the process of dislocation, contemplation and reflection regarding music, dance, meditation and personal experiences in his life, with elements of his creative Balinese cultural background. He continues to trigger imaginative explorations in his art. (*Mikke Susanto*, excerpted from *Modern Indonesian Art from Raden Saleh to the Present Day*, 2010)

Dancing in the Full Moon, 2008
Resin and stainless iron, variable dimensions
Collection of the artist
Courtesy of the artist

Gesticulation #2, 2010
Recycled metal, 135 x 70 x 60 cm
Collection of the artist
Courtesy of the artist

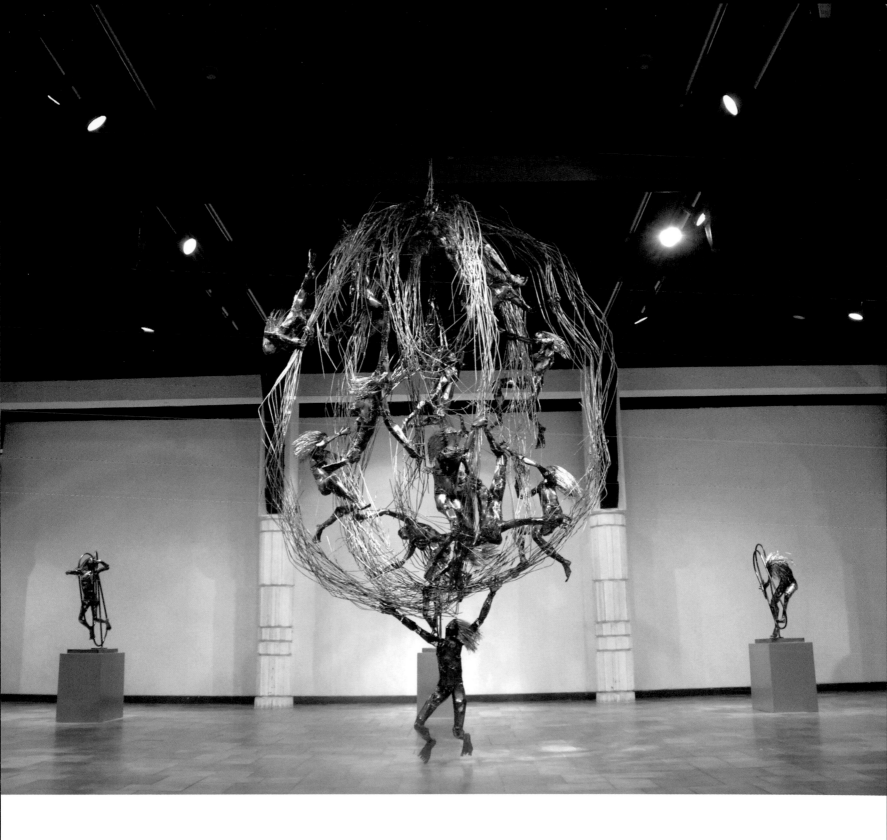

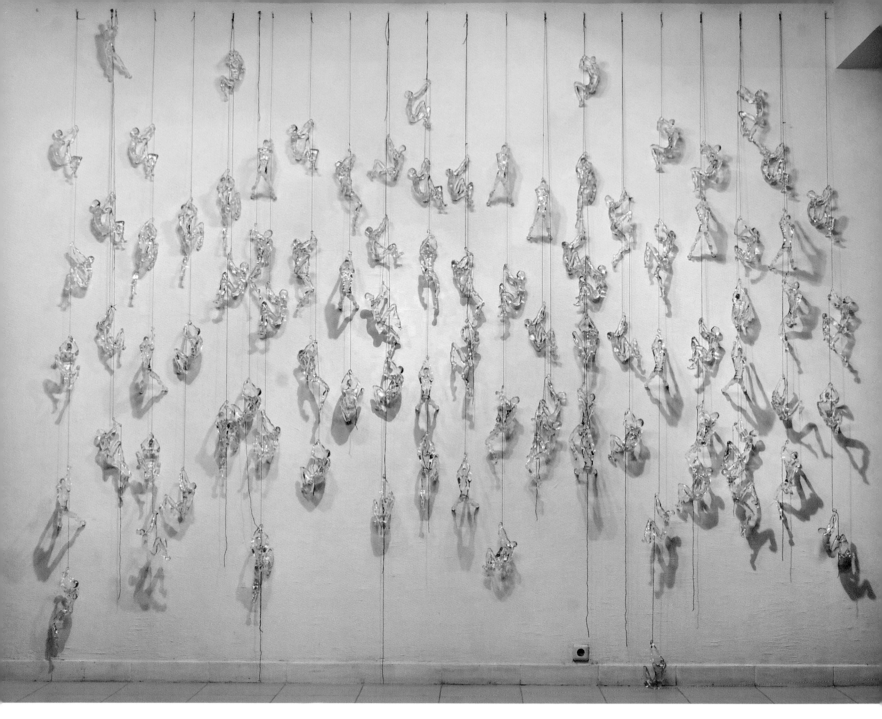

Dancing in the Full Moon,
2008
Resin and stainless iron,
135 x 70 x 60 cm
Collection of the artist
Courtesy of the artist

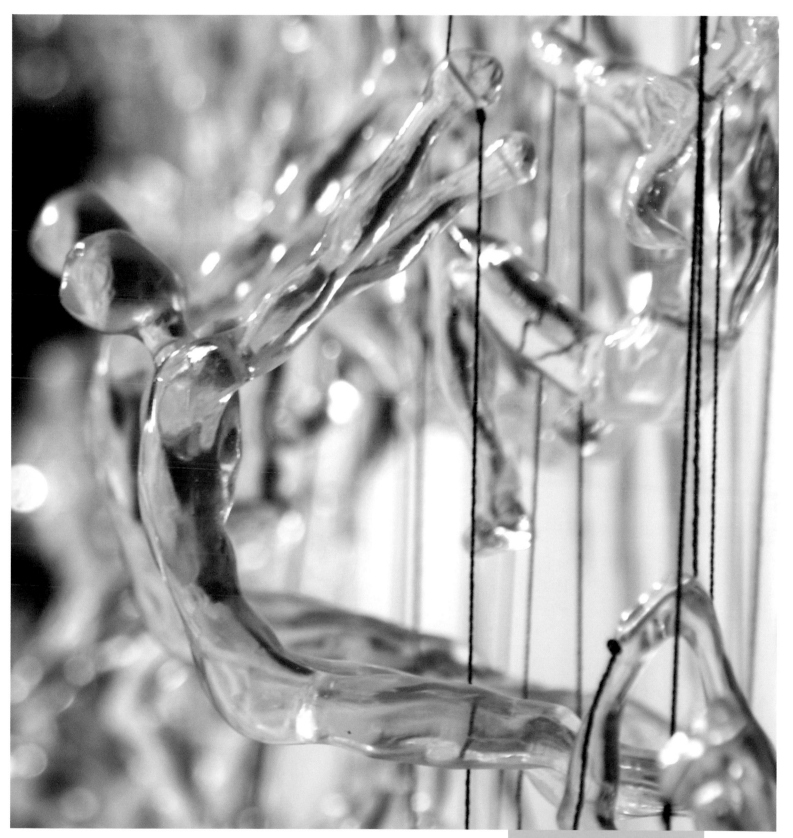

Agus Suwage

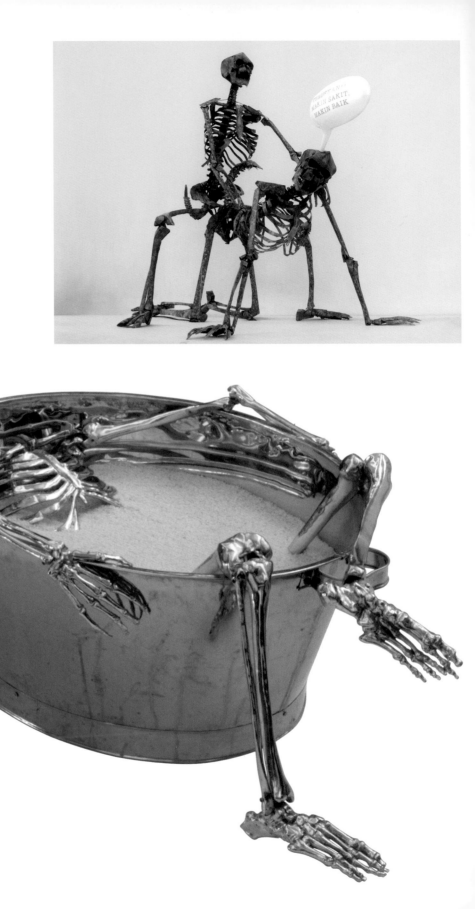

Agus Suwage is one of the most prominent figures in readings and discussions on Southeast Asian contemporary art. His work is considered seminal in the latest development of allegorical realism, placing his name as one of the pioneers in the revival of figurative painting throughout the 1990s. Within the span of his twenty-five-year career, Suwage has been traversing back and forth between different media, undergone some major thematic leaps, and kept his penchant for new materials that could trigger new ideas and forms. For the last couple of years, his work has been dealing with existential questions, particularly concerning life and death. They also demonstrate the coalescence between the artist's current understanding on the perennial subjects, and the strategy and idea of appropriation, which have been persistent themes in his long artistic journey. (*Agung Hujatnikajennong*)

Happiness Is a Warm Gun, 2011
Zinc, acrylic, iron and LED lightbox,
135 x 120 x 160 cm
Private collection
Courtesy of the artist

Luxury Crime 3rd Edition, 2007–09
Stainless steel, gold plated brass and rice,
52 x 77 x 124 cm
Private collection
Courtesy of the artist

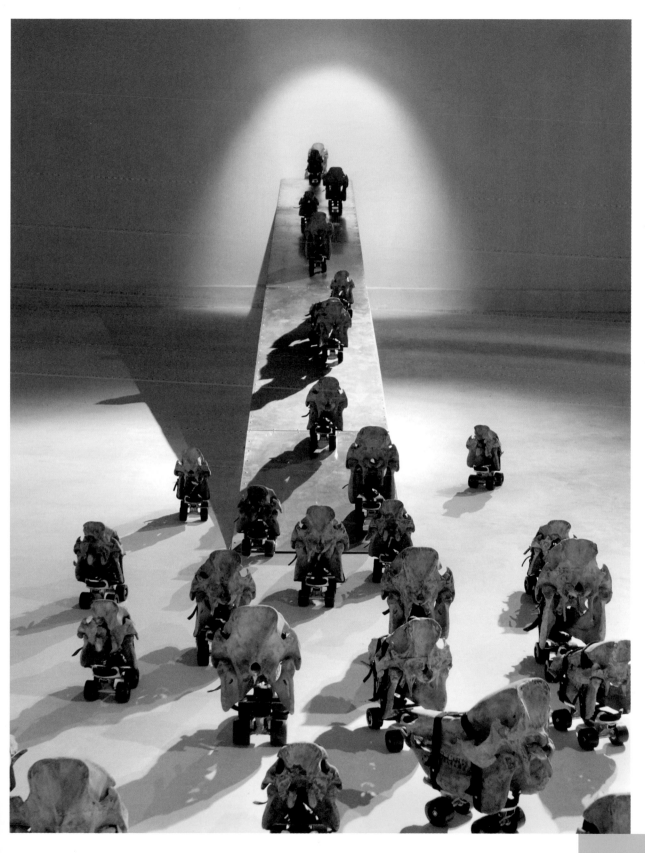

Are You Going with Me?,
2006–07
Resin, aluminium, roller
skates, leather, variable
dimensions
Collection of the artist
Courtesy of the artist

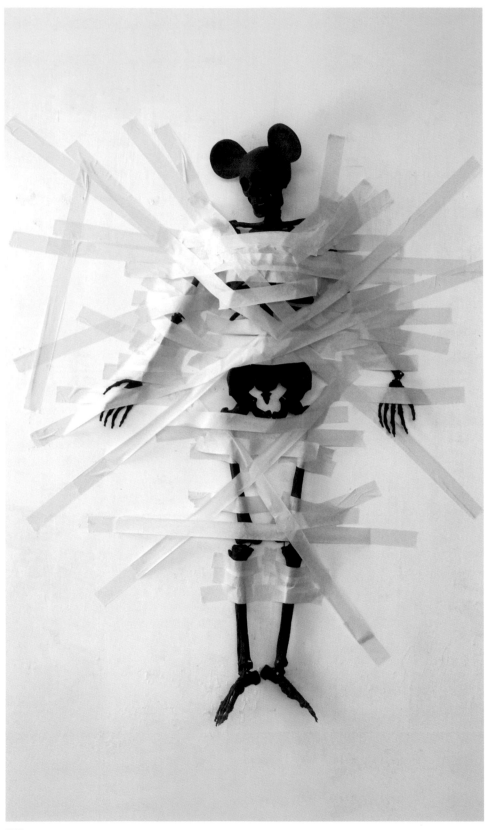

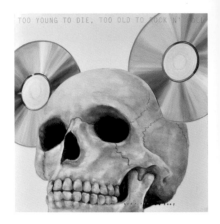

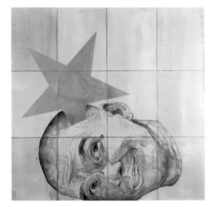

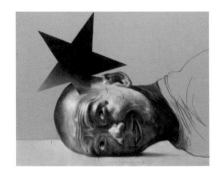

Fool in Love, 2009
Graphite and duct tape,
variable dimensions
Private collection
Courtesy of the artist

*Too Young to Die, too Old
to Rock 'n Roll*, 2007
Acrylic on canvas,
150 x 145 cm
Umahseni collection
Courtesy of the artist

Man of the Year, 2009
Watercolour on paper,
227.5 x 229 cm
Private collection
Courtesy of the artist

Man of the Year, 2009
Oil on linen, 200 x 250 cm
Private collection
Courtesy of the artist

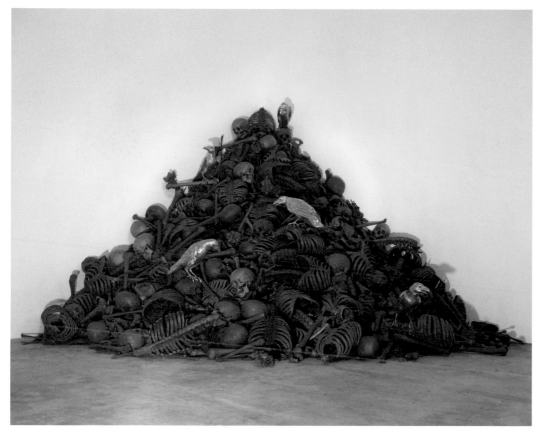

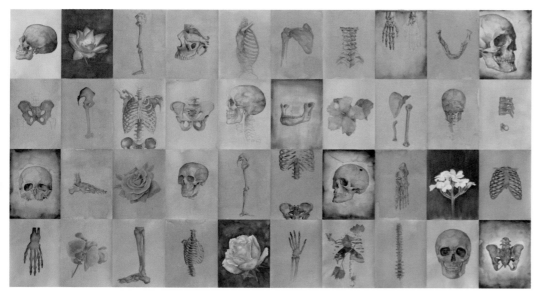

The Cycle, 2010
Graphite polyester, gold
plated brass,
235 x 220 x 220 cm
Collection of the Langgeng
Art Foundation
Courtesy of the artist

Eros Kai Thanatos #1, 2010
Watercolour, tobacco juice
on paper, 40 panels,
56 x 42 cm each
Collection of the artist
Courtesy of the artist

Still Alive, 2010
Oil, copper and zinc,
119.5 x 91.5 cm,
110 x 41 x 12 cm
Private collection
Courtesy of the artist

The Kiss #3, 2010
Oil on zinc, 70 x 92 cm
Private collection
Courtesy of the artist

Gintani Nur Apresia Swastika

Gintani highlights notions of femininity, cuteness and "freshness" in her work. Working with ordinary objects found from daily surroundings, especially fabrics and second-hand clothes, she employs collage, embroidery and cross-stitching techniques to portray daily events in a witty and youthful way.

Effortless, 2008
Silkscreen and fabric
collage, 100 x 163 cm
Collection of the artist
Courtesy of the artist and
Valentine Willie Fine Art

Sacrifice, 2009
Silkscreen and hand-
stitching on canvas,
145 x 102 cm
Collection of the artist
Courtesy of the artist and
Valentine Willie Fine Art

Gintani Nur Apresia Swastika

285

Anthem, 2009
Silkscreen and hand-
stitching on canvas,
60 x 300 cm
Private collection
Courtesy of the artist and
Valentine Willie Fine Art

Gintani Nur Apresia Swastika

For me, all works of art are the visualization of God's gifts and blessing. The process of creating an artwork is a spiritual one: transforming sense into positive energy that is communicated through visual language. In 2007 I created a character, a little girl named Gwen Silent. Gwen Silent is a metaphor for feeling vulnerable, and for the events that happen around me thanks to the permission of God, who knows all of our sighs and complaints.

Gloom, 2007
Monoprint on canvas,
148 x 150 cm
Courtesy of the artist

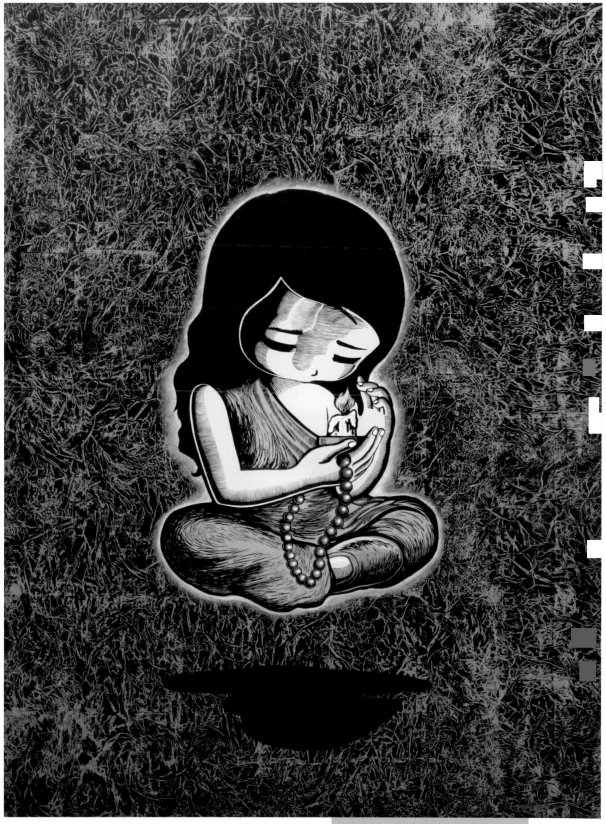

The Prayer, 2008
Woodcut, monoprint and
acrylic on canvas,
200 x 145 cm
Courtesy of the artist

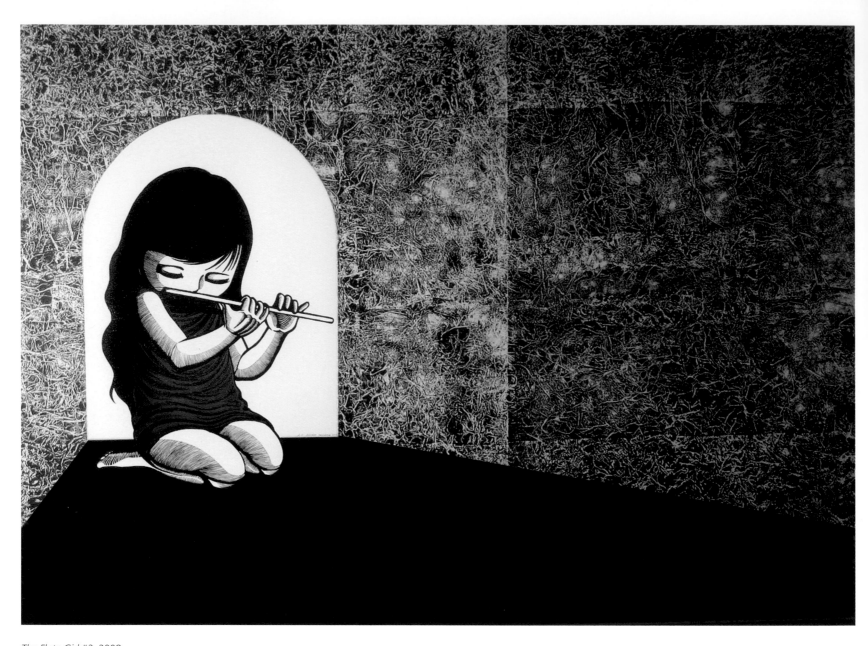

The Flute Girl #2, 2008
Monoprint on canvas,
145 x 200 cm
Courtesy of the artist

Kyrie Eleison, 2010
Dacron and fabric, variable
dimensions
Collection of OHD Museum
of Magelang
Courtesy of the artist

A. C. Andre Tanama

Prilla Tania

Prilla Tania delivers simple questions through her work. She is primarily concerned with the everyday issues of life by questioning the connection between what is natural and cultural, and how these correlate to generate the life we live in. She chooses to work with different kinds of media because she believes each of them is a message.

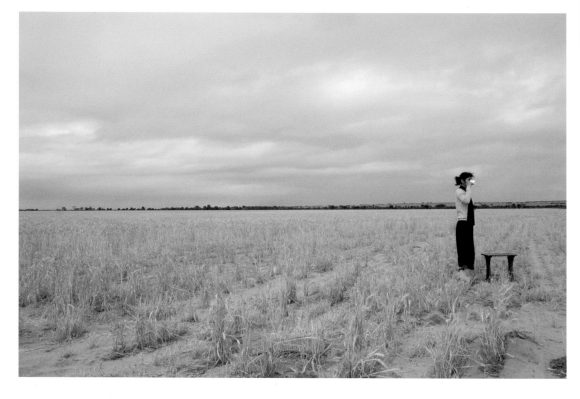

Hello and Goodbye Act 3, 2007
Photograph, 70 x 100 cm
Collection of the artist
Courtesy of the artist

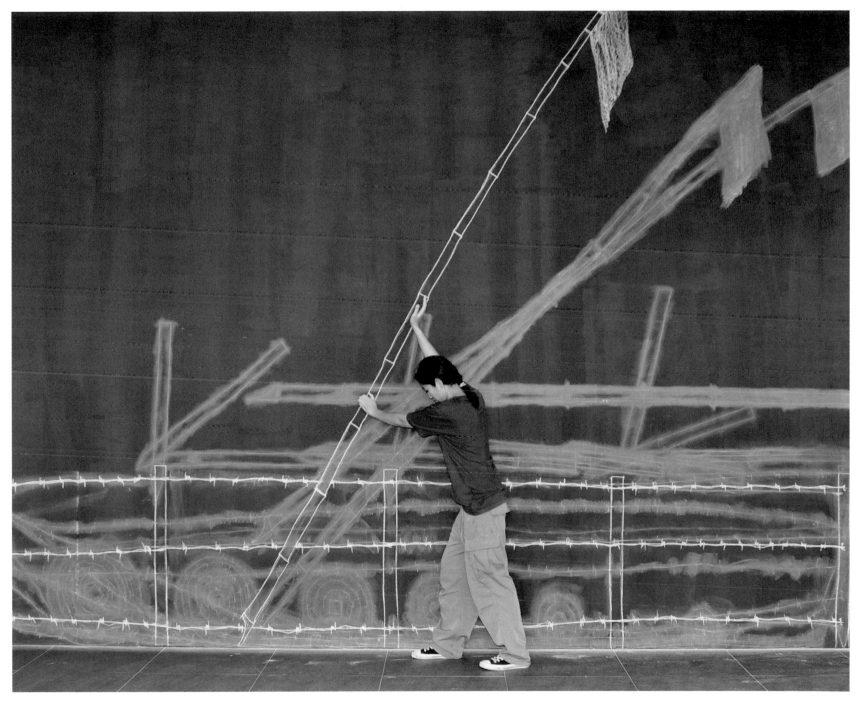

Space within Time #8:
This Is Budi's Mother, 2010
Video, 2 min. 40 sec.
Collection of the artist
Courtesy of the artist

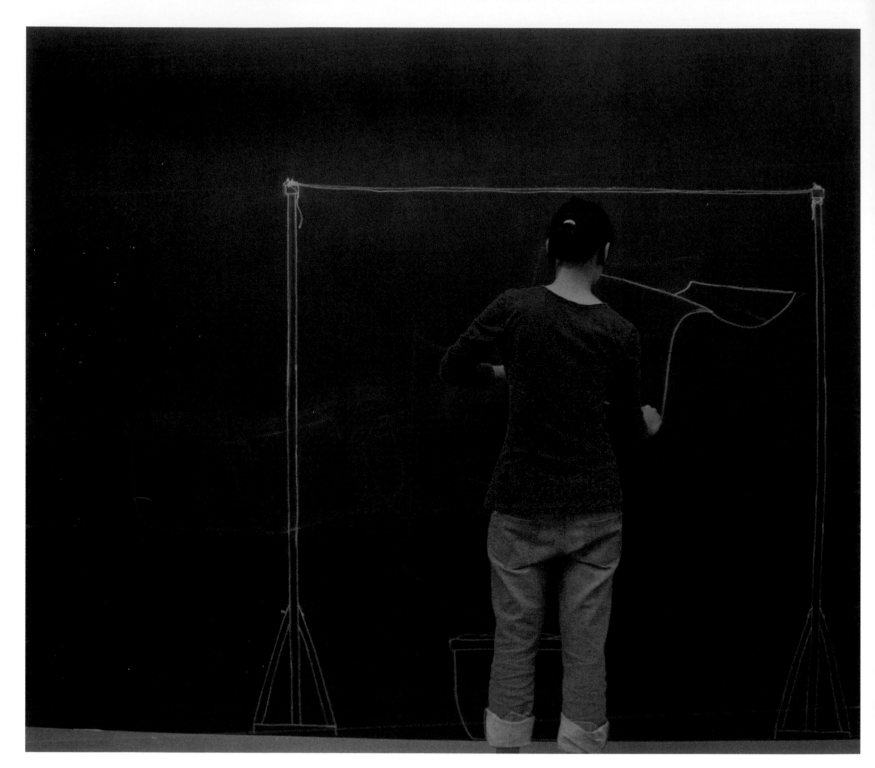

Space within Time #6:
Harvesting Solar, 2009
Video, 1 min. 20 sec.
Collection of the artist
Courtesy of the artist

Voluntarily Dictated, 2010
Live performance, 15 min.
Drawing: water on black wall
Collection of the artist
Courtesy of the artist

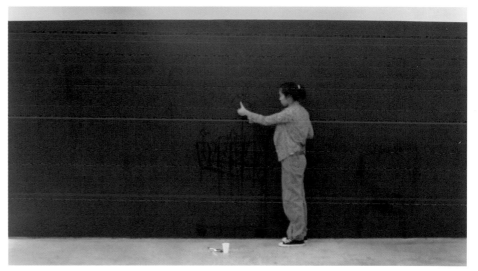

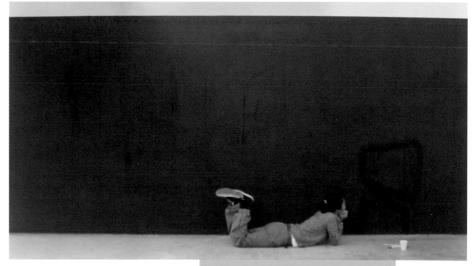

Prilla Tania

Titarubi

My work investigates relations between the Western idea of the perfect body, masculinity, colonialism, the female gaze and desire and the Western principles of modern arts and crafts.

Her Story on White #1, 2005
Plastic and acrylic beads,
approx. 175 x 155 x 75 cm

Her Story on White #2, 2007
Plastic and acrylic beads, iron,
lamp, 175 x 155 x 75 cm

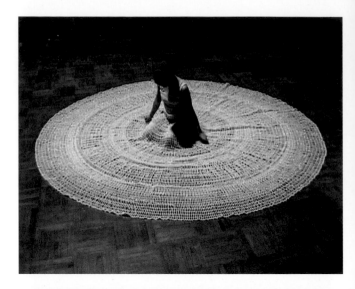

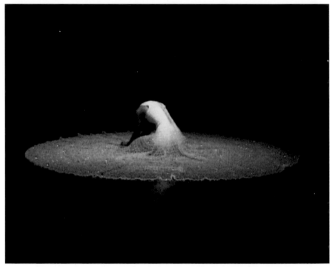

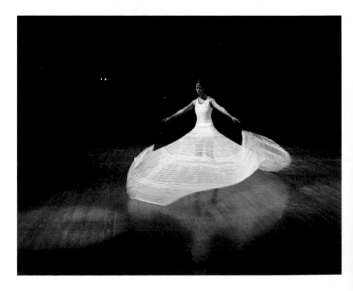

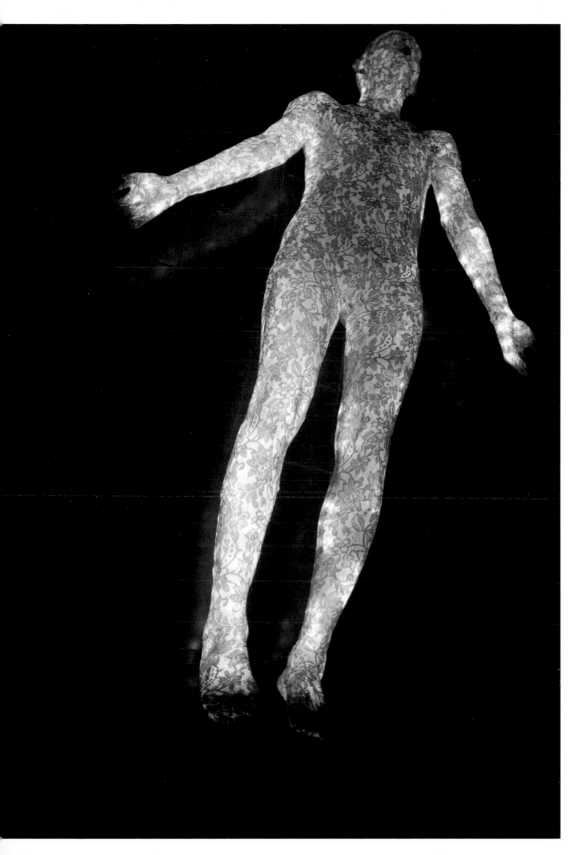

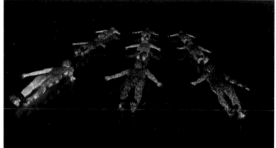

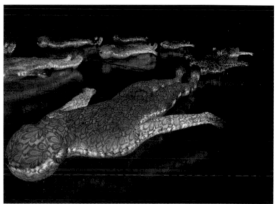

Bodyscape, 2007
Brocade/lace covered with
resin, lamp, vinyl, 9 pieces,
life size

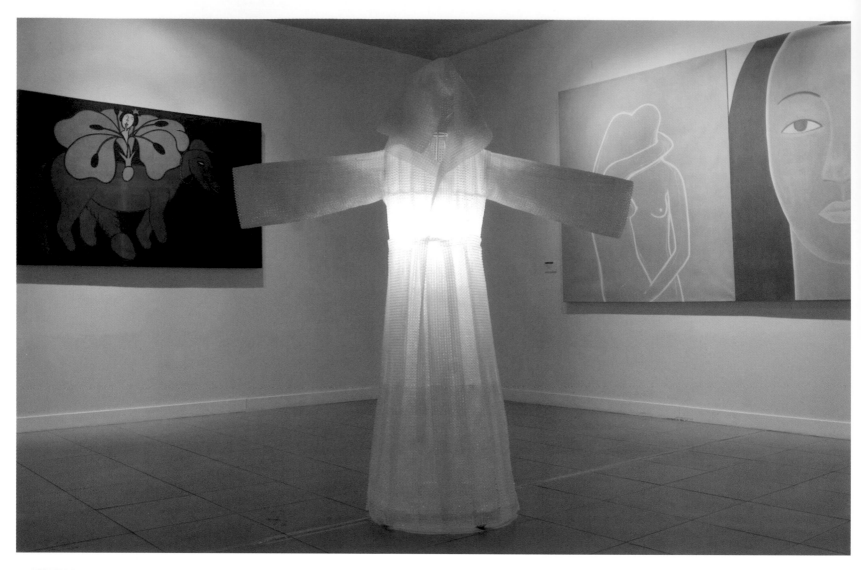

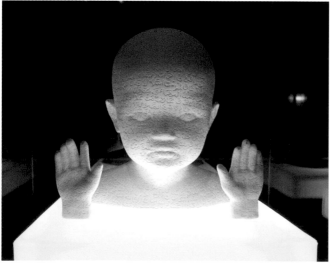

*Shadow of the Tiniest
Kind #6*, 2007
Stoneware, acrylic, MDF,
lamp, 175 x 36 x 36 cm
Courtesy of the artist

Her Story on White #2, 2007
Plastic and acrylic beads, iron,
lamp, 175 x 155 x 75 cm
Courtesy of the artist

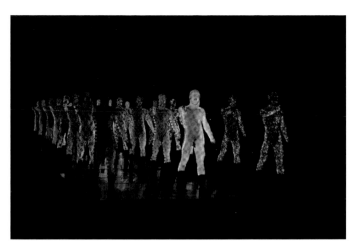

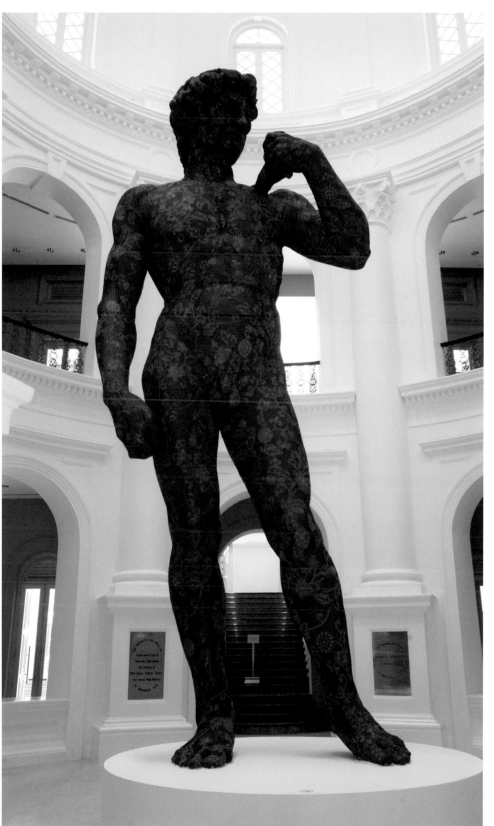

Brocade Platoon, 2007–10
Brocade/lace covered with
resin, lamp, vinyl, 30 pieces,
life size, each approx.
800 x 500 cm

Surrounding David, 2008
Embroidery covered with
fibreglass, lamps, steel,
360 x 900 cm

Tromarama

Tromarama is a group of three bright, young and fun-loving young people: Febie Babyrose, Herbert Hans Maruli and Ruddy Alexander Hatumena. Their works are fresh, playful and humorous, whilst sophisticated and imaginative. Creating artworks by combining images, embroidery, stop motion with highly skilled techniques in media and infectious music is Tromarama's new, more personal approach to art that brings work closer to the subjects' daily character.

Daydreaming 01, 2010
72 pen drawings on Yupo paper, 21 x 50 cm each, music box, stainless steel, table
Collection of the artists
Courtesy of the artists

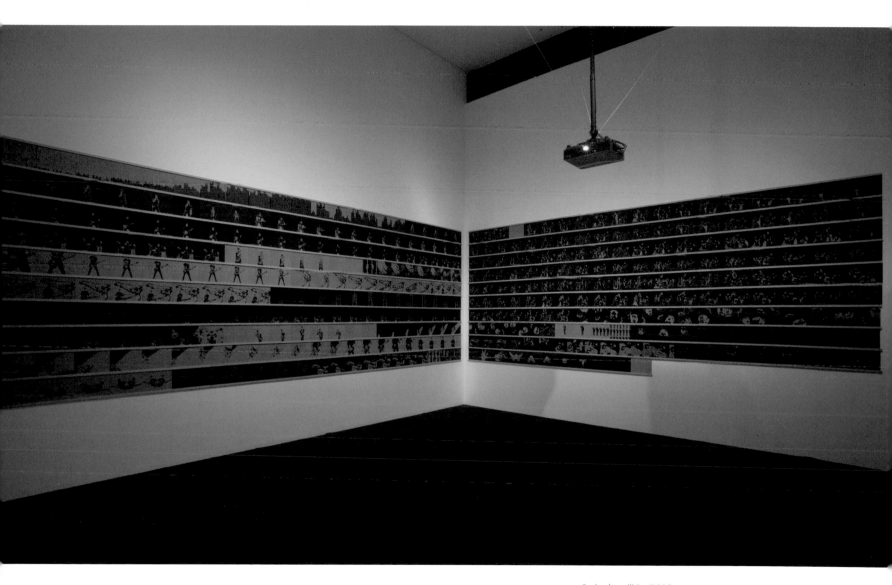

Serigala militia, 2006
Stop motion animation with
plywood woodcut, variable
dimensions
Mori Art Museum Collection
Courtesy of Kioku Keizo

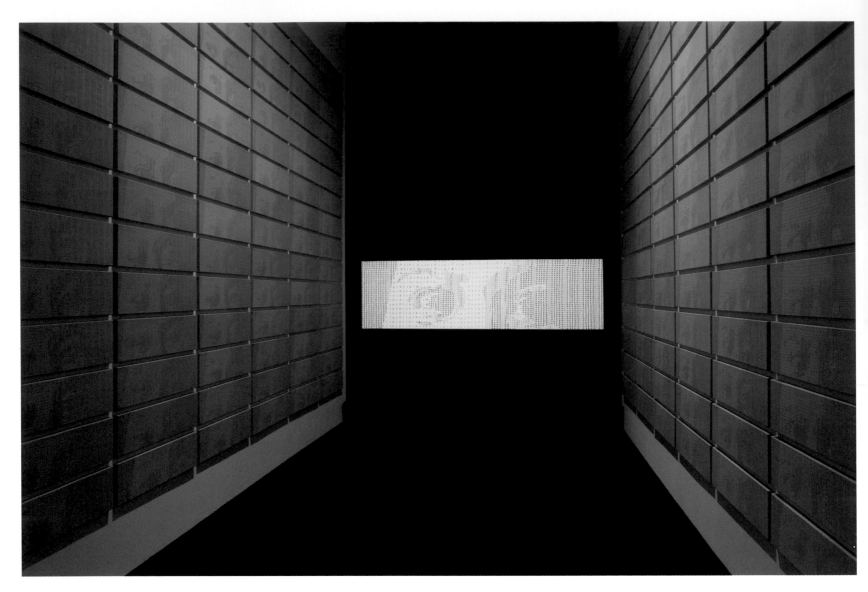

Extraneous, 2010
Rotoscoping animation with
batik on cotton, variable
dimensions
Private collection
Courtesy of Kioku Keizo

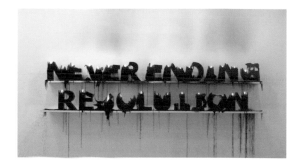
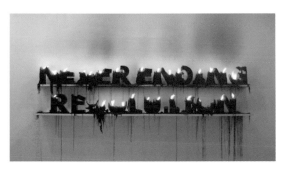
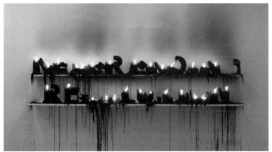
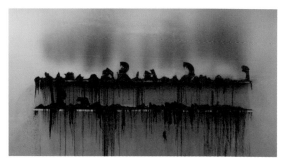

Never ending resolution,
2010
21 candles, variable
dimensions
Private collection
Courtesy of the artists

Ugo Untoro

Native Indonesian horses are at the brink of extinction. To look at, the native breed is not as beautiful or impressive as the crossbred horse with foreign lineage from Arabia, Australia or America. Instead, they have a small body and lack elegance. Although they have unique beauty and are resilient against the tropical climate in Indonesia, they are considered unimportant, and people mark them with tattoos and by tearing ears. I find it tragic that the native Indonesian horses are marginalized in this way and are slowly disappearing, because to me they look charming and unique.

I'm Ready, 2007
Horse feet, variable
dimensions
Collection of the artist
Courtesy of the artist

The End of Badai, 2005
Sand, iron and wood,
78 x 60 x 180 cm
Collection of the artist
Courtesy of the artist

Trojan, 2006
Horse skin and wood,
variable dimensions
Collection of the artist
Courtesy of the artist

Little Wonder, 2007
Horse skin, variable
dimensions
Collection of the artist
Courtesy of the artist

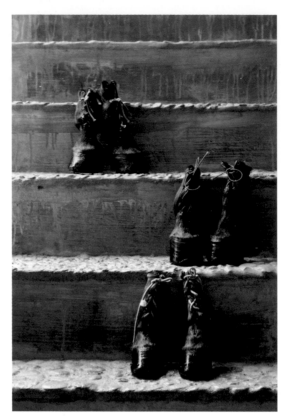

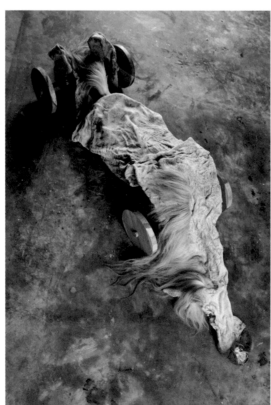

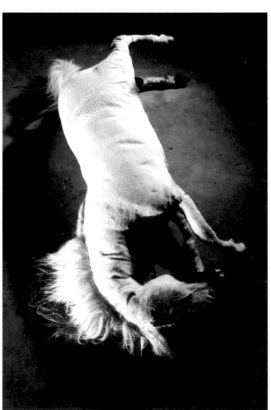

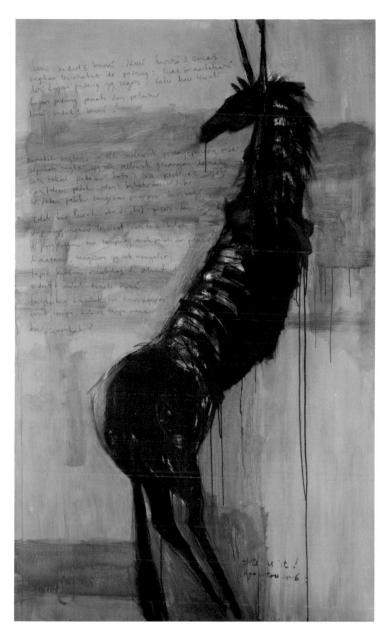

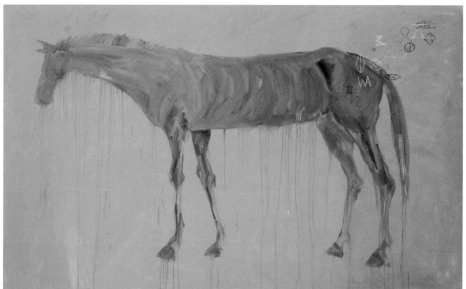

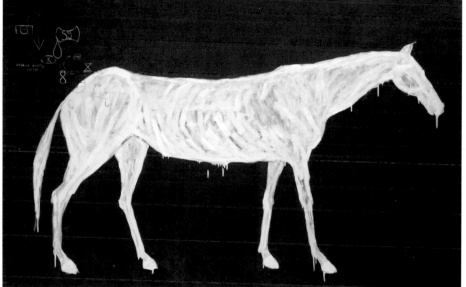

This Is It!, 2006
Acrylic and charcoal on
canvas, 250 x 150 cm
Collection of the artist
Courtesy of the artist

Artificial Identity #2, 2006
Oil on canvas, 200 x 300 cm
Collection of the artist
Courtesy of the artist

Artificial Identity #3, 2006
Oil on canvas, 200 x 300 cm
Collection of the artist
Courtesy of the artist

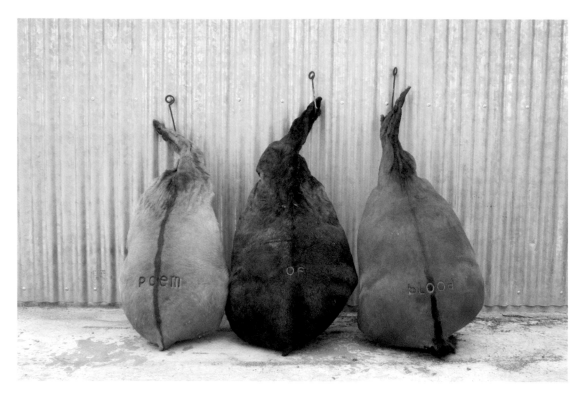

Poem of Blood, 2006
Horse skin, variable
dimensions, 10 pieces
Collection of the artist
Courtesy of the artist

Wrapping History #2, 2006
Oil on canvas, 200 x 300 cm
Courtesy of the artist

Identity is Yours, 2006–07
Iron and wood, variable
dimensions
Collection of the artist
Courtesy of the artist

The Last Race, 2006
Horse skin and sand,
variable dimensions
Collection of the artist
Courtesy of the artist

From Wild Meadow
Collapsed on the Asphalt,
2007
Horse skin and wood,
variable dimensions
Collection of Susanna Perini,
Biasa Art Space
Courtesy of the artist

Made Wiguna Valasara

As a natural resource, the forest is an important part of human civilization, and until recently maintained this role. Humans need forests for many reasons: as a place to live, a place to hunt for food, to gather fruits, vegetation, medicine, and finally as a place to provide materials such as wood to build houses and use for fuel. When the modern industrialized world started to dominate human civilization, the relation between humans and the forest began to change. Forests started to be overexploited and humans no longer saw them as a source of life, but as a source of commodity. We still need forests as one of our richest natural living resources and demand they grow bigger and bigger; but at the same time, ironically, human greed is starting to destroy this resource. The impact of overexploitation has made the number of existing forests in the world decrease dramatically. We are now starting to realize this loss and understand that the diminishment of living resources in the world threatens our existence and that of other living creatures. Those who are suffering the most are undoubtedly the forest animals; some species will soon be extinct, and if these conditions continue the whole ecosystem will vanish.

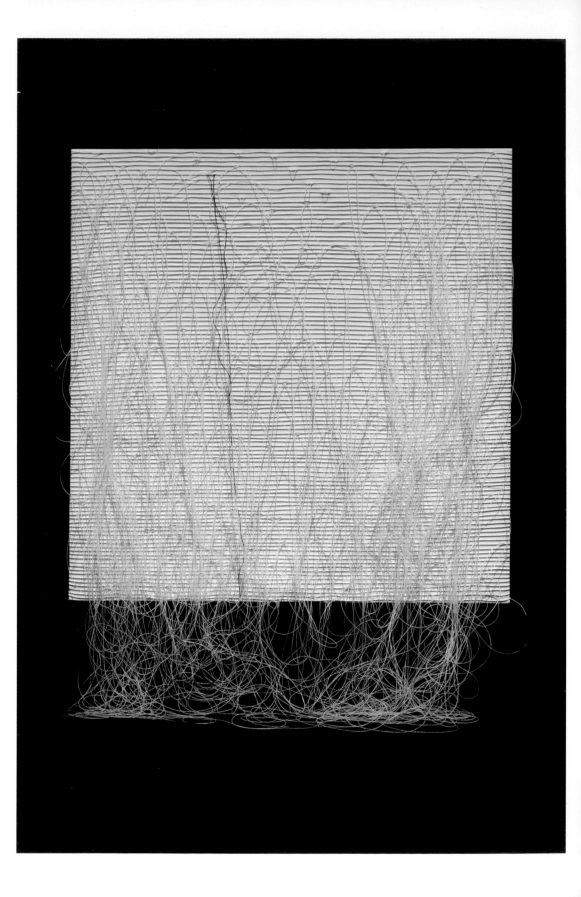

Inside the Earth, 2009
Acrylic, dacron, yarn and plastic hose on canvas, 200 x 200 cm
Private collection
Courtesy of the artist

Sleeping in Memories, 2010
Series *Emboss*
Acrylic and dacron on canvas, 180 x 200 cm
Private collection
Courtesy of the artist

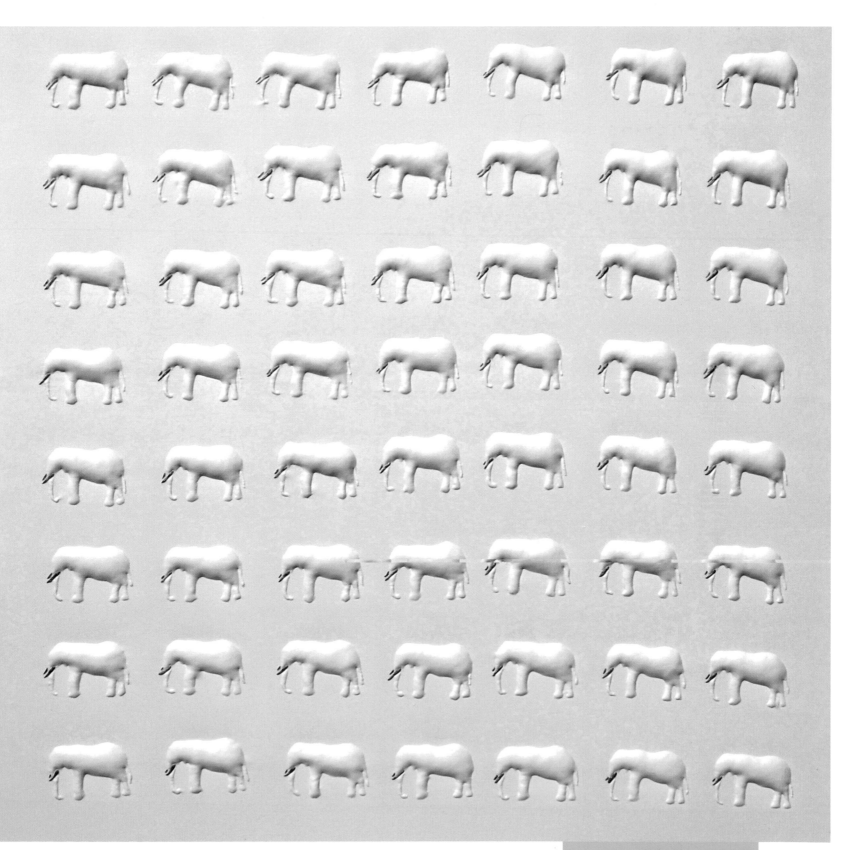

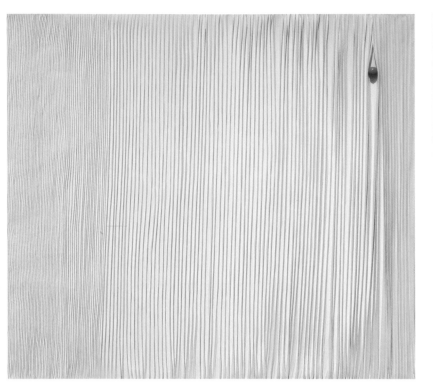

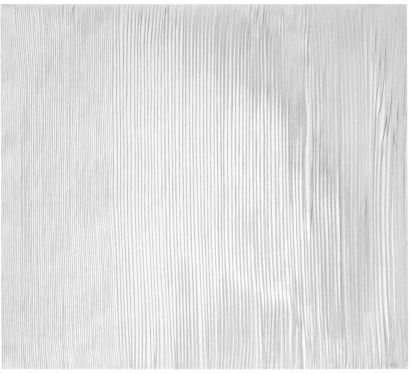

Small World in the White Image, 2009
Acrylic, string, teak wood
on canvas, 200 x 400 cm,
2 panels
Private collection
Courtesy of the artist

Earth's Fences, 2009
Acrylic, dacron and yarn on
canvas, 175 x 170 cm
Collection of the artist
Courtesy of the artist

The Last Generation, 2010
Bronze, 100 x 100 cm
Private collection
Courtesy of the artist

Lenny Ratnasari Weichert is a multimedia artist whose work derives from a multitude of corresponding identities, entrenched in a deeply rooted curiosity for the exploration of the conflicting aspects of human uniqueness. Having always been at the crossroads of the "glocal" reference system, her art contemplates a multi-layered embedding of personality, spirit and gender within this context. By connecting a distinctive multi-faceted heuristic journey between the Orient and the Occident, she investigates religion, subculture, taboo and the position of women in society. She sees her work in the context of being an Indonesian woman, and is quick to distinguish herself from Western or Arab Muslim feminists.

Shanti Shanti Shanti, 2008
Fiber, enamel, variable dimensions
Private collection
Courtesy of the artist and StudionoMaden

Go Fly Away, 2008
Metal and teak wood,
variable dimensions
Private collection
Courtesy of the artist and
StudionoMaden

Mending the Earth, 2010
Stainless steel, variable
dimensions
Private collection
Courtesy of the artist and
StudionoMaden

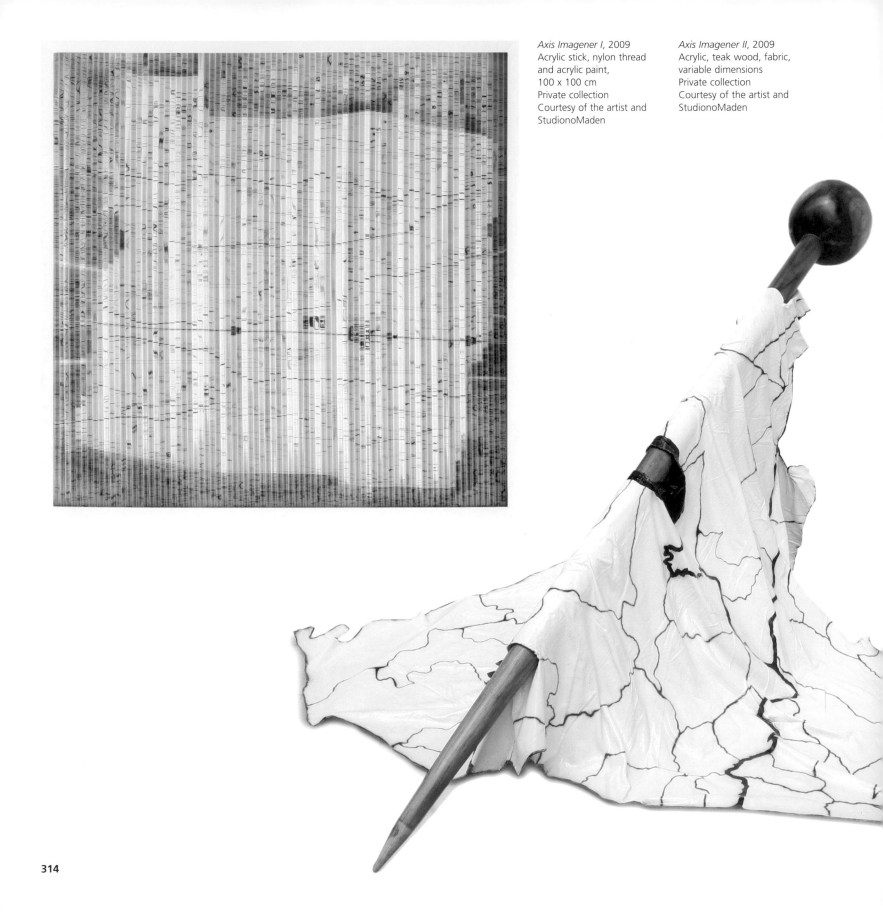

Axis Imagener I, 2009
Acrylic stick, nylon thread
and acrylic paint,
100 x 100 cm
Private collection
Courtesy of the artist and
StudionoMaden

Axis Imagener II, 2009
Acrylic, teak wood, fabric,
variable dimensions
Private collection
Courtesy of the artist and
StudionoMaden

Post-Modernism, 2011
Polyester resin,
10 x 15 x 30 cm
Private collection
Courtesy of the artist and
StudionoMaden

Lenny Ratnasari Weichert

Made Wianta

What Made Wianta asserts is that in his work it is not the market or the media that motivate him but instead he is driven by his search to achieve something stable, a mark that holds its place within the network of a painting. This is the great discovery, the kernel of gold that pierces through his achievement as an artist. When Wianta nails barbed wire to his four-panel painting where white calligraphy intercedes over black, he is showing that this art is not coming from the Internet or the glossy pages of a trendy magazine. This is coming directly from the heart and mind of an artist from another part of the world; from an artist possessed with a subtle brilliance, with energy and modesty; and who is, at this moment, in the process of developing an aesthetic to transform his Balinese nature into a universal concept of awareness. His work is constantly searching for a means to grapple with what remains unseen in our lives, an attempt to reveal what is really in front of us. He attempts to understand the beauty and complexity of a world where nature is still the root of our primordial values, with its unequivocal and undeniable forces and energies. This is where Wianta's art becomes significant. It leads us back to a place we never knew, but should have known. And here in Bali we begin again with the unseen – the world of nerves and stars, rivers and rice, of light and instinctual darkness – the place where dogs run wild. (*Robert C. Morgan*, excerpted from *Wild Dogs in Bali: The Art of Made Wianta*, 2005)

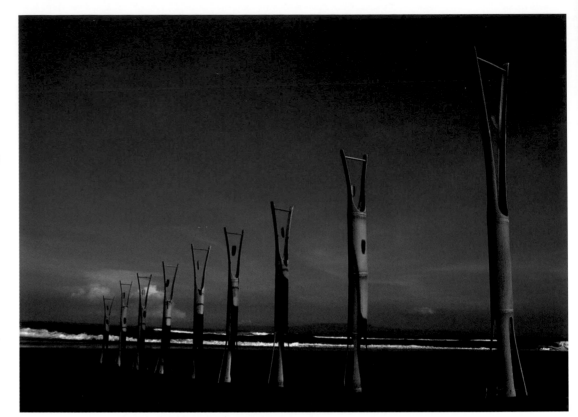

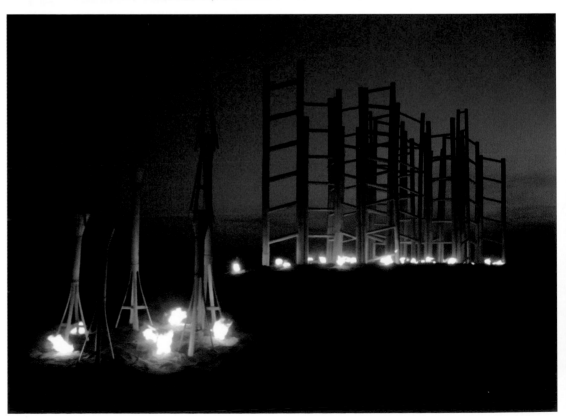

Stairway to Heaven I, 2005
Bamboo, coconut and rice,
variable dimensions
Collection of the artist
Courtesy of the artist

Stairway to Heaven II, 2005
Bamboo, coconut and rice,
variable dimensions
Collection of the artist
Courtesy of the artist

At Last, 2008
Pertamina steel sheet and
metal cutter
Collection of the artist
Courtesy of the artist

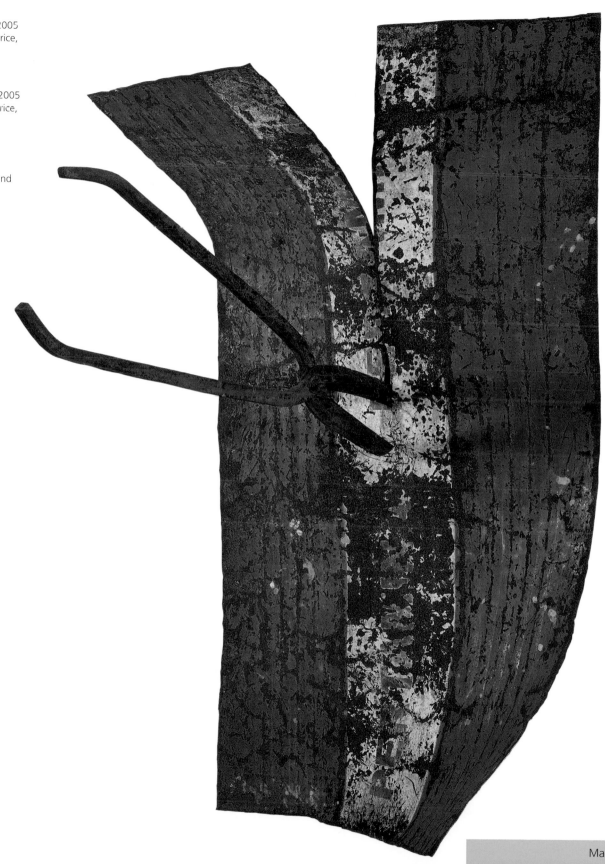

Made Wianta

318

p. 318
Symphony II, 2008
Needles on canvas
Collection of the artist
Courtesy of the artist

left
Symphony I , 2009
Nails, oil, canvas, mounted
on plywood, 300 x 150 cm
Courtesy of the artist and
Oei Hong Djien Museum

Entang Wiharso

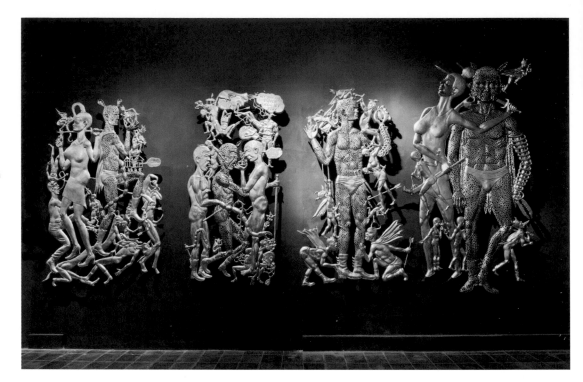

The visual representations in my work range from narrative figuration through to extreme non-narrative imagery. The figures I create are sometimes unrelated to one another at all. I depict the condition of people who are divided by multi-layered artistic, social, political, ethnic, racial and religious power systems; they coexist yet they don't communicate with each other. The figures look as if they were interconnected intuitively as well as by intellectual imaging. Some of the symbols I adopt for exploring connections include ornamental vegetation, tongues, tails, intestines, animal skin patterns, fences and detailed landscapes.

Black Goat vs Aesthetic and Identity Crime, 2010
Series *Comic Book*
Aluminum plate, cast aluminum, car paint, 1000 x 10,000 cm
Collection of the artist
Courtesy of the artist

Black Goat vs Aesthetic and Identity Crime (detail), 2010
Series *Comic Book*
Aluminum and acrylic, variable dimensions
Collection of the artist
Courtesy of the artist

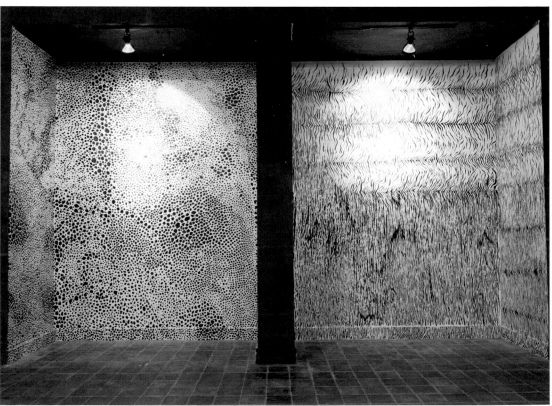

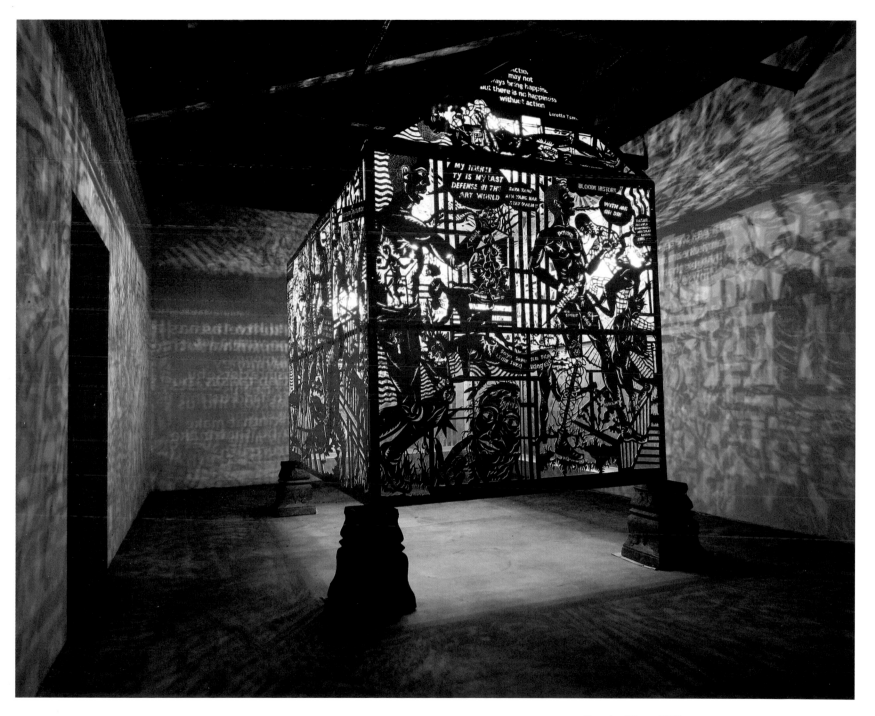

Temple of Hope, 2010
Stainless steel, aluminum
plate, resin, light bulbs,
cable, lava stone,
350 x 300 x 200 cm
Collection of Prasodjo
Winarko
Courtesy of the artist

Entang Wiharso 321

Melt, 2008
Acrylic, spray paint, car
paint, collage photo detail,
oil on canvas, 300 x 600 cm
Collection of Matthias Arndt
Courtesy of the artist

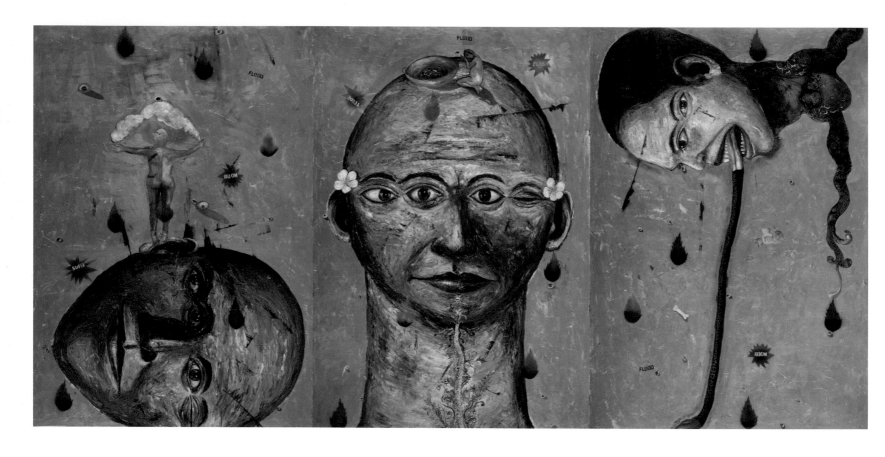

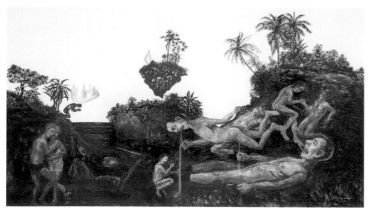

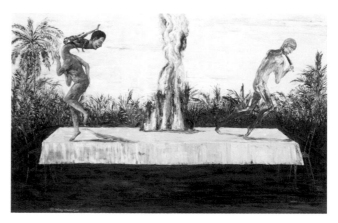

Floating Island, 2010
Oil and acrylic on linen,
300 x 500 cm
Collection of Mr Sunarjo
Courtesy of the artist

Before and After #3, 2010
Oil on linen, 154 x 200 cm
Collection of
Mr Jean-Marc Decrop
Courtesy of the artist

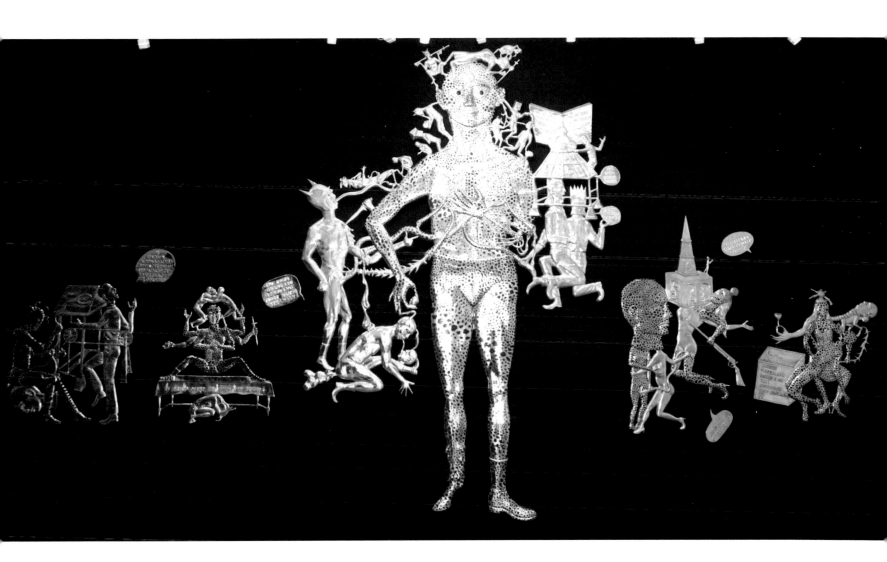

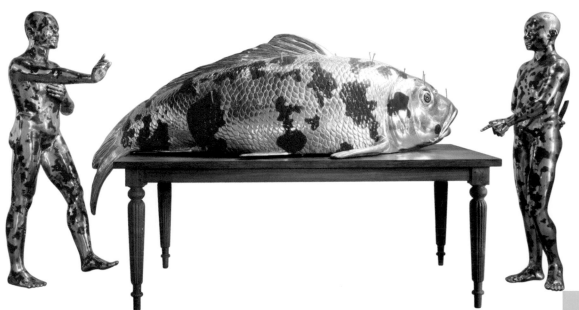

Undeclared Text, 2010
Cast aluminium, car paint,
450 x 800 cm
Collection of
Mr Deddy Kusuma
Courtesy of the artist

Feast Table, 2010
Cast aluminum, colonial
style table, car paint, resin,
175 x 400 x 100 cm
Collection of the artist
Courtesy of the artist

Entang Wiharso

I Wayan Wirawan

I Wayan Wirawan's work explores the interaction between nature and the human being in an era when the natural world has been dramatically exploited. In his paintings, Wirawan juxtaposes the images of natural and artificial objects in order to create a symbolic, poetic tension between nature and culture. His works contain messages that articulate the importance of maintaining ecological balance to preserve the life on this planet.

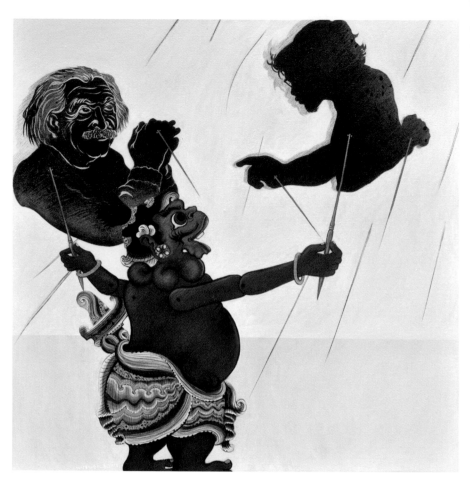

It's Your Play, 2010
Acrylic on canvas,
100 x 100 cm
Collection of the artist
Courtesy of the artist and
Tonyraka Art Gallery

Changing Shadow, 2010
Acrylic on canvas,
140 x 180 cm
Collection of the artist
Courtesy of the artist and
Tonyraka Art Gallery

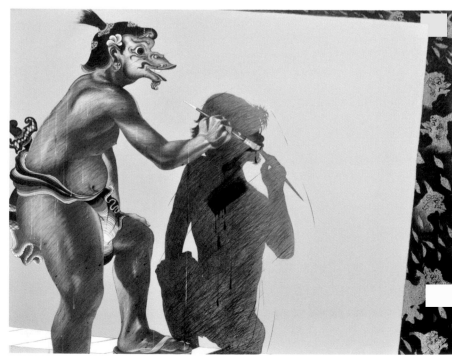

West & East, 2010
Acrylic on canvas,
145 x 180 cm
Collection of the artist
Courtesy of the artist and
Tonyraka Art Gallery

I Wayan Wirawan **325**

Sangut Delem, 2010
Acrylic on canvas,
2 panels, 140 x 60 cm each
Collection of the artist
Courtesy of the artist and
Tonyraka Art Gallery

Party, 2010
Acrylic on canvas,
150 x 250 cm
Collection of the artist
Courtesy of the artist and
Tonyraka Art Gallery

Welcome Party, 2010
Acrylic on canvas,
100 x 120 cm
Collection of the artist
Courtesy of the artist and
Tonyraka Art Gallery

I Wayan Wirawan　　　**327**

Tintin Wulia

Generally Tintin Wulia's work offers different perspectives and layers of reality, all at once. Her body of work results from an ongoing practice-based research on the notion of borders and boundaries, for which she often orchestrates interactive performances. These performances, ranging from simple games to collective mural making, serve as tactile playgrounds for her audience to participate in a process where borders are either hidden or made visible, and where chance and randomness become their prominent features. The props in her performances often include video, murals, objects and texts. She also works with these media separately.

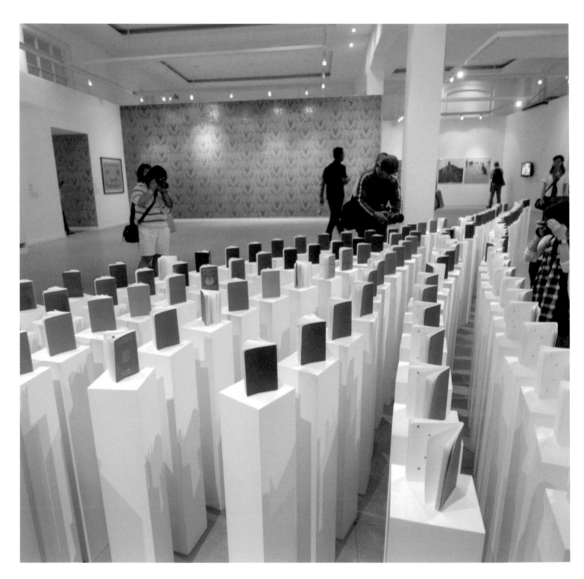

(Re)Collection of Togetherness – Stage 4, 2009
Installation (imitation passports, imitation mosquitoes, imitation bloodspeck, names, pedestals), variable dimensions
Collection of the artist
Courtesy of Jakarta Biennale
Photograph courtesy of the Jakarta Biennale

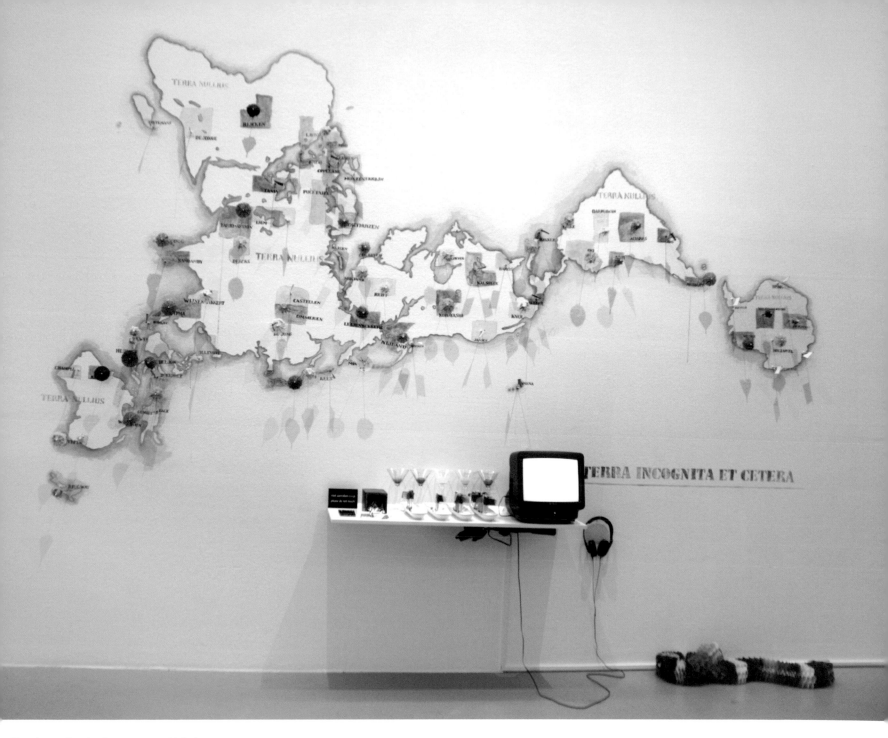

Terra Incognita, et cetera,
2009
Interactive performance and
installation with single
channel video (watercolour
mural, video projection,
cocktail flags, cocktail
umbrellas, wood glue,
serving trays, imitation
money, lottery box, pencils,

cocktail glasses,
watercolour, paintbrushes),
variable dimensions
Collection of the artist
Courtesy of Krijn
Christiaansen

Tintin Wulia

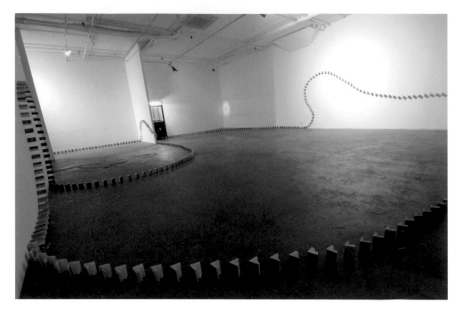

Lure, 2009
Interactive installation
(imitation passports,
vending machine), variable
dimensions
Collection of the artist
Courtesy of Osage Gallery

*The WOCΛ (Window
of Contemporary Art) Book*,
2010
Digital print on Splendorgel
paper, beer mat paper
and threads
Courtesy of the artist

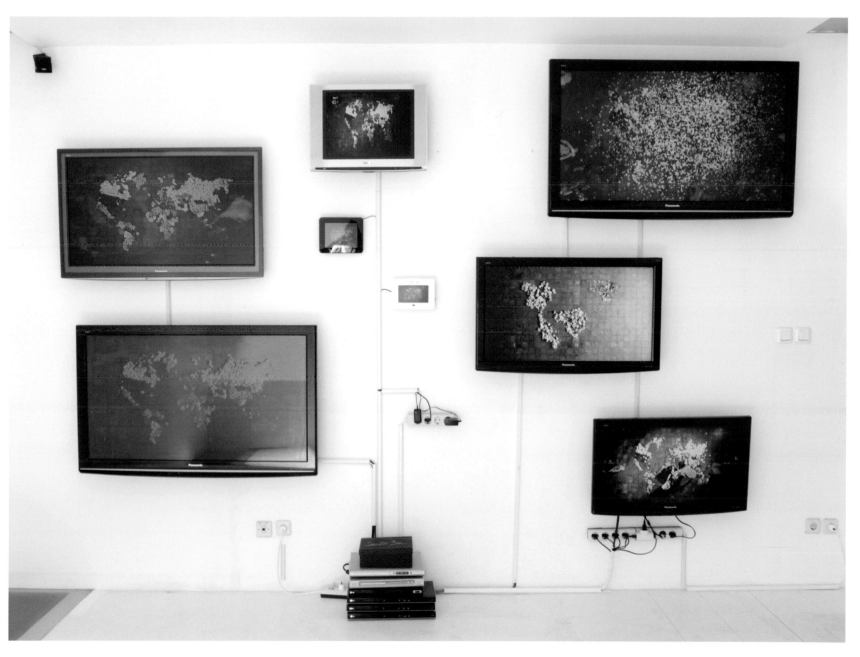

*Nous ne notons pas
les fleurs*, Jakarta, 2010
Interactive performance
and installation with video
octaptych (flowerbuds,
chillies, onion, garlic,
peanuts, camera, TV
monitor), variable
dimensions
Collection of the artist
Courtesy of the artist

Gede Mahendra Yasa

Gede Mahendra Yasa's artwork experiments with the art of painting itself. He melts together a variety of sources and influences from the history of Western painting into his work, rejecting the concept of painting as a mere domain of representation. He works diligently on the philosophical and epistemological aspects of painting, questioning the meaning of being a "painter" in the contemporary art world and society.

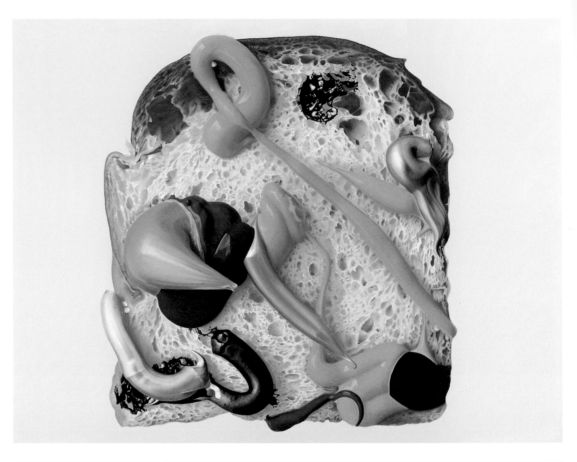

Bread Talk #2, 2010
Oil on canvas, 150 x 200 cm
Courtesy of the artist and
SIGIart Gallery

Spaghetti Incident, 2010
Oil on canvas, 150 x 225 cm
Courtesy of the artist and
SIGIart Gallery

332

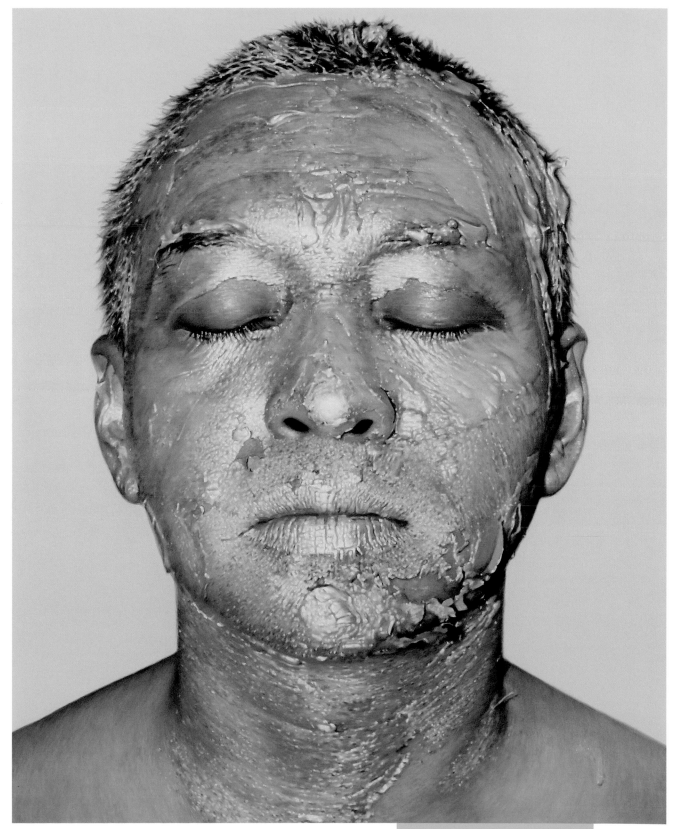

Gold Acrylic Paint on Face
#1, 2009
Oil on canvas, 150 x 120 cm
Courtesy of the artist and
SIGIart Gallery

Gede Mahendra Yasa **333**

Acrylic Color on Face #1,
2009
Oil on canvas, 250 x 200 cm
Courtesy of the artist and
SIGIart Gallery

Black Acrylic Paint on Face
#1, 2009
Oil on canvas, 150 x 120 cm
Courtesy of the artist and
SIGIart Gallery

White Acrylic Paint on Face
#1, 2009
Oil on canvas, 150 x 120 cm
Courtesy of the artist and
SIGIart Gallery

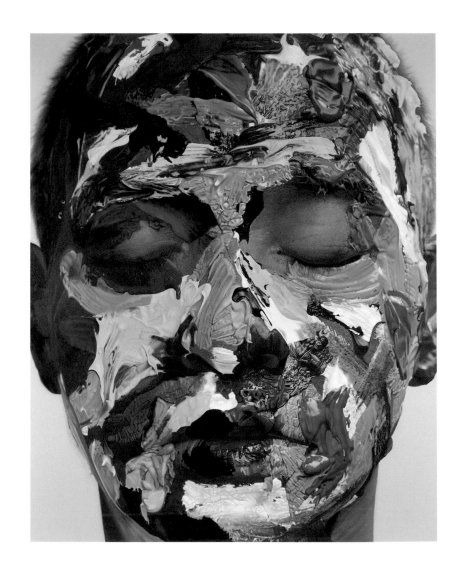

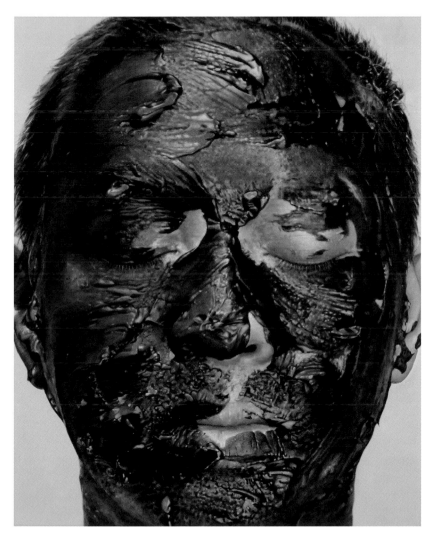

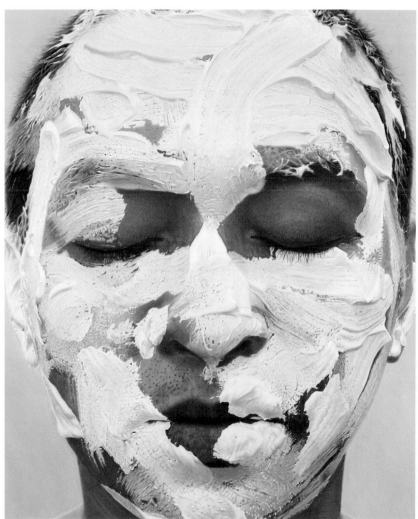

Muhammad "Ucup" Yusuf

There is a common thematic thread in Ucup's work that reflects the artist's mission to defend marginalized people. He is a founding member of "Taring Padi", a group of socio-political artists. His work is bold and filled with protest, depicting the struggles of the working class in both the past and present, expressed unequivocally in his intricate woodcuts and works on canvas. Ucup tackles the themes of injustice that surround him, from class disparity and greed to unbridled consumerism and environmental degradation. He says, "We are critical. But we are not anti-government".

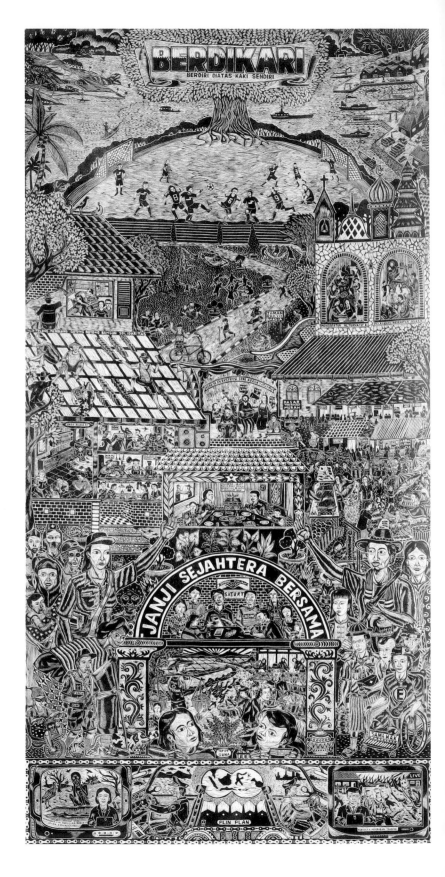

Wealth Promise, 2008
Woodcut print on fabric,
200 x 120 cm
Collection of the Singapore Art Museum
Courtesy of the artist and Valentine Willie Fine Art

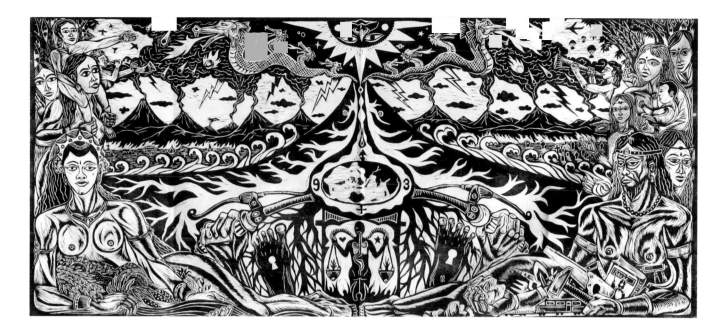

Nature Scale, 2007
Woodprint on fabric,
56 x 120 cm
Collection of Valentine
Willie Fine Art Singapore
Courtesy of the artist

Food Not Terror, 2009
Woodcut print on fabric,
88 x 120 cm
Collection of Valentine
Willie Fine Art Singapore
Courtesy of the artist

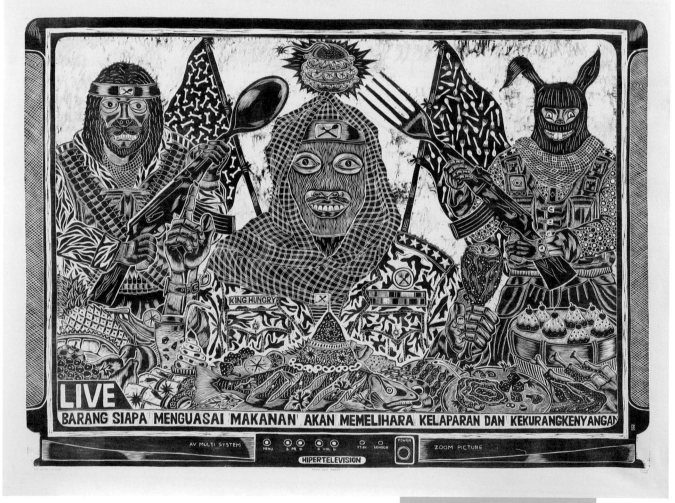

Muhammad "Ucup" Yusuf

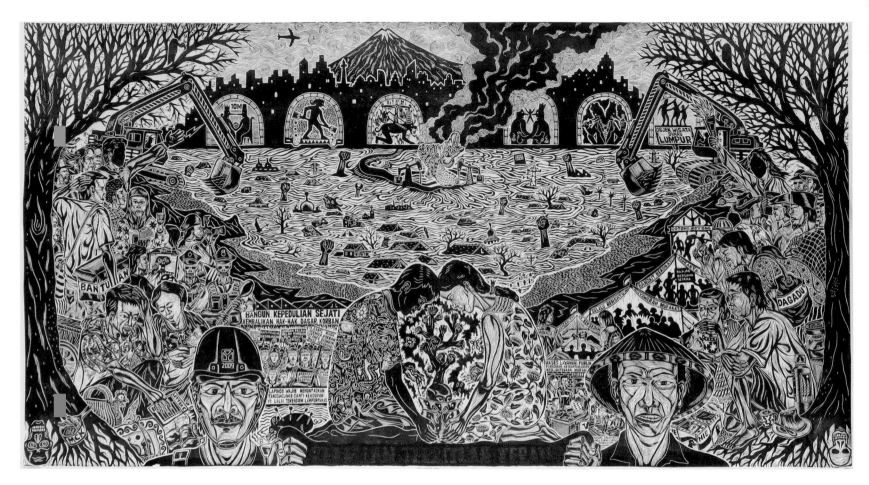

Unflagging, 2009
Woodcut print on fabric,
120 x 140 cm
Collection of the Singapore
Art Museum
Courtesy of the artist and
Valentine Willie Fine Art

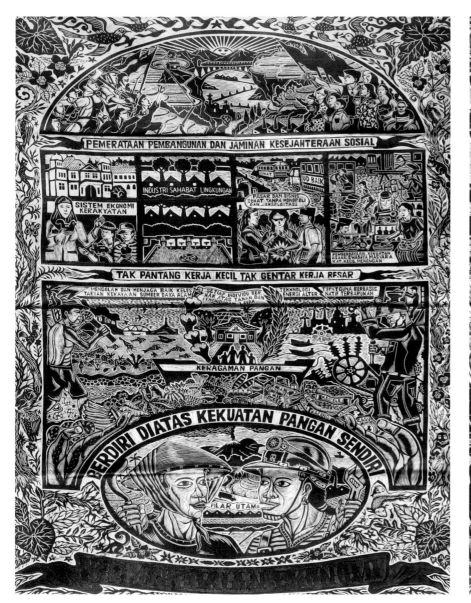

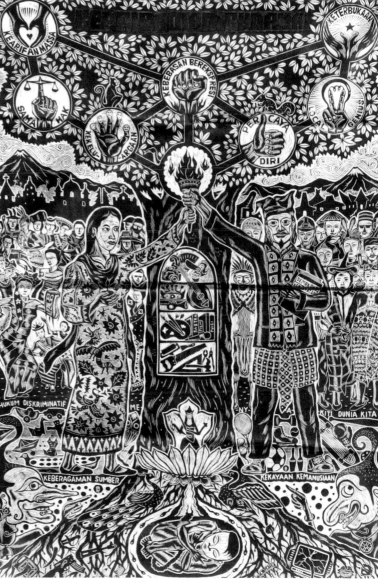

Trisakti #2, 2009
Woodcut print on fabric,
120 x 79 cm
Collection of Valentine
Willie Fine Art Singapore
Courtesy of the artist

Trisakti #3, 2009
Woodcut print on fabric,
120 x 79 cm
Collection of Valentine
Willie Fine Art Singapore
Courtesy of the artist

Biographies of the Artists

Nindityo Adipurnomo (p. 44)

Born in 1961 in Semarang, Central Java, Indonesia.

Solo exhibitions
- 2010
Napoleon Complex Loose-Fitting Merchant (Napoleon Kompleks Saudagar Komprang), Galeri Semarang at Jakarta Art District, Jakarta.
- 2006
Self Portrait, Amsterdams Grafisch Atelier (AGA), Amsterdam.
- 2005
Machow, Bentara Budaya, Jakarta.
- 2002
Beyond the Modesty, Plastique Kinetic Worms, Singapore.
- 2000
Portrait of Residency in Cardiff, Cemeti Art House, Yogyakarta, Central Java.

Selected group exhibitions
- 2011
Kaap (Cape), Utrecht, The Netherlands.
1001 Doors: Reinterpreting Traditions, Ciputra World Marketing Gallery, Jakarta.
- 2010
Mexico Contemporary Art, Galeri Nasional Indonesia, Jakarta.
The Grand Church, Alkmaar, The Netherlands.
- 2009
Jogja Jamming, 10th Jogja Biennale at Jogja National Museum, Yogyakarta, Central Java.
Next Nature, Galeri Nasional Indonesia, Jakarta.
The Museum of the Unworthy, video performance, Cemeti Art House, Yogyakarta, Central Java.
- 2007
Fetish Object Art Project #1, Biasa ArtSpace, Seminyak, Bali.
Wherever We Go, San Francisco Art Institute, San Francisco, California.
- 2006
Saigon Open City, Museum of War, Saigon, Vietnam.
Wherever We Go, Spazio Oberdan, Museo di Fotografia Contemporanea, Milan.
- 2005
The Wahana Project Imagined Legacies, Selasar Sunaryo Art Space, Bandung, West Java.
- 2004
Filling of Chasm, Uniting People, Busan Metropolitan Art Museum, Busan, South Korea.
Globalisation Versus Identity, Art Museum, Chiang Mai, Thailand; The National Gallery, Bangkok; Museen Dahlem, Berlin.

Awards
- 2009
10th Jogja Biennale Art Awards, Yogyakarta, Central Java.
- 2005
John D. Rockefeller Third Award, The Asian Cultural Council, New York.

Public collections
Municipality of Amsterdam, The Netherlands.
Municipality of Filderstadt, Stuttgart, Germany.
Singapore Art Museum, Singapore.
Foundation of Fine Arts, Amsterdam.
Museum Haji Widayat, Magelang, Central Java.
Queensland Art Gallery, Brisbane, Australia.
Fukuoka Asian Art Museum, Fukuoka, Japan.

Bob Yudhita Agung (p. 48)

Born in 1971 in Yogyakarta, Central Java, Indonesia.

Solo exhibitions
- 2010
Bob Varium, Srisasanti Gallery, Yogyakarta, Central Java.
- 2008
Life Is Beautiful, Sin Sin Fine Art, Hong Kong.
- 2007
Happy Birthday Nin, Jogja National Museum, Yogyakarta, Central Java.
- 2005
New Kid on the Block, Museum Dan Tanah Liat, Yogyakarta, Central Java.
- 2004
Under Ketepang Tree, On Springbed, Kedai Kebun Forum, Yogyakarta, Central Java.
- 2002
I Love My Father, LIP, Centre culturel français, Yogyakarta, Central Java.
- 2001
Sick Is Bliss, Kedai Kebun Forum, Yogyakarta, Central Java.
- 2000
Grabbing Victory, Millennium Gallery, Jakarta.

Group exhibitions
- 2010
Romance 91, Sangkring Art Space, Yogyakarta, Central Java.
Fever Soccer, Galeri Canna, Jakarta.
- 2009
Exposigns. Great Exhibition of Indonesian Visual Art, 25th Institut Seni Indonesia (ISI) at Jogja Expo Center, Jogyakarta, Central Java.
Hi June, Taman Budaya, Yogyakarta, Central Java.
Reach for the Heart, Sin Sin Fine Art, Hong Kong.
In Rainbow, Esa Sampoerna Art House, Surabaya, East Java.
Ideas Party, Ruang Seni Ars Longa, Yogyakarta, Central Java.
Friendship Code, Syang Art Space, Magelang, Central Java.
- 2008
Indonesian Invasion, Sin Sin Fine Art, Hong Kong.
Jogja Salon, CG Art Space, Plaza Indonesia, Jakarta.
Tribes, Sin Sin Fine Art, Hong Kong.
Red District Project, Koong Gallery, Jakarta
Loro Bloyo Wedding Contemporary, Magelang, Central Java.
69 Seksi Nian, Jogja Gallery, Yogyakarta, Central Java.
Manifesto, Galeri Nasional Indonesia, Jakarta.

Growing Rice on the Sky, Ark Galerie, Jakarta.
- 2007
SISA, Sydney.
IVAA Boook AID, Nadi Gallery, Jakarta.
Asia Contemporary-Inaugural, Singapore.
What Is Contemporary Art? (Contemporary Art Apaan Tuh?), Museum Affandi, Yogyakarta, Central Java.
Fetish Object Art Project #1, Biasa ArtSpace, Seminyak, Bali.
International Literary Biennale, Langgeng Gallery, Magelang, Central Java.

Made Aswino Aji (p. 52)

Born in 1977 in Gianyar, Bali. Lives and works in Bali.

Solo exhibitions
- 2009
Color Me Bad, Kedai Kebun Forum, Yogyakarta, Central Java; Galeri Semarang, Semarang, Central Java.
- 2008
Aji's Exhibition, IVAA Hobby Studio, Yogyakarta, Central Java.
Gibby's Holiday, illustrative drawings' exhibition, stories by Grace Samboh, Twice Bar, Kuta, Bali.
- 2003
Condolence Flower (Bungaduka), Via-Via Café, Yogyakarta, Central Java.
- 2001
Apotik Komik's Public Art Mural Project, Apotik Komik Headquarters, Yogyakarta, Central Java.

Selected group exhibitions
- 2010
Sehati-Hati Griya Santrian, Sanur, Bali.
Art|Jog|10. Indonesian Art Now: The Strategies of Being, Taman Budaya, Yogyakarta, Central Java.
- 2009
Truck Dies with Its Baby (Kunduran Truk), Kersan Art Studio, Yogyakarta, Central Java.
Exposigns. Great Exhibition of Indonesian Visual Art, 25th Institut Seni Indonesia (ISI) at Jogja Expo Center, Jogyakarta, Central Java.
- 2008
Hello Print!, Edwin's Gallery, Jakarta.
Second (Detik), Sangkring Art Space, Yogyakarta, Central Java.
Jogja Art Fair #1, Taman Budaya, Yogyakarta, Central Java.
Hybridity, Jogja Gallery, Yogyakarta, Central Java.
Reinventing Bali – Sanggar Dewata, Sangkring Art Space, Yogyakarta, Central Java.
- 2007
Sanur Village Festival, Santrian Gallery, Sanur, Bali.
- 2006
8 Young Contemporaries, Art Forum, Singapore.
- 2005
Di Sini & Kini, 8th Jogja Biennale, Taman Budaya, Yogyakarta, Central Java.
- 2004
Reformasi, Sculpture Square, Singapore.

Muhammad Reggie Aquara (p. 56)

Born in 1982 in Bandung, West Java, Indonesia.

Selected group exhibitions
• 2010
Reality Effects, Galeri Nasional Indonesia, Jakarta.
Recreate x Reality x Representation 15 x 15 x 15, Galeri Soemardja, Bandung, West Java.
Recent Art from Indonesia: Contemporary Art-Turn, SBin Art Plus, Singapore.
Bandung New Emergence Vol. 3, Selasar Sunaryo Art Space, Bandung, West Java.
The Final Judgement, Umahseni@Mentengartspace, Jakarta.
Almost White Cube, CG Art Space, Plaza Indonesia, Jakarta.
Halimun, Lawangwangi Artpark Launching, Bandung, West Java.
• 2009
Post Mortem, Vanessa Artlink, Jakarta.
Bazaar Art Jakarta 2009, Pacific Place, Jakarta.
Restart – Recollection, D'gallery, Jakarta.
Bandung Expanding, Tonyraka Art Gallery, Ubud, Bali.
Imagined Portraits, Galeri Soemardja, Bandung, West Java.
Trans-Allegory, a group exhibition by Cecep M. Taufik, M. Reggie Aquara & Yogie Achmad Ginanjar, Galeri Roemah Roepa, Jakarta.
• 2008
Salim/Siapa Salim, Galeri Nasional Indonesia, Jakarta.
Bandung Initiative #1 (Conversation Pieces), Galeri Roemah Roepa, Jakarta.
Masa Sunda Aksara Muda, Galeri Kita, Bandung, West Java.
Bandung Contemporary Artists, Soft Launching, Galeri Roemah Roepa, Jakarta.
Linescape Exhibition, Space 59, Bandung, West Java.
• 2007
Pameran 20 Perupa Muda Bandung, Congo Gallery, Bandung, West Java.
Festival Tanda Kota, Galeri Cipta II, Taman Ismail Marzuki, Jakarta.
Capo Exhibition, Common Room, Bandung, West Java.
1001 Cover Concept Exhibition, Senayan Plaza, Jakarta.
• 2006
36 Frame, Artepolis Exhibition, Architect IT, Bandung, West Java.
12th Button (Buton Kultur 21) launching, openhouse & exhibition, Bandung, West Java.
Place, Ground, Practice, Asia Pacific New Media Arts, New Zealand.
• 2005
Bandung Video Checkpoint, video art screening, Common Room, Bandung, West Java.
Textrorizm, Bandung Art Project, Bandung, West Java.
I (Play) Therefore I Am, Galeri Nasional Indonesia, Jakarta.
Brit Nite Out, video music screening, Amare Lounge, Bandung, West Java.
• 2004
Steallife, Galeri Soemardja, Bandung, West Java.

Dewa Ngakan Made Ardana (p. 60)

Born in 1980 in Semarapura, Bali.

Solo exhibitions
• 2010
Beyond Still Life, Galeri Semarang at Jakarta Art District, Jakarta.
Yogyakarta, Juni 1812, Galeri Nasional Indonesia, Jakarta.
• 2009
Anonymous Project, Galeri Semarang, Semarang, Central Java.
• 2008
On Content and Messages, Ark Galerie, Jakarta.
• 2004
Space In Between, CP Artspace, Jakarta.

Group exhibitions
• 2010
Magainin, Jakarta Art District, Grand Indonesia, Jakarta.
• 2008
Art with an Accent, A1 Association, Art 64, Vanessa Artlink, Shanghai.
Manifesto, Galeri Nasional Indonesia, Jakarta.
A New Force in Southeast Asia, Asian Art Centre, Beijing.
• 2007
Tasty Loops, Galeri Semarang, Semarang, Central Java.
• 2006
Young Arrows, Jogja Gallery, Yogyakarta, Central Java.
Taxu Art Clinic 2006, CP Artspace, Jakarta.
• 2005
TRANS-It, Biasa ArtSpace, Seminyak, Bali.
Urban/Culture, 2nd CP Open Biennale, Museum Bank Indonesia, Jakarta.
Realis(Me) Banal, Gracia Gallery, Surabaya, East Java.
… Reading Realism, Nava Gallery, Denpasar, Bali.
• 2004
Tamarind… In Pursuit of Identity, Nava Gallery, Denpasar, Bali.
Cooking & History, Cemeti Art House, Jogyakarta, Central Java.
• 2003
Interpellation, 1st CP Open Biennale, Galeri Nasional Indonesia, Jakarta.
Caution!!! There is a Taxu Ceremony!, Taxu Art Clinic, Denpasar, Bali.
• 2002
Attention, Matamera Communication, Denpasar, Bali.
• 2001
Loose, Titik Dua Building, Denpasar, Bali.
Sesari, Kuta News Anniversary, Titik Dua Building, Denpasar, Bali.
• 2000
Rare '99, Bali Museum, Denpasar, Bali.

Samsul Arifin (p. 64)

Born in 1979 in Malang, East Java, Indonesia.

Solo exhibitions
• 2010
The Maker, Ark Galerie, Jakarta.
• 2008
Goni's Journey # 1, Galeri Semarang, Semarang, Central Java

Selected group exhibitions
• 2011
Closing the Gap: Indonesian Contemporary Art, MIFA Gallery, Melbourne, Australia.
• 2010
Art|Jog|10. Indonesian Art Now: The Strategies of Being, Taman Budaya, Yogyakarta, Central Java.
Artpreneurship. Space & Image, Ciputra World Marketing Gallery, Jakarta.
Soccer Fever, Galeri Canna, Jakarta.
• 2009
Jogja Jamming, 10th Jogja Biennale at Jogja National Museum, Yogyakarta, Central Java.
In Rainbow, Esa Sampoerna Art House, Surabaya, East Java.
Jogja Art Fair #2, Taman Budaya, Yogyakarta, Central Java.
IVAA Archive AID, Galeri Nasional Indonesia, Jakarta.
• 2008
Refresh: New Strategies in Indonesian Contemporary Art, Valentine Willie Fine Art, Singapore.
A Slice of Indonesian Contemporary Art, Soka Art Center, Beijing.
Jogja Art Fair #1, Taman Budaya, Yogyakarta, Central Java.
Manifesto, Galeri Nasional Indonesia, Jakarta.

Awards
• 2003
The Best 7th Nomination, Pratisara Affandi Adhikarya, Indonesia.
• 2001
The Best Glass, ISI, Yogyakarta, Central Java.
The Best Water Colour Painting, ISI, Yogyakarta, Central Java.
The Best Sketch, ISI, Yogyakarta, Central Java.

Ay Tjoe Christine (p. 68)

Born in 1973 in Bandung, West Java, Indonesia.

Solo exhibitions
• 2010
Symmetrical Sanctuary, SIGIarts Gallery, Jakarta.
Lama Sabachthani Club, Lawangwangi Artpark Launching, Bandung, West Java.
• 2009
Panorama without Distance, Hong Kong Art Fair, Hong Kong Convention & Exhibition Centre.
Eating Excess, Singapore Tyler Print Institute, Singapore.

• 2008
Interiority of Hope, Emmitan CA Gallery,
Surabaya, East Java.
Wall Prison (Part Two), Scope Miami Art Fair,
Miami, Florida.
• 2007
Silent Supper, Ark Galerie, Jakarta.
• 2006
Ego Execution, Edwin's Gallery, Jakarta.
• 2003
Reach Me, Cemeti Art House, Yogyakarta,
Central Java.
Aku/ Kau/ Uak, Edwin's Gallery, Jakarta.
• 2002
At the Day of German Unity, German Embassy,
Jakarta.
• 2001
Open To See, RedPoint Gallery, Bandung,
West Java.

Group exhibitions
• 2011
Closing the Gap: Indonesian Art Today,
Melbourne International Fine Art, Melbourne and
Victoria, Australia.
• 2010
Art Paris, Grand Palais, Champs Elysées, Paris.
Shanghai Contemporary 2010, Shanghai.
• 2009
Bandung Art Now, Galeri Nasional Indonesia,
Jakarta.
Enam Pekan Perempuan, Galeri Salihara, Jakarta.
Awareness. Indonesian Art Today, Canvas
International Art, Amsterdam.
Indonesia Contemporary Drawing, Galeri
Nasional Indonesia, Jakarta.
• 2008
*International Print Talk: From the Dark
Background of Etchings*, Ark Galerie, Jakarta.
CIGE 2008, China World Trade Center, Beijing.
*Expose #1. A Presentation of Indonesian
Contemporary Art by Deutsche Bank & Nadi
Gallery*, Four Seasons Hotel, Jakarta.
Manifesto, Galeri Nasional Indonesia, Jakarta.
E-motion, Galeri Nasional Indonesia, Jakarta.
180 x 180, One Gallery, Jakarta.
Hello Print!, Edwin's Gallery, Jakarta.
A Decade of Dedication: Ten Years Revisited,
Selasar Sunaryo Art Space, Bandung, West Java.
Shanghai Contemporary 2008, Shanghai.
• 2007
Indonesian Contemporary Art Now, Nadi Gallery,
Jakarta.
China International Gallery Exposition 2007,
China World Trade Center, Beijing.
Anti Aging, Gaya Fusion Art Space,
Ubud, Bali.
Intimate Distance, Indonesian Women Artists,
Galeri Nasional Indonesia, Jakarta.
Conscience Celebrated, Gandaria Heights, Jakarta.
Shanghai Contemporary 2007, Main Fountain
Square, Shanghai Exhibition Center, Shanghai.
The 22nd Asian International Art Exhibition,
Selasar Sunaryo Art Space, Bandung,
West Java.
Petisi Bandung, Langgeng Gallery, Magelang,
Central Java.
Kuota 2007, Galeri Nasional Indonesia, Jakarta.

• 2006
Trail in Trail, Goethe Haus, Goethe-Institut,
Jakarta.
China International Gallery Exposition,
China World Trade Center, Beijing.
Langgeng Contemporary Art Festival 2006,
Langgeng Gallery, Magelang, Central Java.
• 2005
*Taboo and Transgression in Contemporary
Indonesian Art*, Johnson Museum, Cornell
University, New York.
The Beppu Asia Biennale of Contemporary Art,
Beppu Art Museum, Beppu, Oita Prefecture,
Japan.
Love Symbol, Edwin's Gallery, Jakarta.
Jejak–Jejak Drawing, Edwin's Gallery, Jakarta.
21th and Beyond, Edwin's Gallery, Jakarta.
Vision & Resonance, Asian Civilization Museum,
Singapore.
Bandung Petition, Langgeng Gallery, Magelang,
Central Java.
Fragments–KII 13, Edwin's Gallery, Jakarta.

Awards and residencies
• 2009
2009 Scmp Art Futures Prize Winner, Hong Kong
Art Fair, Hong Kong.
• 2008
Artist in Residence in STPI, Singapore.
• 2001
Top 5 of Philip Morris Indonesian Art Award.

Wimo Ambala Bayang (p. 72)

Born in 1976 in Magelang, Central Java,
Indonesia.

Solo exhibitions
• 2010
Not So High (Heels), D'gallery, Jakarta.
• 2009
Wimo Film and Video Festival, Kedai Kebun
Forum, Yogyakarta, Central Java.
• 2003
Select All, Ruang MES 56, Yogyakarta,
Central Java.

Selected group exhibitions
• 2010
Landing Soon, Erasmus Huis, Jakarta.
Look! See?, Nadi Gallery, Jakarta.
*Cut 2010. New Photography from Southeast
Asia*, Parallel Universe, Valentine Willie Fine Art,
Kuala Lumpur, Malaysia.
There is Still Gus Dur (Masih Ada Gus Dur),
Langgeng Gallery, Magelang, Central Java.
Look! (Lihat!). Video Art from Indonesia, Galería
Jesús Gallardo, Instituto Cultural de León, León,
Mexico.
Contemporaneity: Contemporary Art in Indonesia,
Museum of Contemporary Art, Shanghai.
*OK. Video – Jakarta International Video Festival.
A Retrospective*, Art And Culture International
e.V., KunstBüroBerlin, Berlin.
• 2009
Landing Soon #7, Heden, The Hague.
Arena, Jakarta 12th Biennale, Galeri Nasional
Indonesia, Jakarta.

Comedy, OK Video Festival, Galeri Nasional,
Jakarta.
Topology of Flatness, Edwin's Gallery, Jakarta.
The South Project, Kedai Kebun Forum,
Yogyakarta, Central Java.
South Project, Melbourne Reflection, Bus Project,
Melbourne, Australia.
• 2008
The Past – The Forgotten Time, National
Museum, Singapore.
*Defenders of Video From Indonesia / Australia,
Next 2008*, Art Chicago, Chicago, Illinois.
Overload, LIP, Centre culturel français,
Yogyakarta, Central Java.
Manifesto, Galeri Nasional Indonesia,
Jakarta.
Interaction XXI 2008, Associazione Culturale
Arka, Assemini, Sardinia, Italy.
Cut 2: New Photography from Southeast Asia,
Valentine Willie Fine Art, Singapore.
The Mask as an Intermediary, Heden,
The Hague.
Taiwan International Video Art, Hong Gah
Museum, Taipei.
Dynamic Duo, Langgeng Gallery, Magelang,
Central Java.
Havana Affair, One Gallery, Jakarta.
A Survey of Contemporary Indonesian Art,
Melbourne, Australia.
• 2007
The Past – The Forgotten Time, BizArt,
Shanghai; Rumah Seni Yaitu, Semarang,
Central Java; Erasmus Huis, Jakarta; Cemeti
Art House, Yogyakarta, Central Java;
The Netherlands Institute of War Documenation,
Amsterdam; Artotheek, The Hague,
The Netherlands.
Militia, Third OK Video Festival, Galeri Nasional
Indonesia, Jakarta.
*Punkasila, 5th Asia-Pasific Triennial of
Contemporary Art*, Gallery of Modern Art,
Brisbane; Ding Dong Lounge, Melbourne,
Australia.
• 2006
Young Arrows, Jogja Gallery, Yogyakarta,
Central Java.
Bitmap, Loop, Seoul, South Korea.
Beauty Contest, Insomnium, Malang,
East Java.
Going Digital, Theater Kikker, Utrecht,
The Netherlands.
• 2005
Di Sini & Kini, 8th Jogja Biennale, Taman Budaya,
Yogyakarta, Central Java.
Ayis, video screening, Konan Women's College,
Japan.
Where Troubles Melt Like Lemon Drops,
Koninklijke Academie voor Schone
Kunsten, Hogeschool Antwerpen, Antwerp,
Belgium.
Video Works Screening, Yunnan Art Academy,
Kunming, Yunnan Province, China.
Jianghu IX, ALAB, Kunming, Yunnan Province,
China.
Urban/Culture, 2nd CP Open Biennale, Museum
Bank Indonesia, Jakarta.
I'm Not a Good Interpreter!, ALAB, Kunming,
Yunnan Province, China.

Awards and residencies
• 2009
South Project/Monash, Melbourne, Australia.
Heden Kunst Van Nu, The Hague.
• 2005
Lijiang Studio, Kunming and Lijiang, Yunnan
Province, China.

Dadang Christanto (p. 76)

Born in 1957 in Tegal, Central Java, Indonesia.

Solo exhibitions
• 2007
Work of Body, Jan Manton Art Gallery, Brisbane,
Australia.
• 2006
Pilgrim Project, Gaya Fusion Art Space,
Ubud, Bali.
• 2005
Testimonies of the Trees, CP Artspace, Jakarta.
Heads and Trees, Sherman Gallery, Sydney.
They Give Evidence, Asian Gallery, Art Gallery of
New South Wales, Sydney.
• 2004
Head from the North, Marsh Pond, Sculpture
Garden, National Gallery of Australia,
Canberra, Australia.
• 2002
Unspeakable Horror, Bentara Budaya, Jakarta.
• 2001
The Dark Century, Raft Art Space, Darwin,
Australia.
• 2000
Beginning of the Dark Age, Centre de réflexion
sur l'image et ses contextes, Sierre, Switzerland.
Reconciliation, 24 Hour Art Gallery,
Darwin and Watch This Space, Alice Springs,
Australia.

Group exhibitions
• 2007
Imagined Affandi, Indonesian Archive Building,
Jakarta.
Threshold and Tolerance, School of Art Gallery,
Australian National University, Canberra,
Australia.
• 2006
Echigo-Tsumari Triennial, Niigata, Japan.
Artery Inaugural Exhibition, Singapore
Management University, Singapore.
• 2005–06
Open Letter, touring exhibition, Sydney, Bangkok,
Manila and Kuala Lumpur, Malaysia.
• 2005
Echoes of Home, Museum Brisbane, Brisbane,
Australia.
Future Tense: Security and Human Right, Dell
Gallery, Griffith Univerity, Brisbane, Australia.
• 2004
Contact Pre Text Me, Sherman Galleries,
Sydney.
Contemporary Territory, Museum and Art Gallery
Northern Territory, Darwin, Australia.
• 2003
They Give Evidence, opening exhibition for
Contemporary Asian Space, Art Gallery of
New South Wales, Sydney.

Country-Bution, Yogyakarta Biennale,
Yogyakarta, Central Java.
Interpellation, 1st CP Open Biennale, Galeri
Nasional Indonesia, Jakarta.
Witnessing to Silence: Art and Human Rights,
School of Art Gallery, Australian National
University, Canberra, Australia.
Mourning Lost Paradise, Indonesian Pavilion,
Venice Biennale, Venice.
Austral-Asia Zero Three, Sherman Galleries,
Sydney.
• 2000
Gwangju Biennale 2000, Gwangju, South Korea.
From Asian Forests, Yokohama open-air art
exhibition, Yokohama, Japan.

Grants and awards
• 2004
Australian Art Council.
• 1997
The Pollock-Krasner Foundation, New York.

S. Teddy D. (p. 80)

Born in 1970 in Padang, West Sumatra,
Indonesia.

Solo exhibitions
• 2010
Role Play (Sandiwara), Sin Sin Fine Art, Hong
Kong.
War, Ark Galerie, Jakarta.
• 2009
Love Tank (The Temple), National Museum,
Singapore.
I Want to Be Your Nest, Emmitan CA Gallery,
Surabaya, East Java.
• 2008
Meditation of Peanut, CIGE, organized by
Langgeng Gallery, Beijing.
• 2007
Pictura, Nadi Gallery, Jakarta.
• 2001
Metallic Shit, Cemeti Art House, Yogyakarta,
Central Java.
• 2000
Essence Art Gallery, Jakarta.

Selected group exhibitions
• 2011
The Alleys of a City Named Jogya, Primo Marella
Gallery, Milan.
• 2010
Indonesian Contemporary Art, Beijing.
*Art|Jog|10. Indonesian Art Now: The Strategies of
Being*, Taman Budaya, Yogyakarta, Central Java.
Rehorny, Jogja National Museum, Yogyakarta,
Central Java.
Art Amsterdam, RAI Exhibition Centre, Amsterdam.
Post Psychedelia, Selasar Sunaryo Art Space,
Bandung, West Java.
• 2009
Jogja Art Fair #2, Taman Budaya, Yogyakarta.
Bazaar Art Jakarta 2009, Pacific Place, Jakarta.
Reach for the Heart, Sin Sin Fine Art, Hong Kong.
Drawing, Galeri Nasional Indonesia, Jakarta.
Emotional Drawing, Drawing Centre at Seoul
Olympic Museum of Art, Seoul.

• 2008
*Strategies Towards the Real. S. Sudjojono and
Contemporary Indonesian Art*, NUS Museum,
Singapore.
Indonesian Invasion, Sin Sin Fine Art, Hong Kong.
SH Contemporary 08, organized by Langgeng
Gallery, Shanghai.
Imagining Asia, 22nd Asian International Art
Exhibition, Selasar Sunaryo Art Space, Bandung,
West Java.
Drawing in Emotion, Museum of Modern Art,
Tokyo.
*Bentuk-Bentuk: Contemporary Indonesia Art in
3D*, Melbourne Art Fair, Melbourne, Australia.
• 2007
Thermocline of Art: New Asian Waves, ZKM,
Karlsruhe, Germany.
Indonesian Invasion, Sin Sin Fine Art, Hong Kong.
Leftover (Sisa), Technology University, Sydney.
• 2006
Signed and Dated, 10th Anniversary, Valetine
Willie Fine Art, Kuala Lumpur, Malaysia.
• 2005
Culturen in Contact II, Museum Het Oude
Raadhuis, Urk, The Netherlands.
*Vision and Resonance, Asian Contemporary
Inaugural Exhibition*, River Room Gallery, Asian
Civilization Museum, Singapore.
• 2004
*Multi Sub-Culture, Two-Dimensional Indonesian
Fine Art*, Berlin.
• 2003
Children Art Lover, NIK Gallery, Seoul.
• 2002
Under Construction, Japan Foundation, Tokyo
Opera City, Tokyo.
• 2001
Osaka Triennial, Osaka Culture Foundation,
Osaka, Japan.
Not I, Am I, Circle Point Gallery, Washington, DC.
• 2000
Mixed Visual Art (Seni Rupa Campur), Centrum
Beeldende Kunst, Dordrecht, The Netherlands.
Where About, Stichting Zet, Amsterdam.

Awards
• 2001
Twelve Choice Lucky Strike Young Talented Artists
(sculpture artist), Gedung 28, Jakarta.
• 2000
The Best Five Finalist Philip Morris Indonesian Art
Awards.

Andy Dewantoro (p. 84)

Born in 1973 in Tanjung Karang, Sumatra,
Indonesia.

Selected solo exhibitions
• 2010
Empty Space – Landscapes, Galeri Semarang,
Semarang, Central Java.
• 2008
Silent World, Ark Galerie, Jakarta.
• 2007
Shade of Colors, Four Seasons, Jakarta.
• 2006
Floating, Galeri Hidayat, Bandung, West Java.

Selected group exhibitions
• 2011
Art Stage Singapore 2011, Marina Bay Sands, Singapore.
• 2010
ArtIJogI10. Indonesian Art Now: The Strategies of Being, Taman Budaya, Yogyakarta, Central Java.
Contemporaneity: Contemporary Art in Indonesia, Museum of Contemporary Art, Shanghai.
Reach for the Heart 10/11, Sin Sin Fine Art, Hong Kong.
Cold Memories, Vivi Yip Art Room, Jakarta.
Artpreneurship. Space & Image, Ciputra World Marketing Gallery, Jakarta.
Bandung Initiative #5: Veduta, Vanessa Artlink, Jakarta.
• 2009
Layer of Visuality, Artsphere Gallery, Jakarta.
Pan Amsterdam 2009, RAI Exhibition Centre, Amsterdam.
Two Sides of Solitude, Garis Art Space, Jakarta.
Diverse: 40 x 40, Sin Sin Fine Art, Hong Kong.
Nature Peace, Geumgang Nature Art Pre Biennale 2009, Geumgang, South Korea.
Indonesia Young Artists Exhibition 2009, Cheongju Arts Center, Cheongju, South Korea.
Jogja Art Fair #2, Taman Budaya, Yogyakarta, Central Java.
The Korkep: 35th International Art Camp's Exhibition, Lazarea Castle, East Transylvania, Romania.
Awareness. Indonesian Art Today, Canvas International Art, Amsterdam.
Hybridization, North Art Space, Jakarta.
• 2008
Jogja Art Fair #1, Taman Budaya, Yogyakarta, Central Java.
At a Party, V Art Gallery, Yogyakarta, Central Java.
Manifesto, Galeri Nasional Indonesia, Jakarta.
Young Contemporary Southeast Asian, Richard Koh Fine Art, Kuala Lumpur, Malaysia.
Ruang & Subyek, Lontar Gallery, Jakarta.
• 2007
Artvertising, Galeri Nasional Indonesia, Jakarta.
• 2006
Simplicity, Galeri Canna, Jakarta.
• 2005
Spring Festival, Four Seasons, Jakarta.
• 2004
Abstract, Toimoi, Jakarta.

Residencies
• 2009
Art Camp Lazarea, Gyergyószárhegy, East Transylvania, Romania.

I Made Widya Diputra (p. 88)

Born in 1981 in Lampung, South Sumatra, Indonesia.

Solo exhibitions
• 2010
White Lotus, Mon Decor Art Gallery, Jakarta Art District, Jakarta.

Group exhibitions
• 2011
Bandung Contemporary Art Award (Bacaa), Lawangwangi Artpark Launching, Bandung, West Java.
1001 Doors: Reinterpreting Traditions, Ciputra World Marketing Gallery, Jakarta.
• 2010
Bazaar Art Jakarta 2010, Art Sociates, Langgeng Gallery, Pacific Place, Jakarta.
ArtIJogI10. Indonesian Art Now: The Strategies of Being, Taman Budaya, Yogyakarta, Central Java.
Answering Question Marks, Bentara Budaya, Yogyakarta, Central Java.
Artpreneurship. Space & Image, Ciputra World Marketing Gallery, Jakarta.
Survey I.10, Edwin's Gallery, Jakarta.
Halimun, Lawangwangi Artpark Launching, Bandung, West Java.
Two Cities Two Stories, Galeri Semarang, Semarang, Central Java.
The Object in Sculpture, Griya Santrian Gallery, Sanur, Bali.
• 2009
Jogja Jamming, 10th Jogja Biennale at Joqja National Museum, Yogyakarta, Central Java.
Exposigns. Great Exhibition of Indonesian Visual Art, 25th Institut Seni Indonesia (ISI) at Jogja Expo Center, Jogyakarta, Central Java.
Fun September (September Ceria), 3rd anniversary of Jogja Gallery, Jogja Gallery, Yogyakarta, Central Java.
Jogja Art Fair #2, Taman Budaya, Yogyakarta, Central Java.
Up & Hope, D'Peak Art Space, Jakarta.
Truck Dies with Its Baby (Kunduran Truk), Kersan Art Studio, Yogyakarta, Central Java.
In Rainbow, Esa Sampoerna Art House, Surabaya, East Java.
Poly[chromatic], V-Art Gallery, Bentara Budaya, Yogyakarta, Central Java.
• 2008
SDI Now, Tonyraka Art Gallery, Ubud, Bali.
Nostalgia, Joglo Seni ARTsociates, Yogyakarta, Central Java.
New Sculptures from Jogja, Tembi Contemporary, Yogyakarta, Central Java.
Jogja Art Fair #1, Taman Budaya, Yogyakarta.
Loro Blonyo, Tri Bhakti House, Magelang, Central Java.
Hibridity: Bali Art Now, Jogja Gallery, Yogyakarta, Central Java.
Carousel, Jogja Gallery, Yogyakarta, Central Java.
Survey, Edwin's Gallery, Jakarta.
Reinventing Bali, Sanggar Dewata Indonesia, Sangkring Art Space, Yogyakarta, Central Java.
• 2007
Tribute to Young Artists, Sangkring Art Space, Yogyakarta, Central Java.
Here We Come, Sangkring Art Space, Yogyakarta, Central Java.
Dies Natalis XXIII, Institut Seni Indonesia, Yogyakarta, Central Java.
• 2006
The Error One, Kinoki, Yogyakarta, Central Java.
The Bad, Galeri Biasa, Yogyakarta, Central Java.
Wedding, Tobacco & Art OHD, Tri Bhakti House, Magelang, Central Java.

Ordinary Art, Bale Rupa SDI, Sewon Bantul, Yogyakarta, Central Java.
• 2005
Multy Happy Dimensional, Ruang Per Ruang #3, Third Eye Studio, Jakarta.
Biennale Bali, Sika Gallery, Ubud, Bali.
Dari 15 cm³ =…., Kelompok Kakul, Parkir Space, Yogyakarta, Central Java.
Eating Visual Art (Makan Seni Rupa), Jurug Sewon Bantul, Yogyakarta, Central Java.
Glass And Cup (Gelas & Cangkir), Parkir Space, Yogyakarta, Central Java.
Inside Out, Ruang Per Ruang #2, Via-Via Café Prawirotaman, Yogyakarta, Central Java.
• 2004
Inside Out, Ruang Per Ruang #2, Jurug Sewon Bantul, Yogyakarta
Open the Door (Buka Pintu), Kelompok Kakul, Bale Rupa Sdi, Yogyakarta
Having Fun, Sanggar Dewata Indonesia, Langgeng Gallery, Magelang, Central Java.
• 2003
Spirit of the Soul, Bale Rupa SDI, Yogyakarta, Central Java.
Termogram, Sanggar Dewata Indonesia, Museum Neka, Ubud, Bali.
• 2002
Togetherness 32th SDI, Taman Budaya, Yogyakarta, Central Java.
Enviromental Art Sand Statue (Patung Pasir), Kuta, Bali.

Awards
• 2010
25 Best Art Work, Bandung Contemporary Art Awards.

Heri Dono (p. 92)

Born in 1960 in Jakarta, Indonesia.

Selected solo exhibitions
• 2009
Shadow of Trojan Horse, Tondi Gallery, Medan, North Sumatra.
Heridonology, Jogja Gallery, Yogyakarta, Central Java.
• 2008
Post-Ethnology Museum, Gaya Fusion Art Space, Ubud, Bali.
Nobody's Land, Galeri Nasional Indonesia, organised by Edwin's Gallery, Jakarta.
Ose Tara Lia – I See Nothing, Ozasia Festival, Art Space, Adelaide Festival Centre, Adelaide, Australia.
Heri Dono: Pleasures of Chaos, Walsh Gallery, Chicago, Illinois.
• 2007
Angels: Bang! Bang!, Sherman Galleries, Sydney.
The Dream Republic, SASA Gallery, University of South Australia, Adelaide, Australia.
• 2006
Heri War Dono, Galeri Soemardja, Bandung, West Java.
Civilization of Oddness, Walsh Gallery, Chicago, Illinois.
• 2005
Free-D.O.M., 3,14 Stiftelsen, Bergen, Norway.

- 2004
Who's Afraid of Donosaurus, Galeri Nasional Indonesia, Jakarta.
- 2003
Upside Down Mind, Circle Point Art Space, Washington, DC.
Heri Dono, Australian Print Workshop, Melbourne, Australia.
Heri Dono. A Spiritual Journey, Galeri Semarang, Semarang, Central Java.
- 2002
Interrogation, Center A, Vancouver.
Heri Provokes Heri, Nadi Gallery, Jakarta.
Reworking Tradition I & II, Singapore Art Museum, Glass Hall, Nanyang Playhouse, National Institute of Education, Singapore.
- 2001
Trap's Outer Rim, Cemeti Art House, Yogyakarta, Central Java.
Fortress of the Heart, Gajah Gallery, Singapore.
- 2000
Dancing Demons and Drunken Deities, The Japan Foundation Forum, Tokyo.

Selected group exhibitions
- 2008
Reflection of Time and Space, V-Art Gallery, Bentara Budaya, Yogyakarta, Central Java.
Self Portrait, Jogja Gallery, Yogyakarta, Central Java.
A Decade of Dedication: Ten Years Revisited, Selasar Sunaryo Art Space, Bandung, West Java.
Christmas, VWFA, Manila.
After Forty, Sangkring Art Space, Yogyakarta, Central Java.
Expose #1. A Presentation of Indonesian Contemporary Art by Deutsche Bank & Nadi Gallery, Four Seasons Hotel, Jakarta.
Manifesto, Galeri Nasional Indonesia, Jakarta.
A New Force of South East Asia, Asia Art Centre, Beijing.
CIGE 2008 (China International Gallery Exposition), Nadi Gallery, Beijing.
- 2007
Neo Nation, 9th Jogja Biennale at Jogja National Museum, Yogyakarta, Central Java.
The Wind from the East, Kiasma Contemporary Art Museum, Helsinki.
Imagined Affandi, Indonesian Archive Building, Jakarta.
Soft Power, Asian Attitude, Zendai MoMA Museum, Shanghai.
Re-Creation 80, Class of 1980 ASRI, STSRI ASRI, ISI Reunion, Jogja National Museum, Yogyakarta, Central Java.
- 2006
The Inoyama Donation: A Tale of Two Artists, Singapore Art Museum, Singapore.
Gwangju Biennale, Gwangju, South Korea.
- 2005
Exhibition of Indoor Collections, Kirishima Open-Air Museum, Kagoshima, Japan.
About Beauty, Haus der Kulturen der Welt, Berlin.
Beta. 20, Post Electronic Art Performances, Theatre Garasijn, Bergen, Norway.
Inspiration Festival Dewaruci, performance, Byron Bay, Australia.

Floating Legacies, Selasar Sunaryo Art Space, Bandung, West Java.
Licking the Ozone, performance, Melbourne Fringe Festival, Lithuanian Club, Melbourne, Australia.
Belonging, Sharjah International Biennial, Sharjah, United Arab Emirates.
Biennale Internazionale dell'Arte Contemporanea di Firenze, Fortezza da Basso, Florence.

Awards
- 2003
2nd Annual Enku Grand Awards, Gifu Prefectural Government, Japan.
Yogyakarta Art Prize, Sri Sultan Hamengkubuwono X, Yogyakarta, Central Java.
- 2000
UNESCO Prize for the International Art Biennial, Shanghai.

Public collections
Deutsche Guggenheim Frankfurt (Deutsche Bank AG Frankfurt), Germany.
Artoteek Den Haag, The Netherlands.
Fukuoka Art Museum, Fukuoka, Japan.
Kirishima Open-Air Museum, Kagoshima, Japan.
Museum der Kulturen, Basel, Switzerland.
National Gallery of Australia, Canberra, Australia.
Okinawa Art Museum, Okinawa, Japan.
Queensland Art Gallery, Brisbane, Australia.
Singapore Art Museum, Singapore.
Stedelijk Museum de Lakenthal, Leiden, The Netherlands.

Hanafi (p. 96)

Born in 1960 in Purworejo, Central Java, Indonesia.

Solo exhibitions
- 2010
At Fifty, Komaneka Fine Art Gallery, Ubud, Bali; Galeri Nasional Indonesia, Jakarta.
- 2009
Swan Song. Bandung Recalled Rendra, Indonesia Sue Building, Bandung, West Java.
Of Spaces and Shadows, Selasar Sunaryo Art Space, Bandung, West Java; Galeri Salihara, Jakarta.
- 2007
Enigma, O House Gallery, Jakarta.
Home of Images, Museu d'Art de Girona, Girona, Spain.
Darkness, Taksu Gallery & Cream, Singapore.
Foreign People, The Arts House, Singapore.
Id, O House Gallery, Jakarta and Jogja Gallery, Yogyakarta, Central Java.
- 2006
Id, O House Gallery, Galeri Nasional Indonesia, Jakarta.
Configu(Art)Ion, Espai[B] Contemporary Gallery, Barcelona.
Reading Hand Language, Taksu Gallery, Jakarta.
- 2005
Three Days in Shoes, Bentara Budaya, Jakarta.

Selected group exhibitions
- 2011
1001 Doors: Reinterpreting Traditions, Ciputra World Marketing Gallery, Jakarta.
- 2010
Tramendum, Galeri Nasional Indonesia, Jakarta.
Crossing and Blurring the Boundaries: Medium in Indonesian Contemporary Art, Andi's Gallery and Galeri Nasional Indonesia, Jakarta.
Sign and After, Lawangwanqi Artpark Launching, Bandung, West Java.
Time Conversation, Galeri Nasional Indonesia, Jakarta.
Artpreneurship. Spaces & Images, Ciputra World Marketing Gallery, Jakarta.
- 2009
Art/Ention Hotel, Indonesian Contemporary Art and Design, Grand Kemang Hotel, Jakarta.
Common Sense, Galeri Nasional Indonesia, Jakarta.
Gift #2, Think Outside the Box, Nadi Gallery, Jakarta.
2nd Odyssey, Srisasanti Gallery, Yogyakarta, Central Java.
Bazaar Art Jakarta 2009, Pacific Place, Jakarta.
The Running Stars, North Art Space, Jakarta.
Hybridization, North Art Space, Jakarta.
Vox Populi, Sangkring Art Space, Yogyakarta, Central Java and Bentara Budaya, Jakarta.
Revisiting the Last Supper, CG Art Space, Plaza Indonesia, Jakarta.
- 2008
Love Letter on the Twelfth Month, O House Gallery, Jakarta
Self Portrait. Famous Living Artists of Indonesia, Jogja Gallery, Yogyakarta, Central Java.
History and Floor Coming Upward, O House Gallery, Jakarta
From Prison to Frame (Dari Penjara Ke Pigura), Galeri Salihara, Jakarta.
Art Beijing 2008, Beijing.
This Is It (Ini Baru Ini), Vivi Yip Art Room, Jakarta.
Indonesia Contemporary All Star, Tujuh Bintang Art Space, Yogyakarta, Central Java.
E-Motion, Galeri Nasional Indonesia, Jakarta.
Manifesto, Galeri Nasional Indonesia, Jakarta.
Art Shanghai, Shanghai.
- 2007
Neo Nation, 9th Jogja Biennale at Taman Budaya, Yogyakarta, Central Java.
The 12th Guangzhou International Art Fair, Guangzhou, China.
200th Raden Saleh, Jogja Gallery, Yogyakarta, Central Java.
Man, Come On, Man! (Bung Ayo Bung!), 100 Years of Affandi Exhibition, Museum Affandi, Yogyakarta, Central Java.

Awards
- 2005
Top 10 Golden Palette, Ancol, Jakarta.
- 2003
Finalis Indofood Art Awards.
- 1997
Top 10 Philip Morris Art Award.

Eddie Hara (p. 100)

Born in 1957 in Salatiga, Central Java, Indonesia. Currently lives and works in Basel.

Selected solo exhibitions
• 2011
Nadi Gallery, Jakarta.
• 2007
Global Warming, Cool Art!, Nadi Gallery, Jakarta.
• 2005
Captain Fuck & Co, Galeri Canna, Jakarta.
• 2004
We Are Not Alone. Lost Heroes and Sensible Weirdoes, Jendela Art Space, Esplanade, Singapore.
• 2003
Blues for Mimmo, Eulenspiegel Galerie, Basel.
The Beasts in Me, Chouinard Gallery, Hong Kong.
• 2002
Sweat Beasts, Galeri Semarang, Semarang, Central Java.
• 2001
Carnival of the Fools, Ost–West Galerie, Riehen, Switzerland.
Postcards from the Alps, Öffentliche Fachbibliothek Schüle für Gestaltung, Basel.
• 2000
Work on Paper, Bentara Budaya, Yogyakarta, Central Java.
• 1999
Artrock 99, La Passerelle, Saint-Brieuc, France.
Sweet Beast, Atelier Katharina F, Basel.

Selected group exhibitions
• 2011
Art Amsterdam, Artipoli Gallery, Noorden, The Netherlands.
Finding Me, Galeri Semarang, Semarang, Central Java.
• 2010
Art Hong Kong, Hong Kong (with Nadi Gallery, Jakarta).
Art Amsterdam, with Artipoli Gallery, Noorden, The Netherlands.
Jazzcraft Vaganza, Kota Baru Parahyangan, Bandung, West Java.
Emptiness, International Art Redlight, Amsterdam.
• 2009
Jogja Jamming, 10th Jogja Biennale at Jogja National Museum, Yogyakarta, Central Java.
Beyond the Dutch. Indonesia, The Netherlands and the Visual Arts from 1900 until Now, Centraal Museum, Utrecht, The Netherlands.
• 2008
Expose #1. A Presentation of Indonesian Contemporary Art by Deutsche Bank & Nadi Gallery, Four Seasons Hotel, Jakarta.
Manifesto, Galeri Nasional Indonesia, Jakarta.
Beyond Cartoon, Beyond Art Space, Beijing.
Indonesian Invasion, Sin Sin Fine Art, Hong Kong.
• 2007
Imagined Affandi, Indonesian Archive Building, Jakarta.
You Say Art We Say Yeah, Daeppen Galerie, Basel.
Indonesian Contemporary Artists, Sin Sin Fine Art, Hong Kong.

• 2005
Invasion of Punks: Christophe Lambert & Eddie Hara, Espace courant d'art, Chevenez, Jura, Switzerland.

Residencies
• 1991
Double Dutch, Stichting Kunst Mondiaal, Tilburg, The Netherlands.
• 1996
IAAB, Christoph Merian Stiftung (CMS), Basel.
• 2004
Studio 106, LASALLE College of the Arts, Singapore.
• 2005
Recyclart, Brussels.

Collections
Deutsche Bank, Jakarta.
Lontar Foundation, Jakarta.
Ministry of Social Affairs, The Hague.
Municipality of Filderstadt, Stuttgart, Germany.
Museum der Kulturen, Basel.
OHD Museum of Modern & Contemporary Indonesian Art, Magelang, Central Java.
Singapore Art Museum, Singapore.
Museum Haji Widayat, Magelang, Central Java.
Zurich Insurance, Jakarta.

FX Harsono (p. 104)

Born in 1949 in Blitar, East Java, Indonesia.

Selected solo exhibitions
• 2010
FX Harsono: Testimonies, Singapore Art Museum, Singapore.
Re:Petition/Position, Langgeng Art Foundation, Yogyakarta, Central Java.
• 2009
The Erased Time, Galeri Nasional Indonesia, Jakarta.
• 2009
Surviving Memories, Vanessa Artlink, Beijing.
• 2008
Aftertaste, Koong Gallery, Jakarta.
• 2007
Point of Pain (Titik Nyeri), Langgeng–Icon Gallery, Jakarta.
• 2004
Mediamor(e)Phosa, Galeri Puri, Malang, East Java.
• 2003
Displaced, Galeri Nasional Indonesia, Jakarta and Cemeti Art House, Yogyakarta, Central Java.

Selected group exhibitions
• 2011
Edge of Elsewhere: Group Exhibition of Artists From Australia, Asia and the Pacific, 4A Centre for Contemporary Asian Art, Sydney.
• 2010
Contemporaneity: Contemporary Art in Indonesia, Museum of Contemporary Art, Shanghai.

Recent Art from Indonesia: Contemporary Art-Turn, SBin Art Plus, Singapore.
Pleasures of Chaos. Inside New Indonesian Art, Primo Marella Gallery, Milan.
Digit(all): Indonesian Contemporary New Media Practices, Umahseni@Mentengartspace, Jakarta.
• 2009
Beyond the Dutch. Indonesia, The Netherlands and the Visual Arts from 1900 until Now, Centraal Museum, Utrecht, The Netherlands.
Face Value. Exhibition of 4 Artists, Agus Suwage, Budi Kustarto, Astari Rasyid and FX Harsono, SIGlarts Gallery, Jakarta.
Technosign, Surabaya Art Link, Surabaya, East Java.
Milestone, Vanessa Artlink, Jakarta.
• 2008
Highlight, ISI, Jogja National Museum, Yogyakarta, Central Java.
Art with Accent. Group Exhibition of Four Countries: China, Japan, Korea and Indonesia, Guangzhou, China.
Allegorical Bodies, A-Art Contemporary Space, Taipei.
Res Publicum, Galeri Canna, Jakarta.
Reflective Asia, 3rd Nanjing Triennale, Nanjing, China.
Manifesto, Galeri Nasional Indonesia, Jakarta.
Space/Spacing, Galeri Semarang, Semarang, Central Java.
• 2007
Kuota 2007, Langgeng–Icon Gallery, Jakarta.
Artchipelago Alert, Tonyraka Art Gallery, Ubud, Bali.
Imagined Affandi, Indonesian Archive Building, Jakarta.
The Past – The Forgotten Time, Cemeti Art House, Yogyakarta, Central Java.
• 2006
Out Now, Singapore Art Museum. Singapore.
Anti Aging, Gaya Fusion Art Space, Ubud, Bali.
• 2005
Kuota 2005, Langgeng–Icon Gallery, Jakarta.
Taboo and Transgression in Contemporary Indonesian Art, Herbert F. Johnson Museum of Art, Cornell University, New York.
Text Me, Sharman Gallery, Sydney.
Goods Exodus, Nadi Gallery, Jakarta.
• 2004
Reformasi, Sculpture Square, Singapore.
• 2003
Exploring Vacuum 2, Cemeti Art House, Yogyakarta, Central Java.
Interpellation, 1st CP Open Biennale, Galeri Nasional Indonesia, Jakarta.
• 2001
Reading Frida Kahlo, Nadi Gallery, Jakarta.
International Print Triennial, Kanagawa, Yokohama, Japan.
Print in the Future, Cemeti Art House, Yogyakarta, Central Java.
• 2000
Reformation of Indonesia: Protest in Beeld, Museum Nusantara, Delft, The Netherlands.
Gwangju Biennale, Gwangju, South Korea.
Half Century of Indonesian Graphics, Bentara Budaya, Jakarta.

Iswanto Hartono (p. 108)

Born in 1972 in Purworejo, Central Java, Indonesia.

Solo exhibitions
• 2010
Museum of Innocence, Galeri Canna, Jakarta.
• 2009
Mood Indigo, Gasatelier Landeshaupstadt, Düsseldorf, Germany.
• 2008
Void, Maruki Museum, Saitama, Japan.
• 2007
Mellow, Gallery K, Tokyo.
Blue, Galeri Soemardja, Bandung, West Java.
• 2006
Oil Incorporated, Cemara 6 Galeri, Jakarta.
• 2005
-45° C, With Mint, O House, Jakarta.
Game Is Not [Yet] Over, Galeri Lawang, Jakarta (with Ak-47).
• 2004
Oil Incorporated: Works in Engine Oil, Red Mill Gallery, Vermont Studio Center, Johnson, Vermont.
• 2002
Nest and Solitude, LIP, Centre culturel françois, Yogyakarta, Central Java.

Selected group exhibitions
• 2010
Manifesto of New Aesthetics: Seven Artists from Indonesia, Institute of Contemporary Art, LASALLE College of the Arts, Singapore.
Only Giving, Expect No Returns (Hanya Memberi Tak Harap Kembali), Galeri Soemardja, Bandung, West Java.
Ecce Homo, Galeri Semarang, Semarang, Central Java
• 2009
Next Nature, Vanessa Artlink and Galeri Nasional Indonesia, Jakarta.
Parcours Interdit, Malkasten Park, Düsseldorf, Germany.
Fluid Zones, Jakarta 13th Biennale, Galeri Nasional Indonesia, Jakarta.
• 2008
What Game Shall We Play Today?, Tokyo Wonder Site, Shibuya, Tokyo.
Labyrinth, Gaya Fusion Art Space, Ubud, Bali (with Hamad Khalaf).
• 2007
Kuota 2007, Galeri Nasional Indonesia, Jakarta.
For the Sake of Mass (Demi Massa), Galeri Nasional Indonesia, Jakarta.
• 2006
Voices from the Forest, Kanagawa, Japan.
• 2005
Urban/Culture, 2nd CP Open Biennale, Museum Bank Indonesia, Jakarta.
Abstract (Scratched), Cemara 6 Galeri, Jakarta.
Transindonesia: Scoping Culture in Contemporary Indonesian Art, Govett-Brewster Art Gallery, New Playmouth, New Zealand.
• 2004
Mapping Indonesian Art, ISCP Open Studio, New York.

Small Works, Kahn Barn, Vermont Studio Center, Johnson, Vermont.
• 2003
Geumgang International Nature Art Exhibition, Gong-Ju Cultural Center, Korea.
• 2002
Geumgang International Nature Art Exhibition, Gong-Ju Cultural Center, Korea.

Residencies
• 2009
Kulturamt Landeshaupstadt, Düsseldorf, Germany.
• 2008
Tokyo Wonder Site, Tokyo.
• 2004
Vermont Studio Center, Johnson, Vermont.

Hayatudin (p. 112)

Born in 1972 in Lampung, South Sumatra, Indonesia.

Solo exhibitions
• 2009
Kota Tanpa Nama, Galeri Semarang, Semarang, Central Java.
• 2006
Survivor, Bentara Budaya, Yogyakarta, Central Java.

Selected group exhibitions
• 2010
Transfiguration, Galeri Semarang at Jakarta Art District, Jakarta.
• 2009
Jogja Jamming, 10th Jogja Biennale at Jogja National Museum, Yogyakarta, Central Java.
Greget 95 Ketik Reg Manjoer, Sangkring Art Space, Yogyakarta, Central Java.
Reflection of Time and Space, V-Art Gallery, Bentara Budaya, Yogyakarta, Central Java.
Reborn, H2 Gallery, Semarang, Central Java.
Utan Kayu Literary Biennale 2009, Galeri Salihara, Jakarta.
• 2008
Indonesia and the Mainstream, CIGE with Galeri Canna, Beijing.
69 Seksi Nian, Jogja Gallery, Yogyakarta, Central Java.
Souvenirs (Cendra Mata VI), Bentara Budaya, Yogyakarta, Central Java and Jakarta.
• 2007
Forgetting the Way Home, Galeri Semarang, Semarang, Central Java.
Force Majeure: Utan Kayu International Literary Biennale, Langgeng Gallery, Magelang, Central Java.
Souvenirs (Cendra Mata V), Bentara Budaya, Yogyakarta, Central Java.
Imagined Affandi, Indonesian Archive Building, Jakarta.
Neo Nation, 9th Jogja Biennale at Societet Militer Building, Yogyakarta, Central Java.
Shanghai Art Fair, Shanghai.
• 2006
Behind Realism, V-Art Gallery, Bentara Budaya, Yogyakarta, Central Java.
Earthquake (Lindu), Bentara Budaya, Yogyakarta, Central Java and Jakarta.

Vice Versa, Taman Budaya, Yogyakarta, Central Java.
Jakarta Art Award, Jakarta.
• 2005
Intermezzo, Langgeng Gallery, Magelang, Central Java.
Biennale Yogyakarta, Societet Militer Building, Yogyakarta, Central Java.
Bazzart, Yogyakarta Art Festival (FKY), Fort Vredenburg Museum, Yogyakarta, Central Java.
Glass, Parkir Space, Yogyakarta, Central Java.
Seeing Kaliurang Universe, Ullen Sentalu, Yogyakarta, Central Java.
• 2004
Lustrum IV ISI, The Indonesia Institute of the Arts, Yogyakarta, Central Java.
Barcode, 16th Yogyakarta Art Festival (FKY), Taman Budaya, Yogyakarta, Central Java.
Bazzart, Yogyakarta Art Festival (FKY), Fort Vredenburg Museum, Yogyakarta, Central Java.
• 2003
Opening Rumah Seni Muara, Yogyakarta, Central Java.
2# Rumah Seni Muara, Yogyakarta, Central Java.
Indofood Art Award, Galeri Nasional Indonesia, Jakarta.
Bazzart, Yogyakarta Art Festival (FKY), Fort Vredenburg Museum, Yogyakarta, Central Java.
• 2002
Human 2002, Dirix Art Gallery, Yogyakarta, Central Java.
Nature in Humans' Inspiration, Oktober Gallery, Yogyakarta, Central Java.
Diversity and Harmony, Gedung Societet Militer, Yogyakarta, Central Java.
Tropical (Duri Latu), Yogyakarta Art Festival (FKY), Fort Vredenburg Museum, Yogyakarta, Central Java.
A Plate of Indonesia, Gelaran Budaya, Yogyakarta, Central Java.
Aqehubution, Edwin's Gallery, Jakarta.

Awards
• 2006
The Best J A A, Jakarta.
• 2004
The Best Lustrum ISI IV.
• 2003
The Best Indofood Art Award.
• 2000
5 Major Philip Morris Asian Awards.

Rudi Hendriatno (p. 116)

Born in 1980 in Padang, West Sumatra, Indonesia.

Selected group exhibitions
• 2010
Bakaba, Sakato Art Community, Jogja National Museum, Yogyakarta, Central Java.
Homage, Seven Stars Art Space, Yogyakarta, Central Java.
Contemporaneity, Indonesia Biennale Art Exhibition Award, Galeri Nasional Indonesia, Jakarta.

• 2009
Between Names and Names, Jogja National
Museum, Yogyakarta, Central Java.
Cross/Piece, Galeri Canna, Jakarta.
The Dream, Seven Stars Art Exhibition Award,
Jogja National Museum, Yogyakarta, Central Java.
• 2008
Life Is Art, Art Is Life, Jogja Bike Rendezvous,
Coaral Gallery, Yogyakarta, Central Java.
• 2006
Connecting Bapilin (Jalin Bapilin), Student Minang
Indonesian Art Institute, Yogyakarta, Fortress and
Taman Budaya, Yogyakarta, Central Java.
• 2002
Sa_Aka 99, Full of Culture, Yogyakarta,
Central Java.

Awards and residencies
• 2009
The Work of the Seven Stars Best Art Award,
Jogja National Museum, Yogyakarta,
Central Java.
• 2010
Indonesia Art Award 2010.

Noor Ibrahim (p. 120)

Born in 1966 in Tidar, West Java, Indonesia.

Selected solo exhibitions
• 2009
Lamentation, Kemang Icon, Jakarta.
• 2008
Palon, Galeri Nasional Indonesia, Jakarta.
• 2004
Flood, Arya Seni Gallery, Singapore.
• 2003
Him, CSIS, Jakarta.

Selected group exhibitions
• 2010
1001 Doors: Reinterpreting Traditions, Ciputra
World Marketing Gallery, Jakarta.
Sang Ahli Gambar Dan Kawan-Kawan, Galeri
Canna, Jakarta.
Surabaya Art Festival, Balai Pemuda, Surabaya,
East Java.
Beyond Animal, Resto Nine Wismilak, Surabaya,
East Java.
Coexistence, Dimensi Art Gallery, Surabaya,
East Java.
• 2009
Jogja Jamming, 10th Jogja Biennale at Jogja
National Museum, Yogyakarta, Central Java.
Survival, CCCL, Surabaya, East Java.
In Rainbow, Esa Sampoerna Art House, Surabaya,
East Java.
*Exposigns. Great Exhibition of Indonesian Visual
Art*, 25th Institut Seni Indonesia (ISI) at Jogja
Expo Center, Jogyakarta, Central Java.
Narrative, Asosiasi Pematung Indonesia, Syang
Art Space, Magelang, Central Java.
• 2008
Art Sidewalk (Art Trotoar), Pemuda Street,
Surabaya, East Java.
• 2007
Meeting Malioboro, Museum MPU Tantular,
Surabaya, East Java.

• 2006
The Root of Asia: Indonesia, Japan, Malaysia,
Bidadari Art Gallery, Banjar Mas, Bali.
Wedding, Tobacco & Art OHD, Tri Bhakti House,
Magelang, Central Java.
Gelar Senirupa Jawa Timur, Taman Budaya
Jawa Timur, Surabaya, East Java.
• 2005
51st Venice Biennale, Indonesian Pavilion at
Telecommunication Centre, San Marco, Venice.
The Here and Now, 8th Biennale at Yogyakarta
Pasca Sarjana Group, Galeri Biasa, Yogyakarta,
Central Java.
Individual Memory, Langgeng Gallery, Magelang,
Central Java.
• 2004
Mo Limo, Bentara Budaya, Yogyakarta,
Central Java.
Spacious Territory, Ysri and Audi, Jakarta.
• 2003
Ops! Cut Head (Ops! Kepala Terpenggal),
Galeri Semarang, Semarang, Central Java.
Mozaik Indonesia, Vanessa Artlink,
Jakarta.
Circle Point Biennale, Galeri Nasional
Indonesia, Jakarta.
• 2002
Expression of an Era, Hotel Padma Kuta, Bali.
Art Meeting Yogyakarta–Manado, Sahid Hotel
Kawanua, Manado, North Sulawesi.
• 2001
Not Just the Political, Museum Haji Widayat,
Magelang, Central Java.
Save Our Sea!, Galeri Nasional Indonesia,
Jakarta.

Public collections
Indonesian Institute of the Arts, ISI, Yogyakarta,
Central Java.
Galeri Nasional Indonesia, Jakarta.
OHD Museum of Modern & Contemporary
Indonesian Art, Magelang, Central Java.
Ir. Ciputra Art Foundation, Jakarta
Akili Museum of Art, Jakarta.
Museum Haji Widayat, Magelang,
Central Java.
Willy Walla Sculpture from La Pietà Chapel
(51st Venice Biennale) kept in Surabaya,
East Java.
Melani Setiawan Art Space, Jakarta.

Soni Irawan (p. 124)

Born in 1975 in Yogyakarta, Central Java,
Indonesia.

Solo exhibitions
• 2010
Ode to Permata Unguku, Galeri Semarang at
Jakarta Art District, Jakarta.
• 2001
Mural Exhibition, Apotik Komik, Yogyakarta,
Central Java.

Selected group exhibitions
• 2010
Dua Kota Dua Cerita, Galeri Semarang,
Semarang, Central Java.

• 2009
Jogja Jamming, 10th Jogja Biennale at Jogja
National Museum, Yogyakarta, Central Java.
Malaysia Art Expo, Kuala Lumpur,
Malaysia.
Jogja Art Fair #2, Taman Budaya, Yogyakarta,
Central Java.
Fundrising Online IVAA Archive AID 2009,
Yogyakarta, Central Java.
We're Millionaire, AOD Art Space, Jakarta.
In Rainbow, Esa Sampoerna Art House,
Surabaya, East Java.
Guru Oemar Bakrie, Jogja Gallery, Yogyakarta,
Central Java.
Hybridization, North Art Space, Jakarta.
Street–Noise, Galeri Semarang, Semarang,
Central Java.
Fresh 4 U, Jogja Gallery, Yogyakarta,
Central Java.
• 2008
Loro Blonyo Kontemporer, Magelang, Central
Java.
Urban Art Feast, Mural Project, Kompas
Newspaper Anniversary, Pantai Karnaval, Ancol,
Jakarta.
69 Seksi Nian, Jogja Gallery, Yogyakarta,
Central Java.
Komedi Putar, Jogja Gallery, Yogyakarta,
Central Java.
• 2006
Fringers Art, Toi Moi Gallery, Jakarta.
• 2005
Art for ACEH, Taman Budaya, Yogyakarta,
Central Java.
• 2004
Neo Indies, Kedai Kebun, Yogyakarta, Central
Java.
Gedebook!!!, Kedai Kebun Forum, Yogyakarta,
Central Java.
Mural Exhibition, Duke Distro & Clothing,
Bali.
• 2003
Countrybution, 7th Yogyakarta Biennale), Taman
Budaya, Yogyakarta, Central Java.
Digital Art Exhibition, Gramedia Bookstore,
Yogyakarta, Central Java.
Nobody, Mon Decor Art Gallery, Jakarta.
• 2002
Age-Hibition, Edwin's Gallery, Jakarta.
Mural Exhibition, Apotik Komik, Lempuyangan
Flyover, Yogyakarta, Central Java.
Graphics Exhibition Exploring Medium, Bentara
Budaya, Jakarta.
Asian Art Award Exhibition, Bali.
Hitam Putih Rasa Strawberry, Purna Budaya,
Yogyakarta, Central Java.
Indonesian Art Award Exhibition, Galeri Nasional
Indonesia, Jakarta.
Plus (+) Edisi Khusus, Gelaran Budaya,
Yogyakarta, Central Java.
• 2000
Kelompok Otak Berbenah, LIP, Centre culturel
français, Yogyakarta, Central Java.

Grants and awards
• 2001
Philip Morris Asian Art Award.
Lima Besar Philip Morris Indonesia Art.

Mella Jaarsma (p. 128)

Born in 1960 in the Netherlands. Lives and works in Yogyakarta, Central Java.

Selected solo exhibitions
• 2009
The Fitting Room, Selasar Sunaryo Art Space, Bandung, West Java; Galeri Nasional Indonesia, Jakarta.
Zipper Zone, S.14, Bandung, West Java.
• 2006
De Meeloper / The Follower, Artotheek, The Hague.
Shelter Me, Gaya Fusion Art Space, Ubud, Bali.
• 2005
Asal, Etemad Gallery, Tehran.
• 2004
The Shelter, Valentine Willie Fine Art, Kuala Lumpur, Malaysia.
• 2002
Moral Pointers, Lontar Gallery, Jakarta.
• 2001
I Eat You Eat Me, The Art Center, Center of Academic Resources, Chulalongkorn University, Bangkok.

Selected group exhibitions
• 2011
New Mythologies, Espace Louis Vuitton, Paris.
Kaap, Fort Ruigenhoek, Utrecht, The Netherlands.
Manila Contemporary, Manila.
• 2010
GSK Contemporary – Aware: Art Fashion Identity, The Royal Academy of Arts, London.
Shadowdance, Kunsthal Kade, Amersfoort, The Netherlands.
Material Girls, 24hr Art, Darwin, Australia.
No Direction Home, Edwin's Gallery at Galeri Nasional Indonesia, Jakarta.
Making History, Jendela Gallery, Esplanade, Singapore.
Faith and Reason, Manila Contemporary, Manila.
• 2009
Jogja Jamming, 10th Jogja Biennale at Jogja National Museum, Yogyakarta, Central Java.
Beyond the Dutch. Indonesia, The Netherlands and the Visual Arts from 1900 until Now, Centraal Museum, Utrecht, The Netherlands.
Fusion Folks, Bo-Pi Liao, Taipei.
New Nature, Vanessa Artlink at Galeri Nasional Indonesia, Jakarta.
The Incheon Women Artists' Biennale, Art Platform, Incheon, Korea.
Re-Addressing Identities, Katonah Museum, New York.
Living Legends, Edwin's Gallery at Galeri Nasional Indonesia, Jakarta.
Blue Print, Tembi Contemporary, Yogyakarta, Central Java.
Designing Peace: A Show of Imagination, Museum of Contemporary Art and Design, Manila.
Asian Contemporary Art Exchange, Thamada Gallery, Yangon, Myanmar.
• 2008
A Decade of Dedication: Ten Years Revisited, Selasar Sunaryo Art Space, Bandung, West Java.

8888, La Cartuja, Sevilla; Cultural Council, Sitges, Spain.
10th Sonsbeek: Grandeur, Park Sonsbeek, Arnhem, The Netherlands.
Urban Concerns, Bildmuseet, Umeå, Sweden.
• 2007
Kuota 2007, Galeri Nasional Indonesia, Jakarta.
Neo Nation, 9th Jogja Biennale at Taman Budaya, Yogyakarta, Central Java.
The Curtain Opens, Galeri Nasional Indonesia, Jakarta.
Man, Come On, Man! (Bung Ayo Bung!), 100 Years of Affandi Exhibition, Museum Affandi, Yogyakarta, Central Java.
Very Fun Park II, Fubon Art Foundation, Taipei.
Fashion Accidentally, MoCA Museum of Contemporary Art, Taipei.
Shelter, Museum de Fundatie, Zwolle–Heino, The Netherlands.
Wherever We Go, San Francisco Institute of the Arts, San Francisco, California.
• 2006
Saigon Open City, War Museum, Ho Chi Ming City, Vietnam.
Wherever We Go, Spazio Oberdan, Museo di Fotografia Contemporanea, Milan.
Nederland 1, Museum Gouda, Gouda, The Netherlands.
Flucht Vertreibung Intergration, Haus de Geschichte der Bundesrepublik Deutschland, Bonn; Deutschen Historischen Museum, Berlin; Zeitgeschichtlichen Forum, Leipzig, Germany.

Residencies and awards
• 2011
Manila Contemporary, Manila.
• 2010
Image of No Dream, Het Vijfde Seizoen, Den Dolder, The Netherlands (with Yudi Tajudin).
• 2006
John D. Rockefeller 3rd Award, New York (with Nindityo Adipurnomo).
• 2004
Rimbun Dahan, Kuala Lumpur, Malaysia.
• 2003
Studio 106, LASALLE College of the Arts, Singapore.
• 2001
Art Center, Chulalongkorn University, Thailand.

Agapetus A. Kristiandana (p. 132)

Born in 1968 in Yogyakarta, Central Java, Indonesia.

Solo exhibitions
• 2006
Allegorical Subjects, Galeri Semarang, Semarang, Central Java.
• 2003
Fourth Horizon, Edwin's Gallery, Jakarta.

Selected group exhibitions
• 2010
Bazaar Art Jakarta 2010, Pacific Place, Jakarta.
Your World, My World, Our World, Wendt Gallery, New York.

Artpreneurship. Space & Image, Ciputra World Marketing Gallery, Jakarta.
International Art & Science Festival, Vrahneika, Patra, Greece.
Power Wagon, Jogja National Museum, Yogyakarta, Central Java.
Merti Bumi, Kampung Seni Lerep, Ungaran, Semarang, Central Java.
Space/Spacing, Galeri Semarang, Semarang, Central Java.
180 x 180, One Gallery, Jakarta.
Art Singapore, Singapore.
Indonesia Now, Linda Gallery, Singapore.
• 2007
Imagined Affandi, Indonesian Archive Building, Jakarta.
• 2006
The 12th International Biennial Print and Drawing Exhibition, ROC, Taipei.
Lindu, Bentara Budaya, Yogyakarta and Jakarta.
People Need the Lord, Gramedia Ballroom, Jakarta.
• 2004
Threshold, Museum Affandi, Yogyakarta.
Olympics, Pakubuwono Residence Hall, Nadi Gallery, Jakarta.
Small Is Beautiful XII, Edwin's Gallery, Jakarta.
Equatorial Heat, Indonesia Painting Exhibition, Sichuan Art Museum, Sichuan, China.
• 2002
The Four Town Indonesian Art Exhibition, MHC Gallery, Canada, New Jersey, Virginia, New York.
In Memoriam Gampingan Satu, Gelaran Budaya, Yogyakarta, Central Java.
• 2001
Seven Liars, Purna Budaya, Yogyakarta and Air Art House, Jakarta.
Limitation Bias, Edwin's Gallery, Jakarta.
Small Is Beautiful IX, Edwin's Gallery, Jakarta.

Awards
• 2000
Philip Morris Indonesia Art Award.

Agung Kurniawan (p. 136)

Born in 1968 in Jember, East Java, Indonesia. Currently lives and works In Yogyakarta, Central Java, Indonesia.

Selected solo exhibitions
• 2006
Budiman Project, Artiipol Gallery, Amsterdam.
Mural Project: Could I Entertain You Sir, Esplanade, Singapore.
• 2003
Sex, Lies, and Drawing, Goethe-Institut, Jakarta.
• 2001
Lick Me, Please!, Cemeti Art House, Yogyakarta, Central Java.
• 2000
Lapendoz, LIP, Centre culturel français, Yogyakarta, Central Java.
Barak Gallery, Bandung, West Java.

Selected group exhibitions
• 2010
Art Amsterdam, Amsterdam.

Artpreneurship. Space & Image, Ciputra World Marketing Gallery, Jakarta.
Crossing and Blurring the Boundaries: Medium in Indonesian Contemporary Art, Andi's Gallery and Galeri Nasional Indonesia, Jakarta.
Manifesto of New Aesthetics: Seven Artists from Indonesia, Institute of Contemporary Art, LASALLE College of the Arts, Singapore.
• 2009
Beyond the Dutch. Indonesia, The Netherlands and the Visual Arts from 1900 until Now, Centraal Museum, Utrecht, The Netherlands.
Jogja Art Fair #2, Taman Budaya, Yogyakarta, Central Java.
The Living Legends, Galeri Nasional Indonesia, Jakarta.
One Minute Mute, performance project at the 10th Jogja Biennale, Yogyakarta, Central Java.
• 2008
Be[com]ing Dutch, Stedelijk Van Abbemuseum, Eindhoven, The Netherlands.
The Scale of Black Drawing Exhibition, Valentine Willie Fine Art, Singapore.
Grafis Hari Ini, Bentara Budaya, Jakarta.
• 2007
Man, Come On, Man! (Bung Ayo Bung!), 100 Years of Affandi Exhibition, Museum Affandi, Yogyakarta, Central Java.
T-Shirt from March, Bentara Budaya, Yogyakarta, Central Java.
• 2006
Museum Sukrodimejo, project on visual history (with Agus Suwage, Lian Sahar, And Maryanto), Cemeti Art House, Yogyakarta, Central Java.
Drawing Exhibition, Biasa ArtSpace, Seminyak, Bali.
Aicon, Jogja National Gallery, Yogyakarta, Central Java.
• 2004
Reading Widayat's World (Membaca Dunia Widayat), Museum Haji Widayat, Magelang, Central Java.
On the Edge, Pakubuwono Residence, Loft Gallery, Hong Kong and Jakarta.
Barcode, 16th Yogyakarta Art Festival (FKY), Taman Budaya, Yogyakarta, Central Java.
Indonesia Contemporary Art, Loft Gallery, Hong Kong and Barcelona.
Insomnia 48, a nonstop 48 hour event of performance, clubbing, music, happenings, videos, installations, ateliers, workshops and social interactions, Old Parliament Building, Singapore.
• 2003
Read, Cemeti Art House, Yogyakarta, Central Java.
Love, Nadi Gallery, Jakarta.
In-Between, Andi's Gallery, Jakarta.
Exploring Vacuum, Cemeti Art House, Yogyakarta, Central Java.
• 2002
An Unseen Scenery, Gwangju Biennale, Gwangju, South Korea.
Read, British Council, Jakarta.
Awas! Closing Exhibition, Bentara Budaya, Jakarta.
• 2001
Printmaking in the Future, Cemeti Art House, Yogyakarta, Central Java.

Not Just the Political, Museum Haji Widayat, Magelang, Central Java.
10th Asian Art Biennale Bangladesh 2001, Dhaka, Bangladesh.
• 2000
Reformation of Indonesia: Protest in Beeld, Museum Nusantara, Delft, The Netherlands.
A Half Century Indonesian Print Making, Bentara Budaya, Jakarta.

Collections
Heden, The Hague.
Singapore Art Museum, Singapore.
National Art Council, Singapore.
Queensland Arts Gallery, Brisbane, Australia.
KLM, The Netherlands.
The Jakarta Post, Jakarta.
Deutsche Bank, Jakarta.
OHD Museum of Modern & Contemporary Indonesian Art, Magelang, Central Java.

Budi Kustarto (p. 140)

Born in 1972 in Karangbawang, Central Java, Indonesia.

Solo exhibitions
• 2008
Ice Creams Series, Soka Art Center, Beijing.
Among Others, Soka Art Center, Beijing.
• 2006
Hetero: Green, Galeri Semarang, Semarang, Central Java.
• 2005
Budi, Nadi Gallery, Jakarta.
Equatorial Heat, Indonesia Painting Exhibition, Sichuan Art Museum, Sichuan, China.
Meta Atalase, Galeri Semarang, Semarang, Central Java.

Selected group exhibitions
• 2010
The Show Must Go On, Nadi Gallery 10th Anniversary, Jakarta.
Contemporaneity: Contemporary Art in Indonesia, Museum of Contemporary Art, Shanghai.
Clouds: Power of Asian Contemporary Art, Soka Art Center, Beijing.
• 2009
Indonesian Contemporary Drawing, Galeri Nasional Indonesia, Jakarta.
Self-Portrait, SIGIarts Gallery, Jakarta.
Jogja Jamming, 10th Jogja Biennale at Jogja National Museum, Yogyakarta, Central Java.
• 2008
Manifesto, Galeri Nasional Indonesia, Jakarta.
The Highlight, Jogja National Museum, Yogyakarta, Central Java.
• 2007
Indonesian Contemporary Art Now, Nadi Gallery, Jakarta.
Imagined Affandi, Indonesian Archive Building, Jakarta.
Soka's View. Southeast Asia Contemporary Art, Soka Art Center, Beijing and Taipei.
Ilusi–Ilusi Nasionalisme, Jogja National Gallery, Yogyakarta, Central Java.

Common Grounds, Galeri Nasional Indonesia, Jakarta.
Fetish Object Art Project #1, Biasa ArtSpace, Seminyak, Bali.
Neo Nation, 9th Jogja Biennale, Yogyakarta, Central Java.
• 2006
Icon: Retrospective, Jogja National Gallery, Yogyakarta, Central Java.
Beyond. The Limit and Its Challenges, Jakarta Biennale, Jakarta.
• 2005
Urban/Culture, 2nd CP Open Biennale, Museum Bank Indonesia, Jakarta.
Aku, Chairil Dan Aku, Nadi Gallery, Jakarta.
Meta-Etalase, Galeri Semarang, Semarang, Central Java.
Realis(Me) Banal, Gracia Gallery, Surabaya, East Java.
It, Biasa ArtSpace, Seminyak, Bali.
Di Sini & Kini, 8th Jogja Biennale, Taman Budaya, Yogyakarta, Central Java.
• 2004
Contemporary Indonesia Art: Fruits of Change, Sichuan Art Museum, Sichuan, China.
• 2003
Interpellation, 1st CP Open Biennale, Galeri Nasional Indonesia, Jakarta.
Mc(Row) Media, Langgeng Gallery, Magelang, Central Java.
Equatorial Heat, Indonesia Painting Exhibition, Sichuan Art Museum, Sichuan, China.
Specious Territory (Yayasan Seni Rupa Indonesia), Audi Building, Jakarta.
• 2002
Age-Hibition, Edwin's Gallery, Jakarta.
Alpha Omega Alpha, Air Art House, Jakarta.
Sculptural Art, Embun Gallery, Yogyakarta, Central Java.

Jompet Kuswidananto (p. 144)

Born in 1976. Lives in Bali and Yogyakarta, Central Java, Indonesia.

Solo exhibitions
• 2010
Third Realm, Para-Site Art Space, Hong Kong.
• 2010
Java's Machine: Phantasmagoria, Osage Gallery, Hong Kong.
• 2009
Java's Machine: Phantasmagoria, Osage Gallery, Singapore.
• 2008
Java's Machine: Phantasmagoria, Cemeti Art House, Yogyakarta, Central Java.

Selected group exhibitions
• 2011
Closing the Gap, MIFA Gallery, Melbourne, Australia.
Influx, Ruang Rupa, Jakarta.
• 2010
Mental Archive, Cemeti Art House, Yogyakarta, Central Java.
Kuandu Biennale, Kuandu Museum of Fine Arts, Taipei National University of the Arts, Taipei.

Art Forte, Gana Art Center, Seoul.
Media Landscape, Zone East, Contemporary Urban Culture, Liverpool, United Kingdom.
Contemporaneity: Contemporary Art in Indonesia, Museum of Contemporary Art, Shanghai.
Loss of the Real, Selasar Sunaryo Art Space, Bandung, West Java.
Art HK 10, Hong Kong.
Asia Art Award Exhibition, Seoul Olympic Museum Of Art, Seoul.
The Tradition of the New, Sakshi Gallery, Mumbai.
• 2009
Jogja Jamming, 10th Jogja Biennale at Jogja National Museum, Yogyakarta, Central Java.
Beyond the Dutch. Indonesia, The Netherlands and the Visual Arts from 1900 until Now, Centraal Museum, Utrecht, The Netherlands.
10th Lyon Biennale, Musée d'art contemporaine, Lyon, France.
War, Words And Visual (Perang, Kata dan Rupa), Galeri Salihara, Jakarta.
Tradition of the New, Sakshi Gallery, Taipei.
Magnetic Power, Coreana Museum of Arts, Seoul.
Biennale Cuvee 09, OK Offenes Kulturhaus Oberösterreich, Linz, Austria.
Compilation, Bus Gallery, Melbourne, Australia.
Jakarta Biennale, Galeri Nasional Indonesia, Jakarta.
• 2008
Yokohama Triennale, Yokohama, Japan.
Landing Soon, Erasmus Huis, Jakarta.
Manifesto, Galeri Nasional Indonesia, Jakarta.
• 2007
Neo Nation, 9th Jogja Biennale at Taman Budaya, Yogyakarta, Central Java.
Equatorial Rhythms, Stenersen Museum, Oslo, Norway.
OK Video #3, Militia, Galeri Nasional Indonesia, Jakarta.
Anti Aging, Gaya Fusion Art Space, Ubud, Bali.
• 2005
Fukuoka Asian Art Triennale, Fukuoka Asian Art Museum, Fukuoka, Japan.
Urban/Culture, 2nd CP Open Biennale, Museum Bank Indonesia, Jakarta.
Revolution Ugly, No Beauty, Cemeti Art House, Yogyakarta, Central Java.
• 2004
Insomnia 48, Arts House, Singapore.
Move On Asia, SBS 1st Floor Atrium, Korea.
Artscope, Selasar Sunaryo Art Space, Bandung, West Java.
Identities versus Globalisation? Positions of Contemporary Art in Southeast Asia, Chiang Mai Art Museum, Chiang Mai, Thailand; National Gallery, Bangkok; Dahlem Museum Complex, Berlin.
• 2003
Transit: 8 Views of Indonesia, Umbrella Studio Contemporary Arts, Townsville, Australia.
Urban Art Project, Subway Stations, Melbourne, Australia.
• 2002
Worm Fest III, Plastique Kinetic Worms, Singapore.

Residencies and awards
• 2010
Geumcheon Art Space, Seoul.
Asia Art Award Finalist, Loop Gallery, Seoul.

Rudi Mantofani (p. 148)

Born in 1973 in Padang, West Sumatra, Indonesia.

Solo exhibitions
• 2005
CP Artspace, Jakarta.
• 2003
Chouinard Gallery, Hong Kong.
• 2002
Double Horizon, Nadi Gallery, Jakarta.

Selected group exhibitions
• 2011
Art Stage Singapore 2011, Marina Bay Sands, Singapore (with Gajah Gallery).
Collectors Stage, Singapore Art Museum, Singapore.
• 2010
Pleasures of Chaos. Inside New Indonesian Art, Primo Marella Gallery, Milan.
Almost White Cube, CG Art Space, Plaza Indonesia, Jakarta.
Artparis, Grand Palais, Champs Elysées, Paris.
Bakaba, Sakato Art Community, Jogja National Museum, Yogyakarta, Central Java.
Sign & After, Islamic Contemporary Art, Lawangwangi Artpark Launching, Bandung, West Java.
Contemporaneity: Contemporary Art Indonesia, Museum of Contemporary Art, Shanghai.
Reflective Asia, 3rd Nanjing Triennale, Nanjing, China.
Rainbow Asia, Seoul Arts Center, Seoul.
• 2009
Jendela. A Play of the Ordinary, NUS Museum, Singapore.
Fluid Zones, Jakarta 13th Biennale, Galeri Nasional Indonesia, Jakarta.
In Rainbow, Esa Sampoerna Art House, Surabaya, East Java.
Exposigns. Great Exhibition of Indonesian Visual Art, 25th Institut Seni Indonesia (ISI) at Jogja Expo Center, Jogyakarta, Central Java.
The 6th Asia-Pacific Triennial of Contemporary Art, Brisbane, Australia.
Jogja Jamming, 10th Jogja Biennale at Jogja National Museum, Yogyakarta, Central Java.
• 2008
Indonesian Invasion, Sin Sin Fine Art, Hong Kong.
Manifesto, Galeri Nasional Indonesia, Jakarta.
SH Contemporary 08, organized by Langgeng Gallery, Shanghai.
• 2007
Contemporary Indonesian Art Now, Nadi Gallery, Jakarta.
Imagining Asia, 22nd Asian International Art Exhibition, Selasar Sunaryo Art Space, Bandung, West Java.
Jendela Group "Peekaboo", Valentine Willie Fine Art, Kuala Lumpur, Malaysia.
Plus, 40 Minus, Sin Sin Fine Art, Hong Kong.

The Contemporary Asian Art Fair Singapore, Gajah Gallery, Singapore.
• 2006
The Culture of Things, CP Artspace, Jakarta.
Icon: Retrospective, Jogja Gallery, Yogyakarta, Central Java.
Art Saturdays, Sin Sin Fine Art, Hong Kong.
7th Shanghai Art Fair International Contemporary, Langgeng Gallery, Beijing.
• 2005
Sculpture Expanded, CP Artspace, Jakarta.
Southeast Asia Landscape, Gajah Gallery, Singapore.
Realis(Me) Banal, Gracia Gallery, Surabaya, East Java.
Equatorial Heat, Edwin's Gallery, Jakarta.
Pseudo Still Life: Obyek Dan Auranya, Galeri Semarang, Semarang, Central Java.
Oven View, Biasa ArtSpace, Seminyak, Bali.
Jendela Group "The Ordinary", Nadi Gallery, Jakarta.
Urban/Culture, 2nd CP Open Biennale, Museum Bank Indonesia, Jakarta.
Sanggar Sakato. Re-Reading "Landschap", Nadi Gallery, Jakarta.
Art Saturdays, Sin Sin Fine Art, Hong Kong.
• 2004
Wings of Words Wings of Color, Langgeng Gallery, Magelang, Central Java.
Reading Widayat's World (Membaca Dunia Widayat), Museum Haji Widayat, Magelang, Central Java.
The Contemporary Asian Art Fair 2004, Singapore.
Object(ify), Nadi Gallery, Jakarta.
Considering Tradition (Mempertimbangkan Tradisi), Galeri Nasional Indonesia, Jakarta.
Rereading Convention (Membaca Kembali Konvensi), Edwin's Gallery, Jakarta.
Sculpture Exhibition, Indonesian Sculpture Association, Yogyakarta, Central Java.
4 Healthy, Limo Perfect (4 Sehat Mo-Limo Sempurna), Bentara Budaya, Yogyakarta, Central Java.
Small Is Beautiful, Edwin's Gallery, Jakarta.
Spacious Territory, Audi Center, Jakarta.
Equatorial Heat, Indonesia Painting Exhibition, Sichuan Art Museum, Sichuan, China.
Have We Met?, Foundation Forum, Tokyo.

Ronald Manullang (p. 152)

Born in 1954 in Tarutung, North Sumatra, Indonesia.

Solo exhibitions
• 2011
The Final Judgement 2, Art Stage Singapore 2011, Singapore.
• 2010
The Final Judgement, Umahseni@Mentengartspace, Jakarta.

Selected group exhibitions
• 2010
Artparis+Guest, Grand Palais, Champs Elysées, Paris.
Artpreneurship. Space & Image, Ciputra World Marketing Gallery, Jakarta.

Unity. The Return to Art, Wendt Gallery, New York.
Made In Indonesia, Galerie Christian Hosp, Berlin.
KIAF, Seoul.
• 2009
Revisit Last Supper, CG Art Space, Jakarta.
Objective Border, Srisasanti Galleri, Yogyakarta, Central Java.
In Rainbow, Esa Sampoerna Art House, Surabaya, East Java.
Indonesian Contemporary Drawing, Galeri Nasional Indonesia, Jakarta.
Art Hong Kong, Langgeng Gallery, Hong Kong.
Happiness 9, Philo Art Space, Jakarta.
Common Sense, Galeri Nasional Indonesia, Jakarta.
Jogja Jamming, 10th Jogja Biennale at Jogja National Museum, Yogyakarta, Central Java.
• 2008
69 Seksi Nian, Jogja Gallery, Yogyakarta, Central Java.
Manifesto, Galeri Nasional Indonesia, Jakarta.
Shanghai Contemporary Art Fair, Shanghai.
Expanding Contemporary Realism, Akili Museum of Art, Jakarta.
Self Portrait. Famous Living Artists of Indonesia, Jogja Gallery, Yogyakarta, Central Java.
The Highlight, Dari Medium ke Transmedia, Jogja National Museum, Yogyakarta, Central Java.
• 2007
Yogyakarta Icons, Yogja Gallery, Yogyakarta, Central Java.
Imagined Affandi, Indonesian Archive Building, Jakarta.
Illusions of Nationalism, 200 Years of Raden Saleh, Jogja Gallery, Yogyakarta, Central Java.
Man, Come On, Man! (Bung Ayo Bung!), 100 Years of Affandi Exhibition, Museum Affandi, Yogyakarta, Central Java.
Sovereign Asian Art Prize, Atrium, The Landmark, Hong Kong.
Louis Vuitton Asian Art, Hong Kong.
• 2006
Full Moon (Pameran Bulan Purnama), Galeri Canna, Jakarta.
• 2005
Mata-Mata Jakarta, Galeri Nasional Indonesia, Jakarta.
Bride And Groom Poem (Syair Penganten), Galeri Canna, Jakarta.
• 2004
Olympics Art, The Pakubuwono Residence Hall, Nadi Gallery, Jakarta.
• 2003
Indofood Art Award, Galeri Nasional Indonesia, Jakarta.

Awards
• 1976
Affandi Prize.
• 1990
Creativity Art Direction Magazine Award, USA.
• 2003
Indofood Art Award.
• 2007
Finalist Sovereign Asian Art Prize, Hong Kong.

Yusra Martunus (p. 156)

Born in 1973 in Padang Panjang, West Sumatra, Indonesia.

Solo exhibitions
• 2009
Sensuous, Valentine Willie Fine Art, Singapore.
• 2008
Preppy (Nécis), Nadi Gallery, Jakarta.

Selected group exhibitions
• 2009
In Rainbow, Esa Sampoerna Art House, Surabaya, East Java.
CIGE 2009 (China International Gallery Exposition), Beijing.
Art HK 09 (Hong Kong International Art Fair), Hong Kong.
Jendela, a Play of the Ordinary, NUS Museum, Singapore.
• 2008
The Highlight, Jogja National Museum, Yogyakarta, Central Java.
Yogya Salon, CG Art Space, Plaza Indonesia, Jakarta.
A Decade of Dedication: Ten Years Revisited, Selasar Sunaryo Art Space, Bandung, West Java.
Forms (Bentuk-Bentuk). Contemporary Indonesian Art in 3D, Melbourne Art Fair 2008, Melbourne, Australia.
Manifesto, Galeri Nasional Indonesia, Jakarta.
Life Is Art, Art Is Life, Jogja Bike Rendezvous, Coaral Gallery, Yogyakarta, Central Java.
De Paris à Jakarta, Galeri Nasional Indonesia, Jakarta.
• 2007
Fetish Object Art Project #1, Biasa ArtSpace, Seminyak, Bali.
Peekaboo! (Cilukba!), KSRJ (Kelompok Seni Rupa Jendela), Valentine Willie Fine Art, Kuala Lumpur, Malaysia.
Common Grounds, Galeri Nasional Indonesia, Jakarta.
Indonesian Contemporary Art Now, Nadi Gallery, Jakarta.
• 2006
Icon: Retrospective, Jogja Gallery, Yogyakarta, Central Java.
Passing on Distance, Base Gallery, Tokyo.
• 2005
Space and Scape, Summit Event Bali Biennale, Bali.
Beauté et Expression Terrorisé, Galerie Loft, Paris.
Urban/Culture, 2nd CP Open Biennale, Museum Bank Indonesia, Jakarta.
Open View, Biasa ArtSpace, Seminyak, Bali.
Goods Exodus (Eksodus Barang), Nadi Gallery, Jakarta.
• 2004
Spacious Territory, Audi Centre, Jakarta.
Silent Action: Creativity for Tolerance and Peace, 4th Art Summit, Galeri Nasional Indonesia, Jakarta.
Re-Reading Convention (Membaca Kembali Konvensi), Edwin's Gallery, Jakarta.
Asian Art Award 2004, The National Gallery of Thailand, Bangkok.

Barcode, 16th Yogyakarta Art Festival (FKY), Taman Budaya, Yogyakarta, Central Java.
Considering Tradition (Mempertimbangkan Tradisi): Sanggar Sakato, Galeri Nasional Indonesia, Jakarta.
The Soul of Arts, Senayan Plaza, Jakarta.
Object(ify), Nadi Gallery, Jakarta.
Wings of Words, Wings of Colors, Langgeng Gallery, Magelang, Central Java.
Reading Widayat's World (Membaca Dunia Widayat), Museum Haji Widayat, Magelang, Central Java.
• 2003
Indonesia Asian Art Award 2003, Grya Dome, Medan, North Sumatra; The Asean Secretariat, Jakarta.
Interpellation, 1st CP Open Biennale, Galeri Nasional Indonesia, Jakarta.
Implosion, Expatri-Art Gallery, Jakarta.
25 x 25 x 50, Lontar Gallery, Jakarta; Benda Art House, Yogyakarta, Central Java.

Awards
• 2005
Winner of "Kudus Kota Kretek" Monument Competition.
• 2004
Finalist of Asean Art Award.
• 2003
The Best of Indonesia Asean Art Award.
• 1994
The Best of McDonald Art Award.

Wiyoga Muhardanto (p. 160)

Born in 1984 in Jakarta, Indonesia.

Solo exhibitions
• 2008
Window Display, Selasar Sunaryo Art Space, Bandung, West Java.

Selected group exhibitions
• 2010
Art|Jog|10 – Indonesian Art Now: The Strategies of Being, Taman Budaya, Yogyakarta, Central Java.
Artpreneurship. Space & Image, Ciputra World Marketing Gallery, Jakarta.
Landing Soon #6-11, Erasmus Huis, Jakarta.
Halimun, Lawangwangi Artpark Launching, Bandung, West Java.
Codex Code, Kedai Kebun Forum, Yogyakarta, Central Java.
Katallogcatalog, AOD Artspace, Jakarta.
• 2009
Bandung Art Now, Galeri Nasional Indonesia, Jakarta.
Fluid Zones, Jakarta 13th Biennale, Galeri Nasional Indonesia, Jakarta.
Contemporary Archaeology, SIGIarts Gallery, Jakarta.
Bandung Initiative #4, Rumah Rupa, Jakarta.
Reach Art Project – Regression, Plaza Indonesia, Jakarta.
Landing Soon #11, Cemeti Art House, Yogyakarta, Central Java.

Jogja Art Fair #2, Taman Budaya, Yogyakarta, Central Java.
Everybody Got Mix the Feel Between Form & Function, Goethe-Institut, Jakarta.
Beyond the Dutch. Indonesia, The Netherlands and the Visual Arts from 1900 until Now, Centraal Museum, Utrecht, The Netherlands.
XYZ, Edwin's Gallery, Jakarta.
Kado, Nadi Gallery, Jakarta.
Jakarta Contemporary Ceramic Biennale, Nas Taman Impian Jaya Ancol, Jakarta.
• 2008
Survey, Edwin's Gallery, Jakarta.
A Slice of: Indonesian Contemporary Art Show, Soka Art Center, Beijing.
Alih-Alih, Cemeti Art House, Yogyakarta, Central Java.
15 x 15 Project (Metaphoria), Galeri Soemardja, Bandung, West Java.
Come in: Interior Design as a Contemporary Art Medium in Germany, Galeri Nasional Indonesia, Jakarta.
• 2007
After Sculpture, Bentara Budaya, Yogyakarta, Central Java.
A Prelude: Our Vision through Experimental Design, Elysium Shop, Bandung, West Java.
100% Indonesia: Wake up to Design, Jakarta Art District, Grand Indonesia, Jakarta.
Fetish Object Art Project #1, Biasa ArtSpace, Seminyak, Bali.
Mettisages. Crossbreeding Contemporary Art with Textiles, Selasar Sunaryo Art Space, Bandung, West Java.
Imagining Asia, 22nd Asian International Art Exhibition, Selasar Sunaryo Art Space, Bandung, West Java.
Petisi Bandung, Langgeng Gallery, Magelang, Central Java.
Kuota 2007, Galeri Nasional Indonesia, Jakarta.

Residencies
• 2011
3331 Arts Chiyoda, Tokyo.

Krisna Murti (p. 164)

Born in 1957. Lives and works in Jakarta.

Selected solo exhibitions
• 2010
Mediatopia. Retrospective Show 1993–2010, Galeri Semarang, Semarang, Central Java.
Mute! Theater, Bentara Budaya, Jakarta.
• 2008
Forbidden Zone, Gaya Fusion Art Space, Ubud, Bali; Galeri Nasional Indonesia, Jakarta; Cemeti Art House, Yogyakarta, Central Java.
• 2005
Video SPA, Gaya Fusion Art Space, Ubud, Bali.
• 2004
Video SPA, Galeri Nasional Indonesia, Jakarta.

Selected group exhibitions
• 2010
Beach Time and *The Bubbles*, Kunstmuseum, Bonn, Germany.

Artpreneurship. Space & Image, Ciputra World Marketing Gallery, Jakarta.
Look! (Lihat!). Video Art from Indonesia, Galería Jesús Gallardo, Instituto Cultural de León, León, Mexico.
• 2009
Beyond the Dutch. Indonesia, The Netherlands and the Visual Arts from 1900 until Now, Centraal Museum, Utrecht, The Netherlands.
Britto New Media Art Festival, National Gallery, Dhaka, Bangladesh.
Littoral Drift, University of Technology, Sydney Gallery, Sydney.
Living Legend, Edwin's Gallery and Gaya Fusion of Senses Gallery, Jakarta.
Cartographical Lure, Valentine Willie Fine Art, Kuala Lumpur, Malaysia.
Exposigns. Great Exhibition of Indonesian Visual Art, 25th Institut Seni Indonesia (ISI) at Jogja Expo Center, Jogyakarta, Central Java.
• 2008
Going Digital, Pindakaas Festival, Den Bosch, The Netherlands.
Manifesto, Galeri Nasional Indonesia, Jakarta.
• 2007
Neo Nation, 9th Jogja Biennale at Yogyakarta National Museum, Yogyakarta, Central Java.
Thermocline of Art: New Asian Waves, ZKM, Karlsruhe, Germany.
• 2006
Going Digital, Festival Oversteek, Theater de Kikker, Utrecht, The Netherlands.
• 2005
Venice Biennale, Indonesian Pavilion, Venice.
• 2004
Art and the Contemporary: Moving Picture, Singapore Art Museum, Singapore.
Identities versus Globalisation? Positions of Contemporary Art in Southeast Asia, Chiang Mai Art Museum, Chiang Mai, Thailand; National Gallery, Bangkok; Dahlem Museum Complex, Berlin.
• 2003
Asia Videoart Conference (AVICON) 2003, Pola Annex Museum, Ginza, Tokyo.
House: 10 Video Artists of Indonesia, Plastique Kinetic Worms, Singapore.
• 2002
Spice Routes, IFA-Galerie, Stuttgart, Germany.
36 Ideas from Asia: Contemporary South-East Asian Art, Küppersmühle Museum, Duisburg, Germany.

Public collections
Fukuoka Asian Art Museum, Fukuoka, Japan.
Art Council of Singapore, Singapore Art Museum, Singapore.
Galeri Nasional Indonesia, Jakarta.

Nasirun (p. 168)

Born in 1965 in Cilacap, Central Java, Indonesia.

Selected solo exhibitions
• 2009
Salam Bakti, Sangkring Art Space, Yogyakarta, Central Java.

• 2002
Nadi Gallery, Jakarta.
• 2000
Galeri Nasional Indonesia, Jakarta.
• 1993
Mirota Kampus, Yogyakarta, Central Java.
Café Solo, Bank Bali, Yogyakarta, Central Java.

Selected group exhibitions
• 2011
Jogjanews.com, Jogja National Museum, Yogyakarta, Central Java.
• 2010
Lesbumi, Pesantren Kali Opak, Yogyakarta, Central Java.
The Birth of Color, Syang Art Space, Magelang, Central Java.
Artpreneurship. Space & Image, Ciputra World Marketing Gallery, Jakarta.
Ethnicity Now, Galeri Nasional Indonesia, Jakarta.
• 2009
Friendship Code, Syang Art Space, Magelang, Central Java.
Guru Oemar Bakrie, Jogja Gallery, Yogyakarta, Central Java.
In Rainbow, Esa Sampoerna House, Surabaya, East Java.
Living Legend, Edwin's Gallery, Jakarta.
Launching of Public Space of Bank Indonesia, Museum Bank Indonesia, Yogyakarta, Central Java.
Jogja Jamming, 10th Jogja Biennale at Jogja National Museum, Yogyakarta, Central Java.
2nd Odyssey, Srisasanti Gallery, Yogyakarta, Central Java.
Art(i)culation, Hanna Art Space, Gianyar, Bali.
• 2008
The (Un)Real, Galeri Nasional Indonesia, Jakarta.
Artvertising, Galeri Nasional Indonesia, Jakarta.
Pos–Ideologi, Gracia Gallery, Surabaya, East Java.
Neo Nation, 9th Jogja Biennale, Yogyakarta, Central Java.
Portofolio, Jogja Gallery, Yogyakarta, Central Java.
Silent Celebration, Tonyraka Art Gallery, Ubud, Bali.
Manifesto, Galeri Nasional Indonesia, Jakarta.
Indonesian Triple Bill, SMU Gallery, Singapore.
• 2007
Eksisten, Jogja Gallery, Yogyakarta, Central Java.
The Circle of Life, Rumah Arus Art Gallery, Lombok, West Nusa Tenggara, Indonesia.
Imagined Affandi, Indonesian Archive Building, Jakarta.
• 2006
Lindu, Bentara Budaya, Yogyakarta, Central Java.
Multi-Tradisi (Multi-Faced), Sanggar Luhur, Bandung, West Java.

Awards
• 1997
Winner of Philip Morris Award, Jakarta.

Aditya Novali (p. 172)

Born in 1978.

Selected solo exhibitions
• 2004
Art Portable, CP Artspace, Jakarta.

• 1997
View on Woman, Galeri Linggar, Jakarta.
• 1995
Transition, Bentara Budaya, Jakarta.

Selected group exhibitions
• 2011
Sovereign Asian Art Prize 2010. Finalist Exhibition, Hong Kong.
1001 Doors: Reinterpreting Traditions, Ciputra World Marketing Gallery, Jakarta.
Art Stage Singapore 2011, Marina Bay Sands, Singapore (with Galeri Canna).
• 2010
All Paper, Dia.Lo.Gue Artspace, Jakarta.
Sovereign Asian Art Prize 2010. Finalist Exhibition, Singapore.
Jakarta Art Award 2010. Finalist Exhibition, North Art Space, Jakarta.
Bazaar Art Fair, Vivi Yip Art Room, Jakarta.
• 2006
Jakarta Biennale, Galeri Cipta II, Taman Ismail Marzuki, Jakarta.
• 2005
Exodus, Nadi Gallery, Jakarta.
Urban/Culture, 2nd CP Open Biennale, Museum Bank Indonesia, Jakarta.
Di Sini & Kini, 8th Jogja Biennale, Taman Budaya, Yogyakarta, Central Java.
Pameran Nusantara, Galeri Nasional Indonesia, Jakarta.
• 2003
Interpellation, 1st CP Open Biennale, Galeri Nasional Indonesia, Jakarta.
Implosion, Expatri-Art Gallery, Jakarta.
Malaysia Indonesia Artists, Taksu Gallery, Jakarta.
• 2002
Indofood Art Award, Galeri Nasional Indonesia, Jakarta.
• 2000
Fragmen, Kembang Gallery, Jakarta.
Bandung Young Artist Exhibition, Griya Seni Popo Iskandar, Bandung, West Java.

Awards
• 2011
Winner BACAA (Bandung Contemporary Art Award).
• 2010
Finalist Sovereign Asian Art Prize.
• 2003
Finalist Indonesia Asean Art Award.
• 2002
Finalist Indofood Art Award.

Eko Nugroho (p. 176)

Born in 1977 in Yogyakarta, Central Java, Indonesia.

Solo exhibitions
• 2009
Hidden Violence, Cemeti Art House, Yogyakarta, Central Java.
In the Name of Pating Tlecek, Nadi Gallery, Jakarta.
Under the Shadow, Pekin Fine Art, Beijing.

Galerie Nouvelles Image, The Hague, The Netherlands.
• 2008
It's All About Coalition, National Museum (Commission Project), Singapore.
Pleasure of Chaos, Ark Galerie, Jakarta.
Multicrisis is Delicious, Galeri Semarang, Semarang, Central Java.
• 2007
In Wonderland, Valentine Willie Fine Art, Kuala Lumpur, Malaysia.
• 2005
Sorry I Am Late to Celebrate, Artnivora Gallery, Jakarta.

Selected group exhibitions
• 2011
Close the Gap: Indonesia Art Today, MIFA Gallery, Melbourne, Australia.
The Alleys of a City Named Jogya, Primo Marella Gallery, Milan.
Indonesia International Fiber Art Exhibition 2011, Taman Budaya, Yogyakarta, Central Java.
Transfiguration & Contemporary Mythologies, Espace Culturel Louis Vuitton, Paris.
• 2010
Lonarte 10 Festival, alongside the beach in Calheta, Madeira Island, Portugal.
The 2010 Next Wave Festival: The Ultimate Time Lapse Megamix, Melbourne, Australia.
Paralinear, Pekin Fine Arts, Beijing.
Look! (Lihat!). Video Art from Indonesia, Galería Jesús Gallardo, Instituto Cultural de León, León, Mexico.
• 2009
Fluid Zones, Jakarta 13th Biennale, Galeri Nasional Indonesia, Jakarta.
Dorodoro, Doron!, Hiroshima Contemporary Art Museum, Hiroshima, Japan.

Awards and residencies
• 2011
ZKM Center, Karlsruhe, Germany.
SAM Art Projects, Villa Raffet, Paris.
• 2009
Veduta Project, 10th Lyon Biennale 2009, Lyon, France.
• 2008
Contemporary Arts Center New Orleans, New Orleans, Lousiana.

Public collections
Tropen Museum, Amsterdam.
Asia Society Museum, New York.
Gallery Of Modern Art (GoMA), Brisbane, Australia.
Contemporary Arts Center, New Orleans, Louisiana.
OHD Museum of Modern & Contemporary Indonesian Art, Magelang, Central Java.
Museum and Art Gallery of the Northern Territory, Darwin, Australia.
Akili Museum of Art, Jakarta.
Haus der Kulturen der Welt, Berlin.
Heden, The Hague, The Netherlands.
Ark Galerie, Jakarta.
Cemeti Art House, Yogyakarta, Central Java.
Deutsche Bank, Frankfurt, Germany.

Arya Pandjalu (p. 180)

Born in 1976 in Bandung, West Java, Indonesia.

Solo exhibitions
• 2009
Phone Number My Hand, O House Gallery, Jakarta.
• 2008
Lost, Andergrond, The Hague, The Netherlands.
• 2004
Chichitchuit, Parkir Space, Yogyakarta, Central Java.

Selected group exhibitions
• 2010
ID–Contemporary Art Indonesia, Kunstraum Kreuzberg / Bethanien, Berlin.
Cut 2010, New Photography From South East Asia, Parallel Universe, Kuala Lumpur, Singapore, Yogyakarta and Manila.
Art\Jog\10. Indonesian Art Now: The Strategies of Being, Taman Budaya, Yogyakarta, Central Java.
Emerging Wave, Asean, South Korea.
• 2009
Cross/Piece, Galeri Canna, Jakarta.
Andergrond, The Hague, The Netherlands.
Deer Andry, Ruang MES 56, Yogyakarta, Central Java.
Kunduran Truk, Kersan Art Studio, Yogyakarta, Central Java.
• 2008
In Transition, Museum of Fine Arts, Ekaterinburg, Russia.
Red District Project, Koong Gallery, Jakarta.
Utopia Negativa, Langgeng Gallery, Magelang, Central Java.
Interface, Open Space Gallery, Vienna.
• 2007
Neo Nation, 9th Jogja Biennale, Yogyakarta, Central Java.
Kuota 2007, Galeri Nasional Indonesia, Jakarta.
Interface, Interbiennale, Galeria HIT, Bratislava, Slovakia.
Birdprayers, Sika Gallery, Ubud, Bali (with Sara Nuytemans).
Sisa, UTSGallery, Sydney.
Landing Soon #1, Artotheek, The Hague, The Netherlands.
• 2006
Sedulur Gempa, Goethe Haus, Goethe Institut, Jakarta.
Drawing from the Stockrooms, Biasa Artspace GANG Festival, New Indonesian Visual Art and Single Channel Video, Firstdraft Gallery, Sydney.
• 2005
Re-Publik Art Project, Yogyakarta, Central Java.
Calon Arang, Bilik Marsinah, Yogyakarta, Central Java.
Graphics and Painting Exhibition 3 in 1, Cemara 6 Galeri, Jakarta.
• 2004
3rd Annual Miniprint, Lasendra, Bulgaria.
• 2003
Fusion Strange, Yogyakarta–Singapore Performance Project, Benda Gallery, Yogyakarta, Central Java.
You' Re Welcome, an international contemporary

art and cultural exchange between Indonesia (Apotik Komik) and San Francisco (Clarion Alley Mural Project), Intersection for the Art, San Francisco, California.
Street Art Festival, 509 Gallery, San Francisco.
• 2002
Graphics Exhibition Exploring Medium, Bentara Budaya, Jakarta.
Mind Print, LIP, Centre culturel françois, Yogyakarta, Central Java.
Struggle & Creation, Erasmus Huis, Jakarta.
Mural Kota: Sama-sama, Yogyakarta, Central Java.
Morning Glory (Serangan Fajar), Fort Vredenburg Museum, Yogyakarta, Central Java.
Ruang per Ruang #1: Don't Try This at Home, Soboman, Yogyakarta, Central Java.
Alfa Omega Alfa, Air Art House, Jakarta.
Pameran Collective Taring Padi, 24 Art, Northern Territory Centre for Contemporary Art, Darwin, Australia.

Award and residencies
• 2010
Kunstraum Kreuzberg / Bethanien, Berlin.
Kosmopolis, The Hague, The Netherlands.
First Prize Winner, Spilzman Award.
• 2007
Andergrond, The Hague, The Netherlands.
Sika Gallery, Ubud, Bali.
• 2006–2007
Landing Soon #1, Cemeti Art House, Yogyakarta, Central Java (in collaboration with Heden, The Hague).
• 2003
Camp (Clarion Alley Mural Project and Apotik Komik), San Francisco, California.

Edo Pillu (p. 184)

Born in 1969 in Bandung, West Java, Indonesia.

Solo exhibitions
• 2009
Between Wall & Sky, Vanessa Artlink, Beijing.
Infinite Juxtaposition, Emmitan CA Gallery, Surabaya, East Java.
• 2007
To Whom It May Concern, Koong Gallery, Jakarta.
• 2000
Menungso (Human), Air Art House, Jakarta.
• 1999
Foot Note on Coarseness, LIP, Centre culturel français, Jogyakarta, Central Java.

Group exhibitions
• 2011
Art Stage Singapore 2011, Marina Bay Sands, Singapore (with Vanessa Artlink).
Art Motoring I, Galeri Nasional Indonesia, Jakarta.
• 2010
2x, Jakarta Art District, Grand Indonesia, Jakarta.
Bazaar Art Jakarta 2010, Pacific Place, Jakarta (with Vanessa Artlink).
Pose Historia, Vanessa Artlink, Singapore.
Let's Bounce, Vanessa Artlink, Jakarta Art District, Jakarta.

• 2009
Jogja Jamming, 10th Jogja Biennale at Jogja National Museum, Yogyakarta, Central Java.
Exposigns. Great Exhibition of Indonesian Visual Art, 25th Institut Seni Indonesia (ISI) at Jogja Expo Center, Jogyakarta, Central Java.
Kado #2, Nadi Gallery, Jakarta.
A Maze, Public Art Project, Pacific Place, Jakarta.
Art Taipei, presented by Vanessa Artlink, Taipei.
Up & Hope, D'peak Art Space, Jakarta.
CIGE 2009, presented by Vanessa Artlink and Koong Gallery, Beijing.
• 2008
Ya Sin, Jogja Gallery, Yogyakarta, Central Java.
Manifesto, Galeri Nasional Indonesia, Jakarta.
Reddistrict, Koong Gallery, Jakarta.
Indonesia Contemporary All Star, Tujuh Bintang Art Space, Yogyakarta, Central Java.
Dari Penindasan Ke Cita-Cita Kemerdekaan, Galeri Salihara, Jakarta.
Asvigus Project 1, IVAA Hobby Studio, Yogyakarta.
What Is Contemporary Art? (Contemporary Art Apaan Tuh?), Museum Affandi, Yogyakarta, Central Java.
• 2007
IVAA Book AID, Nadi Gallery, Jakarta.
Openng New Place, Koong Gallery, Jakarta.
• 2006
Subversive Ornament, Antena Project, Yogyakarta, Central Java.
• 2005
Art 4 ACEH, Societet Militer, Yogyakarta, Central Java.
Tali Kasih, Edwin's Gallery, Jakarta.
Java Fundamental, Jenggala Gallery, Jimbaran, Bali.
Bharata Yudha on Canvas, Galleria Mall, Yogyakarta, Central Java.
Mari Mencari Gembira, Kedai Kebun Forum, Yogyakarta, Central Java.
• 2004
Multi Sub Culture, Berlin.
Bazzart, Yogyakarta Art Festival (FKY), Fort Vredenburg Museum, Yogyakarta, Central Java.
Olympiade, Pakubuwono Residence, Jakarta (organized by Nadi Gallery).
• 2003
Infatuated, Sunn Jin Gallery, Singapore.
In Between, Andi's Gallery, Jakarta.
Bazzart, Yogyakarta Art Festival (FKY), Fort Vredenburg Museum, Yogyakarta, Central Java.
• 2002
Shadow of Vulcano. Contemporary Indonesian Artists, MHC Gallery, Canada and New York, New Jersey and Virginia, USA.
Archipelago Visual Art II 2002, Galeri Nasional Indonesia, Jakarta.
Art Meeting Yogyakarta–Manado, Sahid Hotel Kawanua, Manado, North Sulawesi.
Re-Creation, Museum Haji Widayat, Magelang, Central Java.
• 2001
Limitation Bias, Edwin's Gallery, Jakarta.
Seven Liars, Purna Budaya, Yogyakarta and Air Art House, Jakarta.
• 2000
Indonesian Expression, Soobin Gallery, Singapore.
Knalpot, Puri Lukisan Museum, Ubud, Bali.

Awards
• 2006
Top 30 Finalist Sovereign Asia Art Prize 2006, Hong Kong.
Finalist M.I.A.D. Venado Tuerto 2006, Digital Art International, Argentina.
• 2004
Finalist Million Face of Megawati, TBS, Surakarta, Central Java.
• 2001
Finalist Philip Morris Indonesia Art Award.
• 2000
Finalist Philip Morris Indonesia Art Award.
• 1999
Finalist Winsor and Newton Indonesia Art Award.

Eddi Prabandono (p. 188)

Born in 1964 in Java, Indonesia.

Selected solo exhibitions
• 2010
Wonderful Fool, Red Mill Gallery, Johnson, Vermont.
• 2009
Strategic Presentation: Sculpture Luz, and Illusion, SIGIarts Gallery, Jakarta.
• 2005
Asoka, Rougheryet Gallery, Okinawa, Japan.
• 2002
Watashi wo Mite Kudasai, Maejima Art Center, Okinawa, Japan.
Mini Series, Akane Animal Hospital, Okinawa, Japan.

Selected group exhibitions
• 2011
Help New Zeland!, print exhibition and sale, CfSHE ANNEX Gallery, Tokyo.
The Alleys of a City Named Jogya, Primo Marella Gallery, Milan.
Art Stage Singapore 2011, Marina Bay Sands, Singapore.
• 2010
The 24th Ube Biennale Model Exhibition, Ube City, Yamaguchi, Japan.
The Down Town Sculpture Show 2010, Municipal Building, Johnson, Vermont.
Recent Art from Indonesia: Contemporary Art-Turn, SBin Art Plus, Singapore.
Colour of Asia, Okinawa Art Museum, Okinawa, Japan.
• 2009
Jogja Jamming, 10th Jogja Biennale at Jogja National Museum, Yogyakarta, Central Java.
September Ceria, Jogja Gallery, Yogyakarta, Central Java.
Jogja Art Fair #2, Taman Budaya, Yogyakarta, Central Java.
Bazaar Art Jakarta 2009, Pacific Place, Jakarta.
Guanlan International Print Biennial, Guanlan, China.
Lessedra Tenth World Art Print Annual, Lessedra Gallery & Contemporary Art Projects, Sofia, Bulgaria.
• 2008
Contemplation Performance: Made Surya Darma, Eddi Prabandono, Wilman Syahnur (Biennale

Yogyakarta IX Side Event), Sangkring Art Space, Yogyakarta, Central Java.
IVAA Book AID Volume 2: "Boys|Girls. Contemporary Art Youth Life and Culture in Two Parts", Edwin's Gallery, Jakarta.
Lessedra Seventh World Art Print Annual, Lessedra Gallery & Contemporary Art Projects, Sofia, Bulgaria.
• 2007
Man, Come On, Man! (Bung Ayo Bung!), 100 Years of Affandi Exhibition, Museum Affandi, Yogyakarta, Central Java.
Art, Food and Eat, Kedai Kebun Forum, Yogyakarta, Central Java.
Neo Nation, 9th Jogja Biennale at Sangkring Art Space, Yogyakarta, Central Java.
• 2006
Bride and Groom, Kedai Kebun Forum, Yogyakarta, Central Java.
• 2005
Lessedra Fifth World Art Print Annual, Lessedra Gallery & Contemporary Art Projects, Sofia, Bulgaria.
• 2004
Eight Asian Artists from the Nagasawa Program, Fleisher Art Memorial, Philadelphia, Pennsylvania.
Lessedra Third World Art Print Annual, Lessedra Gallery & Contemporary Art Projects, Sofia, Bulgaria.
Object(ify), Nadi Gallery, Jakarta.
Anthology of Art, Akademie der Kunste, Berlin.
• 2003
Wanakio 2003, Wanakio Organizing Committee, Okinawa, Japan.
International Kitchen, Noren Market, Naha, Okinawa, Japan.

Public collections
Johnson State College, Johnson, Vermont.
Johnson Municipal, Johnson, Vermont.
Center for the Science of Human Endeavor, Tokyo.
Okinawa Prefectural Art Museum, Okinawa, Japan.

Bambang Pramudiyanto (p. 192)

Born in 1965 in Klaten, Central Java, Indonesia.

Solo exhibitions
• 2001
When Anxiety Always On, Bentara Budaya, Jakarta.
• 1999
Icon Realism, Kinara Gallery, Nusa Dua, Bali.
• 1995
Cars, Bentara Budaya, Yogyakarta, Central Java.

Selected group exhibitions
• 2009
Reborn, H2 Art Gallery, Semarang, Central Java.
Exposigns. Great Exhibition of Indonesian Visual Art, 25th Institut Seni Indonesia (ISI) at Jogja Expo Center, Jogyakarta, Central Java.
Jogja Jamming, 10th Jogja Biennale at Jogja National Museum, Yogyakarta, Central Java.
• 2008
Wong Liyo, Bentara Budaya, Yogyakarta.

Manifesto, Galeri Nasional Indonesia, Jakarta.
Freedom, Mon Decor Painting Festival, Taman Budaya, Yogyakarta and Galeri Nasional Indonesia, Jakarta.
The Opening of Lerep Ungaran Art Village, Galeri Semarang, Semarang, Central Java.
• 2007
Gendakan, Bentara Budaya, Yogyakarta, Central Java.
200th Raden Saleh, Jogja Gallery, Yogyakarta, Central Java.
Man, Come On, Man! (Bung Ayo Bung!), 100 Years of Affandi Exhibition, Museum Affandi, Yogyakarta, Central Java.
• 2006
Time & Sign, Vanessa Artlink, Jakarta.
Space, V- Art Gallery, Bentara Budaya, Yogyakarta, Central Java.
Lindu, Bentara Budaya, Yogyakarta, Central Java.
Surface, Emmitan CA Gallery, Surabaya, East Java.
• 2005
Small World, Vanessa Art House, Jakarta.
• 2004
Artsingapore, Suntec Building, Singapore.
Milestone 2004, Vanessa Art House, Jakarta.
• 2003
Interpellation, 1st CP Open Biennale, Galeri Nasional Indonesia, Jakarta.
Visual Art Stepping Boundaries, Vivante Gallery, Medan, North Sumatra.
• 2002
Diversity and Harmony, Gedung Societet Militer, Yogyakarta, Central Java.
Raden Saleh Dimension, Galeri Semarang, Semarang, Central Java.
Jula Juli's Self Portrait, Bentara Budaya, Yogyakarta, Central Java.
Short Story Illustration Kompas 2002, Yogyakarta, Jakarta, Bali and Bandung.
Painting Exhibition: + 3 Talents, Galeri Puri, Malang, East Java.
Journey of Humans Resonance, Vanessa Art House, Jakarta.
• 2001
Bazzart, Yogyakarta Art Festival (FKY), Fort Vredenburg Museum, Yogyakarta, Central Java.
Yogyakarta Painting Exhibition 2001, Taman Budaya, Yogyakarta, Central Java.

Julius Ariadhitya Pramuhendra (p. 196)

Born in 1984 in Bandung, West Java, Indonesia.

Solo exhibitions
• 2009
Spacing Identities, NUS Museum, Singapore.
On Last Supper, Cemara 6 Galeri, Jakarta.
Spacing Identities: Part Two. Mapping Asia, CIGE 2009, Beijing.
Taxonomy of the Other, Platform 3 Artspace, Bandung.

Group exhibitions
• 2010
Middlebare Akte, Galeri Soemardja, Bandung, West Java.

• 2009
Broadsheet Notations: Epilogue, Tang Contemporary Art, Bangkok.
The Hand that Draws Itself, 18 Gallery, Shanghai.
• 2008
Passions: Best of Discovery Project, SH Contemporary, Shanghai (with Agus Suwage).
Manifesto, Galeri Nasional Indonesia, Jakarta.
• 2007
Seven, Galeri Soemardja, Bandung, West Java.

Anggar Prasetyo (p. 200)

Born in 1973 in Cilacap, Central Java, Indonesia.

Solo exhibitions
• 2011
Texture | Structure, Tembi Contemporary, Yogyakarta, Central Java.
• 2005
Body Language, Andi's Gallery, Yogyakarta, Central Java.
• 2004
Improvisation of Aesthetics, Regent Hotel, Jakarta.
• 2001
At the Edge of Appearance, Illen Gallery, Jakarta.

Group exhibitions
• 2011
Cultural Party, Gedung Tridharma, Bandung, West Java.
Jogja Is Indeed Special, Gedung Pusat Kebudayaan Koesnadi Hardjasoemantri – UGM, Yogyakarta, Central Java.
• 2010
The Beauty of Thankfulness and Patience, Sanggar Bambu, Taman Budaya, Surakarta, Central Java.
Romance 91, Sangkring Art Space, Yogyakarta, Central Java.
• 2009
Exposigns. Great Exhibition of Indonesian Visual Art, 25th Institut Seni Indonesia (ISI) at Jogja Expo Center, Jogyakarta, Central Java.
Up and Hope, D'peak Art Space, Jakarta.
Drawing Contemporary Indonesia, Galeri Nasional Indonesia, Jakarta.
Hyperlink, Tujuh Bintang Art Space, Yogyakarta, Central Java.
Teacher Oemar Bakri, Jogja Gallery, Yogyakarta, Central Java.
Carousel, Bentara Budaya, Jakarta.
Soft Opening, de-Sava Art Gallery, Yogyakarta, Central Java.
My Art Is Not Long Lasting (Seniku Tak Berhenti Lama), Taman Budaya, Yogyakarta, Central Java.
• 2008
Visual Art Exhibition of South–East Asia Artists, Thailand, Vietnam, Indonesia and Malaysia.
Colourful Jakarta Art Awards 2008, TMII, Jakarta.
Indonesia and the Mainstream, China International Gallery Exposition (CIGE), Beijing.
Indonesia Contemporary All Star, Tujuh Bintang Art Space, Yogyakarta, Central Java.
Jogja Art Fair # 1, Taman Budaya, Yogyakarta, Central Java.
City: Anggar & Laksmi, Galeri Canna, Jakarta.

The Textures in Painting, Jogja Gallery, Yogyakarta, Central Java.
Common to the Throne (Kere Munggah Bale), Bentara Budaya, Yogyakarta, Central Java
• 2007
The Beppu Asia Biennale of Contemporary Art, Beppu Art Museum, Beppu, Oita Prefecture, Japan.
Beautiful Death, Bentara Budaya, Yogyakarta, Jakarta, Surabaya, Malang and Bali.
Buzer dot com, Taman Budaya, Yogyakarta, Central Java.
International Literary Biennale, Langgeng Gallery, Magelang, Central Java.
• 2006
Spoilers of Jakarta Art Award 2006, TMII, Jakarta.
Homage 2 Homesite, Jogja National Museum, Yogyakarta, Central Java.
Langgeng Contemporary Art Festival 2006, Langgeng Gallery, Magelang,Central Java.
Twosome: Anggar dan Nengah, Sawah Art Gallery, Singapore.
18th Yogyakarta Art Festival (FKY), Fort Vredenburg Museum, Yogyakarta, Central Java.
• 2005
Intermezzo, Langgeng Gallery, Magelang, Central Java.

Angki Purbandono (p. 204)

Born in 1971 in Cepiring, Central Java, Indonesia.

Solo exhibitions
• 2011
Iop Pop, SBin Art Plus, Singapore.
• 2010
Noodle Theory, Garis Art Space, Jakarta.
2 Folders from Fukuoka, Vivi Yip Art Room, Jakarta.
• 2009
Kissing the Methods, Richard Koh Fine Art, Kuala Lumpur, Malaysia.
• 2008
Happy Scan, Biasa ArtSpace, Seminyak, Bali.
• 2007
Industrial Fiesta, Cemeti Art House, Yogyakarta, Central Java.
• 2006
Industrial Fiesta, Changdong Art Studio, Seoul.
• 2000
My Brain Packages, Centre culturel français, Jakarta.

Selected group exhibitions
• 2011
Decompression #10: Expanding the Space and Public, Galeri Nasional Indonesia, Jakarta.
• 2010
AND_Writers, 1st Nanjing Biennale, Jiangsu Provincial Art Museum, Nanjing, China.
Rainbow Asia, Hangaram Art Museum, Seoul.
Contempraneity. Contemporary Art Indonesia, Museum of Contemporary Art, Shanghai.
Art|Jog|10. Indonesian Art Now: The Strategies of Being, Taman Budaya, Yogyakarta, Central Java.
Emerging Wave, Asean–Korea Contemporary Photo Exhibition, Hangaram Art Museum, Seoul.

• 2009
Live and Let Live: Creators of Tomorrow, 4th Fukuoka Asian Triennial, Fukuoka Asian Art Museum, Fukuoka, Japan.
Ilustrasi Cerpen Kompas, Bentara Budaya, Jakarta, Yogyakarta and Bali.
City One-minute Project [Video] Rietveld, Venice Biennale, Arsenale Novissimo, Venice.
Blueprint for Jogja, Ruang MES 56, Tembi Contemporary, Yogyakarta, Central Java.
Arena. Zona Pertarungan, 13th Jakarta Biennale, Jakarta.
• 2008
Refresh: New Strategies in Indonesian Contemporary Art, Valentine Willie Fine Art, Singapore.
Photoartasia Expo, Zen Exhibition Lounge, Central Zen, World Trade Center, Bangkok.
Anonymous – Landing Soon Project, Artotheek, The Hague; Cemeti Art House and Erasmus Huis, Jakarta.
Manifesto, Galeri Nasional Indonesia, Jakarta.
• 2007
Kuota 2007, Galeri Nasional Indonesia, Jakarta.
Fetish Object Art Project #1, Biasa ArtSpace, Seminyak, Bali.
3 Young Contemporary Artists, Valentine Willie Fine Art, Kuala Lumpur, Malaysia.
Anonymous – Landing Soon #1, Cemeti Art House, Yogyakarta, Central Java.
• 2006
Open Studio – Document Changdong, Changdong Art Studio, Seoul.
Goyang International Art, Goyang, South Korea.
Bikini in Winter, Loop Alternative Space, Seoul.
International Digital Design Invitation Exhibition, Joongbu University, Seoul.
Alterorgasm, Kedai Kebun Forum, Yogyakarta, Central Java.
• 2005
Road/Route, 1st Pocheon Asian Art Festival, Pocheon, South Korea.
Space and Shadows. Contemporary Art from Southeast Asia, Haus der Kultur der Welt, Berlin.
Where Troubles Melt Like Lemon Drops, Koninklijke Academie voor Schone Kunsten, Hogeschool Antwerpen, Antwerp, Belgium.
Trans Indonesia, Govett-Browser Art Gallery, New Playmouth, New Zealand.
• 2004
Beauty Point, International Media Art Award, Baden, Germany.
Holiday in Jakarta, Ruang MES 56, Passage de Retz, Paris.
Urban Moslem in Yogyakarta, Museum Nusantara, Delft, The Netherlands.

Residencies
• 2011
SBin Art Plus, Singapore.
• 2009
Fukuoka Asian Art Museum, Fukuoka, Japan.
• 2006–2007
Artotheek, The Hague, The Netherlands and Cemeti Art House, Yogyakarta, Central Java.
• 2005–06
Changdong Art Studio, Seoul.

Agus "Baqul" Purnomo (p. 208)

Born in 1975 in Kendal, Central Java, Indonesia.

Selected solo exhibitions
• 2010
Secret Garden, Vivi Yip Art Room, Jakarta.
• 2009
Recite! / Iqra!, Valentine Willie Fine Art, Kuala Lumpur, Malaysia.
• 2008
Vortex 8, Tembi Contemporary, Yogyakarta, Central Java.
• 2005
Final Work, The Indonesia Institute of the Arts (ISI), Yogyakarta, Central Java.

Selected group exhibitions
• 2010
Salon Remix, Valentine Willie Fine Art, Kuala Lumpur, Malaysia.
South East Art Domain, Taman Budaya, Yogyakarta, Central Java.
Faith + Reason, Manila Contemporary, Manila.
Proclamation!, Watergate Gallery, Seoul and Chang Art, Beijing.
Artriangle 3, National Art Gallery, Kuala Lumpur, Malaysia.
Sign and After: Contemporary Islamic Art, Lawangwangi Artpark Launching, Bandung, West Java.
T R A M E N D U M, Philo Art Space's 5th Anniversary Exhibition, Galeri Nasional Indonesia, Jakarta.
4th Anniversary of Jogja Gallery, Jogja Gallery, Yogyakarta, Central Java.
Artlicious, Tujuh Bintang Art Space, Yogyakarta, Central Java.
• 2009
Headlight, Valentine Willie Fine Art, Singapore.
Fresh 4 U, Jogja Gallery, Yogyakarta, Central Java.
Hello Hello Manila Contemporary, Manila.
Parameters + Play + Repetition = Patterns, Manila Contemporary, Manila.
Blueprint for Jogja, Tembi Contemporary, Yogyakarta, Central Java.
Survey #2, Edwin's Gallery, Jakarta.
Cogito, Philo Art Space, Jakarta.
Bazaar Art Jakarta 2009, Pacific Place, Jakarta.
Exposigns. Great Exhibition of Indonesian Visual Art, 25th Institut Seni Indonesia (ISI) at Jogja Expo Center, Jogyakarta, Central Java.
Jogja Jamming, 10th Jogja Biennale at Jogja National Museum, Yogyakarta, Central Java.
• 2008
Celebrating the Differences, Elegance Gallery, Jakarta.
Grand Openning of Tembi Contemporary, Tembi Contemporary, Yogyakarta, Central Java.
Looking InWard, Elegance Gallery, Jakarta.
New Java, Srisasanti Gallery, Yogyakarta, Central Java.
Jogja Art Fair, Taman Budaya, Yogyakarta, Central Java.
Reunion Detik 96, Sangkring Art Space, Yogyakarta, Central Java.
AHA, V-Art Gallery, Bentara Budaya, Yogyakarta, Central Java.

888, Bale Black Box Laboratory, Yogyakarta, Central Java.
Ya'sin: The Untranslatable, Jogja Gallery, Yogyakarta, Central Java.
Play with 3D Objects, Jogja National Museum, Yogyakarta, Central Java.
South East, Novas Contemporary Urban Center (CUC), Liverpool, United Kingdom.
All I Want for X-Mas, Manila Contemporary, Manila.
• 2007
Indonesia Telling Story (Nusantara Berkisah), Taman Budaya, Yogyakarta, Central Java.
Artriangle, Wisma Soka Gakkai, Kuala Lumpur, Malaysia.
Abstract Relation, Xoas Gallery, Kuala Lumpur, Malaysia.
Buzer, Taman Budaya, Yogyakarta, Central Java.
• 2006
Art for Yogya, Taman Budaya, Yogyakarta, Central Java.
Artcare, Soboman, Yogyakarta, Central Java.
Wedding, Tobacco & Art OHD, Tri Bhakti House, Magelang, Central Java.
International Print & Drawing Biennale, National Museum, Taiwan.
The Spoiler for Jakarta, Jakarta Art Award, Jakarta.
Terror?, Intersection for the Art, San Francisco, California.
• 2005
Art for ACEH, Taman Budaya, Yogyakarta, Central Java.
China Love (Cina Cinta), Mon Decor Art Gallery, Jakarta.
One by One and One, Ombo Gallery, Yogyakarta, Central Java.
Bazzart, Yogyakarta Art Festival (FKY), Fort Vredenburg Museum, Yogyakarta, Central Java.
Abstract Reality = Nir Rupa, Taman Budaya, Yogyakarta, Central Java.

Awards
• 1999
Finalist of Nokia Art Award, Jakarta.
• 2006
Finalist of Jakarta Art Award, Jakarta.
Finalist of International Print & Drawing Biennale, Taiwan.

Haris Purnomo (p. 212)

Born in 1956 in Klaten, Central Java, Indonesia.

Selected solo exhibitons
• 2009
The Babies: Allegory of Docile Bodies, COCA Museum, Seattle, Washington and Bentara Budaya, Jakarta.
• 2008
Unbridgeable Future, Vanessa Artlink, Beijing.
Burn Baby Burn, Hong Kong International Art Fair, Hong Kong.
• 2007
Alien: Nation, Galeri Nasional Indonesia, Jakarta.
• 2006
Di Bawah Sayap Garuda, Nadi Gallery, Jakarta.

Selected group exhibitions
• 2011
Closing the Gap, MIFA Gallery, Melbourne, Australia.
• 2010
Artpreneurship. Space & Image, Ciputra World Marketing Gallery, Jakarta.
• 2009
Jogja Jamming, 10th Jogja Biennale at Jogja National Museum, Yogyakarta, Central Java.
Scope Art Basel 2009, Basel, Switzerland.
Prague Biennale 2009, Prague.
Hybridization, North Art Space, Jakarta.
Post-Tsunami Art, Primo Marella Gallery, Milan.
Arte Bologna 2009, Bologna, Italy.
Dallas Art 2009, Dallas, Texas.
• 2008
Refleksi Ruang dan Waktu, V-Art Gallery, Bentara Budaya, Yogyakarta, Central Java.
The Highlight, Jogja National Museum, Yogyakarta, Central Java.
Allegorical Bodies, A Gallery, Taipei.
Art Asia Miami 2008, Miami, Florida.
Art Paris–Abu Dhabi 2008, Abu Dhabi, United Arab Emirates.
Art Taipei 2008, Taipei.
ACAF, New York.
Reflective Asia, 3rd Nanjing Triennale, Nanjing, China.
Shanghai Contemporary Art Fair 2008, Shanghai.
CIGE 2008, Beijing.
Space/Spacing, Galeri Semarang, Semarang, Central Java.
Manifesto, Galeri Nasional Indonesia, Jakarta.
• 2007
Kuota 2007, Galeri Nasional Indonesia, Jakarta.
Art Singapore 2007, Singapore.
Shanghai Contemporary Art Fair 2007, Shanghai.
Imagined Affandi, Indonesian Archive Building, Jakarta.
• 2006
Icon Yogyakarta, Jogja Gallery, Yogyakarta, Central Java.
• 2005
Jakarta Spies/Eyes (Mata-Mata Jakarta), Galeri Nasional Indonesia, Jakarta.

Awards
• 2007
The Schoeni Public Vote Prize, Sovereign Asian Art Prize.

Pupuk Daru Purnomo (p. 216)

Born in 1964 in Yogyakarta, Central Java, Indonesia.

Solo exhibitions
• 2009
Doxa Faces as a Metaphor: Pupuk Daru Purnomo, NUS Museum, Singapore.
• 2008
The Theater of Face, Garis Art Space, Jakarta.
• 2006
Living Landscape, Gajah Gallery, Singapore.

• 2005
Reflection of Pupuk DP's Artistic Journey, Galeri Nasional Indonesia, Jakarta.
• 2004
Block Note, Museum Haji Widayat, Magelang, Central Java.
• 2001
Inner Essence, Gajah Gallery, Singapore.
• 1995
Pilgrimage into Anima, Bentara Budaya, Yogyakarta, Central Java.

Group exhibitions
• 2009
Famous Living Landscape, Jogja Gallery, Yogyakarta, Central Java.
Awareness. Indonesian Art Today, Canvas International Art, Amsterdam.
Jogja Jamming, 10th Jogja Biennale at Jogja National Museum, Yogyakarta, Central Java.
• 2008
Indonesian Triple Bill, Singapore Management University, Singapore.
• 2007
Artvertising, Galeri Nasional Indonesia, Jakarta.
• 2006
Angkor – The Djin Within, Gajah Gallery, Singapore.
• 2004
Creations and Lines by the Sons of Nation, Mercantile Club, Jakarta.
• 2003
Impressionist, Jakarta Design Center, Jakarta.
Infatuated, Sunjin Gallery, Singapore.
Borobudur International Festival, Museum Haji Widayat, Magelang, Central Java.
Agitative Borobudur, Langgeng Gallery, Magelang, Central Java.
• 2002
Diversity in Harmony, Taman Budaya, Yogyakarta, Central Java.
Re-Creation, Museum Haji Widayat, Magelang, Central Java.
Not Just the Political, Museum Haji Widayat, Magelang, Central Java.
Rainbow Cabinet, Bentara Budaya, Yogyakarta, Central Java.
• 2000
Heart of Jogja, Gajah Gallery, Singapore.
• 1998
Expressions of the Inner Realm, Santi Gallery, Jakarta.
• 1997
Philip Morris Art Awards, Agung Rai Museum of Art, Ubud, Bali.
• 1996
Seven Artists, Hotel Indonesia, Jakarta.
• 1994
Pratisara Affandi Adhi Karya, ISI, Yogyakarta, Central Java.
Class of '87, Bentara Budaya, Yogyakarta, Central Java.

Awards
• 1994
Finalist, Philip Morris Art Award.

Agung Mangu Putra (p. 220)

Born in 1963 in Sangeh, Bali, Indonesia.

Solo exhibitions
• 2008
Silent Words, Gajah Mas Art Gallery, Ubud, Bali.
• 2007
Mandala, Bidadari Art Gallery, Ubud, Bali.
• 2006
Believe, Rupa Gallery, Surabaya, East Java
• 2005
Spiritual Landscape, Gajah Gallery, Singapore.
• 2003
At the Edge of Bali's Light (Di Tepi Cahaya Bali), Bentara Budaya, Jakarta.
• 2002
Grunt of Water, Land, and Rock (Gerutu Air, Tanah Dan Batu), Santi Gallery, Jakarta.
• 2000
Nature, Culture, Tension, Jezz Gallery, Denpasar, Bali.

Selected group exhibitions
• 2011
Art Stage Singapore 2011, Marina Bay Sands, Singapore.
• 2010
Korea International Art Fair, Seoul.
Bali and Beyond, Sanggar Dewata Indonesia, Bentara Budaya, Bali.
Contemporaneity: Contemporary Art in Indonesia, Museum of Contemporary Art, Shanghai.
• 2008
I+, Galeri Canna, Jakarta.
• 2007
The 7th Nude Crouquis Exhibition, Seoul.
• 2006
Full Moon, Galeri Canna, Jakarta.
• 2005
The Wedding, Galeri Canna, Jakarta.
Bali–Jeju, Jejudo Art Hall, Jeju, Korea.
Milestone, Vanessa Art House, Jakarta.
Art Singapore, Santec City, Singapore.
Erotica, Tonyraka Art Gallery, Ubud, Bali.
• 2004
Diversity, Unity & Harmony, Galeri Canna, Jakarta.
Reading Multi Culture, Haus der Weltkulturen, Berlin.
Singapore Art Fair, Suntec City, Singapore.
Still Life, Tonyraka Art Gallery, Ubud, Bali.
Self Exploration, Tonyraka Art Gallery, Ubud, Bali.
Ilustrasi Cerpen Kompas 2002, travelling in Indonesia.
Indofood Art Award, Agung Rai Museum of Art, Ubud, Bali.
Reading Raden Saleh, Galeri Semarang, Semarang, Central Java.
Safe Our Sea, Galeri Nasional Indonesia, Jakarta.
Aspects of a Mountain, Sidik Jari Museum, Denpasar, Bali.
• 2003
Di Tepi Cahaya Bali, Bentara Budaya, Jakarta.
• 2002
Gerutu Air, Tanah dan Batu, Santi Gallery, Jakarta.

I Wayan Sudarna Putra (p. 224)

Born in 1976 in Ubud, Bali, Indonesia.

Solo exhibitions
• 2001
API, Sika Gallery, Ubud, Bali.
• 2000
Playing with Fire, Edwin's Gallery, Jakarta.

Group exhibitions
• 2010
Open Space, Bledog Art Space, Ubud, Bali.
Noun, N – Art T-Shirt, Ubud, Bali.
• 2009
Janus, T–Artspace, Ubud, Bali.
Exposigns. Great Exhibition of Indonesian Visual Art, 25th Institut Seni Indonesia (ISI) at Jogja Expo Center, Jogyakarta, Central Java.
Common Sense, Galeri Nasional Indonesia, Jakarta.
My Name is Tho Land, Galeri Tanah Tho, Ubud, Bali.
• 2008
Silence Celebration, Tonyraka Art Gallery, Ubud, Bali.
Thing + Think = Everythink, Gracia Gallery, Surabaya, East Java.
Beginning of Fantasy, One Gallery, Jakarta.
Res Republicum, Galeri Canna, Jakarta.
• 2007
Love Letter, Tonyraka Art Gallery, Ubud, Bali.
• 2006
Greenzone, Green House Pertiwi Resort & Spa, Monkey Forest, Ubud, Bali.
Young Arrows, Jogja Gallery, Yogyakarta, Central Java.
The Ubud Festival 2006, Ubud, Bali.
Nostalgia, Komaneka Fine Art Gallery, Ubud, Bali.
• 2005
Art for ACEH, Gedung Societet Militer, Taman Budaya, Yogyakarta, Central Java.
Seeing the Universe from Kaliurang, Djagad Academic Gallery, Museum Ullen Sentalu, Kaliurang, Yogyakarta, Central Java.
Incarnation Group: Lima, Bentara Budaya, Yogyakarta, Central Java.
Bazzart, Yogyakarta Art Festival (FKY), Fort Vredenburg Museum, Yogyakarta, Central Java.
The Realistage, Galeri Gong, Bandung, West Java; Galeri Semar, Malang, East Java; Museum Haji Widayat, Magelang, Central Java.
Transaction, One Gallery, Jakarta.
Space and Scape, Museum Nyoman Gunarsa Klungkung, Bali.
• 2004
Reading Widayat's World, Museum Haji Widayat, Magelang, Central Java.
Temptation, Studio Budaya, Langgeng Gallery, Magelang, Central Java and V-Art Gallery, Bentara Budaya, Yogyakarta, Central Java.

Awards
• 1999
Philip Morris Indonesia Art Award VI.

Wedhar Riyadi (p. 228)

Born in 1980 in Yogyakarta. Lives and works in Yogyakarta, Central Java, Indonesia.

Solo exhibitions
• 2008
Expression of Desire, Ark Galerie, Jakarta.

Group exhibitions
• 2010
Digit(all): Indonesian Contemporary New Media Practices, Umahseni@Mentengartspace, Jakarta.
KIAF 10, COEX Hall, Seoul.
• 2009
Jogja Jamming, 10th Jogja Biennale at Jogja National Museum, Yogyakarta, Central Java.
Exposigns. Great Exhibition of Indonesian Visual Art, 25th Institut Seni Indonesia (ISI) at Jogja Expo Center, Jogyakarta, Central Java.
Gift (Kado), Nadi Gallery, Jakarta.
Utan Kayu Literary Biennale 2009, Galeri Salihara, Jakarta.
Art Taipei 2009, Taipei.
The Topology of Flatness, Edwin's Gallery, Jakarta.
Next Wave, Avanthay Contemporary, Zurich.
Art Hong Kong 2009, Hong Kong.
Tales from Wounded Land, Tyler Rollins Gallery, New York.
Freedom in Geekdom, Nadi Gallery, Jakarta.
• 2008
Highlight, Jogja National Museum, Yogyakarta, Central Java.
Wanakio 2008, Okinawa, Japan.
Refresh: New Strategies in Indonesian Contemporary Art, Valentine Willie Fine Art, Singapore.
Hello Print, Edwin's Gallery, Jakarta.
Manifesto, Galeri Nasional Indonesia, Jakarta.
A Slice of Indonesian Contemporary Art, Soka Art Center, Beijing.
Flower War (Perang Kembang), Bentara Budaya Yogyakarta, Central Java.
Utopia Negativa, Langgeng Gallery, Magelang, Central Java.
Lullaby, V-Art Gallery, Bentara Budaya, Yogyakarta, Central Java.
• 2007
Get It (W)all, LIP, Centre culturel français, Yogyakarta, Central Java.
Agaris Koboi, Jogja National Gallery, Yogyakarta, Central Java.
T-Shirt fom March, Bentara Budaya, Yogyakarta, Central Java.
Black Urban Art, Yogyakarta, Surabaya, Jakarta and Bandung.
One Month Shop, Kedai Kebun Forum, Yogyakarta, Central Java.
Imagined Affandi, Indonesian Archive Building, Jakarta.
Popscape: Everyday in Indonesia, Cultural Center of the Philippines, Manila.
Visualisation of Gendakan Aphorism (Visualisasi Parikan Gendhakan), Bentara Budaya, Yogyakarta, Central Java.
Shout Out, 19th Yogyakarta Art Festival, Yogyakarta, Central Java.
Man, Come On, Man! (Bung Ayo Bung!), 100

Years of Affandi Exhibition, Museum Affandi, Yogyakarta, Central Java.
Leaked #2 (Bocor #2), Cemeti Art House, Yogyakarta, Central Java.
Superb Ambition, Senayan Plaza, Jakarta.
Artvertising, Galeri Nasional Indonesia, Jakarta.
Neo Nation, 9th Jogja Biennale, Yogyakarta, Central Java.
• 2006
Gloomy Attack of Light Raining Month (Serangan Sendu Bulan Gerimis), Kafe Deket Rumah, Yogyakarta, Central Java.
Terror, Intersection for the Art, San Francisco, California.
Art for Jogja, Taman Budaya, Yogyakarta, Central Java.
Paper Soles, Via-Via Café, Yogyakarta, Central Java.
Tributes, Cemeti Art House, Yogyakarta, Central Java.
Young Arrows, Jogja Gallery, Yogyakarta, Central Java.
Midnight Live Mural Project, Beringharjo Centre, Yogyakarta, Central Java.
• 2005
Pseudo Still Life: Object And its Aura, Galeri Semarang, Semarang, Central Java.
Urban/Culture, 2nd CP Open Biennale, Museum Bank Indonesia, Jakarta (with Daging Tumbuh).
Let's Laugh (Ayo Ngguyu), Bentara Budaya, Yogyakarta, Central Java.
Pra Biennale Bali 2005, V-Art Gallery and Museum Affandi, Yogyakarta, Central Java.
Re:Publik Art, Yogyakarta, Central Java.
• 2004
Perception in Vibration (Persepsi Dalam Vibrasi), Edwin's Gallery, Jakarta.
Unidentified Fucking Object, Kedai Kebun Forum, Yogyakarta, Central Java.
Burn the Space, CC DOC Studio, Yogyakarta, Central Java.
Barcode, 16th Yogyakarta Art Festival (FKY), Taman Budaya, Yogyakarta, Central Java.

Residencies and awards
• 2008
Wanakio 2008, Okinawa, Japan.
• 1999
Pratita Adhi Karya tor the Best Oil Painting.

ruangrupa (p. 232)

ruangrupa is an artists' initiative established in 2000 by a group of artists in Jakarta. It is a not-for-profit organization that strives to support the progress of art ideas within the urban context and the larger scope of culture, by means of exhibitions, festivals, art labs, workshops, research and journal publication.

Selected collaborations, projects and exhibitions
• 2010–11
Exhibition, *Singapore Night Festival*, Singapore Art Museum, Singapore.
A ruangrupa collaborative travelling exhibition series: *Only Giving, Not Expecting Return (Hanya Memberi Tak Harap Kembali),* Soemardja Gallery,

Bandung, Kedai Kebun Forum, Yogyakarta and Galeri Nasional Indonesia, Jakarta.
ruangrupa 10th Anniversary,
DECOMPRESSION#10 – Expanding the Space and Public, exhibitions, public art projects, workshops, film screening, seminars, bazaar, music festival and launch of ruangrupa publications, Jakarta, Bandung and Yogyakarta.
Art project, *4th Jakarta 32°C*, exhibition, workshop, public art project and discussion program for Jakarta students, Jakarta.
• 2009
ruangrupa presentation, Utrecht Manifest, Biennial for Social Design: The Grand Domestic Revolution, *Beyond the Dutch*, Casco – office for art, design & theory, Utrecht, The Netherlands.
Conference, *On Globalism*, Museum Moderner Kunst (MUMOK), Vienna.
OK. Video Comedy, 4rd Jakarta International Video Festival, Jakarta.
• 2008
ruangrupa changed its organization format into: ART LAB, Support & Promote, Video Development and ruangrupa Research & Development Division.
Seminar, *After Hours – New Institutionalism in Asia*, Yokohama, Japan.
3rd Jakarta 32°C, exhibition, discussion and workshop programme for Jakarta students, Jakarta.
Special screening program, International Short Film Festival, Oberhausen, Germany.
ruangrupa presentation, *Constellation 3: Extra/Ordinary Cities: The Cultural Dynamics of Urban Intervention*, associated with Sydney Biennale 2008, Sydney.
• 2007
OK. Video Militia, 3rd Jakarta International Video Festival, Jakarta.
Leadership training, Independent Creative Art Space Centre by Asia–Europe Foundation, Trans Europe Halles and Arts Factory, Paris.
Single-channel video Art Festival, *Move on Asia*, Loop Gallery, Seoul.
In 2007 *Karbon Journal* was transformed into an online journal: www.karbonjournal.org
• 2006
Exhibition, *Rethinking Nordic Colonialism,* Faroe Island, Denmark.
Public art project, *Exociti,* Istanbul.
2nd Jakarta 32°C, exhibition, discussion and workshop program for Jakarta students, Jakarta.
Exchange program, *Artists Run Festival & Creative Exchange Program,* GANG Festival, Sydney.
OK. Video: Kuala Lumpur, Jakarta International Video Festival in Kuala Lumpur, in collaboration with Parking Project & Galeriiizu, Kuala Lumpur, Malaysia.
Workshop, *Multiplying Emergence: City Space and Cultural Interventions*, Bangkok.
• 2005
Exhibition, *9th Istanbul Biennale*, Istanbul.
OK. Video Sub-version, 2nd Jakarta International Video Festival, Jakarta.
Exhibition, *KO Video Art Festival*, Durban, South Africa.
ruangrupa 5th Anniversary: *ruangrupa V.5.1 Greatest Hits*, exhibition, music, video,

workshop and video screening, Jakarta.
Exhibition, *Urban/Culture*, 2nd CP Open Biennale, Museum Bank Indonesia, Jakarta.
• 2004
Documentary film project, *Valley of the Dog Songs*, Amsterdam.
1st Jakarta 32°C, exhibition, discussion and workshop program for Jakarta students, Jakarta.
Sustainable development forum, Open Circle, Mumbai.
ruangrupa presentation, EOF Gallery, Paris.
• 2003
OK. Video, 1st Jakarta Video Art Festival, Jakarta.
A ruangrupa collective exhibition, *Lekker Eten Zonder Betalen,* Cemeti Art House, Yogyakarta, Central Java.
• 2002
Exhibition, *P_A_U_S_E*, 4th Gwangju Biennale, Gwangju, South Korea.

Tisna Sanjaya (p. 236)

Born in 1958 in Bandung, West Java, Indonesia.

Solo exhibitions
• 2011
Cigondewah Project of Art, NUS Museum, Singapore.
• 2008
Incarnation, Artsphere, Jakarta.
Cigondewah, Gallery Kendra, Seminyak, Bali.
Ideocrazy, Galeri Nasional Indonesia, Jakarta.
• 2007
Sunset in Cigondewah, Cultural Center Foundation, Bandung, West Java.
• 2004
Installation and Graphic Arts, Bentara Budaya, Jakarta.
• 2003
Special Supplication for the Dead, Lontar Gallery, Jakarta.

Selected group exhibitions
• 2008
Scale in Black, Valentine Willie Fine Art, Singapore.
Manifesto, Galeri Nasional Indonesia, Jakarta.
Graphic Art, Ark Galerie, Jakarta.
Indonesian Invasion, Sin Sin Fine Art, Hong Kong.
• 2007
Neo Nation, 9th Jogja Biennale at Jogja National Museum, Yogyakarta, Central Java.
Art Pupa Ke'ruh, YPK Building, Bandung, West Java.
Imagined Affandi, Indonesian Archive Building, Jakarta.
Luminesence, Tonyraka Art Gallery, Ubud, Bali.
• 2006
Graphic Arts Ay Tjoe Christine, Devy Perdianto and Tisna Sanjaya, Goethe-Institut, Jakarta.
• 2005
Graphic Art Exhibition, Lahore Art Foundation, Lahore, Pakistan.
• 2004
Gwangju Biennale, Gwangju, South Korea.
• 2003
Venice Biennale, Venice, Italy.
Underground Carriage, Bandung, West Java.

• 2001
Reading Frida Kahlo, Nadi Gallery, Jakarta.
Via Printmaking, Galeri Soemardja, Bandung, West Java (with 34 Bandung artists).
50th Base Magazine, Bentara Culture Gallery, Yogyakarta, Central Java.
• 2002
Wild Imagination, Langgeng Gallery, Magelang, Central Java.
Offside, Hiroshima Museum of Contemporary Art, Hiroshima, Japan.

Awards
• 2006
Award as Artist, Cultural Forum, The Government of West Java.
• 1997
Best Artist, Philip Morris Indonesia Art Awards 1997.
Award Sponsors of The Sapporo International Print Competition 1997, Sapporo, Japan.
• 1996
Top 10 Painter, Indonesian Art Awards 1996.

Handiwirman Saputra (p. 240)

Born in 1975 in Bukittinggi, West Sumatra, Indonesia.

Selected solo exhibitions
• 2009
Things: The Order of Handiwirman, Cemeti Art House, Yogyakarta, Central Java.
• 2007
Archaeology of a Hotel Room, Nadi Gallery, Jakarta.
• 2004
Apa-Apanya Dong?, Nadi Gallery, Jakarta.
• 2001
Patah Hati; Broken Heart, Cemeti Art House, Yogyakarta, Central Java.
• 2000
Provocative Objects, Lontar Gallery, Jakarta.
• 1999
Benda, Benda Art Space, Yogyakarta, Central Java.

Selected group exhibitions
• 2011
Collectors' Stage: Asian Contemporary Art from Private Collections, Singapore Art Museum, Singapore.
• 2010
Made in Indonesia, Galerie Christian Hosp, Berlin.
Contemporaneity: Contemporary Art of Indonesia, Museum of Contemporary Art, Shanghai.
Clouds: Power of Asian Contemporary Art, Soka Art Center, Beijing.
• 2009
Pleasures of Chaos. Inside New Indonesian Art, Primo Marella Gallery, Milan.
• 2008
Coffee, Cigarettes and Pad Thai: Contemporary Art in Southeast Asia, Eslite Gallery, Taipei.
• 2007
Soka's View, Southeast Asian Contemporary Art, Soka Art Center, Beijing.

• 2006
Belief, Singapore Biennale, City Hall, Singapore.
Icon: Retrospective, Jogja Gallery, Yogyakarta, Central Java.
• 2005
Eksodus Barang, Nadi Gallery, Jakarta.
Pseudo Still Life: Obyek Dan Auranya, Galeri Semarang, Semarang, Central Java.
Urban/Culture, 2nd CP Open Biennale, Museum Bank Indonesia, Jakarta.
• 2004
Mempertimbangkan Tradisi, The Traditional Gallery, Jakarta.
• 2003
Read, Cemeti Art House, Yogyakarta, Central Java.
Interpellation, 1st CP Open Biennale, Galeri Nasional Indonesia, Jakarta.
Countrybution, 7th Yogyakarta Biennale, Taman Budaya, Yogyakarta, Central Java.
• 2002
Dream Project: Under Construction, Fabriek Gallery, Bandung, West Java.
Under Construction: New Dimension of Asian Art, Tokyo Opera City, Tokyo.
Ecstaticus Mundi, Selasar Sunaryo Art Space, Bandung, West Java and Air Art House, Jakarta.
Pose, Affandi Museum, Yogyakarta, Central Java.
• 2001
Contemporary Craft, Galeri Nasional Indonesia, Jakarta.
• 1999
6th Yogyakarta Biennale, Purna Budaya Art Center, Yogyakarta, Central Java.
Sakato, Fort Vredenburg Museum, Yogyakarta, Central Java.
• 1997
Pelukis Muda Yogyakarta, Fort Vredenburg Museum, Yogyakarta, Central Java and Agung Rai Museum of Art, Ubud, Bali.

Dadi Setiyadi (p. 244)

Born in 1977 in Tasikmalaya, West Java, Indonesia.

Solo exhibitions
• 2009
Transmission, House of Matahati, Kuala Lumpur, Malaysia.
• 2006
Indonesian Folklore, Berlin.
• 2006
Sepenggal Kisah Nusantara (Indonesian Folklore), Jakarta.
• 2004
Fantastic Figure, Yogyakarta.
• 2000
Human Genome Project, Gelaran Budaya, Yogyakarta, Central Java.

Group exhibitions
• 2011
Speak Off, Jogja National Museum, Yogyakarta, Central Java.
• 2010
The Slave Route, Rue Saint-Bernard, Brussels.
Your Red Number, Craiova, Dolj, Romania.

Learning Differences, Elgin Art Show Case, Elgin, Illinois.
Beauty Is, SPA 310, Richmond, Virginia.
Miniature Masterpiece, Aswara Gallery, Kuala Lumpur, Malaysia.
Mail Art in the World 2010, Sinnai, Sardinia, Italy.
Ranah Seni Tenggara, Taman Budaya, Yogyakarta, Central Java.
Indonesia Art Awards 2010: Contemporaneity, Galeri Nasional Indonesia, Jakarta.
10th Anniversary Exhibition, One Gallery, Jakarta.
Artlicious, Tujuh Bintang Art Space, Yogyakarta, Central Java.
• 2009
Exposigns. Great Exhibition of Indonesian Visual Art, 25th Institut Seni Indonesia (ISI) at Jogja Expo Center, Jogyakarta, Central Java.
Almanak Senirupa Yogyakarta, Biennale Group Show, Jogja National Museum, Yogyakarta, Central Java.
• 2008
Animal Kingdom, Jogja Gallery, Yogyakarta, Central Java.
Kopi Kretek Kraton, Gallery Kebun Mimpi, Kuala Lumpur, Malaysia.
Art Triangle Malaysia-Philippines-Indonesia, Soka Gakkai, Kuala Lumpur, Malaysia.
G-8, Balai Black Box, Yogyakarta, Central Java.
Self, Philo Art Space, Jakarta.
Versus, Gallery 678, Jakarta.
• 2007
Art Care Indonesia, Soboman, Yogyakarta, Central Java.
Nusantara Berkisah, Taman Budaya, Yogyakarta, Central Java.
Ilusi–Ilusi Nasionalisme, Jogja National Gallery, Yogyakarta, Central Java.
Portofolio, Jogja Gallery, Yogyakarta, Central Java.
Global Warming, GWK Cultural Park, Bali.
Behind Horizon, Srisasanti Gallery, Yogyakarta, Central Java.
• 2006
Realis(Me) Banal, Gracia Gallery, Surabaya, East Java.
Bazzart, Yogyakarta Art Festival (FKY), Fort Vredenburg Museum, Yogyakarta, Central Java.
Pra Biennale Bali, Museum Affandi, Yogyakarta, Central Java.
Style Life, Vanessa Artlink, Jakarta.
Time and Sign, Vanessa Artlink, Jakarta.
Art Fair, Beijing.
Wedding, Tobacco & Art OHD, Tri Bhakti House, Magelang, Central Java.
The 12th International Biennial Print and Drawing Exhibition, ROC, Taiwan

Residencies and awards
• 2009
House of Matahati, Kuala Lumpur, Malaysia.
Rimbun Dahan, Kuala Lumpur, Malaysia.
• 2006
International Biennale of Drawing and Print Nominations, Taiwan.
• 2002
Finalist Indonesia Indofood Art Awards.
• 2000
Winner of Indonesia Nokia Arts Awards Asia Pacific.

Farhan Siki (p. 248)

Born in 1971 in Lamongan, East Java. Lives and works in Yogyakarta, Central Java, Indonesia.

Solo exhibitions
• 2010
294cans/9999brands/@ll items!, Emmitan CA Gallery, Surabaya, East Java.
• 2008
Breaking the Wall, Koong Gallery, Jakarta.
• 2007
Urban Ruptures, Biasa ArtSpace, Seminyak, Bali.
• 2003
Animalscriba, Via-Via Café, Yogyakarta, Central Java.
• 2002
The Yellow Project, Gramedia-Merdeka, Bandung, West Java.
• 2000
Trash Story, Garbage Bins Comic Project (Aikon), Jakarta.

Selected group exhibitions
• 2011
Homo Ludens #2, Emmitan CA Gallery, Surabaya, East Java.
IVAA Archive AID 2011, Jakarta Art District, Jakarta.
Motion and Reflection, Indonesia Art Motoring I, Galeri Nasional Indonesia, Jakarta.
Divergence, international stencil art exhibition, North Art Space, Jakarta.
Bridge Of Culture, Wendt Gallery, New York.
The Alleys of a City Named Jogya, Primo Marella Gallery, Milan.
Art Stage Singapore 2011, Marina Bay Sands, Singapore (with Primo Marella Gallery).
• 2010
Reflection of Megacities: Jakarta Art Award, North Art Space, Jakarta.
Bazaar Art Jakarta 2010, Pacific Place, Jakarta.
Art|Jog|10. Indonesian Art Now: The Strategies of Being, Taman Budaya, Yogyakarta, Central Java.
Wall Street Art, Jakarta–Paris Graffiti Exhibition, Galeri Salihara, Jakarta.
Proclamation: Five Artists From Indonesia, Chang Art Gallery, Beijing and Watergate Gallery, Seoul.
Manifesto, Galeri Nasional Indonesia, Jakarta.
Hyperlinks, Biasa ArtSpace, Seminyak, Bali.
Recent Art from Indonesia: Contemporary Art Turn, SBin Art Plus, Singapore.
Artpreneurship. Space & Image, Ciputra World Marketing Gallery, Jakarta.
Almost White Cube, CG Art Space, Plaza Indonesia, Jakarta.
• 2009
Cross/Piece, Galeri Canna, Jakarta.
Jogja Jamming, 10th Jogja Biennale at Jogja National Museum, Yogyakarta, Central Java.
Gift #2, Nadi Gallery, Jakarta.
Common Sense, Galeri Nasional Indonesia, Jakarta.
The Topology of Flatness, Edwin's Gallery, Jakarta.
Jogja Art Fair #2, Taman Budaya, Yogyakarta, Central Java.
Bazaar Art Jakarta 2009, Pacific Place, Jakarta.

Borderless World, 2 Years of Srisasanti Gallery, Yogyakarta, Central Java.
Mosaic 2009, Vanessa Artlink, Beijing.
Exploring the Root, Galeri Nasional Indonesia, Jakarta.
Oemar Bakrie Teacher, Jogja Gallery, Yogyakarta, Central Java.
Street–Noise, Galeri Semarang, Semarang, Central Java
Fresh 4 U, Jogja Gallery, Yogyakarta, Central Java.

Awan Parulian Simatupang (p. 252)

Born in 1967 in Jakarta, Indonesia.

Solo exhibitions
• 2009
The Other Life, MD Art Space, Jakarta.
• 2007
Housing as a Verb, CP Artspace, Jakarta.
• 2000
Jak Art @ 2000, Wijoyo Center, Jakarta.

Selected group exhibitions
• 2010
T R A M E N D U M, Philo Art Space's 5th Anniversary Exhibition, Galeri Nasional Indonesia, Jakarta.
Institute of Art Jakarta Exhibition, Taman Ismail Marzuki, Jakarta.
Illustration Kompas 2010, Bali, Indonesia.
Artpreneurship. Space & Image, Ciputra World Marketing Gallery, Jakarta.
• 2009
Artention, Grand Kemang, Jakarta.
XYZ, Edwin's Gallery, Jakarta.
Indonesian Art Festival, Galeri Cipta II, Taman Ismail Marzuki, Jakarta.
In Rainbow, Esa Sampoerna Art House, Surabaya, East Java.
The Spirit of Interactions, Erasmus Huis, Jakarta.
• 2007
Domestic Art Object, Yogyakarta, Central Java.
• 2006
Contemporary Indonesian Sculptors, Galleria del Parco Sculture del Chianti, Siena, Italy.
Small Works, API, Taman Budaya, Yogyakarta, Central Java.
• 2005
Small Is Beautiful, Edwin's Gallery, Jakarta.
Bali Biennale, Darga Gallery, Denpasar, Bali.
Urban/Culture, 2nd CP Open Biennale, Museum Bank Indonesia, Jakarta.
Two Fire Spots, Galeri Puri, Malang, East Java.
• 2004
Two Sides, Edwin's Gallery, Jakarta.
Convention, Edwin's Gallery, Jakarta.
Idea dan Exploration, One Gallery, Jakarta.
Six Urban People, Bentara Budaya, Yogyakarta, Central Java.
• 2003
In Search of Peace, WTC, Jakarta, Indonesia.
Mc'row Media, Langgeng Gallery, Magelang, Central Java.
• 2002
Patung @edwingallery.com, Edwin's Gallery, Jakarta.
Metropolitan, Taman Ismail Marzuki, Jakarta.

1001 Indonesian Statues, Bimasena Club, Jakarta.
Struggle and Creation, Erasmus Huis, Jakarta.
• 2001
Metromini, Millennium Gallery, Jakarta.

Awards
• 2005
Winner of Monument Competition Kudus Kota Kretek.
• 1995
Winner of Sculpture Competition Citra Raya Nuansa Seni.

Lekung Sugantika (p. 256)

Born in 1975 in Singapadu, Bali, Indonesia.

Solo exhibitions
• 2010
Finding Objects, Hitam Putih Art Space, Sangeh, Bali.
• 2003
Saign, Taman Budaya, Denpasar, Bali.

Group exhibitions
• 2011
Hictman, Kelompok Hitam Putih, Danes Art Veranda, Denpasar, Bali.
• 2010
Bali Making Choices, Galeri Nasional Indonesia, Jakarta.
• 2009
Man to Man, Tonyraka Art Gallery, Ubud, Bali.
New + News, Gracia Gallery, Surabaya, East Java.
My Name is Tho Land, Galeri Tanah Tho, Ubud, Bali.
Me and My Art, Hitam Putih Art Space, Sangeh, Bali.
• 2008
Animal Kingdom: The Last Chronic, Jogja Gallery, Yogyakarta, Central Java.
Silence Celebration, Tonyraka Art Gallery, Ubud, Bali.
Ahimsa, Bentara Budaya, Jakarta.
Bali Art Now, Jogja Gallery, Yogyakarta, Central Java.
Textures on Painting, Jogja Gallery, Yogyakarta, Central Java.
The Most Wanted, Galeri Biasa, Yogyakarta, Central Java.
Equilibrium, Tonyraka Art Gallery, Ubud, Bali.
Green, Sanur Festival Village, Sindhu Beach, Sanur, Bali.
Aku Yang Bebas, Darga Gallery, Sanur, Bali.
• 2007
Love Letter, Tonyraka Art Gallery, Ubud, Bali.
Atmosphere, Sanur Festival Village, Danes Art Veranda, Denpasar, Bali.
Me Between Us, Tonyraka Art Gallery, Ubud, Bali.
Global Warming, GWK Cultural Park, Bali.
• 2006
Masculine, Danes Art Veranda, Denpasar, Bali.
• 2005
The Painter from Gianyar, Niko Hotel, Jakarta.
27th Bali Art Festival, Taman Budaya, Denpasar, Bali.
Pra Bali Bienale, Tama Gallery, Ubud, Bali.

Hibridity, Kelompok Hitam Putih, Pilar Batu Gallery, Ubud, Bali.
Bali 1st Biennale, Sika Gallery, Ubud, Bali.
• 2004
What Is Behind a Picture, Sudana Gallery, Ubud, Bali.
Five in One, Montiq Gallery, Jakarta.
Red, Kelompok Hitam Putih, Tama Gallery, Ubud, Bali.
• 2003
Black Shit (Tai Black), Sangga Bhuana, Denpasar, Bali.
Big, Perupa 16, Bali Art Centre, Denpasar, Bali.
25th Bali Art Festival, Taman Budaya, Denpasar, Bali.
Vertical, Kelompok Hitam Putih, Rare Angon Gallery, Sanur, Bali.
• 2002
Discovery and Concern, Bali Art Centre, Denpasar, Bali.
24th Bali Art Festival, Taman Budaya, Denpasar, Bali.
Unity, Perupa 16, Gabrig Art Gallery, Sanur, Bali.
Paradise. Youth Activity for Humanity, Sangga Bhuana, Denpasar, Bali.

Awards
• 1999
The Best 40 Finalist of Winsor & Newton Award.
• 1995
Award From the Embassy of Peru.
Award from the Vice President of the Republic of Indonesia, Mr Try Sutrisno.
• 1990
First Winner of Painting Competition of the Bali Museum.

Joko "Gundul" Sulistiono (p. 260)

Born in 1970 in Grobogan, Central Java, Indonesia.

Selected solo exhibitions
• 2005
Eyes, Taman Budaya, Bali.
• 2003
Koong Gallery, Jakarta.
1998
Trash, Dria Manunggal, Yogyakarta, Central Java.
Tight (Sesak), Aikon, Yogyakarta, Central Java.

Selected group exhibitions
• 2010
Jogja Art Share, Jogja National Museum, Yogyakarta, Central Java.
J.A.D., Andi's Gallery, Jakarta.
F.S.S., Surabaya, East Java.
Java Land, Taman Budaya, Yogyakarta, Central Java.
Artlicious, Tujuh Bintang Art Space, Yogyakarta, Central Java.
Face and Mask, Andi's Gallery, Jakarta.
Power Wagon, Jogja National Museum, Yogyakarta, Central Java.
A. Art Fair, Galeri Apik, Singapore.
Hip!, Hip!, Hero!, Galeri Apik, Jakarta.
Expressive, Jogja Gallery, Yogyakarta, Central Java.

The Sun, PP Group at Taman Budaya, Yogyakarta, Central Java.
Inventory, Pesantren Kaliopak, Yogyakarta, Central Java.
Bank Bank K, Bentara Budaya, Yogyakarta, Central Java.
• 2009
Having Fun, Tujuh Bintang Art Space, Yogyakarta, Central Java.
My Art Is Not Long Lasting (Seniku Tak Berhenti Lama), Taman Budaya, Yogyakarta, Central Java.
Jogja Insign, Sozo, Surabaya, East Java.
Exposigns. Great Exhibition of Indonesian Visual Art, 25th Institut Seni Indonesia (ISI) at Jogja Expo Center, Jogyakarta, Central Java.
Jogja Jamming, 10th Jogja Biennale at Jogja National Museum, Yogyakarta, Central Java.
• 2008
Manifesto, Galeri Nasional Indonesia, Jakarta.
Jogja Art Fair #1, Taman Budaya, Yogyakarta, Central Java.
What Is Contemporary Art? (Contemporary Art Apaan Tuh?), Museum Affandi, Yogyakarta, Central Java.
Ya-Sin, Jogja Gallery, Yogyakarta, Central Java.
In Memory of Alit Sembodo, Yogyakarta, Central Java.
Hero, Tujuh Bintang Art Space, Yogyakarta, Central Java.
• 2007
Man, Come On, Man! (Bung Ayo Bung!), 100 Years of Affandi Exhibition, Museum Affandi, Yogyakarta, Central Java.
• 2005
Ceramic, Parkir Space, Yogyakarta, Central Java.
• 2003
Milad, Sanggar Suwung, Yogyakarta, Central Java.
• 2002
Spirit 90, Purna Budaya, Yogyakarta, Central Java.
Transit, Fort Vredenburg Museum, Yogyakarta, Central Java.
• 2000
Seven Liars, Purna Budaya, Yogyakarta and Air Art House, Jakarta.

Awards
• 2000
5 Selected Artist, Philip Morris Indonesia Art Award.

Yudi Sulistyo (p. 264)

Born in 1972 in Yogyakarta, Central Java.

Selected group exhibitions
• 2011
Art Stage Singapore 2011, Marina Bay Sands, Singapore.
Close The Gap: Indonesian Art Today, Melbourne International Fine Art, Melbourne, Australia.
• 2010
Ethnicity Now, Garis Art Space, Galeri Nasional Indonesia, Jakarta.
Korea International Art Fair, Seoul.
Bazaar Art Jakarta 2010, Mon Decor Art Gallery, Pacific Place, Jakarta.

Jogja Art Fair, Taman Budaya, Yogyakarta, Central Yava.
• 2009
Biennale Sastra, Galeri Salihara, Jakarta.
Heroism, Mon Decor Art Gallery, Jakarta.
Exposigns. Great Exhibition of Indonesian Visual Art, 25th Institut Seni Indonesia (ISI) at Jogja Expo Center, Jogyakarta, Central Java.
Jogja Jamming, 10th Jogja Biennale at Jogja National Museum, Yogyakarta, Central Java.
Adopt! Adopt!, Tujuh Bintang Art Space, Yogyakarta, Central Java.
• 2008
Manifesto, Galeri Nasional Indonesia, Jakarta.
After Awakening May 20, Jogja Gallery, Yogyakarta, Central Java.
Narrations of a Nation, Mon Decor Art Gallery, Jakarta.
Utopia Negativa, Langgeng Gallery, Magelang, Central Java.
Homo Homini Lupus, Mon Decor Art Gallery, Jakarta.
• 2007
Neo Nation, 9th Jogja Biennale at Jogja National Museum, Yogyakarta, Central Java.
1001 Cover Concept, Senayan Plaza, Jakarta.
Tribute to Young Artists, Sangkring Art Space, Yogyakarta, Central Java.
Insert Character, Kedai Kebun Forum, Yogyakarta, Central Java.

Awards
• 2007
Kosasih Award.
• 2003
Finalist Indofood Jakarta, Indonesia.

I Made Supena (p. 268)

Born in 1970 in Singapore, China.

Selected solo exhibitions
• 2010
Genealogi, Jogja Gallery, Yogyakarta, Central Java.
• 2008
Emotion, Griya Santrian Gallery, Sanur, Bali.
• 2007
Landscape Made Supena, Gracia Gallery, Surabaya, East Java.
• 2005
Studi Alam Supena, Danes Art Veranda, Denpasar, Bali.
• 2004
The Likeness of Nature, Ganesha Gallery, Jimbaran, Bali.
• 2002
New Painting, Suli Art Gallery, Denpasar, Bali.
About Nature, Mon Decor Art Gallery, Jakarta.

Selected group exhibitions
• 2010
Optimistic, Maha Art Gallery, Sanur, Bali.
Consistence, Dimensi Gallery, Surabaya, East Java.
Dimension, Galeri Canna, Jakarta.
Artpreneurship. Space & Image, Ciputra World Marketing Gallery, Jakarta.

Return to Abstraction, Tonyraka Art Gallery, Ubud, Bali.
Essence, Gaya Fusion Art Space, Ubud, Bali.
Jakarta Award, North Art Space, Jakarta.
Bejing Biennale, Beijing.
• 2009
Fresh 4 U, Jogja Gallery, Yogyakarta, Central Java.
Kompas Illustration, Bentara Budaya, Jakarta.
Singapadu Village Creates Itself, Griya Santrian Gallery, Sanur, Bali.
• 2008
100 Years of National Awakening, Jogja Gallery, Yogyakarta, Central Java.
Soul Entity, Taman Budaya, Denpasar, Bali.
Bali Art Now Hibridity, Jogja Gallery, Yogyakarta, Central Java.
• 2007
Triumph and Defeat, Galang Kangin, Taman Budaya, Yogyakarta.
Thousand Mystery of Borobudur, Jogja Gallery, Yogyakarta, Central Java.
Portfolio, Jogja Gallery, Yogyakarta, Central Java.
• 2006
Behind Realism, V-Art Gallery, Yogyakarta, Central Java.
Triumph and Defeat, Galang Kangin, Santrian Gallery, Sanur, Bali.
Spirit of Bali, Damping Gallery, Ubud, Bali.
• 2005
Interkeation II, Galang Kangin, Taman Budaya, Denpasar, Bali.
Intermezzo, Langgeng Gallery, Yogyakarta, Central Java.
Power of Mind, Orasis Gallery, Surabaya, East Java.
Gianyar Painter Community, Gallery Astra, Jakarta.
Similar (Serupa), Griya Santrian Gallery, Sanur, Bali.
Bali Bienale, Agung Rai Museum of Art, Ubud, Bali.
• 2004
Journey to Foreign Land, Griya Santrian Gallery, Sanur, Bali.
Bali Temptation, Langgeng Gallery, Yogyakarta and V-Art Gallery, Jakarta.
• 2003
In Love with Canvas, Galleri Montic, Jakarta.
The Silent Painting, Griya Santrian Gallery, Sanur, Bali.
Abstract Narration (Narasi Abstrak), Millennium Gallery, Jakarta.
• 2002
Galang Kangin 2001, Taman Budaya, Denpasar, Bali.
Peace Art Festival (Festival Seni Perdamaian), Taman Budaya, Denpasar, Bali.
• 2001
Line and Color, Taman Budaya, Denpasar, Bali.
Bali: Insel der Goether, Mörfelden-Walldorf, Germany.
• 2000
Millennium Exhibition SDI, Museum Neka, Ubud, Bali.
Refleksi Seni II, Darga Gallery, Sanur, Bali.
Landskape and Abstraksi, Museum der Weltkulturen, Frankfurt.

Awards
• 2008
Best Five 100 Year Kebangkitan Jogja Gallery, Yogyakarta, Central Java.
• 2007
Best Five, Thousand Mystery of Borobudur.
• 2005
Award of Excellence, Bali, Indonesia and Prince Edward Island, Canada.
• 2000
Finalist of the Winsor-Newton Competition, Jakarta.
• 1997–2001
Award of Philip Morris Asean, Jakarta.
Award of Menparsenibud, Jakarta.

Public and private collections
Museum der Weltkulturen, Frankfurt.
Museum Neka Ubud, Bali.
Bentara Budaya, Yogyakarta, Central Java.

Melati Suryodarmo (p. 272)

Born in 1969 in Surakarta, Central Java, Indonesia. Lives and works in Braunschweig, Germany and Surakarta.

Solo exhibitions
• 2008
Solitaire, Valentine Willie Fine Art, Kuala Lumpur, Malaysia.
Memorabilia, performance project, Taman Budaya, Jakarta.
Farewell Angel, Lilith Performance Studio, Malmö, Sweden.
• 2007
Perception of Patterns in Timeless Influence, Lilith Performance Studio, Malmö, Sweden.
• 2006
Loneliness in the Boundaries, Cemeti Art House, Yogyakarta, Central Java.

Selected group exhibitions
• 2011
Negotiating Home, History and Nation. Two Decades of Contemporary Art from South East Asia 1991– 2010, Singapore Art Museum, Singapore.
• 2010
Ugo for One Night Stand, Fondazione Volume, Rome.
Exergie-Butter Dance, Lilith performance event, Lilith Performance Studio, Malmö, Sweden.
Exergie-Butter Dance – Extended, Moderna dans Teatern, Stockholm.
Indonesian Contemporary Art Showcase, Artparis, Grand Palais, Champs Elysées, Paris.
• 2009
Kunstbanken, Kunsthalle, Hamar, Norway.
International Incheon Women Artists Biennale, Incheon, South Korea.
Cut. South East Asian Contemporary Photography, travelling to Kuala Lumpur, Singapore and Manila.
Marina Abramovic Presents…, Whitworth Gallery, Manchester, United Kingdom.
Intransit 09, Haus der Kulturen der Welt, Berlin.

• 2008
Tanz im August / Sommer.Bar, Podewil, Berlin.
Sincere Subject, SIGIarts Gallery, Jakarta.
Emerging Discourse: Performance Mimicry II, Bodhi Art, New York.
Manifesta 7, European Biennale, ex Alumix, Bolzano, Italy.
Made Festival, Norlandsoperan, Umeå, Sweden.
• 2007
Insomnia, Nuit Blanche, Le Génerateur, Paris.
The Curtain Opens: Indonesian Women Artists, Galeri Nasional Indonesia, Jakarta.
Erotic Body, Venice Biennale Dance Festival, Venice.
Wind from the East: Perspectives on Asian Contemporary Art, National Gallery, Museum of Contemporary Art, Kiasma, Finland.
• 2006
Deformed Ethic of a Relationship 3.0 for Dormart, Depot, Dortmund, Germany (with Oliver Blomeier).
Accione 06, Madrid.

Residencies
• 2009
IASPIS, Umeå, Sweden.
• 2007
Artist in Studio, Lilith Performance Studio, Malmö, Sweden.

Putu Sutawijaya (p. 276)

Born in 1971 in Angseri, Tabanan, Bali.

Solo exhibitions
• 2011
Gesticlatio, Sangkring Art Space, Yogyakarta, Central Java.
• 2010
Gesticulation, Bentara Budaya, Jakarta and Bali.
• 2008
Man, Mountain, CIGE, Beijing.
Legacy of Sagacity, Galeri Nasional Indonesia, Jakarta.
• 2007
Full Moon, Sin Sin Fine Art, Hong Kong.
Poem of Nature, Valentine Willie Fine Art, Kuala Lumpur, Malaysia.
• 2006
Body-O, Valentine Willie Fine Art, Kuala Lumpur, Malaysia.
• 2005
Dance with Line, Gallery Hotel, Singapore.

Group exhibitions
• 2011
Bali Making Choice, Galeri Nasional Indonesia, Jakarta.
• 2010
Romansa 91, Sangkring Art Space, Yogyakarta, Central Java.
The Birth of Colours, Syang Art Space, Magelang, Central Java.
Museum of Contemporary Art, Shanghai.
Super Socker, Galeri Canna, Jakarta.
Homo Ludens: A Contemporary Art Perspective, Emmitan CA Gallery, Surabaya, East Java.
A Tribute to S. Sudjojono, Sang Ahli Gambar

dan Kawan-Kawan, Galeri Canna, Jakarta.
The Grass Is Greener where You Water It,
Artparis, Grand Palais, Champs Elysées, Paris.
• 2009
Friendship Code, Syang Art Space, Magelang,
Central Java.
Carousel (Komidi Putar), Pameran Seni Rupa
Gasing, Bentara Budaya, Yogyakarta.
Seni Rupa Perang, Kata dan Rupa, Galeri Salihara,
Jakarta.
In Rainbow, Esa Sampoerna Art House, Surabaya,
East Java.
2nd Odyssey, Srisasanti Gallery, Yogyakarta,
Central Java.
Poly-Chromatic, Bentara Budaya, Yogyakarta,
Central Java.
My Art Is Not Dying (Seniku Tak Akan Mati),
Taman Budaya, Yogyakarta, Central Java.
Rainbow, Sunarjo Sampoerna Private Gallery,
Surabaya, East Java.
2D 3D, Sin Sin Fine Art, Hong Kong.
*Exposigns. Great Exhibition of Indonesian Visual
Art*, 25th Institut Seni Indonesia (ISI) at Jogja Expo
Center, Jogyakarta, Central Java.
Bazaar Art Jakarta 2009, Pacific Place, Jakarta.
Next Nature, Galeri Nasional Indonesia, Jakarta.
Oddessy 2nd Anniversary, Srisasanti Gallery,
Yogyakarta, Central Java.
*Humanities: Ben Cabrera, Ahmad Zakii Anwar,
Putu Sutawijaya*, Andrew Shire Gallery,
Los Angeles, California.
Kompas Short Story Illustration Exhibition,
Bentara Budaya, Yogyakarta and Jakarta
Jogja Jamming, 10th Jogja Biennale at Jogja
National Museum, Yogyakarta, Central Java.
• 2008
Reinventing Bali, Sangkring Art Space,
Yogyakarta, Central Java.
The Slice, Soka Art Center, Beijing.
69 Seksi Nian, Jogja Gallery, Yogyakarta,
Central Java.
Space/Spacing, Galeri Semarang, Semarang,
Central Java.
Indonesian Invasion, Sin Sin Fine Art, Hong Kong.
Kompas Short Story Illustration Exhibition,
Galeri Nasional Indonesia, Jakarta.
• 2007
Humanity Mamanoor, Andi's Gallery, Jakarta.
Neo Nation, 9th Jogja Biennale at Taman Budaya,
Yogyakarta, Central Java.
I+, Galeri Canna, Jakarta

Agus Suwage (p. 280)

Born in 1959 in Purworejo, Central Java,
Indonesia.

Selected solo exhibitions
• 2009
Still Crazy After All These Years, Jogja National
Museum, Yogyakarta and Selasar Sunaryo Art
Space, Bandung, West Java.
CIRCL3, Singapore Tyler Print Institute, Singapore.
• 2008
Beauty in the Dark, Avanthay Contemporary,
Zurich.
• 2007
I/CON, Nadi Gallery, Jakarta.

• 2005
Pause / Re-Play, Galeri Soemardja, Bandung,
West Java.
• 2004
Playing the Fool, Valentine Willie Fine Art,
Singapore.
• 2003
Ough… Nguik!!, Galeri Nasional Indonesia and
Nadi Gallery, Jakarta.
• 2002
Atelier Frank and Lee Gallery, Singapore.
Channel of Desire, Nadi Gallery, Jakarta.

Group exhibitions
• 2011
*Negotiating Home, History and Nation: Two
Decades of Contemporary Art From Southeast
Asia, 1991–2010*, Singapore Art Museum,
Singapore.
• 2010
Contemporary Art from Southeast Asia, Arario
Gallery, Seoul.
Illuminance. Agus Suwage + Filippo Sciascia,
Langgeng Art Foundation, Yogyakarta, Central
Java and NUS Museum, Singapore.
Reality Effect, SIGIarts Gallery and Galeri Nasional
Indonesia, Jakarta.
Almost White Cube, CG Art Space, Plaza
Indonesia, Jakarta.
Ecce Homo, Galeri Semarang, Semarang,
Central Java.
Pleasures of Chaos. Inside New Indonesian Art,
Primo Marella Gallery, Milan.
• 2009
Gift #2, Nadi Gallery, Jakarta.
*Broadsheet Notations: Projecting Artworks on
Paper*, Tang Contemporary Art, Bangkok.
Group, Galerie Christian Hosp, Berlin.
Post-Tsunami Art, Primo Marella Gallery, Milan.
Simple Art of Parody, Museum of Contemporary
Art, Taipei.
• 2008
ShContemporary 08, Shanghai Exhibition Center,
Shanghai.
Loro Blonyo Contemporary, Magelang, Central
Java.
Space/Spacing, Galeri Semarang, Semarang,
Central Java.
• 2007
Art Paris—Abu Dhabi, Abu Dhabi, United Arab
Emirates.
Thermocline of Art: New Asian Waves, ZKM,
Karlsruhe, Germany.
• 2006
Singapore Biennale 2006, Singapore.
Past Time, Forgetful Time, Cemeti Art House,
Yogyakarta, Central Java.
Signed and Dated, Valentine Willie Fine Art,
Kuala Lumpur, Malaysia.
• 2005
Beauty and Terror, Loft Gallery, Paris.
Here & Now, Ramzy Gallery, Jakarta.
Kuota 2005, Langgeng–Icon Gallery, Jakarta.
• 2004
Indonesia–China Exhibition, organized by Loft
Gallery Paris, Barcelona, Hong Kong,
Reformasi, Sculpture Square, Singapore.
Olympics, Nadi Gallery, Jakarta.

Silent Action: Creativity for Tolerance and Peace,
4th Art Summit, Galeri Nasional Indonesia,
Jakarta.
Goods Exodus, Nadi Gallery, Jakarta.
Drawing's Trails, Edwin's Gallery, Jakarta.
• 2003
Passion: Etno-Identity, Beijing.
• 2002
Not I Am I, Circle Point Gallery, Washington, DC.

Gintani Nur Apresia Swastika (p. 284)

Born in 1986 in Yogyakarta. Lives and works
in Yogyakarta, Central Java, Indonesia.

Group exhibitions
• 2010
Co-Existence, Tembi Contemporary, Yogyakarta,
Central Java.
Hivos, Hivos, The Netherlands.
• 2009
Hi Grapher, Jogja National Museum, Yogyakarta,
Central Java.
Gift #2, Nadi Gallery, Jakarta.
Jogja Art Fair #2, Taman Budaya, Yogyakarta,
Central Java.
IVAA Archive AID, IVAA, Yogyakarta, Central
Java.
Bohemian Carnival, Galeri Nasional Indonesia,
Jakarta.
Techno Sign, Gramedia Expo, Surabaya, East Java.
Havana Affair, One Gallery, Jakarta.
Type: Reg Effective (Ketik: Reg Manjur), Sangkring
Art Space, Yogyakarta, Central Java.
• 2008
Hello Print!, Edwin's Gallery, Jakarta.
Sacred without Mystique, Jogja Gallery,
Yogyakarta, Central Java.
Indonesian Graphics Now, Tembi Contemporary,
Yogyakarta, Central Java.
Jogja Art Fair #1, Taman Budaya, Yogyakarta,
Central Java.
Carousel, Jogja Gallery, Yogyakarta, Central Java.
Home Sweet Home, Jogja National Museum,
Yogyakarta, Central Java.
• 2007
Cover Boy, girls photography project, Ruang MES
56, Yogyakarta, Central Java.
• 2006
Shocking Bottle, recycled plastic bottle exhibition,
The Gate Café, Yogyakarta, Central Java.
Sneakers Soles, "Customize a Paper Sneakers"
exhibition, Via-Via Café, Yogyakarta, Central Java.
Midnight Live Mural Project, a city mural project
of Jogja Mural Foundation, Yogyakarta, Central
Java.
• 2005
Counter Attract, public art project exhibition,
Cemeti Art House, Yogyakarta, Central Java.
• 2003
*Exhibiting Creation / Creation Degree (Gelar
Karya)*, Modern School of Design, Yogyakarta,
Central Java.

Awards
• 2003
Best Color Composition, Modern School of
Design, Yogyakarta, Central Java.

• 1991
12 Best Drawings, Australia–Indonesia Institute Drawing Contest, Jakarta.

A. C. Andre Tanama (p. 288)

Born in 1982 in Yogyakarta, Central Java, Indonesia.

Solo exhibitions
• 2010
The Tales of Gwen Silent, Bentara Budaya, Yogyakarta.
Final Project of *Master of Art Creation*, Galeri Biasa, Yogyakarta, Central Java.
• 2009
Bazaar Art Jakarta 2009, Indonesian Art Festival, Pacific Place, Jakarta.
• 2007
Technological Hegemony (Hegemoni Teknologi), The Indonesia Institute of The Arts (ISI), Yogyakarta, Central Java.
• 2006
Black and White Scraper (Cukil Hitam Putih), Deket Rumah Café, Yogyakarta, Central Java.
• 2005
Heart Dimension of Life, The Indonesia Institute of The Arts (ISI), Yogyakarta, Central Java.
• 2004
Process, Deket Rumah Café, Yogyakarta, Central Java.

Selected group exhibitions
• 2011
The Alleys of a City Named Jogya, Primo Marella Gallery, Milan.
Art Stage Singapore 2011, Marina Bay Sands, Singapore.
Keberagaman dan Toleransi, Syang Art Space, Magelang, Central Java.
Circus, Galerie Sogan & Art, Singapore.
• 2010
Art towards Global Competition, Langgeng Gallery, Magelang, Central Java.
Bazaar Art Jakarta 2010, Indonesian Art Festival, Pacific Place, Jakarta.
Art|Jog|10. Indonesian Art Now: The Strategies of Being, Taman Budaya, Yogyakarta, Central Java.
Crossing and Blurring the Boundaries: Medium in Indonesian Contemporary Art, Andi's Gallery and Galeri Nasional Indonesia, Jakarta.
Ilustrasi Cerpen Kompas 2009, Bentara Budaya, Jakarta and Yogyakarta, Central Java.
Art for our Life, Gallery of The Ráday Könivesház, Budapest, Hungary.
Monoprint: Between Streams, organized by Andi's Gallery, Jakarta Art District, Grand Indonesia, Jakarta.
Paramitra: Human Eclectic, Mon Decor Art Gallery, Jakarta.
It's a Pop Life!, Zinc Art Space, Kuala Lumpur, Malaysia.
• 2009
Jogja Jamming, 10th Jogja Biennale at Jogja National Museum, Yogyakarta, Central Java.
Exposigns. Great Exhibition of Indonesian Visual Art, 25th Institut Seni Indonesia (ISI) at Jogja Expo Center, Jogyakarta, Central Java.

Robofest, Grha Sabha Pramana, Gajah Mada University, Yogyakarta, Central Java.
Guru Oemar Bakrie, Jogja Gallery, Yogyakarta, Central Java.
Seniku Tak Berhenti Lama!, Taman Budaya, Yogyakarta, Central Java.
• 2008
The Highlight, Jogja National Museum, Yogyakarta, Central Java.
Hello Print, Edwin's Gallery, Jakarta.
Jogja Art Fair #1, Taman Budaya, Yogyakarta, Central Java.
Grafis Hari Ini, Bentara Budaya, Jakarta and Yogyakarta, Central Java.
Harlequin, Langgeng Gallery, Magelang, Central Java.
• 2007
Neo Nation, 9th Jogja Biennale at Taman Budaya, Yogyakarta, Central Java.
Shadows of Prambanan, Jogja Gallery, Yogyakarta, Central Java.
Jogja Printmaking, Taman Budaya Yogyakarta, Central Java.
Conscience Celebrate: September Art Event, organized by Edwin's Gallery, Gandaria City, Jakarta.
Force Majeure: Utan Kayu International Literary Biennale, Langgeng Gallery, Magelang, Central Java.
Trienal Seni Grafis Indonesia II, Selasar Sunaryo Art Space, Bandung, West Java; Galeri Semarang, Semarang, Central Java; Rumah Budaya Jambi and House of Sampoerna Gallery, Surabaya, East Java.
• 2006
Homage 2 Homesite, Jogja National Museum, Yogyakarta, Central Java.
Young Arrows, Jogja Gallery, Yogyakarta, Central Java.
• 2005
8th Jogja Biennale, Karta Pustaka Yogyakarta, Central Java.
Urban/Culture, 2nd CP Open Biennale, Museum Bank Indonesia, Jakarta.

Prilla Tania (p. 292)

Born in 1979 in Bandung, West Java. Lives and works in Bandung.

Solo exhibitions
• 2009
Micro-Cosmos (Mikrokosmos), MD Art Space, Jakarta.
• 2008
Land at the Bottom of the Ocean, Cemara 6 Galeri, Jakarta.
• 2005
Watching Me Watching You Watching Me, Room #1, Bandung, West Java.
• 2003
Phiruku, CCF, Bandung.

Selected group exhibitions
• 2011
Influx, Galeri Cipta II, Taman Ismail Marzuki, Jakarta.
Close the Gap: Indonesian Art Today, MIFA Gallery, Melbourne, Australia.

• 2010
Decompression #10: Expanding the Space and Public, Galeri Nasional Indonesia, Jakarta.
Mediaction, Chiyoda Arts 3331, Tokyo.
Eattoipa, Taiwan International Video Art Exhibition, Hong Gah Museum, Taipei.
Nu Substance: The Loss of the Real, Selasar Sunaryo Art Space, Bandung, West Java.
Look! (Lihat!). Video Art from Indonesia, Galería Jesús Gallardo, Instituto Cultural de León, León, Mexico.
N.B.K. Video-Forum, Neuer Berliner Kunstverein, Berlin.
• 2009
Beyond the Dutch. Indonesia, The Netherlands and the Visual Arts from 1900 until Now, Centraal Museum, Utrecht, The Netherlands.
Very Fun Park, Fubon Art Foundation, Taipei.
Ligne a Ligne, Galeri Nasional Indonesia, Jakarta.
Bandung Art Now, Galeri Nasional Indonesia, Jakarta.
Fluid Zones, Jakarta 13th Biennale, Galeri Nasional Indonesia, Jakarta.
• 2008
Dear Andry, Tribute To Andry Mochamad, S14, Bandung, West Java.
Ze Hui Lai, Taipei Artist Village, Taipei.
Manifesto, Galeri Nasional Indonesia, Jakarta.
The Past – The Forgotten Time, National Museum, Singapore.
• 2007
Beyond the Boundary, IASKA (International Art Space Kellerberrin Australia), Kellerberrin, Australia.
The Past – The Forgotten Time, BizArt, Shanghai; Rumah Seni Yaitu, Semarang, Central Java; Erasmus Huis, Jakarta; Cemeti Art House, Yogyakarta, Central Java; The Netherlands Institute of War Documenation, Amsterdam; Artotheek, The Hague, The Netherlands.
Intimate Distance: Indonesian Women Artists, Galeri Nasional Indonesia, Jakarta (with Videobabes).
Imagining Asia, 22nd Asian International Art Exhibition, Selasar Sunaryo Art Space, Bandung, West Java.
OK Video Militia, Jakarta International Video Festival, Galeri Nasional Indonesia, Jakarta.
• 2006
Beyond, Jakarta Biennale, Galeri Cipta II, Taman Ismail Marzuki, Jakarta.
Passing on Distance, Base Gallery, Tokyo.
Wedding Circle, Gang Festival, Sydney (with Videobabes).
• 2005
OK Video Subversion, Galeri Nasional Indonesia, Jakarta (with Rani Ravenina).
Vague, Centre culturel français, Jakarta.
Passing on Distance, Gallery NAF, Nagoya, Japan.
Imagining Bandung, Galeri Soemardja, Bandung, West Java.
Insomnia, Institute of Contemporary Art, London (with Videobabes).
• 2004
After Party, Common Room, Bandung, West Java.
Premiere Vue, Passage de Retz, Paris.
New-Media@egroups, Lontar Gallery, Jakarta.

Beyond Panopticon, Bandung Electronic City, Bandung, West Java.

Residencies
• 2010
Mediaction, Dis-Locate Residency Program, Chiyoda Arts 3331, Tokyo.
• 2008
TAV (Taipei Artist Village), Taipei.

Titarubi (p. 296)

Born in 1968 in Bandung, West Java, Indonesia.

Solo exhibitions
• 2008
Surrounding David, National Museum, Singapore.
• 2007
Herstory, Bentara Budaya, Jakarta.
A Story without Narration (Kisah Tanpa Narasi), Cemeti Art House, Yogyakarta, Central Java.
• 2004
Seed (Benih), Via-Via Café, Yogyakarta, Central Java.
The Littlest Shadows (Bayang-Bayang Maha Kecil), Kedai Kebun Forum, Yogyakarta, Central Java.
The Littlest Shadows Castle (Bayang-Bayang Maha Kecil Puri), Art Gallery, Malang, East Java.
• 2003
The Littlest Shadows (Bayang-Bayang Maha Kecil), Cemara 6 Galeri, Jakarta.
• 2002
A Body of Thing (Se [Tubuh] Benda), Art Space, Yogyakarta, Central Java.

Selected group exhibitions
• 2011
Negotiating Home, History and Nation. Two Decades of Contemporary Art From South East Asia 1991– 2010, Singapore Art Museum, Singapore.
1001 Doors: Reinterpreting Traditions, Ciputra World Marketing Gallery, Jakarta.
• 2010
Rainbow Asia, Hangaram Art Museum, Seoul Art Center, Seoul.
Welcome to the Bottom (Selamat Datang Dari Bawah), ICAN Art Space, Yogyakarta and Galeri Salihara, Jakarta.
Faith by Chen Hui-Chiao & Titarubi, Sakshi Gallery, Taipei.
The Anniversary of Arti Magazine, Podomoro Park, Jakarta.
Artpreneurship. Space & Images, Ciputra World Marketing Gallery, Jakarta.
Oasis to Be, Maha Art Gallery, Sanur, Bali.
There Is Still Gus Dur (Masih Ada Gus Dur), Langgeng Gallery, Magelang, Central Java.
• 2009
Jakarta Contemporary Ceramics Biennale #1, North Art Space, Jakarta.
Deer Andry, Ruang MES 56, Yogyakarta, Central Java.
My Body, Jakarta Art District, Grand Indonesia, Jakarta.

• 2008
10 Women Visual Artists (10 Perupa Perempuan), Galeri Salihara, Jakarta.
Milestone, Vanessa Artlink, Jakarta.
Re-Reading Driyarkara: Humanity, Education and Nationality (Membaca Kembali Driyarkara: Kemanusiaan, Pendidikan, Kebangsaan), Dies Natalis Universitas Sanata Dharma Ke-53, Yogyakarta, Central Java.
Busan Biennale 2008 Sculpture Project, APEC Naru Park, Busan, South Korea.
The Arafura Craft Exchange: Trajectory of Memories. Tradition and Modernity in Ceramics Museum and Art Gallery of the Northern Territory, Darwin, Australia.
Manifesto, Galeri Nasional Indonesia, Jakarta.
• 2007
Thermocline of Art: New Asian Waves, ZKM, Karlsruhe, Germany.
Neo Nation, 9th Jogja Biennale at Jogja National Museum, Yogyakarta, Central Java.
Ar[t]chipelago Alert, Tonyraka Art Gallery, Ubud, Bali.
Celebr'art'e Fire Boar, Kupu-Kupu Art Gallery, Jakarta and Bali.
Indonesian Women Artists: The Curtain Opens, Galeri Nasional Indonesia, Jakarta.
Fetish Object Art Project #1, Biasa ArtSpace, Seminyak, Bali.
World Social Forum, Kasarani, Moi International Sport Center, Nairobi.
Indonesian Contemporary Artnow, Nadi Gallery, Jakarta.
• 2006
Common Link, Vanessa Artlink, Beijing.
Singapore Biennale 2006, Singapore.
Time and Signs (Masa Dan Tanda-Tanda), Vanessa Artlink, Jakarta.

Public collections
APEC Naru Park, Busan, South Korea.
National Museum, Singapore.

Tromarama (p. 300)

Febie Babyrose, born in 1985 in Jakarta, Indonesia; Herbert Hans Maruli, born in 1984 in Jakarta, Indonesia; Ruddy Alexander Hatumena, born in 1984 in Bahrain.

Solo exhibitions
• 2011
Kidult, Tembi Contemporary, Yogyakarta, Central Java.
• 2010
MAM Project 012, Mori Art Museum, Tokyo.

Selected group exhibitions
• 2010
Made In Indonesia, Galerie Christian Hosp, Berlin.
Video Zone V, The 5th International Video Art Biennial, Tel Aviv.
Art Gwangju 2010, Kim Dae Jung Convention Center, Gwangju, South Korea.
Experimental Deutsche–Indonesian Music and Video, Goethe-Institut, Jakarta.
I Will Cut Thru: Pochoirs, Carvings, and Other Cuttings, The Center for Book Arts, New York

and The Heinheld Visual Arts Center, Sarah Lawrence College, Bronxville, New York.
Contemporaneity: Contemporary Art in Indonesia, Museum of Contemporary Art, Shanghai.
Look! (Lihat!). Video Art from Indonesia, Galería Jesús Gallardo, Instituto Cultural de León, León, Mexico.
Dua Kota Dua Cerita, Galeri Semarang, Semarang, Central Java.
Phitagrafika 2010, The Graphic Unconcious, Philadelphia, Pennsylvania.
Halimun, Lawangwangi Artpark Launching, Bandung, West Java.
• 2009
Jakarta Contemporary Ceramics Biennale #1, North Art Space, Jakarta.
Tropic Lab, Praxis Space, LASALLE College of the Arts, Singapore.
OK Video Comedy, 4th Jakarta International Video Festival, Galeri Nasional Indonesia, Jakarta.
Hybridzation, North Art Space, Jakarta.
Cross Animate, Space C Coreana Arts & Culture Complex, Seoul.
Bandung Art Now, Galeri Nasional Indonesia, Jakarta.
• 2008
Refresh: New Strategies in Indonesian Contemporary Art, Valentine Willie Fine Art, Singapore.
Singapore Biennale 2008, Singapore.
A Decade of Dedication: Ten Years Revisited, Selasar Sunaryo Art Space, Bandung, West Java.
• 2006
Bandung New Emergence, Selasar Sunaryo Art Space, Bandung, West Java.

Selected screenings
• 2010
Long Night of the Austrian Museum, Kunsthalle, Vienna.
Children's Season, Moving Image Gallery, SAM 84, Singapore
Arts for Health, Singapore National Eye Center, Singapore.
• 2009
A Window to the World, Hiroshima City Museum of Contemporary Art, Hiroshima, Japan.

Ugo Untoro (p. 304)

Born in 1970 in Purbalingga, Central Java, Indonesia.

Solo exhibitions
• 2011
Papers and Ugo, Taman Budaya, Yogyakarta, Central Java.
• 2009
Poem of Blood, Rome Contemporary Art Fair, Rome and Nadi Gallery, Jakarta.
• 2008
Terrible Desire, Langgeng Gallery, Hong Kong International Art Fair, Hong Kong.
Poem of Blood, Biasa ArtSpace, Seminyak, Bali and Shanghai Art Fair, Shanghai.
• 2007
Poem of Blood, Galeri Nasional Indonesia, Jakarta

and Taman Budaya, Yogyakarta, Central Java.
Words of Ugo, Art Forum, Singapore.
• 2006
My Lonely Riot, Biasa ArtSpace, Seminyak, Bali.
Short-Short Stories, Valentine Willie Fine Art,
Kuala Lumpur, Malaysia.
• 2004
Silent Texts, Edwin's Gallery, Jakarta.
• 2002
Goro-Goro, Nadi Gallery, Jakarta.

Selected group exhibitions
• 2010
*Art|Jog|10. Indonesian Art Now: The Strategies of
Being*, Taman Budaya, Yogyakarta, Central Java.
Artpreneurship. Space & Image, Ciputra World
Marketing Gallery, Jakarta.
Arte Fiera, Bologna, Italy.
• 2009
Emotional Drawing, The National Museum of
Modern Art, Kyoto, Japan and National Museum,
Seoul.
Arthk 09, Hong Kong International Art Fair, Hong
Kong
Polychromatic, Bentara Budaya, Yogyakarta,
Central Java.
Perang Kata dan Rupa, Komunitas Salihara,
Jakarta.
Indonesia Contemporary Drawing, Galeri
Nasional Indonesia, Jakarta.
The Topology of Flatness, Edwin's Gallery, Jakarta.
Fundraising IVAA, Yogyakarta, Central Java.
Next Nature, Vanessa Artlink, Jakarta.
• 2008
Tjap Djaran: Katuranggan, Bentara Budaya,
Yogyakarta, Central Java.
Artikulasi/Articulate, One Gallery, Jakarta.
Perang Kembang, Bentara Budaya, Yogyakarta,
Central Java.
Indonesian Invasion, Sin Sin Fine Art, Hong Kong.
CIGE, Beijing.
Detour, Koong Gallery, Jakarta.
Sciascia Untoro, Biasa ArtSpace, Seminyak,
Bali.
Emotional Drawing, The National Museum
of Modern Art, Tokyo.
Indonesia Contemporary All Star, Tujuh Bintang
Art Space, Yogyakarta, Central Java.
Arus-Arus Terpencil, Emmitan CA Gallery,
Surabaya, East Java.
Highlight, Jogja National Museum, Yogyakarta,
Central Java.
• 2007
Indonesia Contemporary Art Now, Nadi Gallery,
Jakarta.
Fetish Object Art Project #1, Biasa ArtSpace,
Seminyak, Bali.
Imagined Affandi, Indonesian Archive Building,
Jakarta.
International Literary Biennale, Langgeng Gallery,
Magelang, Central Java.
Man, Come On, Man! (Bung Ayo Bung!), 100
Years of Affandi Exhibition, Museum Affandi,
Yogyakarta, Central Java.
IAAE, Selasar Sunaryo Art Space, Bandung,
West Java.
Indonesian Contemporary, 1918 Art Space,
Beijing.

• 2006
Rampogan, Taman Budaya, Surakarta, Central
Java.
8 Young Contemporaries, Art Forum, Singapore.
Similar to Shakes (Sedulur Gempa), Goethe-
Institut, Jakarta.
Mysterious Dolls, Old Prints, Erasmus Huis,
Jakarta.
• 2005
Vision and Resonance, Asia Contemporary
Inaugural Exhibition, Riveroom Gallery and Asian
Civilizations Museum, Singapore.
Expanded Sculpture, CP Artspace, Jakarta.
*Beauty and Expression of Terror of Indonesian
Contemporary Art*, Galerie Loft, Paris.
Equatorial Heat, Indonesia Painting Exhibition,
Sichuan Art Museum, Sichuan, China.

Awards
• 2007
Man of the Year 2007, Tempo Magazine.
The Best Artist and Work, Kuota Exhibition,
Galeri Nasional Indonesia, Jakarta.
• 1998
Philip Morris Award, Jakarta. The Best 5 Finalist.
Finalist, Philip Morris Competition in Hanoi,
Vietnam.

Made Wiguna Valasara (p. 308)

Born in 1983 in Sukawati, Bali, Indonesia.

Solo exhibitions
• 2010
Animal Behaved, Mon Decor Art Gallery, Jakarta
and Selasar Sunaryo Art Space, Bandung, West
Java.
• 2009
Marshalling Lines And Colors, Galeri Canna,
Jakarta.
*Line as Creation of Painting Expression (Garis
Sebagai Ekspresi Penciptaan Seni Lukis)*, The
Indonesia Institute of The Arts (ISI), Yogyakarta,
Central Java.

Group exhibitions
• 2010
Bali Making Choices, Galeri Nasional Indonesia,
Jakarta.
Medi(a)esthetic, G-Five group exhibition,
Tonyraka Art Gallery, Ubud, Bali.
*Crossing and Blurring the Boundaries:
Medium in Indonesian Contemporary Art*,
Andi's Gallery and Galeri Nasional Indonesia,
Jakarta.
Contemporaneity, Biennale IAA 2010, Galeri
Nasional Indonesia, Jakarta.
Artpreneurship. Space & Image, Ciputra World
Marketing Gallery, Jakarta.
Survey I.10, Edwin's Gallery, Jakarta.
Return to Abstraction, Tonyraka Art Gallery,
Ubud, Bali.
Action 01, Taman Budaya, Yogyakarta, Central
Java.
Almost White Cube, CG Art Space, Plaza
Indonesia, Jakarta.
I Sense, G-Five Community, Galeri Canna,
Jakarta.

• 2009
Jogja Jamming, 10th Jogja Biennale at Jogja
National Museum, Yogyakarta, Central
Java.
September Ceria, Jogja Gallery, Yogyakarta,
Central Java.
The Dream, Tujuh Bintang Art Award, Tujuh
Bintang Art Space, Yogyakarta, Central Java.
Asyaaf Dan Art Season, Galeri Canna, Jakarta.
From Painting to Digital Art, Surabaya Artlink,
Surabaya, East Java.
New+News, Gracia Gallery, Surabaya, East Java.
• 2008
Loro Blonyo Kontemporer, OHD Museum of
Modern & Contemporary Indonesian Art,
Magelang, Central Java.
Bali Art Now: Hybridity, Jogja Gallery, Yogyakarta,
Central Java.
Tracing the Way of Line (Meniti Jalan Garis),
Galeri Semarang, Semarang, Central Java.
Reinventing Bali SDI, Sangkring Art
Space, Yogyakarta, Central Java.
Survey I, Edwin's Gallery, Jakarta.
Harlequin, Langgeng Gallery, Magelang,
Central Java.
• 2007
Artmhosfer Academik, Jogja Gallery, Yogyakarta,
Central Java.
Earth, Mon Decor Art Gallery, Jakarta.
Souvenir (Cenderamata), Bentara Budaya,
Yogyakarta, Central Java.
*Sun Modern Calligraphy (Modern Kaligrafi
Matahari)*, Museum Affandi, Yogyakarta,
Central Java.
Illusions of Nationalism, Jogja Gallery, Yogyakarta,
Central Java.
Turn Right Go Straight (Belok Kanan Jalan Terus),
Sangkring Art Space, Yogyakarta, Central Java.
*Sudden, Orderliness Is Freedom (Sentak,
Keteraturan Adalah Kebebasan)*, Museum
Affandi, Yogyakarta, Central Java.
Tribute to Young Artists, Sangkring Art Space,
Yogyakarta, Central Java.
Identification, Bentara Budaya, Yogyakarta,
Central Java.
Domestic Art Object, Jogja Gallery, Yogyakarta,
Central Java.
Harlah Asri, Fort Vredenburg Museum,
Yogyakarta, Central Java.

Awards
• 2010
Finalist Jakarta Art Award.
Finalist Biennale Indonesia Art Award.
• 2009
Best Award The Dream, Tujuh Bintang
Art Award.

Lenny Ratnasari Weichert (p. 312)

Born in 1970 in Bandung, West Java, Indonesia.
Lives and works in Jakarta, Yogyakarta and
Singapore.

Selected solo exhibitions
• 2003
Open Studio, Sky Light Gallery Delfina Studio,
London, United Kingdom.

• 1998
Up to You, Kedai Kebun Forum, Yogyakarta, Central Java.
• 1996
Kotodesek, Impala Haz Gallery, Szeged, Hungary.

Selected group exhibitions
• 2010
Power Wagon, Jogja National Museum, Yogyakarta, Central Java.
• 2009
Vote Notes, Tembi Contemporary, Yogyakarta, Central Java.
Exposigns. Great Exhibition of Indonesian Visual Art, 25th Institut Seni Indonesia (ISI) at Jogja Expo Center, Jogyakarta, Central Java.
Fun September (September Ceria), Jogja Gallery, Yogyakarta, Central Java.
Truck Dies with Its Baby (Kunduran Truk), Kersan Art Studio, Yogyakarta, Central Java.
Blueprint for Jogya, Tembi Contemporary, Yogyakarta, Central Java.
• 2008
Jogja Salon, CG Art Space, Jakarta.
Fund Rising Red District Project, Koong Gallery, Jakarta.
Table Response "Loro Blonyo", Magelang, Central Java (in collaboration with German artist Franziska Fennert).
• 2007
It's Fun(d), Kelompok Katalist Art Forum and Galeri Biasa, Yogyakarta, Central Java.
Arts for Friends (Bersama Berbagi Daya), Galeri Nasional Indonesia, Jakarta.
• 2002
Experimental Women, The British Council, Jakarta.
Real Indonesian Ethnic Beauty, Joglo Jago, Yogyakarta, Central Java.
• 2001
Women and the Dissemination of Meaning and Space, Galeri Nasional Indonesia, Jakarta.
The Quiet Group, Sheraton Mustika Hotel, Yogyakarta, Central Java.
• 2000
Sculpture 2000, API, Asosiasi Pematung Indonesia, Garuda Hotel, Yogyakarta, Central Java.
Conversation in Mid-Field, Erasmus Huis, Jakarta.
Night's Scream, Embun Gallery, Yogyakarta, Central Java.

Residencies
Art Collaboration Project U(dys)Topia in Dresden and Berlin.

Made Wianta (p. 316)

Born in 1949 in Bali, Indonesia.

Selected solo exhibitions
• 2007
James Gray Gallery, Bergamot Station Centre, Santa Monica, California.
• 2004
Artfolio, Kuala Lumpur, Malaysia.
• 2003
Dream Land, Gaya Fusion Art Space, Ubud, Bali.

• 2002
Dmitry Semenov Gallery, Saint Petersburg, Russia.
• 2000
Retrospective 1970–2000, Museum Rudana, Ubud, Bali.
Amenity Gallery, Tokyo.
• 1999
Art and Peace, Sanur, Bali.
Galerie Darga Lansberg, Paris.
Saint Petersburg and Art Manage Gallery Moscow.
• 1998
Made Wianto's Evolution, Tokyo Station Gallery, Tokyo.
• 1996
Opera Gallery, Singapore.
• 1995
EP Gallery, Düsseldorf, Germany.
• 1993
Fort Mason Centre, San Francisco, California.
• 1992
Bunkamura Gallery, Tokyo.
• 1991
Jernander Art Gallery, Brussels.
• 1990
Gedung Seni Rupa Depdikbud and Taman Ismail Marzuki, Jakarta.

Selected group exhibitions
• 2010
Artpreneurship. Space & Image, Ciputra World Marketing Gallery, Jakarta.
• 2009
CIGE 2009, Beijing.
Exposigns. Great Exhibition of Indonesian Visual Art, 25th Institut Seni Indonesia (ISI) at Jogja Expo Center, Jogyakarta, Central Java.
• 2008
Beijing Olympics And Shanghai Art Fair.
• 2006
Video installation & workshop, The Art Institute of California, San Francisco, California.
• 2005
Mike Weiss Gallery, Chelsea, New York.
• 2004
Art Summit, Indonesia.
Galeri Nasional Indonesia, Jakarta.
+ *Positive*, 2nd Biennale, Merano, Italy.
• 2003
50th Venice Biennale, Venice.
6th International Exhibition of Sculptures and Installations, Open 2003, Venice.
• 1998
Catur Yuga, LASALLE College of the Arts, Singapore.
• 1993
Indonesia Modern Art, Amsterdam.
• 1985
Art Asia At Fukuoka Museum, Fukuoka, Japan.

Entang Wiharso (p. 320)

Born in 1967 in Tegal, Central Java, Indonesia.

Selected solo exhibitions
• 2011
Love Me or Die, Kalamazoo Institute of Arts, Kalamazoo, Michigan and Primo Marella Gallery, Milan.

• 2010
Love Me or Die, Galeri Nasional Indonesia, Jakarta.
• 2008
Black Goat Is My Last Defense, 5 Traverse Gallery, Providence, Rhode Island.
Black Goat, The Drawing Room Contemporary Art, Manila.
Black Goat Space, Ark Galerie, Jakarta.
I Am Black Goat, SMU Concourse. Singapore.
• 2007
Intoxic, Rumah Seni Yaitu, Semarang, Central Java.
• 2006
Puppet Blues, Western Michigan University, Kalamazoo, Michigan.
• 2005
Inter-Eruption, Bentara Budaya, Jakarta.
• 2004
Sublime Tunnel, Circle Point Art Space, Jakarta.
• 2003
Hurting Landscape: Between Two Lines, Gallery Agniel, Providence, Rhode Island and Chouinard Gallery, Hong Kong.
• 2001
Anger Island (Nusaamuk), Galeri Nasional Indonesia and Nadi Gallery, Jakarta.
Anger (Amuk), CP Artspace, Washington, DC.
• 2000
Chouinard Gallery, Hong Kong.
Melting Souls, Gallery Agniel, Providence, Rhode Island.

Group exhibitions
• 2011
Beyond the East: Indonesian Contemporary Art, Museo d'Arte Contemporanea di Roma (MACRO), Rome.
Asia: Looking South, ARNDT, Berlin.
Body Kontemporer: Indonesian Soul, Richmond Center for Visual Arts, Western Michigan University, Kalamazoo, Michigan.
The Ephemeral, ARNDT, Berlin.
Closing the Gap, Melbourne International Fine Art, Melbourne, Australia.
• 2010
The Private Museum. The Passion for Contemporary Art in the Collections of Bergamo, Galleria d'Arte Moderna e Contemporanea (GAMEC), Bergamo, Italy.
AND_Writers, 1st Nanjing Biennale, Jiangsu Provincial Art Museum, Nanjing, China.
Rainbow Asia, Hangaram Art Museum, Seoul.
Pleasures of Chaos. Inside New Indonesian Art, Primo Marella Gallery, Milan.
Contemporaneity: Contemporary Art in Indonesia, Museum of Contemporary Art, Shanghai.
Vault Portrait Series, New Bedford Art Museum, New Bedford, Massachusetts.
Time Conversation, Galeri Nasional Indonesia, Jakarta.
Collectors' Turn, Lawangwangi Artpark Launching, Bandung, West Java.
Crossing and Blurring the Boundaries: Medium in Indonesian Contemporary Art, Andi's Gallery and Galeri Nasional Indonesia, Jakarta.

• 2009
Expanded Painting 3, 4th Prague Biennale, Prague.
A Transversal Collection: From Duchamp to Nino Calos, from Cattelan to Entang Wiharso, Arte Contemporanea ALT – Arte Lavoro Territorio, Bergamo, Italy.
Viewing and Viewing Point, 2nd Asian Art Biennale, National Taiwan Museum of Fine Arts, Taipei.
Common Sense, Galeri Nasional Indonesia, Jakarta.
South East Asia B(l)ooming, Primo Marella Gallery, Milan.
Exposigns. Great Exhibition of Indonesian Visual Art, 25th Institut Seni Indonesia (ISI) at Jogja Expo Center, Jogyakarta, Central Java.
Jogja Jamming, 10th Jogja Biennale at Jogja National Museum, Yogyakarta, Central Java.
Living Legends, Galeri Nasional Indonesia, Jakarta.
• 2008
Highlights From ISI, Jogja National Museum, Yogyakarta, Central Java.
Self Portrait. Famous Living Artists of Indonesia, Jogja Gallery, Yogyakarta, Central Java.
Manifesto, Galeri Nasional Indonesia, Jakarta.
The Third Space: Cultural Identity Today, Mead Art Museum, Amherst, Massachusetts.
Grounded in Space, Eli Marsh Gallery, Amherst, Massachusetts.
Indonesian Invasion, Sin Sin Fine Art, Hong Kong.
A New Force of South East Asia, Edwin's Gallery – Asia Art Centre, Beijing.

Public collections
Arte Contemporanea ALT, Bergamo, Italy.
Carnegie Mellon University, Pittsburgh, Pennsylvania.
Marino Golinelli Foundation, Bologna, Italy.
Mariyah Gallery, Dumaguete City, Philippines.
Mead Art Museum, Amherst, Massachusetts.
OHD Museum of Modern & Contemporary Indonesian Art, Magelang, Central Java.
RISD Museum, Providence, Rhode Island.
Rubell Family Collection, Miami, Florida.
Rudi Akili Museum, Jakarta.
Singapore Art Museum, Singapore.
Singapore Management University, Singapore.

I Wayan Wirawan (p. 324)

Born in 1975 in Sukawati, Gianyar, Bali, Indonesia.

Solo exhibitions
• 2005
Onani, Bentara Budaya, Yogyakarta, Central Java.
• 2000
Album Launching by Katon Bagaskara, Bentara Budaya, Jakarta (in collaboration with Damai Dan Cinta).

Group exhibitions
• 2010
Exposigns. Great Exhibition of Indonesian Visual Art, 25th Institut Seni Indonesia (ISI) at Jogja Expo Center, Jogyakarta, Central Java.

Noun (Kata Benda), N-Art, Ubud, Bali.
• 2009
Spirit 95 (Greget 95), Sangkring Art Space, Yogyakarta, Central Java.
Experimental Art, Sanur Festival, Sanur, Bali (in collaboration with Kelompok Lingkar).
• 2008
Equilibrium, Tonyraka Art Gallery, Ubud, Bali.
Souls Entity, Taman Budaya, Bali.
Super Ego, Ego Gallery, Jakarta.
• 2007
Two Firmaments (Dua Cakrawala), Ten Fine Art, Bali.
Eleven Painters, Galeri Canna, Jakarta.
Sanur Festival, Sanur, Bali.
Global Warming, GWK Cultural Park, Bali.
• 2006
Expert (Jago), Niki Gallery, Ubud, Bali.
Indonesian Traffic, Mon Decor Art Gallery, Jakarta.
Rotten Head (Kepala Busuk), Taman Budaya, Denpasar, Bali.
Green Zone, Green House, Ubud, Bali.
• 2005
Small Word, Vanessa Art House, Jakarta.
Mini Market, Museum Bali, Denpasar, Bali.
• 2003
Six Appearances Six Colours, One Gallery, Jakarta.
Crazy Era (Zaman Edan), Bentara Budaya, Yogyakarta, Central Java.
Threesome (Bertiga), Taksu Gallery, Jakarta.
• 2002
Finalist of Philip Morris Indonesian Art Award, Galeri Nasional Indonesia, Jakarta.
Human Transformation (Transformasi Manusia), Galeri Canna, Jakarta.
• 2001
Balinese Young Artists, Bentara Budaya, Jakarta.
Suara Hati, Bentara Budaya, Yogyakarta, Central Java.
Bias in Border, Edwin's Gallery, Jakarta.
• 2000
Tritaksu, INA Gallery, Jakarta.

Awards
• 2000
Finalist Nokia Award.
• 1998
Dies Natalis XVI Awards from ISI, Yogyakarta, Central Java.

Tintin Wulia (p. 328)

Born in 1972 in Bali, Indonesia. Lives and works in Jakarta, Indonesia and Melbourne, Australia.

Selected solo exhibitions
• 2011
Terra in Toto, Langgeng Gallery at Jakarta Art District, Jakarta.
• 2010
Deconstruction of a Wall, Ark Galerie, Jakarta.
• 2008
Invasion, Motive Gallery, Amsterdam.
Landing Soon #5, Cemeti Art House, Yogyakarta, Central Java.

• 2007
Plug in #21, Van Abbemuseum, Eindhoven, The Netherlands.
• 2006
Everything's OK, The White Cube, Norrlandsoperan, Sweden.

Selected group exhibitions, screenings and broadcasts
• 2011
Influx: Multimedia Arts Strategy in Indonesia, ruangrupa 10th Anniversary, Galeri Cipta II, Taman Ismail Marzuki, Jakarta.
Kaap Biennial, Fort Ruigenhoek, Groenekan, The Netherlands.
The Indonesia, Espace Culturel Louis Vuitton, Paris.
• 2010
Recorded Waves: Moving Images from Indonesia, Para/Site Art Space, Hong Kong.
Manifesto of New Aesthetics: Seven Artists from Indonesia, Institute of Contemporary Art, LASALLE College of the Arts, Singapore.
Last Words: Asian Traffic, 4A Centre for Contemporary Asian Art, Sydney.
Inventory: New Art From Southeast Asia, Osage Gallery, Singapore.
• 2009
Beyond the Dutch. Indonesia, The Netherlands and the Visual Arts from 1900 until Now, Centraal Museum, Utrecht, The Netherlands.
Diaspora, Edinburgh Festival, Edinburgh, Scotland.
13th Jakarta Biennale, Jakarta.
38th International Film Festival, Rotterdam, The Netherlands.
Some Rooms, Osage Gallery, Hong Kong.
• 2008
Tea Pavillion, Guangzhou Triennial, Guangzhou, China.
Be[com]ing Dutch, Stedelijk Van Abbemuseum, Eindhoven, The Netherlands
30th Clermont-Ferrand Short Film Festival, Clermont-Ferrand, France.
• 2007
Geopolitics of the Animation, Centro Andaluz de Arte Contemporáneo, Sevilla, Spain.
Taipei Film Festival, Taipei.
12th International Media Art Biennale, Wroclaw, Poland.
Mapping the City, Stedelijk Museum, Amsterdam.
• 2006
Hiding City, Seeking City, Liverpool Biennial, Liverpool, United Kingdom.
Trial Balloons, Museo de Arte Contemporáneo de Castilla y León, León, Spain.
Archipeinture, FRAC Île de France Le Plateau, France.
Jakarta Biennial, Jakarta.
• 2005
Spaces and Shadows, Haus der Kulturen der Welt, Berlin.
Yokohama Triennial 2005, Yokohama, Japan.
9th Istanbul Biennial, Istanbul.
Insomnia, Institute of Contemporary Art, London.
34th International Film Festival, Rotterdam, The Netherlands.

• 2004
Indonesia Under Construction, Witte de With, Center for Contemporary Art, Rotterdam.
9th Busan International Film Festival, Busan, South Korea.
Reformation: Indonesian Artists After Soeharto, Singapore Arts Festival, Singapore.
11th New York Underground Film Festival, New York.
• 2003
Worms Festival 5: House, Plastique Kinetic Worms, Singapore.
8th Manchester International Short Film and Video Festival, Manchester, United Kingdom.
19th Hamburg International Short Film Festival, Hamburg, Germany.
16th Singapore International Film Festival, Singapore.

Selected residencies and awards
• 2008
• Residency, Market Value Project at Preston Market, Australia.
• 2005
Residency, 72-13/International Centre of Asian Arts, Singapore.
• 2004
Residency, Goethe-Institut, Göttingen, Germany.
• 2003
1st Special Mention, 19th Hamburg International Short Film Festival, Hamburg, Germany.
• 2002
Best Film (Set Awards) and Best Technical Achievement (Kuldesak Awards), Festival Film Video Independent Indonesia 2002, Jakarta.
• 2000
Best Conceptual Film (Kuldesak Awards), Festival Film Video Independent Indonesia 2000, Jakarta.

Public collections
Stedelijk Van Abbemuseum, Eindhoven, The Netherlands.

Gede Mahendra Yasa (p. 332)

Born in 1967 in Singaraja, Bali, Indonesia.

Solo exhibitions
• 2010
As the Face No Longer Bespeaks the Soul, SIGIarts Gallery, Jakarta.
• 2009
Hendra's Woman: Reframing de Kooning, SIGIarts Gallery, Jakarta.
• 2008
The Painter's Palette, The Aryaseni Art Gallery, Singapore.
White Series: Allegory of Painting, Richard Koh Fine Art, Kuala Lumpur, Malaysia.
• 2007
Hendra Membaca Pollock, Emmitan CA Gallery, Surabaya, East Java.

Group exhibitions
• 2010
Reality Effect, Galeri Nasional Indonesia, Jakarta.
Pleasures of Chaos. Inside New Indonesian Art, Primo Marella Gallery, Milan.

• 2009
Post-Tsunami Art, South East B(l)ooming, Primo Marella Gallery, Milan.
Hybridization, North Art Space, Jakarta.
Expanded Painting 3, 4th Prague Biennale, Prague.
Friendship Code, Syang Art Space, Magelang, Central Java.
• 2008
Taxu 2008: Painting Rejuvenation, SIGIarts Gallery, Jakarta.
Space, Galeri Semarang, Semarang, Central Java.
Manifesto, Galeri Nasional Indonesia, Jakarta.
• 2007
Kuota 2007, Galeri Nasional Indonesia, Jakarta.
On Appropriation, Galeri Semarang, Semarang, Central Java.
• 2006
Surface, Emmitan CA Gallery, Surabaya, East Java.
Langgeng Contemporary Art Festival, Langgeng Gallery, Magelang, Central Java.
Taxu Art Clinic 2006, CP Artspace, Jakarta.
• 2005
Urban/Culture, 2nd CP Open Biennale, Museum Bank Indonesia, Jakarta.
Trans-It, Biasa ArtSpace, Seminyak, Bali.
...Reading Realism, Nava Gallery, Denpasar, Bali.
• 2004
Tamarind... In Pursuit of Identity, Nava Gallery, Denpasar, Bali.
Cooking & History, Cemeti Art House, Yogyakarta, Central Java.
• 2003
Interpellation, 1st CP Open Biennale, Galeri Nasional Indonesia, Jakarta.
Caution!!! There Is a Taxu Ceremony, Klinik Seni (Art Clinic) Taxu, Denpasar, Bali.
• 2001
Against Bali Art Festival, in front of Latta Mahosadi Museum, Indonesian Art College, Denpasar, Bali.
To Breaking Down Hegemony, Kamasra (the association of visual art students) of Indonesian Art College, Denpasar, Bali.
• 2000
Democracy in Visual Expression, the 8th Anniversary of Denpasar, Bali.

Muhammad "Ucup" Yusuf (p. 336)

Born in 1975 in Yogyakarta. Lives and works in Yogyakarta, Central Java, Indonesia.

Solo exhibitions
• 2005
Arok Dedes Pramoedya Ananta Toer. A Visual Interpretation, Lontar Gallery, Jakarta.

Group exhibitions
• 2010
100 Days of Gusdur, Langgeng Gallery, Magelang, Central Java.
Mirroring on Mud (Bercermin Dalam Lumpur), El Pueblo Café, Yogyakarta, Central Java.
• 2009
Type Reg Effective (Ketik Reg Manjur), Sangkring Art Space, Yogyakarta, Central Java.

Reform, Jogja National Museum, Yogyakarta, Central Java.
Indonesian Contemporary Art, Bus Gallery, Sydney.
Never Ending Courage, conference of Bird Gallery, Bangkok.
Exposigns. Great Exhibition of Indonesian Visual Art, 25th Institut Seni Indonesia (ISI) at Jogja Expo Center, Jogyakarta, Central Java.
Festival Kesenian Indonesia, Taman Ismail Marzuki, Jakarta.
Triennial Grafis III, Bentara Budaya, Jakarta, Yogyakarta and Bali.
Jogja Jamming, 10th Jogja Biennale at Jogja National Museum, Yogyakarta, Central Java.
Indonesian History Mural (Mural Hikayat Indonesia), Museum Istana, Yogyakarta, Central Java.
• 2008
Print of Wood Crowbar (Cetak Cukilan Kayu), Warung Madura, Lumajang, East Java.
What Is Contemporary Art? (Contemporary Art Apaan Tuh?), Museum Affandi, Yogyakarta, Central Java.
Jogja Art Fair #1, Taman Budaya, Yogyakarta, Central Java.
Reform, Langgeng Bistro, Yogyakarta, Central Java.
Taringpadi Woodblock, Rock Paper Scissors Gallery, Oakland, California.
• 2007
If You See Something, Say Something, 4a Gallery, Sydney.
International Literary Biennale, Langgeng Gallery, Magelang, Central Java.
Leftover (Sisa), University of Technology, Sydney.
• 2006
Draw, Museum Dan Tanah Liat, Yogyakarta, Central Java.
Stockroom, Biasa ArtSpace, Seminyak, Bali.
Similar to Shake (Sedulur Gempa), Goethe-Institut, Jakarta.
GANG Festival, Sydney.
• 2005
Art for Nature, Rimbun Dahan Gallery, Selangor, Malaysia.
Intercity, Inter-Province (Antar Kota, Antar Propinsi), Indonesian Red Cross Building, Jember, West Java.

Awards
• 2009
Finalist of Graphic Triennale III, Indonesia.
Mural Hikayat Indonesia at Museum Istana, Yogyakarta, Central Java.

Authors and Curators

Susan Ingham obtained her PhD from the University of New South Wales College of Fine Arts in 2008. Her thesis on contemporary Indonesian art is being prepared for publication. Since retiring from a 25-year career teaching the history and theory of art in the Department of Technical and Further Education Schools of Fine Arts, she has concentrated on research and publications. These include the *Contemporary Arts + Culture Broadsheet*, South Australia, and *C Arts*, Singapore, as well as essays associated with exhibitions including the travelling show *Asian Traffic*, 2004–06 and *Contemporaneity: Contemporary Art of Indonesia*, Shanghai, 2010.

Asmudjo Jono Irianto (b. 1952) is an independent curator, whose career began in the 1990s. His curatorial projects include the 6th Yogyakarta Biennale (1998), CP Biennale (2003 and 2005) and the most recent *1001 Doors: Reinterpreting Traditions* at Ciputra World Marketing Gallery, Jakarta (2011). He has been a lecturer at the Faculty of Art and Design in Bandung Institute of Technology since 1992. Well known also as an artist, he has taken part in several art exhibitions. In 2002 he established an alternative space named "Fabriek Gallery" in Bandung, West Java.

Amanda Katherine Rath (b. 1965), PhD in Art History, Cornell University, is a Fellow in the Department of Southeast Asian Studies at the University of Frankfurt, Germany. She also lectures in the Curatorial Studies Program at that university. She specializes in the discourses of contemporary art of Southeast Asia with an emphasis on Indonesia and Malaysia. Her published works include articles on internationally known artists such as Entang Wiharso, Krisna Murti, Mella Jaarsma, Nindityo Adipurnomo and FX Harsono. Her current research and teaching interests revolve around issues of community-based work as artists travel between different locations.

Jim Supangkat (b. 1948) is an art critic and chief curator of CP Foundation in Jakarta. He was professor of Fine Arts and Design, Bandung Institute of Technology for twenty years. As the leading curator in Indonesia, in the 1970s he initiated the "Indonesia New Art Movement" regarded as the beginning of contemporary art discourse in Indonesia. He has been curating international contemporary art exhibitions in Indonesia including *Contemporary Art of the Non-Aligned Countries* (1995), the 1st and 2nd CP Biennales (2003 and 2005), *Contemporaneity: Contemporary Art in Indonesia* at MoCA Shanghai (2010). He has written several books and numerous essays introducing contemporary art in Asia and Indonesia to the international art world. In 1997, he received the Prince Claus Award for this attempt.

Leonor Veiga (b. 1978) is a postgraduate in Curatorial Studies from the Fine Arts School of Lisbon University, where she is currently a Research Fellow at CIEBA (Fine Arts Research and Studies Centre). Her dissertation *Memory and Contemporaneity* describes the role of tradition and its contribution to contemporary art practices in the Indonesian context. Recent talks at various venues include *Ashley Bickerton: – A New Asia* and *Indonesian Batik: The Encounter with China*. Her curatorial works include exhibitions in Macau, Mozambique, Portugal and more recently in Indonesia, including the seminal *Tough Love* in Lisbon, Portugal as the assistant curator to Shaheen Merali with whom she has been associated since 2009. Her overall interest can be described as working at the forefront of emerging issues and theories from the Asian continent.

Tsong-Zung Chang is a guest professor of China Art Academy in Hangzhou and Director of Hanart TZ Gallery in Hong Kong. Chang has been active in curating exhibitions of Asian contemporary art since the 1980s. In 1995, he was asked to select the Chinese artists for the Venice Biennale and curated the special Chinese Exhibition for the 23rd São Paulo Biennial in Brazil (1996), the third Guangzhou Triennial (2008), and *Spiritual Space: A Dimension in Lacquer* (Hubei Province Museum of Art, 2009).

Serenella Ciclitira has an Honours Degree in Art History from Trinity College, Dublin and has worked extensively with artists and galleries throughout the world. With her husband David Ciclitira, she is the Co-founder and Curator of Korean Eye and editor of the *Korean Eye* book. She has been an Honorary Fellow at the Royal College of Art in London and since 1990 has been awarding the Parallel Prize for Painting and the Serenella Ciclitira Scholarship for Sculpture. One winner was later nominated for the Turner Prize and three of her choices went to win the prestigious Jerwood Sculpture Prize.

Nigel Hurst is Gallery Director and Chief Executive of the Saatchi Gallery in London. He graduated from Goldsmiths College, London University in 1986 and since then has curated numerous international exhibitions. He joined the Saatchi Gallery as a curator in 1997, working on *Sensation* at the Royal Academy of Arts, London, the Nationalgalerie at the Hamburger Bahnhof, Berlin and the Brooklyn Museum of Art in New York. More recent exhibitions have focused on Asian contemporary art, including *The Revolution Continues: New Art from China* (2008), *Unveiled: New Art from the Middle East* (2009), *The Empire Strikes Back: Indian Art Today* (2010) and *The Silk Road* in collaboration with the City of Lille, France (2011). He has also been a member of The Royal Borough of Kensington & Chelsea Public Art Advisory Board since 2009.

Everyone recognizes Indonesia as a big nation with an abundant and diverse cultural heritage. This makes us proud to be one of the *Indonesian Eye* sponsors. Also, we feel highly privileged to take part in the undertakings of improving Indonesia's contemporary arts. These undertakings, in turn, are expected to bring Indonesian arts to the international level.

Very few organizations in the world are led by visionaries with ambitious dreams and with the capacity, resources and whole-hearted determination to realize them. I am proud to say that Ciputra Group is one of them. And our company motto is: "Creating World Entrepreneur".

I founded Ciputra Group in 1981 with a vision to develop a property business group with a spirit of excellence and innovation; and, looking beyond what is and seeing what might be, to create better value for society and bring welfare and prosperity for the stakeholders.

For me, building a new city is like creating a beautiful statue – I hope to create a masterpiece for all to enjoy. An idea becomes an inspiration, and combined with my personal artistic touch it blooms towards implementation. The integration of nature and green spaces with artistic designs is a common and visible theme in our work.

I am grateful to have the support of a team of talented and dedicated people in the Ciputra Group who share my drive of value creation with constant innovation to win the hearts of customers. The spirit of excellence inherited by the team has clearly become the fuel for the innovation of the group.

Our team has a single mission: to become the frontrunner in the property business by striving to be the best, professionally and financially, so it will become the customers' first choice, the employees' most interesting and challenging workplace, the stockholders' most profitable investment and the nation's top contributor. For this Ciputra Group has been thought of by many to be one of the prime property business enterprises in Indonesia.

Our group has embarked on projects both in Indonesia and overseas. We specialize in City & Township Development, Commercial and Mixed & Single Use Developments. Domestically, we have expanded to sixteen cities covering twenty-six projects. Internationally, we have footprint in Vietnam, Cambodia and China.

Ciputra Group is currently developing its latest prominent projects. Two mega mixed-use projects: Ciputra World Surabaya and Jakarta with around US $1 billion in total costs. The projects are expected to be completed in 2011 and 2012, respectively. It is in the Ciputra World Jakarta that we will build the Ciputra World Artpreneur Centre that will include a gallery, a museum, an exhibition hall, a studio and a performing art theatre.

As a keen art lover and collector, my interest in the Indonesian art world development led me to envision this centre with a purpose to improve the living standards of Indonesian artists and the art world. I believe that the spirit of entrepreneurship will unleash unto Indonesian artists the potential to create a more prosperous future. The two consecutive major artpreneurship events in Jakarta in March 2010 and January 2011 aim at creating more national and international exposure for Indonesian artists. Ciputra World Artpreneur Centre will amplify the impact of artpreneurship and I hope this message continues to be spread around the world.

When once asked what encourages me to make all of these efforts, I feel that Kahlil Gibran summed it up best: "Love has no other desire but to fulfil itself". My love of art and entrepreneurship has realized itself in the dream, the drive and the ultimate determination to create betterment for humanity through art and entrepreneurship.

Last but not least, we at Ciputra Group are honoured to contribute to a beneficial prestigious event like the *Indonesian Eye*. We wish to thank David and Serenella Ciclitira, the founders of Indonesian Eye for their unwavering support and perpetual dedication. It is with their assistance that we are able to provide more access and publication for our talented Indonesian artists.

Ir. Ciputra
Founder of Ciputra Group